Aesthetic Revolutions

and Twentieth-Century Avant-Garde Movements

Duke University Press Durham and London 2015

Aesthetic Revolutions
and Twentieth-Century Avant-Garde Movements

ALEŠ ERJAVEC, EDITOR

© 2015 Duke University Press
All rights reserved
Printed in the United States of America on acid-free paper ∞
Text designed by Courtney Leigh Baker
Typeset in Trade Gothic and Minion Pro
by Tseng Information Systems, Inc.

Library of Congress Cataloging-in-Publication Data
Aesthetic revolutions and twentieth-century avant-garde
movements / Aleš Erjavec, editor.
pages cm
Includes bibliographical references and index.
ISBN 978-0-8223-5861-9 (hardcover : alk. paper)
ISBN 978-0-8223-5872-5 (pbk. : alk. paper)
ISBN 978-0-8223-7566-1 (e-book)
1. Avant-garde (Aesthetics)—History—20th century.
2. Aesthetics—Political aspects. I. Erjavec, Aleš.
BH301.A94A37 2015
700.9′04—dc23 2014039594

Cover design: New Collectivism.

Contents

Illustrations

Acknowledgments

The idea for this book arose in Beijing in November 2009. In the months that followed, our group assembled and started to work on the nascent book. Sadly David Craven and Heinz Paetzold passed away in 2012. We miss them.

For his support and continuous interest in the project I wish to express special gratitude to Terry Smith. The following people have also been instrumental in bringing this book from the mental shelf to the bookshelf: Thomas Berghuis, Günter Berghaus, IRWIN, Gerardo Mosquera, Gao Jianping, Curtis Carter, Desiderio Navarro, Katya Mandoki, Wang Jie, Wang Jianjiang, Brian Winkenweder, Paula Zupanc, Erik Bachman, and Simon Tecco.

I also wish to recognize the continuous support of my home institution, the Institute of Philosophy, Scientific Research Center of the Slovenian Academy of Sciences and Arts. Special mention to Matej Ažman, who on every step of the winding publishing path supplied versatile technical support. The editorial guidance of Ken Wissoker is hereby gratefully acknowledged, as well as the support, advice, and alacrity of various people at Duke University Press during the preparation and production of this book. Finally, our sincere gratitude to the anonymous readers for their comments, advice, and especially criticism.

Introduction

ALEŠ ERJAVEC

Three Propositions

In this book we discuss the art, acts, actions, and ideas of those avant-garde movements of the last century that not only offered new artistic representations of the world (i.e., introduced into art radical changes in style and technique) but also demanded that art transforms the world rather than only representing it.

Artists always to some extent transform the world with their art. But it makes a big difference which of these two goals—representation or transformation—an artist regards as art's essence and purpose and thus assigns priority. If the artist's primary goal is to be the transformation of the world,

then this demands a transformation both of life itself and of the community. If the goal instead involves representing the world, then this means supplying meaning and causing the happening of truth—as when Paul Cézanne learns how to paint a "tablecloth white as a layer of fresh-fallen snow."[1] The pleasure involved is—as Aristotle writes in *Poetics* and Ernst Gombrich agrees—"one of recognition."[2]

My central premise in this introduction and in the conclusion will be that throughout the twentieth century there exists a segment of avant-garde art that is sufficiently specific to warrant a determinate designation, namely that of the "aesthetic" avant-garde art. "Aesthetic" here will be used not as a synonym for "artistic," but rather as its complement, extending from specifically artistic experiences to the broad, holistic domain of lived and imagined experiences, including social, political, bodily, and technological dimensions. The meaning of the "aesthetic" is related to that found in Friedrich Schiller (1759–1805), for whom it is linked to politics, not only to pure beauty and autonomous art, as is today often the case.

The aesthetic, *aisthesis*, while referring to the general perception with all the senses, will in the case of aesthetic avant-gardes relate primarily to their demand to move from representation to transformation of a community—whether a nation, a class, or some other social entity. The aesthetic "is the articulation between art, the individual and the community,"[3] bringing together—as Schiller claims in the fifteenth letter in *On the Aesthetic Education of Man, in a Series of Letters*—the art of the beautiful (*der ästhetische Kunst*) and the art of living (*Lebenskunst*).

The studies that follow support the claim that a substantial portion of the so-called early (also called "classical" and "historical") avant-gardes, a few of the later neo-avant-gardes, and finally some of the "postsocialist" avant-gardes necessitate designation as "aesthetic avant-gardes," whereby it will be possible to grasp the specific features of the radical wing of these twentieth-century movements. I will thus suggest that in the twentieth century we can identify three periods of avant-garde movements; the third is constituted by postsocialist avant-gardes, which otherwise exist in conceptual limbo halfway between postmodern art and global modernisms.

Let me repeat these propositions via three partly interrelated claims:

(1) Avant-garde movements constitute a *spectrum*, with the artistic avant-gardes at one end. These are avant-gardes that introduce into art new styles and techniques (such as cubism or abstract expressionism). They engender new representations of the lived world, thereby occasionally causing an artistic revolution. They represent "pure art"—but only as an ideal type. At

the other end of the same spectrum are avant-gardes that strive to reach beyond art into "life" and aim to transform the world. These latter ones, called interchangeably "extreme," "politicized," "revolutionary," "radical," "artistic-social," "poetico-political," "aesthetic-political," and so on, will be designated as "aesthetic" avant-garde movements and will be the main focus of attention. It is not that the works of an aesthetic avant-garde are devoid of "artistic" features, but simply that their "aesthetic" dominant also shapes the "artistic" elements of such works in a set with an experience-transforming orientation.

If the first kind of avant-gardes (the "artistic" avant-gardes) is predominantly autonomous, then the second is mostly heteronomous. Over time the heteronomous works of avant-garde art become increasingly autonomous: their statements, documentation, and extra-artistic actions are progressively transformed into expanded forms of art.

(2) Aesthetic avant-gardes seek to effect aesthetic revolutions, that is, to substantially affect and transform our ways of experiencing and sensing the world, to change in important ways the manner in which we perceive and experience reality. They aim at a "redistribution of the sensible" (Jacques Rancière) in order to constitute ways in which "the system of divisions . . . assigns parts, supplies meanings, and defines the relationships between things in the common world."[4]

(3) "Postsocialist avant-gardes" (alternatively called "third-generation avant-gardes") are intended to designate movements from present or former socialist countries whose art possessed features common to other avant-garde art of the twentieth century. Due to some similarities with postmodernism, they were sometimes designated as Eastern or postsocialist postmodernism. A part of them once again consisted of "aesthetic avant-gardes."

First Proposition: Aesthetic Avant-Gardes

In 1845 the Fourieriste Gabriel-Désiré Laverdant wrote: "To know . . . whether the artist is truly of the avant-garde, one must know where Humanity is going, know what the destiny of the human race is."[5] Even today such an avant-gardist should be able to tell us where his community is going.

By relating the aesthetic realm to all areas of human activity, Friedrich Schiller was the first to explicitly connect the domains of aesthetics and politics: "If man is ever to solve the problem of politics in practice he will have to approach it through the problem of the aesthetic, because it is only through Beauty that man makes his way to Freedom."[6]

Similarly, Jacques Rancière has recently argued that "social revolution is

the daughter of aesthetic revolution."[7] His opinion is shared by Slavoj Žižek, who has proclaimed Rancière's "assertion of the aesthetic dimension as IN-HERENT in any radical emancipatory politics" to be one of his great break-throughs.[8] In this way, obviously, two central tenets of twentieth-century classical "humanist" Marxist theory—the importance of emancipation and the view of art as the transformation of thought into sensory experience—are slowly being resuscitated.

One of the authors who reminded us of the possible connection between the artistic and the political avant-gardes was Hungarian literary historian Miklós Szabolcsi, who pointed out in 1978 that "a revolution without an avant-garde [in art] is really a pseudo-revolution."[9]

Among the neo-avant-gardes, their contemporaries, and the postsocialist avant-gardes, we encounter paradigmatic cases of avant-garde movements, including aesthetic ones. Perhaps the paramount cases among the postwar avant-gardes were those from the 1960s, which conceived of and practiced alternative lifestyles—including communal living, the "sexual revolution," and so on—thereby substantially changing their life experiences.

Their predecessors in the 1950s and the early 1960s existed in a period not of revolution but of revolt, for they found no political avant-garde on which to rely and which would support their aesthetic actions. Nonetheless, this did not prevent them from envisioning and taking part in political and social projects, even if their actual activity remained limited to art, fiction, and imagination.

Avant-garde movements that I call "aesthetic" have programmatically demanded "that art move from representing to transforming the world."[10] A variation of this demand was their frequent call for the conflation of art and "life," or—expressed in Peter Bürger's Hegelian terms—to "sublate" art: "Art was not to be simply destroyed, but transferred to the praxis of life where it would be preserved, albeit in a changed form."[11] The early aesthetic avant-gardes—the main cases being Italian futurism, constructivism, early surrealism—at the same time belonged to the broader constellation of the "early" avant-gardes and constituted a substantial part thereof.[12]

Other authors have occasionally employed the notion of the aesthetic avant-garde. Thus one of Rancière's commentators distinguishes between the strategic and the aesthetic conception of the avant-garde: "The aesthetic conception of the avant-garde . . . is oriented towards the future and founded on the artistic anticipation of a world in which politics would be transformed into a total life program. . . . The avant-garde is here understood as the attempt to invent tangible forms and material figures for a life to come."[13]

Second Proposition: Aesthetic Revolutions

"Aesthetic revolution" is a term in use from German romanticism (in Friedrich Schlegel, for example) into the twentieth century (as in André Malraux and, of course, more recently in Rancière). In Rancière it denotes a singular historic event (in his case, located approximately two centuries ago, thus following the rather standard interpretation of the birth of modern art) that brings about what he calls the "aesthetic regime of art." He claims that an "aesthetic revolution" is of equal or greater proportions to that of the French Revolution, for it replaces the idea of human nature with the notion of humanity to come. In this volume aesthetic revolutions will be regarded as repeated events caused by aesthetic avant-garde movements in the course of their historical unfolding. We thus speak of futurist, surrealist, and Situationist revolutions.

A closely related event—somewhat dissociated from aesthetic avant-garde movements—would be cultural revolution.

Early artistic avant-gardes, such as expressionism and cubism, may have realized predominantly artistic revolutions—decisive changes in artistic expression and its means (in style and technique)—but the aesthetic avant-gardes engendered profound changes through the ways in which they impacted our sense perception and extended their actions and effects beyond the autonomy of art into other spheres of life. They also affected movements such as Bauhaus and De Stijl, which, along with the Arts and Crafts movement, introduced new expressive potentialities and questioned old ones, thereby starting new timelines in the history of art.

A pronounced interdependence and extreme developments in art, politics, and society precondition the emergence of aesthetic avant-gardes and their evolution as processes in which radical artistic movements and revolutionary segments of society form unions and temporary fusions, welding together the discursive and the pragmatic, and art and life. The main protagonist of the Situationist International (SI), Guy Debord, thus refers to a "unified vision of art and politics," while in the 1980s the Slovenian Laibach group proclaims: "Politics is the highest and all-embracing art, and we who create contemporary Slovenian art consider ourselves to be politicians."[14] Both statements bear witness to the fact that, despite the changed time and circumstances, the ambition to fuse art and politics not only is present among the postwar avant-gardes but also represents one of their permanent characteristics. Nonetheless, in SI and in Russian constructivism there also exists the demand (as in "The Realistic Manifesto" of August 5, 1920) to do away with art altogether.

Miklós Szabolcsi's observation that "a revolution without an avant-garde

[in art] is really a pseudo-revolution" thus cuts both ways: "We can speak of a true avant-garde only if it overlaps with a political revolution, realizes it or prepares it."[15] A related view is expressed by Herbert Marcuse, who claims that although art is not in the domain of radical praxis, it is nonetheless an essential component of revolution, for it expresses a truth, an experience, or a necessity.[16] Without some kind of connection with a political avant-garde, any aesthetic avant-garde agenda—the demand "that art move from representing to transforming the world"—is usually hindered or even made impossible. What is needed in the last resort is not an actual political avant-garde (movement, organization) but involvement in pursuing a persuasive answer to Laverdant's question: where is a certain "community of sense" (class, nation) going, or where should it be going? Some of the third-generation avant-gardes are decisively concerned with the answer to such a question—namely, that of their project, which in recent decades is most often their national agenda or a substantial part thereof. This, then, is but the most recent way of articulating the transformative demand.

The early avant-gardes did not yet encounter this difficult issue. The radical political worldviews they were connected with, or with which they sympathized, or which they sometimes cocreated (the most outstanding case here was Italian futurism) were either pronouncedly society- and class-based (such as Marxism) or fundamentally nationalistic. For the Bolsheviks and their artistic sympathizers, whether in Russia or among Dadaists and surrealists, class obviously played the central role, while the agenda of Italian futurism included an aesthetic revolution that Marinetti conceived as nationalistic—as an "Italian Revolution." He argued that every nation has its own form of *passatismo* to overthrow and therefore that the futurists, just like the Bolsheviks, had their own revolution to make. In Marinetti's opinion, such a revolution in the Italian case concerned not the proletariat but the nation and its artists (who articulated and expressed the spirit of the nation).[17] "The Futurist revolution . . . will bring artists to power," announced Marinetti in 1919.[18] He also made an insightful observation regarding the *equivalence* of national and class interpellations, as the latter were about to be extirpated in Italy and replaced by the former: "The Nation is nothing other than a vast political party."[19] It took Mussolini only a few years to eradicate this class interpellation and make the national one into the cement that held the country together.

Third Proposition: Postsocialist Avant-Gardes, or,
The Third-Generation Avant-Gardes

Peter Bürger has divided the avant-gardes into the historical and the neo-avant-gardes. It is mostly agreed that after World War II in the United States and in Europe there emerged neo-avant-gardes and related individuals and groups. I wish to suggest that a couple of decades later these were followed by the "postsocialist avant-gardes" from former or present socialist countries—first from the Soviet Union, East Europe, and Cuba, and more recently from China—a trend that still continues.[20]

It would be difficult to dispute Gao Minglu's claim that Chinese artists from the 1980s—many of whom called themselves "avant-garde"—operated in many respects as the early avant-gardes have: forming movements, perceiving themselves as possessing a historic mission, and so on. In short, they closely resembled their Western predecessors.[21] Contrary to these precursors, however, the postsocialist avant-gardes didn't possess a political avant-garde with which to share an agenda. Instead, they embarked on group avant-garde journeys, and their major projects tended to be national ones. The third-generation avant-gardes somewhat resembled the neo-avant-gardes, who existed in a similar relationship to an unresponsive world.

When in the 1970s and 1980s postmodernism questioned the legitimacy of modernism and pronounced the end of the ideology of progress, it simultaneously questioned the continued relevance of avant-garde movements. Viewed previously as the spearhead of modernity, these were now regarded as an index of departing modernism. Artistic phenomena that resembled creations of avant-garde movements but at the same time lacked essential features of their authentic predecessors acquired names like "post-avant-gardes" and "trans-avant-gardes." It was in the context of specific postsocialist politicized art that the "avant-gardes" reemerged, soon to be reinscribed with the loose meaning they possessed in the early twentieth century. Another term employed by the Slovenian Neue Slowenische Kunst (NSK) movement in the 1980s was "retro-garde" and its variation "retro-avant-garde," which revealed NSK's ambivalent stance toward the past and the future, limiting its vision to the simulated "State in Time."

Most such art appeared between the early 1970s and the early 1990s, intuitively announcing the disintegration of socialism and its passage into postsocialism. This also signifies that, in most cases today, the "third-generation avant-gardes" are already a past phenomenon. The "State in Time" project being undertaken by the NSK movement, discussed in this volume in the

essay by Miško Šuvaković, is an exception in this regard, for although it was begun in 1992 it still continues. Thus in 2012 and 2013, hundreds of jumbo posters promoting the State in Time as if it were a country attracting new immigrants were displayed along highways and in urban centers in Slovenia, exhibiting the slogan "Time for a new state. Some say you can find happiness there."

Accordingly, the third proposition in this volume is that some of the recent ("third-generation") avant-garde movements from the former socialist countries constitute postsocialist aesthetic avant-gardes. They lack the demand to "sublate art" but retain the totalizing viewpoint on art and history and the belief in the special role of art and artists in a national community. Far from striving to attain a fusion of art and life in the strong sense as envisaged in the 1905–30 period, they instead perceive themselves as the discrete and unobtrusive but nonetheless sole agents who can create and promote art that supports and aids the idea of a possible transformation of an obsolete political, cultural, or national community into a future "community of sense" that is to overcome the past aporias of collectivity and community.[22] Again, the NSK movement would be just such a case, as would postsocialist politicized art from Hungary and the Chinese and Cuban art of the 1980 and early 1990s.[23]

Let me take China as an example. There the avant-garde of the 1980s (especially the '85 Movement) attempted "to effect an aesthetic and ethical transformation of Chinese society and to redefine Chinese identity. Most of the artists saw themselves as representatives of a movement of cultural enlightenment, . . . through their quest for the establishment of a new order for a new man and a new society, they [saw themselves as] accomplices of the official modernization movement."[24]

With the slow but continuous diminution of the relevance of postmodernism as a temporal marker in recent decades, these third-generation avant-gardes are being progressively dissociated from postmodernism, thereby acquiring the capacity to be gauged independently of their postmodern contemporaries and an assumed postmodern context.

Some of the postsocialist avant-garde movements (or segments thereof) should be called "aesthetic," for they followed a political and an artistic agenda, the latter often visibly and forcefully expressing or sympathizing with the former. Such political agendas may be nationalistic, but the aesthetic avant-gardes have been adamant, single-minded, and devoted to their task and project.

According to social sciences informed by Marxism, in the past the national agenda was highly suspect, for it purportedly signaled a historical re-

gression. But what if the nations in question "needed" such a national detour on their way from state socialism to neoliberal capitalism in so far as doing so enabled them to historically "catch up" with their Western counterparts? In the 1980s the need for a nationally imagined community superseding the previous inoperative socialist one was complemented by the need for a viable expression of such a demand. Postsocialist avant-garde art was a response to such a need.

Aesthetic Avant-Garde Movements and the Revolutions They Engendered

Avant-garde movements extend not only into the period after the neo-avant-gardes but also beyond Europe and the United States into Mexico, Nicaragua, Brazil, South Africa, and elsewhere.

A unified vision of art and life—even if it may have sometimes been, in Renato Poggioli's words, only "a sentimental illusion"[25]—and the aesthetic experience implied by it usually denoted a vision of a more authentic future for a community (class or nation) or even for humanity as a whole. Aesthetic avant-gardes linked their artistic projects to political avant-gardes and sometimes even transformed the former into the latter or—when no political agent for their ideas was to be found—limited the political project which they supported to its articulation in manifestos. Every so often—in Italian futurism, Russian constructivism, surrealism, Mexican and Nicaraguan muralism, or in the NSK State in Time—at least a temporary link was not only sought but was also established between the avant-garde artists and movements on the one hand and a political entity on the other, thereby overcoming the usual autonomy-driven separation of art and politics. The vehicle of the latter was a political party or sometimes even a state, but of course only when these two shared a related or similar vision of the future.

IN THE FIRST ESSAY in this book, Sascha Bru discusses Italian futurism, which represents the initial (and hitherto the paradigmatic and most versatile) early aesthetic avant-garde movement. It brought about an aesthetic revolution as well as an artistic one, with its "works" ranging from easel painting, stage design, and political propaganda to cuisine and photography. As Bru points out, the aesthetic revolution realized by futurism so far still has not been sufficiently recognized, given that it went in so many different directions and occurred on so many different terrains.

Bru's starting point is an analysis of the "ugly" in which he pits Croce's traditionalist defense of the beautiful against Marinetti's preference for the ugly. He shows how from its very beginning futurism fused politics and art. He then presents different ways in which Italian futurists aimed at changing various realms of life by taking for granted that artists would be totally involved in their art—encompassing their own lives too, as when many of them joined the Lombard Volunteer Cyclist Batallion in July 1915. Futurists took their new type of political art into the street, into coffeehouses, and onto the San Marco Square. They expanded the notion of art because they expected art and artists to intervene in society and to actively aid futurism in creating the desired future for the Italian nation. Pointing out the inherently activist nature of futurist art, Marinetti named it *art-action*, thereby opposing it to the contemplative gaze.

While Futurists aimed also at a "Reconstruction of the Universe" (as a manifesto announced in 1915) on earth, they primarily focused on Italy. Bru reconstructs the historical and political situation in Italy at the turn of the century and illuminates the ways in which futurism became such a unique player on the Italian political and artistic stage. Regarding the relationship between futurism and fascism, Bru reminds us that futurism emerged in a democratic political constellation and that the political crises in Europe destabilized the artistic field. With the consolidation of Mussolini's power, the historical period of Italian futurism ended.

Russian constructivism arose out of Russian futurism in 1920–21. It involved new technologies and the replacement of composition with construction, thereby giving material a social dimension. Aleksandr Rodchenko hoped constructivism would become the art of the future. Born in circumstances never experienced before in human history, constructivism raised decisive questions as to the nature of "art" under social and historical conditions of the dictatorship of the proletariat and on the way to a classless society, and it offered itself as their answer.

In his essay on constructivism John E. Bowlt takes as his point of departure the September 1921 exhibition $5 \times 5 = 25$, where Rodchenko displayed his three monochrome paintings, signaling the end of painting: "It's all over. Basic colours. Every plane is a plane and there is to be no more representation."[26]

Bowlt offers an in-depth analysis of constructivism in its context, presenting it as a central instance of the Russian avant-garde of the 1920s as he goes on to translate its creations and ideas into categories that contextualize constructivism along politico-historical and conceptual axes. He also shows how

constructivists attempted to contribute ideas to the emergent new society but fell short of this goal because their activities did not touch the masses but instead remained limited to avant-garde circles. Tatlin's *Monument to the III International* remains a good example of this. As Camilla Gray has remarked, such "models came to be a symbol of the Utopian world which these artists had hoped to build. In many ways it is typical for their hopes, so ambitious, so romantic and so utterly impractical."[27] The constructivist aesthetic revolution nevertheless made an impact both abroad and decades after its appearance. In this respect its history was the reverse of that of Italian futurism, the impact of which diminished or almost disappeared due to its linkage with fascism. Benjamin Buchloh offers an interpretation of constructivism that confirms its aesthetic impact: he claims that El Lissitzky's works from the 1920s "introduced a revolution of the perceptual apparatus."[28]

Constructivism implemented an aesthetics of construction, machinery, and even outer space, the latter affinity bringing it in the 1930s into proximity with artistic motifs of Italian futurists (Fillia, Peschi, Nello Voltolina). At the same time it possessed an uncompromising will to create a New Man for the new society in which art would be sublated and integrated into society in the form of objects and devices complemented by industrial design and photography. Bowlt reveals the aesthetic drive of constructivism that resulted not in control over the Bolshevik cultural establishment but rather in the end of its career in the early 1930s.

In his study on surrealism, Raymond Spiteri focuses on case studies of politically involved events in the 1925–32 period that allow him to present some key issues of surrealism in vivid detail. Like Italian futurism, surrealism was an international movement, exerting its influence on life with the help of fellow surrealists and on another reality altogether with the aid of dreams: "I believe in the future resolution of these two states, dream and reality, which are so seemingly contradictory, into a kind of absolute reality, a *surreality*, if one may so speak."[29]

We are accustomed to situations in which the simultaneous existence of a political party and a predominantly artistic avant-garde movement's vying for hegemony over the same political space is not peaceful: instead of finding forms of coexistence in their shared space, they create antagonisms and conflicts. At first glance it would seem that Spiteri makes this claim in his chapter when he argues that surrealism existed in the contested space between culture and politics. At the outset he announces his aim to map this contested space as the terrain of an aesthetic revolution. While attempting to create a common space with the Communist Party, surrealism strove to fuse mind

with matter and the unconscious with the political. Spiteri shows how this radical intent was repeatedly frustrated, only to be incessantly reawakened. Instead of appropriating the permanent fear of the political avant-garde's instrumentalizing of the artistic one, Spiteri offers a very different reading of this encounter: surrealism, he points out, flourished in the contested terrain between culture and politics, employing the ensuing tension between these social fields as an integral element of its own position. This "contested space" turns into an extremely useful concept not only in regard to surrealism and its political involvement, but also when employed in other instances of the encounter of the artistic with the political.

Mexican muralism was born out of a political plan: in 1921 Minister of Public Education José Vasconcelos "invited artists to paint monumental works on public walls."[30] Renato Poggioli had reservations concerning the nature of Mexican muralism (or, as he called it, "modern Mexican painting"), admitting that "one might hesitate to call [it] avant-garde without reservation."[31] Despite Poggioli's doubts, what persuades us that muralism belongs to the avant-gardes is that it thrived "in a climate of continuous agitation" that caused the "coinciding of the ideology of a given avant-garde movement and a given political party" to be much more than just fleeting and contingent.[32] In other words, the permanent "agitation" caused by that relationship between the ruling political parties and Mexican or Nicaraguan muralism remained fairly stable and continuous—a development persuasively depicted by David Craven. Craven interprets Mexican and Nicaraguan muralism not as simple official propaganda but rather as two distinct cases of aesthetic revolution, each of which was central to the revolutionary processes in its country.

From the time of the Sandinistas, Nicaraguan muralism has become an art that is appreciated by the general population in Latin America, is influential across the continent, and remains a style and tradition to be referred to when encountering propaganda and expressive needs such as those in Nicaragua of the 1980s. Craven presents the historical background of Mexican muralism and highlights the creative gestures and characteristics of Rivera, Orozco, and Siqueiros—the three main figures of the Mexican aesthetic avant-garde. Into a Mexican environment otherwise devoid of art, muralists introduced phantasmagoric images and even structures that linked the traditional and the mythical with the modern. Mexican public places and spaces have thus been imbued with art that circumvents the usual venues available to it—museums and galleries. The three central figures among Mexican muralists did not develop a uniform style or technique, for each went his own way creatively. Nonetheless, Mexican muralism created a long-lasting aesthetic revolution,

impacting cultures and nations throughout much of Latin America. Craven argues that Mexico, Cuba, and Nicaragua developed significant politicized art that deserves a special place in modernism and among the aesthetic avant-gardes.

In his essay on the aesthetic revolution of the 1960s in the United States, Tyrus Miller looks at the American neo-avant-gardes, claiming that an insufficiently recognized aesthetic revolution involving a specific redistribution of the sensible took place there at that time. He uses another name for it: cultural revolution. This more familiar concept, related to Lenin's introduction of this term and to its actual practice in China, was meant to represent an overhaul no less radical and thorough than that of the French Revolution. Cultural revolution too is characterized by a redistribution of the sensible. It encompasses "the ways people imagine their social existence, how they fit together with others, how things go on between them and their fellows, the expectations that are normally met, and the deeper normative notions and images that underlie these expectations."[33] According to Miller, a crucial characteristic of the American situation in the 1960s was the increased role of experience that had been formed and transformed by collective action, which emerged as a common denominator of various positions within the American aesthetic revolution at that time, the most perturbing period in recent U.S. history.

Miller claims that the neo-avant-gardes did not merely reiterate but also revised the classical avant-garde precisely in the domain of artistic politics. Elsewhere Miller has characterized this revision as the shift from an artistic politics of ideological actualization to that of presenting "singular examples" of a new hegemony, founded in alternative ways of acting and experiencing our collectively shared worlds.[34] American neo-avant-garde artworks, he suggests, are less likely to be assertive instantiations of an ideological position than they are to be specific and singular occasions for members of the audience to experience an individual aesthetic and political awakening, thereby promoting the very sorts of differences that constitute the texture of freedom in society.

In his other chapter in this book, Raymond Spiteri focuses on the Situationist International (SI), a unique international avant-garde movement (1957–72) whose predecessors were Dada and surrealism and whose central theoretical foundation derived from Marx's social philosophy and philosophy of history.

The SI developed original and insightful positions on a number of issues, ranging from global politics, capitalism, and *Realsozialismus* to concerns re-

garding urban and everyday life. The SI started from art, and at first it consisted of a cluster of artistic avant-garde groups. As in the case of neo-avant-gardes, SI also lacked a political avant-garde that would support its causes and demarginalize it and whose programmatic political demands would coalesce with those of a cultural movement such as SI.

The SI attempted to construct an alternative position to that of the neo-avant-gardes, one that would avoid the recuperation of the strategies of the early avant-gardes, such as Dada, surrealism, and constructivism. The SI was conscious of the challenge posed by the lack of a supporting political avant-garde, hence its focus on transforming everyday life as the medium of political action. This position moreover enabled the brief dialogue with Henri Lefebvre and the group Socialisme ou barbarie, for both groups sought an alternative political position to the French Communist Party.

Spiteri shows how two main foci of SI activities were engagement with everyday life and the critique of the society of the spectacle. This critique merged with another preoccupation of SI, which was to promote and develop philosophy that would transform the world and effect its realization as conceived by the Young Hegelians and the early Marx. A related goal of SI was the elimination of politics and establishment of a nonhierarchical political structure.

Although the SI initially looked to established movements such as surrealism or new ones such as Cobra, the activities of these groups struggled to escape the limited realms of culture and achieve some form of political engagement. The early SI developed the tactics of constructed situations and unitary urbanism in an effort to resolve the tension between the cultural practice of SI members (the artistic dimension) and the intentions of its more politically oriented segment to transform society (the political dimension). This solution was provisional, however, and would be eclipsed by the critique of the spectacle in the 1960s. In his essay Spiteri therefore points out that while internal antagonisms contributed to the demise of the SI, another factor was the unresolved tension between the cultural and political dimension of the movement.

The SI wanted to realize an aesthetic revolution that would allow for a different world—one that would materialize its freedom through the transformation and the ensuing elimination of art, through the implementation of unitary urbanism and the freedom *from* work. Spiteri depicts the path taken by the SI from an aesthetic avant-garde (one that introduced novel procedures such as *détournement* and *dérive*) permanently searching for an equi-

librium between the import assigned to art and its sublation, to its becoming an unexpected influence in the May–June 1968 events. As Spiteri shows, this revolution was fleeting and unsatisfactory, for its success was limited to a temporary respite from the advancement of the spectacle. After 1968 the presence of SI's ideas in France slowly grew, turning it into an intellectual force that exceeded the importance of other radical avant-gardes of that time. Some proof of this impact can be discerned from its influence on thinkers such as Jean Baudrillard and Jean-François Lyotard (whose 1973 book was titled *Dérive à partir de Marx et Freud*).

In 1991 Slovenia proclaimed its independence. Since the new state was not recognized internationally, NSK stepped in by creating "embassies" across the globe that represented NSK itself as well as Slovenia. These two entities soon went their separate ways, with the Republic of Slovenia slowly being transformed into an ordinary state and the NSK State in Time increasingly acquiring features of a fictional political entity. Between 1992 and today, this "state" has existed—to use Šuvaković's conceptual apparatus—as a simulacrum of its symptoms, which are said to consist of the symbols of a state (embassies, flags, national guards) and "everyday" state objects (passports, other documents, car stickers, etc.). The State in Time has acquired a life of its own: recently its citizens—the holders of NSK passports—have started to organize political gatherings, NSK folk art is now being created and collected, and so on. In contemporary political and legal circumstances that are fleeting and uncertain, the NSK State in Time doesn't seem any less real than numerous other local, national, and international institutions and organizations.

In his essay on the NSK movement, Miško Šuvaković first focuses on the complex historical and political roots of Slovenian independence and simultaneously on the early (1983–92) history of NSK. He shows how the groups forming the NSK network or movement in 1983 and 1984 went through various phenomenal stages of artistic development before reaching the stage of "postmedia," a developmental stage where they no longer require an actual material work to be made and exhibited, for what they exhibit in the form of a postmedium is a whole fictitious state. This state (the State in Time) exists in the mind, although it also possesses symbolic artifacts that make this artistic entity visible and offer a proof of its temporal existence. Šuvaković links the development of the State in Time to an international political and economic situation, and he points out that NSK realized political acts, most of which were related to the state of Slovenia, at an early stage. He furthermore argues that the acts of NSK made visible the political, aesthetic, and artistic

revolutions of our contemporaneity by taking the postmedia artistic entity to a new stage of development, thereby transgressing contemporary interpretations of art as such.

Conclusion

In his twenty-seventh "letter on the aesthetic education of man," Schiller answers his own rhetorical question as to where to search for the aesthetic state. His response is: "As a need, it exists in every finely attuned soul; as a realized fact, we are likely to find it . . . only in some few chosen circles."[35] Schiller's aesthetic state exists in the mind only—very much like the NSK State in Time, of which it was said in 1992 that it "confers the status of a state upon the mind and not territory."[36]

In the context of the State in Time, the aesthetic state possesses a fundamental significance for it implies that a contemporary avant-garde vision of the future can exist today, but only in the mind. Through a detour of the early avant-gardes, the world of the avant-garde vision of the future has returned only to be materialized in the world of discourse as opposed to that of actual historical change and transformation. The most recent avant-garde erects its reality in fiction and semblance (Schiller's *Schein*) but not in factual reality— or at least not after the materialization of its finally realized national projects of state-building.

With NSK's ongoing State in Time project, Schiller's idea of the aesthetic as the unity of art and politics—of the "art of the beautiful" and the "art of living"—has been brought full circle: "To a humanity rent by the division of labour, occupations and ranks, [the aesthetic state] promises a community to come that no longer has to endure the alterity of aesthetic experience, but in which art forms will again be what they once were—or what they are said to have been: the forms of an unseparated collective life."[37]

I will return to these issues in my conclusion.

NOTES

1. Merleau-Ponty, "Cézanne's Doubt," 66.
2. Gombrich, *The Image and the Eye*, 12.
3. Robson, "Jacques Rancière's Aesthetic Communities," 79.
4. Tanke, *Jacques Rancière*, 75.
5. Quoted in Poggioli, *The Theory of the Avant-Garde*, 9.
6. Schiller, *On the Aesthetic Education of Man*, 9.
7. Rancière, *Aisthesis*, xvi.

8. Žižek, "The Lesson of Rancière," in Rancière, *The Politics of Aesthetics*, 76.

9. Szabolcsi, "Ka nekim pitanjima revolucionarne avangarde," 14.

10. Groys, *The Total Art of Stalinism*, 14.

11. Bürger, *Theory of the Avant-Garde*, 49. In his 1974 study, Bürger introduces the concept of "historical" avant-gardes, which encompasses both artistic and aesthetic avant-gardes. He finds the notion applicable "primarily to Dadaism and early Surrealism," to the "Russian avant-garde after the October revolution," and "with certain limitations" also to "Italian Futurism and German Expressionism" (109n4). While he admits that cubism "does not share with historical avant-garde movements . . . their basic tendency (sublation of art in the praxis of life)," he nonetheless considers it to be part of the historical avant-garde movements, supporting this claim by stating that cubism "calls into question the system of representation." This appears to be a weak argument: "basic tendency" is an essential characteristic and not a coincidental feature that can be disregarded at will when absent.

12. I am referring to Italian futurism in the period before the Matteotti crisis (1924) and therefore before it became seriously compromised by fascism. For dilemmas arising from the relation between fascism and totalitarianism on the one hand and the avant-garde and modernism on the other, see, e.g., Berghaus, *Futurism and Politics*; Griffin, *Modernism and Fascism*; and Hewitt, *Fascist Modernism*.

13. Rockhill, "The Silent Revolution," 66.

14. Debord, "The Situationists and the New Forms of Action in Politics and Art," in McDonough, *Guy Debord and the Situationist International: Texts and Documents*, 160; Laibach and Neue Slowenische Kunst, *Problemi*, 24.

15. Szabolcsi, "Ka nekim pitanjima revolucionarne avangarde," 14.

16. See Marcuse, *The Aesthetic Dimension*, 1.

17. "For us, the Nation is tantamount to the greatest possible extension of the generosity of the individual, spreading out in a circle to envelop all human beings with whom he feels an affinity" (Marinetti, "Beyond Communism," in *Critical Writings*, 340).

18. Marinetti, "Beyond Communism," 349.

19. Marinetti, "Beyond Communism," 341.

20. For an excellent presentation and analysis of recent and contemporary Chinese art, see Gladston, *Contemporary Chinese Art*. For the *China/Avant-garde* exhibition, see Gao Minglu, "Post-Utopian Avant-Garde Art in China," in Erjavec, *Postmodernism and the Postsocialist Condition*, 247–83. See also, e.g., Gao Minglu, *Total Modernity and the Avant-Garde in Twentieth-Century Chinese Art*.

21. See Gao Minglu, *Total Modernity and the Avant-Garde in Twentieth-Century Chinese Art*, 137–39.

22. See Hinderliter, *Communities of Sense*, 2.

23. We presented and analyzed the main instances of such art in Erjavec, *Postmodernism and the Postsocialist Condition*.

24. Köppel-Yang, *Semiotic Warfare*, 182.

25. Poggioli, *The Theory of the Avant-Garde*, 96.

26. Rodchenko, quoted in Milner, *The Exhibition 5 × 5 = 25*, 35.

27. Gray, *The Russian Experiment*, 226.

28. Buchloh, "From Faktura to Factography, " 93.

29. Breton, *Manifestoes of Surrealism*, 14.

30. Coffey, *How a Revolutionary Art Became Official Culture*, 1.

31. See Poggioli, *The Theory of the Avant-Garde*, 96.

32. Poggioli, *The Theory of the Avant-Garde*, 96.

33. Charles Taylor, *Modern Social Imaginaries*, 25.

34. Miller, *Singular Examples*, 3–14.

35. Schiller, *On the Aesthetic Education of Man*, 219.

36. Eda Čufer and IRWIN, "NSK State in Time" (1992), in Hoptman and Pospiszyl, *Primary Documents*, 301.

37. Rancière, *Aesthetics and Its Discontents*, 100.

Politics as the Art of the Impossible
The Heteronomy of Italian Futurist *Art-Action*

SASCHA BRU

> My object in this paper is to search for what I will provisionally describe
> as real ugliness, understanding that its existence is open to doubt.
> —Bernard Bosanquet (1889)

German expressionist poet Gottfried Benn, admittedly not an impartial commentator, once observed that Italian futurism was "the founding event of modern art in Europe."[1] Benn's assertion requires qualification, but it highlights the importance of the advent of Italian futurism to many writers and artists outside Italy in the first half of the twentieth century. One of the first of its kind in that century, the Italian avant-garde movement introduced a new model of sorts, a shibboleth almost, that was to inspire and shape many later avant-gardes.[2] For never before had an aesthetic movement so forcibly performed the genesis of an avant-garde. The brash histrionics and cunning force with which Filippo Tommaso Marinetti and his followers placed futurism on

the international aesthetic map from the publication of the "Founding and Manifesto of Futurism" in 1909 in *Le Figaro* onward indeed played a vital role in creating a discursive space within which other avant-gardes emerge. For better or worse, futurism is to be thanked for the most fundamental associations and connotations now tied to the notion of the early twentieth-century avant-gardes: the foregrounding of youth and originality, the championing of experimentation, the emancipation of the manifesto as an art form, the adoption of agonistic and antagonist poses toward anything that stands in the way of change, and of course the often paradoxical, but always open-ended, future-inflected program many later avant-gardes put forth in different ways as well.

Yet many facets of the Italian movement also went largely unmatched, not least because few aesthetic revolutions in the first half of the twentieth century unfolded on so many terrains at once as that of futurism. Futurism, which originated in literature, indeed proved quite successful in realizing its attempt to finally actualize the romantic dream of changing life through art—or, as Giacomo Balla and Fortunato Depero put it in 1915, in realizing its ambition of a total "Reconstruction of the Universe" through art. In the course of four decades few aspects of life would not be touched upon by futurists. From clothing and fashion to food and toys, from love to sex, from modern transportation to communication and media, from interior design to advertising and of course the arts in all forms: futurism suggested changes to them all. This wide range of areas in which futurists were active marks how they went against ivory tower aesthetics, willfully sought out art's heteronomy, and always and everywhere looked for ways to question art's alleged autonomy.

The common denominator or crux of the movement's critical endeavor was an expanded notion of art: opposing the reduction of art to mere contemplation or disinterested sensuous pleasure, futurism insisted that art was (to be) action too. This inclusive approach to art did not negate older ways of looking at it; futurists continued to write, paint, and sculpt, for example. Yet their notion of art substantially added to older manners of practicing and reflecting on modern art, as I show in the first part of this chapter. With its expanded notion of art, an art that also included actions and all sorts of practices, futurism came with the suggestion that artists and writers could also *intervene* in society. And perhaps more than any other aspect of futurism (from its verbo-visual celebration of modern technology, metropolitan life, and violence, or its promotion of speed, vitalism, and dynamism, to its heightened sensitivity to sound and noise) that promise endowed the movement with such broad appeal. For although the consequences and full import

of that promise were far from clear yet in futurism's early years, it brought the exciting prospect of a new era in which experimental artists' and writers' social roles and functions would be expanded and enlarged as well.

Consider the bellicose way that Balla, Umberto Boccioni, Carlo Carrà, Luigi Russolo, and Gino Severini recalled their first reading of the "Technical Manifesto of Futurist Painting" (1910) in Turin: "We exchanged almost as many knocks as we did ideas, in order to protect from certain death the genius of Italian art."[3] Few passages illustrate so vividly how *art-action* (the French term Marinetti coined for futurism's expanded notion of art) always took a central place in the movement. Yet the same passage also reminds us of futurism's distinctly Italian character. Indeed, futurism's main concern was with changing life in Italy, a country whose political culture was going through fundamental transitions, in part due to Italy's relatively late industrialization and technological modernization. Many opposing political factions (anarchist and syndicalist leaders in particular) held that Italy as a nation simply lacked a contemporary, modern cultural identity.[4] The futurists had the same view and thus put the creation of a present-day Italy (*italianismo*) at the center of their project. As an aesthetic movement that promoted an experimental and thus always open-ended form of art, however, futurism differed considerably from nationalist groups in the field of politics. Whereas many sought to define *italianità* negatively—that is, as that which was not foreign[5]—and others, such as the later Benito Mussolini, cultivated the memorial cult of *romanità*,[6] the futurists always kept the future of Italy open and never went as far as to bring it to discursive closure. Marinetti indeed tended to look toward the immanent value of the subject to forge a new, nonessentialist Italy. Futurism envisioned an Italian nation of free subjects, then, and portrayed itself as an emancipator of Italians, its art as the key to unlock that new community.[7]

The view that Italian culture lacked a present-day identity was widely held, so it made sense for the futurists to propose to change this situation from within art as part of a broad social and cultural movement for reform. It was not until 1902 that contemporary literature and art became a topic in Italian newspapers, and by consequence gained wide circulation in political culture. In that year the *Giornale d'Italia*, as the first large newspaper, introduced its *terza pagina*, or cultural page, and Benedetto Croce began to fill its columns, shaping a unified "national" taste.[8] Futurists opposed the liberal humanist or "lay pope" Croce in their publications because he mainly contemplated the greatness of Italy's cultural past and disseminated German idealist views— "Against . . . Benedetto Croce, we pit the worldly-wise Italian [*lo scugnizzo ita-*

liano]."[9] Yet futurists, along with a battery of intellectuals, also tried to assert their visibility through the press, aiming to follow in Croce's footsteps. With Guiseppe Prezzolini (editor-in-chief of the journal *La Voce*), Giovanni Papini and Ardengo Soffici (editors of *Lacerba*), and Enrico Corradini, among others, Marinetti began attacking Italy's adoration of its long-gone past. The verbose declamations of *anti-passatismo* that ensued tend to have a silly ring to them today. Yet when we recall that the aesthetic sphere in Italy only gained widespread visibility in the public space through the press beginning in 1902, those diatribes gain a different ring. Clearly, art was in part still rationalizing itself as a functionally differentiated field within the public space or civil society; its public face and function as well as its discursive and structural confines were still being negotiated. It thus appears by no means coincidental that at this very moment futurism began to advocate an expanded notion of art and thereby to engage as well in a negotiation about art's function and place in society at large.

Certain aspects of futurism's historical attempt to negotiate the function of art continue to incite fascination, if not discomfort. The movement appears particularly haunted by its inclusion of political action or practical politics into art, which was to lead to one of few political parties launched from within art in the foregoing century. One objective of this chapter is to show that this "turn to politics" was a logical consequence of its more general expanded notion of art. By zooming in on the political facet of futurism's aesthetic revolution, I aim neither to apologize for the Italian futurist aesthetic revolution nor to reduce it to politics. Rather, I wish to highlight that to properly assess both the paroxysm and the limitations of any aesthetic revolution, including futurism's, political facets remain a mandatory stop along the line.

Art as Action

Anyone who has ever read a futurist manifesto, especially one written during the movement's so-called first or "heroic" phase up and until the March on Rome, will be familiar with the often humorous, hyperbolic, and at times rhetorically inflated ways in which futurism presented itself as the absolute *novum*. Since the emergence of the movement over a century ago, that self-asserted novelty has been so avidly deconstructed by critics that little of it still seems to stand. This has done futurism an unpardonable injustice. For once we look beyond its verbose and exaggerated claims, it is hard to deny that the movement made a difference in thinking about art as a social practice. The common denominator of futurism's ambitious project was an expanded

notion of art: while art so far had been commonly viewed as a site of contemplation, futurism began to look at it principally as a site of action. Introducing "the fist into the struggle of art,"[10] the futurist aesthetic thereby substantially added to long-sedimented ways of thinking about art, particularly about modern art. Modern aesthetics' reflection on the ugly and the inaesthetic especially warrants attention here, not least because one of the key (though often overlooked) passages in which the futurist aesthetic was fleshed out also looked at the ugly: "Bravely, we bring the 'ugly' into literature, and kill off its ritual pomp wherever we find it."[11] As this sentence from Marinetti's "Technical Manifesto of Futurist Literature" (1912) makes clear, futurism inscribed itself in a distinctly modern tradition that emphasized the ugly. Why would it have done so? And why did Marinetti put the notion in scare quotes?

Whether there is a universal ontology or a single definition of the ugly is a vexed issue,[12] yet it is luckily one we can sidestep when dealing with futurism. To bring out the role of the ugly in futurism's aesthetic, it suffices to cast a cursory glance at the category's place and function in the work and thought of just a few predecessors. Some of the founding texts of modern art and literature deal with the ugly. One of the most famous is Friedrich Schlegel's *Über das Studium der griechischen Poesie* (1795). While exploring the very notion of an aesthetic revolution, Schlegel's *Studium* above all stressed the role of beauty in art. Yet the *Studium* also had a few important things to say about the ugly in this context. Espousing a view typical of Jena romanticism,[13] Schlegel implied that art only became truly modern with authors like himself, writers who also paid attention to the ugly. To Schlegel beauty was the norm in art, and its true counterpart was neither the sublime nor the interesting, but the ugly, that which simply was not treated or seen as art. A modern artist, self-conscious of his practice, was therefore also to plunge headfirst into the ugly, to explore it, and to consider whether advances in art could be made by bringing aspects of nonart into the realm of beauty.[14]

Hans-Robert Jauss has pointed out that with Schlegel the insight emerged that the entire dynamic of change in modern art could well be summarized by an endless exploration and domestication of nonart.[15] Indeed, the ugly in modern aesthetics from romanticism onward came to be broadly defined as those forms and topics which, at a certain point in history, challenge what counts as art and literature. The ugly, the name given to the inaesthetic or nonart as it is introduced into art, thus came to be depicted as a category, always broadening the domain of beauty within a specific historical constellation. The most important consequence of this way of looking at the ugly is that it made way for the assertion that true change in modern art always occurs by

bringing into art ugly contents and forms that at a certain point are not regarded as part of art. This is, for example, why the symbolists' turn to the city and everyday metropolitan life in poetry was received as both distasteful and groundbreaking. This is also why Marcel Duchamp's simplest ready-mades are still remembered by a wider audience as constitutive of modern art. Rupture in art, revolution even, always comes with the radically ugly.

In the course of the nineteenth century the ugly was approached time and again. What Schlegel's study of (pre)modern poetry did for German romanticism, Victor Hugo's long introduction to his play *Cromwell* (1827) did for French romanticism. Art portrays nature, Hugo argued, and because nature on occasion is also ugly, its seedier aspects too were to be the subject of writing. Like Schlegel before him, Hugo made beauty turn full circle: here too the ugly and the grotesque were in the end to add luster to, or to expand, the domain of beauty.[16] This tendency to subjugate the ugly to beauty was also characteristic of Karl Rozenkranz's famous *Ästhetik des Hässlichen* (1853), a study that deeply influenced many French symbolists, most notably Charles Baudelaire. A student of Hegel, Rozenkranz was the first to systematically think about the ugly in all its forms. Distinguishing various such forms (in nature, in thought, and in art), Rozenkranz paid ample attention to the grotesque and to caricature. Yet for Rozenkranz too it was the *beauty* of the ugly in art, the way in which seemingly ugly phenomena could be made to bear on beauty, that really mattered.[17] An avid reader of Rozenkranz, Baudelaire in turn looked to beautify the ugly. The title of his most famous book of poetry is obviously telling in this respect: *Les Fleurs du mal*. Thematically introducing in poetry aspects of everyday life that before had no place there — extreme poverty, subjects dying, carcasses, and so on — Baudelaire further praised Goya's portrayal of ugly, monstrous figures, because of their imaginative power. Goya's monsters did not exist in reality, and Baudelaire thereby seconded Hugo's earlier observation that the introduction of the ugly into the realm of beauty could also considerably expand that realm's imaginative horizon.[18] Yet with Baudelaire the realm of the inaesthetic was further enlarged to include not only all given aspects of life outside art, but also all potential products of the imagination artists and writers could censor while producing art. Schlegel's contemporaries Novalis and Tieck, with their glorification of the unconscious and the dreamlike, had ventured there before.

By the turn of the century, just when aestheticism was celebrating the beauty of the ugly in unprecedented ways, some went as far as to bracket the distinction between the ugliness and beauty altogether. Perhaps most importantly, in Italy Benedetto Croce's *Estetica come scienza dell'espressione e lin-*

guistica generale (1902) quite radically broke with previous approaches to the ugly by stating that in the aesthetic process of expression or creation the ugliness/beauty opposition simply had to be bracketed. Whatever means an artist or writer draws on in the act of creation is (and remains) aesthetic, Croce's expressivist theory implied. However, there is little evidence suggesting that Croce's idealist, post-Hegelian view of the ugly left a mark on the Italian futurist aesthetic that was to develop shortly thereafter.[19] Quite the opposite: like their modern predecessors, futurists continued to work with the opposition between the ugly and beauty, trying to domesticate the former within the latter. In his manifestos Marinetti indeed did away with all traditions except with that of the ugly. Like Schlegel, it transpires, Marinetti believed that for (futurist) art to represent an advance, it had to introduce certain forms and contents that so far had not been assigned a place in art. In a speech to Venetians in 1910, for example, he warned: "There's no use howling against the presumed ugliness of the locomotives, trams, motorcars, and bicycles, which for us represent the opening lines of our great Futurist aesthetic."[20] Thus firmly inscribing futurism into a distinctly modern tradition, and explicitly "uglifying" art, Marinetti's efforts at first sight presented little more than a continuation of symbolism's and aestheticism's championing of modern technological advances, violence, and war. Shortly after the "Foundation and Manifesto of Futurism" appeared in *Le Figaro*, René Ghil not incorrectly questioned the originality of futurism in this sense: "What's new in writing about factories, machines, big cities?" Not much, it had to be admitted. "Verhaeren," for example, "did so years ago."[21] What was in part new, however, is that the movement from the outset also bent this older and sedimented tradition into hitherto largely unexplored directions. Indeed, Marinetti did not put "the ugly" in scare quotes in his "Technical Manifesto" by accident.

As can be deduced from my all too brief and schematic survey of the ugly in modern aesthetics, the ugly before futurism had been mainly conceived as a *noumenal* entity—that is, as an idea, motif, or form for contemplation. Futurism went on to extend the ugly to the *phenomenal* level—that is, to the domain of the concrete and tangible, to things and to actions first and foremost. As Marinetti exclaimed in a speech first given in 1910, futurists extolled "Patriotism, War—the sole cleanser of the world—the destructive acts of the anarchists, and the beautiful ideas worth dying for, gloriously opposed to the ugly ideas for which we live."[22] To Marinetti, then, the ugly too was perhaps to be found first and foremost on the level of inaesthetic *practices*, not on the level of reflection or aesthetic ideas. In futurism, as in many later avant-gardes, art was to be action, *art-action*, an experimental practice

that could directly impact society. In its often hyperbolic writings, futurism frequently suggested that it thereby simply obliterated the older intellectual, contemplative concept of art. A century onward it is clear that this hyperbolic suggestion needs qualification for a variety of reasons. For example, one can argue, as Marjorie Perloff has done,[23] that with its manifestos futurism should be viewed as an important precursor of conceptual art, since many of the plans announced in futurist manifestos often remained just that: plans or ideas. And even those ideas that were in part realized were first performatively called to life in manifestos. Ideas and contemplation thus loomed large in futurism. Nonetheless, the movement's claim to novelty, incited by its inclusion of action in art, does highlight that futurists were well aware of the fact that they were substantially widening what was then generally considered to fall under art, and that they drew on that expanded notion of art to ground their totalizing aesthetic project. Ultimately futurism, like a sponge, set out from within the realm of art to absorb and reshape the whole of the inaesthetic (things and actions included), envisioning a point at which a new aesthetic form of life, a universe reconstructed, would come to coincide with life as such outside art.

This "bulimic" project, which needless to say remained a concept for the most part, of course had precursors. Futurists were not the first to include practices of everyday life in art (think of Arts and Crafts), nor was their totalizing project without precedents (consider Wagner's notion of *Gesamtkunstwerk*). Of significance is that all of these precedents converged in Italian futurism, in a particular cultural context, with unmatched brashness and bravura. In his classical survey *Italian Futurist Theatre, 1909–1940*, Günter Berghaus demonstrates that the art forms best capturing (if not encapsulating all of) the futurist aesthetic were theater and performance art. Here, Berghaus shows, futurism proved quite successful in putting its ambitious plan to work.[24] As the movement took *art-action* to the streets from its very inception in provocative performances and public actions, futurism soon became part and parcel of popular culture in Italy and made Marinetti into a national icon; one need but recall the many caricatures of him appearing in the popular press.[25] It was no exception for futurist manifestations to gather several thousands of audience members. Significantly, its verbal public actions also made the movement an artistic phenomenon accessible to an illiterate audience. That audience speaks to us today through census figures which remind us that in 1911 38 percent of Italians aged six and over could not even spell their names,[26] and through the writings of Antonio Gramsci and other politicians and journalists who reported about the manifest presence of workers

during futurist actions in the public space. Berghaus's survey illustrates that basically any action undertaken in public by one or several futurists requires an aesthetic attitude from us. Even visits to exclusive restaurants during which futurists raised havoc with regular customers and establishment owners by demanding highly experimental dishes—a practice that eventually led to the publication of the *Futurist Cookbook* in 1932—formed part and parcel of the movement's *art-action*. So did any public action that was meant to intervene in public debate or even state affairs. In short, from the vantage point of the futurist aesthetic, at least in the way I present it here, we are to regard every public action of a futurist as that of an artist who was always and everywhere bringing into art "ugly" practices.

Futurism's aesthetic practice, on the one hand, and its definition of art, on the other, were to remain inseparable. Particularly throughout the first phase of the movement Marinetti made sure to stress time after time that the movement did not hold a clearly delineated program. While Marinetti and his followers adhered to a small set of sketched-out ambitions (inject Italy with a modern culture through art, expand the action radius of art), they also quite consistently kept stressing the ever experimental nature of the movement, denying it any prophetic quality.[27] As a central character in Marinetti's novel *Gli Indomabili* (*The Untameables*, 1922) asserts, "The great book of Futurism teaches us to improvise everything, even God."[28] These words echo Marinetti's own claim in *Al di là del comunismo* (*Beyond Communism*, 1920) that "history, life itself, the world belong to the Improvisers."[29] In a similar manner futurism never defined art in positive terms beyond the basic idea of *art-action*. As a result, which types of inaesthetic practices it would include in its project was essentially kept open. Yet futurism from the outset also evinced that political practice or practical politics would one day be included in the action radius of art as well.

In 1909, the same year that saw the publication of the "Founding and Manifesto of Futurism," during the general elections in December, Marinetti distributed a small flyer, reprinted on large posters, which read: "Futurist Voters! We Futurists, whose sole political program is one of national pride, energy and expansion, . . . want a national representation which, freed from mummies and from every sort of pacifist cowardice, will be ready to extricate us from any snare and to respond to any offer whatsoever. THE FUTURISTS."[30] Through the ambiguous address "Futurist voters!," which expanded the futurist aesthetic of *art-action* to also cover practical politics, this short text raised the suggestion that the futurists would one day stand in elections, bringing with them a new "national representation." Although we do not

know how the Italian electorate responded to it, the leaflet made an irreversible incision in Italian political culture that eventually led to the erection of a veritable Partito Politico Futurista, or Futurist Political Party (hereafter FPP).

The Democratic Moment

Let us have a closer look at the context in which the futurist turn to politics occurred. I have already highlighted that the movement surfaced at a time when the public face and function of modern art were being negotiated in Italy. This in part accounts for futurism's singular project to expand the discursive and structural confines of the field of art. But it does not quite elucidate why practical politics, with which Italian futurism is associated to this very day, should have figured so prominently in that expansion. The ties between futurism and politics have been the subject of an impressive number of studies, most of which have focused on the interstices between the movement and fascism and totalitarianism. While this has yielded many relevant insights, it has led to neglect of the many socialist and communist inspired futurist factions that cropped up throughout the country in the course of the movement's history.[31] Perhaps above all, however, critical attention to futurism and totalitarianism has obscured the fact that the movement actually emerged in a *democratic* political constellation. In *The Theory of the Avant-Garde* (1962) Renato Poggioli already pointed out that the avant-garde in the West has always required a democratic constellation to flower, "even if it often assumes a hostile pose toward . . . democratic society."[32] Much is to be argued for this view, especially because in non-Western regions too aesthetic revolutions most often have taken root at those moments during which a degree of dissent was at least tolerated and the pluralism typical of liberal democracies was given room to emerge.[33] Poggioli thus drew attention to the more positive, democratic moment during which the polyphonous voice of avant-garde dissent is often heard, seconding more recent findings about liberal democracy which highlight that it is a system driven by lively and energetic debate.

To situate futurism against the backdrop of modern representational democracy is also to recognize that the movement's turn to politics was in part also provoked by events in the political field. Futurism surfaced at a time when Italy went through a crisis-ridden transition toward *mass* democracy. The outcome of this transition is well known: former socialist Benito Mussolini, after briefly having joined forces with the futurists in 1919, became prime minister in 1922, perfectly in accordance with legal democratic procedure. It is the process before that point that is of interest to us here, however, because

during that process all options seemed to lie wide open; the people, divided into different ideological factions, accordingly wished for Italy to move in divergent directions. This constellation led to one of the bloodiest episodes in Italian history, culminating in the so-called *biennio rosso* or red biennium (1919–20), marked by mass strikes and an imminent civil war that left many members of the middle class and the industrials with nothing but fear and frustration, as their businesses were looted and production was brought to a halt.[34] It was during this nebulous interregnum too that futurism seized the opportunity to test its expanded notion of art in practical political terms.

Just as art's role and function were up for negotiation in Italy, so too had the role and function of politics been the subject of debate for quite a while when futurism arrived. Led by the liberal Giovanni Giolitti, chief minister from 1903 to 1914, the country's parliament was elected by only a limited number of Italians. In 1909, only about 10 percent of adult Italians, all male and over thirty, had a right to vote. For these and other reasons, a veritable "anti-Giolitti revolt" existed among Italian youths,[35] and sentiments of anti-parliamentarianism also figured prominently in the writings of many futurists.[36] One of few concrete legal reforms advocated by the movement early on was, unsurprisingly, the introduction of universal (including female) suffrage. Drawing attention to the "mediocre legislative instrument" of vote buying from poor, uneducated women and to the restrictions on suffrage in Italy, Marinetti in 1910 observed that "the people thus remain forever outside government. Yet . . . it is precisely to parliamentarianism that the people owe their very existence."[37] As a way to overcome this impasse, and so as to bring forth the "logical conclusion of the idea of democracy . . . as it was conceived by Jean-Jacques Rousseau and the other harbingers of the French Revolution," he pleaded for universal suffrage.[38]

Futurism's plea proved a safe bet. During the Libyan War, in 1911, Giolitti made suffrage reform part of his political program. To avoid protest, the soldiers fighting for Italy in its colony, most of them illiterate, could not be denied a vote on their return home. Thus, in 1912, all literate men aged twenty-one and over, and all men aged thirty and over, whether literate or not, were given the right to vote.[39] With Giolitti's reform, the electorate suddenly more than doubled (from 3 million in 1909 to an estimated 8.5 million, that is, around 25 percent of the total population). Similarly, in December 1918, as soldiers returned from the First World War, universal male suffrage was introduced. In about half a decade Italy thus witnessed the birth of a mass democracy, and this birth was not without complications, for practical Italian politics was not quite ready to deal with such a large constituency of voters.

Not only did politicians lack experience in properly addressing and representing a mass electorate. Institutionally, too, the country lacked the material means to properly handle such a large electorate. Most importantly, perhaps, after the suffrage reform of 1912 Italy did not have mass parties.

This left the country in a highly politicized and paradoxical situation: while a mass electorate had been erected in the public space, the field of politics had almost no practical instruments to represent or handle it. Futurism's attempt to flesh out a political party from within art thus appears anything but coincidental, not least given the ill-defined structural and discursive confines of both the artistic and the political field. Indeed, political officials too at the time seemed unclear about where art ended and politics began. Already on February 2, 1911, after a futurist performance attended by thousands during which futurists may have read the flyer quoted previously, a political file was opened on Marinetti by the prefect of Milan and sent to the Ministry of Interior, Office of Public Security. It contained this telling "character portrait": "The named Marinetti, Filippo Tommaso . . . doctor of law, poet and novelist, Futurist, is a gifted and highly esteemed person, of good moral conduct, but with a restless and impetuous personality. He [has no] . . . pronounced political profile, but [is] sometimes driven to extremes. . . . This can give more prominence to the Futurist ideas he propagates."[40]

This portrait evinces that within the political field as well, officials were not all that clear on where exactly the boundaries of (futurist) art lay. Most importantly, they did not exclude the possibility that the movement would gain wider bearing in political culture.

Adding to futurism's turn to politics was the fact that the press, in which futurists as well were of course manifestly present, began to play an important role in oppositional politics by the 1912 suffrage reform. The press throughout Europe in the nineteenth century had of course always played a capital role in politics: leading political parties could fall back on their own newspapers to disseminate their ideological position. In Italy, too, the oppositional Socialist Party could count on its own press organ, Avanti!, which was led, from 1912 onward, by Mussolini, while liberalist newspapers favoring the politics of Giolitti, such as La Stampa and La Tribuna, endorsed official political views. The Catholic Church and the Vatican, meanwhile, exerted perhaps the most profound influence in the press and far beyond. The role of the press in Italy nonetheless differed, albeit in degree, from that in other European countries. For as is commonly recognized by Italian political historians, at this point there were great national newspapers, but no great national popular parties.[41] Consequently, success in oppositional politics made it almost a prerequisite

for politicians to reach success in journalism first. Key political players like the Catholic Luigi Sturzo, the communist Gramsci, and the (later) fascist Mussolini indeed all built a political career in journalism first. Gramsci perhaps most succinctly summed up the essential role of the press in Italy after 1912, when he emphasized that the press took on functions that otherwise may be expected of political parties.[42] And the fact that Mussolini later, in 1925, was quick to endorse a Press Law stating that only registered journalists could write in newspapers speaks volumes as well.[43] Delegitimizing the national government in Italy was not so much done in parliament. It was done mainly in print and rehearsed by authors and intellectuals in lectures and public talks. Perhaps unsurprisingly, the birth of the FPP, too, was announced in a (self-named) futurist newspaper. When the movement finally entered the elections in 1919, the ultimate aim of its aesthetic-cum-political experiment was pushed far into the open: the FPP's goal was to activate and incorporate as many members of the mass electorate as possible—to actively engage the mass electorate as a participant in its totalizing aesthetic plan.

Artists to Power (in Art)

The facts about the FPP have been well documented,[44] but they are rarely seen as part and parcel of futurism's artistic production. None of the great exhibitions on futurism, for example, have ventured to incorporate the process leading up to the FPP into futurism's aesthetic project. Whether we turn to the exhibition held at New York's Museum of Modern Art in 1961,[45] to the most comprehensive futurism show so far organized by Pontus Hulten in the Palazzo Grassi in Venice,[46] or, more recently, to the exhibition Le futurisme à Paris at the Centre Pompidou,[47] curators as a rule exclude this most radical aspect of the movement, and relegate it to the margins as nonart. Yet it does not require much effort to show that many types of political practice were made the object of artistic experimentation in the movement. Most obvious are the acts of writing and presenting political texts. An interesting example is the "Programma politico futurista" ("Political Program of Futurism") that was published on October 11, 1913, by Marinetti and cosigned by Boccioni, Russolo, and Carrà. The "Programma" appeared during the first national election campaign since the suffrage reform of 1912 and demanded that "all freedoms" prevail.[48] The way the 1913 "Programma" was composed is striking. It had no sentences, for instance; it contained only phrases and partial clauses. The futurist political program was thus first set out in an elliptical and abbreviated fashion. Similarly, the document concluded by enlisting the pro-

grams of two opposing camps, presented in two adjacent columns: on the left, the "clerical-moderate-liberal program," and on the right, the "democratic-republican-socialist program." When the futurist program is read alongside those two other lists, it becomes abundantly clear that futurists were comparing apples and oranges. The republicans, the text stated, obviously supported the idea of a republic. Was futurism antirepublican or in favor of the monarchy? The "Programma" left readers wondering. Many socialists were anticlerical, but so was futurism. The liberals displayed an "occasional militarism," but futurism wanted a still "bigger fleet and a bigger army."[49] Futurism demanded the "supremacy of gymnastics over books."[50] Yet as to how futurism's opponents related to books and gymnastics, readers were again left in the dark. Thus presenting three lists of political doxa—futurist, liberal-catholic, and social-democratic—the pamphlet was stuffed with indeterminacies. So manifest are these associative blanks today still that it is impossible not to conclude that this piece of political writing successfully actualized the futurist aesthetic of writing first advocated in the "Technical Manifesto of Futurist Literature" a year before. Indeed, what we find in this text are *parole in libertà*, emancipated nouns and phrases whose syntactical interrelation was to be actively constructed by the reader, making the act of reading a performative event.

That event was dramatized and accentuated by the distribution of the 1913 pamphlet. The program first appeared within the columns of *Lacerba*, which between 1912 and 1915 became an internationally renowned organ of futurism. Futurists were careful, however, not to limit the visibility of their text to a journal of such modest circulation attracting mainly a bourgeois audience.[51] In the same week a request went to Guglielmo Janelli, a futurist based in Sicily,[52] to have the text printed as fifteen hundred flyers on paper of different colors. Janelli was asked to take his car to the main streets of Messina and distribute the flyers. Two weeks later the appearance of the "Programma" had gained the status of a veritable event in Italy. In an interview with Marinetti published at the end of October in the *Giornale d'Italia*, the futurist explained that the movement wished to articulate two normally distant if not irreconcilable groups of ideas, and more precisely to "fuse the ideas of the Fatherland and war with the concept of progress and liberty."[53] Indeed, the program pitted largely unrelated views and ideas against one another, forcing a reader to make the parts cohere in a semantic whole. (In the essay "Old Ideas That Go Hand in Glove and Which Need to be Separated," included in his book *Democrazia Futurista: Dinamismo politico* [1919], Marinetti went on to theorize this practice, illustrating how futurist linguistic experimentation could

be used in politics to undo terms of their complacent denotations and give rise to new ones.) In response the interviewer of the *Giornale d'Italia* asked whether the rumor circulating in Rome was true: Marinetti, it was said, was going to stand in elections. The futurist replied that he did not exclude the possibility, but that he would figure only in "a district of real importance."[54] When the Sicilian paper *L'avvenire* interviewed Marinetti in 1915 about the role of Mussolini, who on a number of occasions had demonstrated with the futurists, Marinetti claimed that he and Mussolini above all desired a more youthful and vibrant politics.[55] And, indeed, from 1913 onward the futurists made it their business to storm university buildings and interrupt lecturers in law, philosophy, and aesthetics. The "fuel of liberty" (*benzina di libertà*), as one student called the movement,[56] futurism had become an intellectual *événement*.

In 1914 Marinetti also began to write about experimental ways of declaiming (political) texts. Since its creation the futurist movement had always ridiculed the histrionics of political leaders. Especially the lack of authority stemming from rulers' speeches was often isolated. The "idea of representation" in Italian parliament, Marinetti asserted, was built on speeches exaggerating "beyond measure the value of eloquence." "Emporia of subtle ideas and polished syllogisms" testifying to the absolute power of lawyers working the "malleable metal of the law," the whole of political representation had to be reconsidered. To that end it would one day prove inevitable "to substitute artists — creative talents — for the lawyer class — whose talent is for long-windedness and obfuscation."[57] In order to prepare those "creative talents" Marinetti spelled out prescriptions for futurist orators in the manifesto titled "Dynamic, Multichanneled Recitation" (published in 1916 but for the most part written in 1914). This manifesto is traditionally read against the background of symbolist declamation practices, like those of Sarah Bernhardt. Yet the manifesto made very clear that a didactic if not political element informed it as well, since it was to advance the futurist "lecture-cum-recitation" and to supplant complacent political histrionics.[58] It demanded that "the more populist, more or less ritual gestures" should be avoided.[59] Instead, futurist orators were to dehumanize themselves, visibly and audibly reduce themselves to selfless bodies, "wear self-effacing clothes," "dehumanize the voice," "dehumanize the face," and "gesticulate geometrically."[60] Political speech and futurist poetry thereby again came close to overlapping, as in poetry too Marinetti had advocated a thoroughgoing poetic of depersonalization: "In the new Futurist lyricism, . . . our literary 'I' is burnt up and destroys itself in the superior vibrancy of the cosmos, so that the one who

recites must also disappear, in a manner of speaking, in the dynamic, multi-channeled revelation of the words-in-freedom."[61]

The type of artist-politician emerging from these experiments — a selfless servant and amplifier of civil subjects' conflicting desires and views, a creator of consensus using means unknown so far to practical politics — was reminiscent of the writings of utopian socialist Saint-Simon. Saint-Simon had subjugated the avant-garde to the political elite.[62] Futurism inscribed its political-cum-artistic experiments into a different logic, however, one that departed from the authority of singular subjects and the primacy of art. Be that as it may, the movement was primarily occupied with the shape or form of political things to come. Futurists in the process naturally also toyed with various ideas for practical state reforms, but up and until the elections those ideas kept changing as futurism stuck with its principle of improvisation.

As Marinetti again reminded an audience of students in a 1914 speech, futurism was "an impassioned attempt at introducing life into art."[63] Looking to integrate a maximum of ideas, practices, and experiences from life in art, the movement unsurprisingly announced its indefinite sublation in life when Italy entered the First World War in 1915. In that year the 1913 "Programma" was reissued, and this famous sentence was added to it: "The Futurist movement in the fields of literature, painting and music is currently suspended, owing to the poet Marinetti's absence in the theatre of war."[64] The choice of words was telling. Futurist art as such was not put on hold. It simply radicalized its "theatrical" moment, living (wartime) life in or as art. It goes without saying that the Great War further destabilized the functional boundaries between the fields of art and literature. As the Italian king declared the state of exception and suspended democracy, all domains in civil society ended up being overpoliticized, including art: its institutions and practices were fully subjugated to political rule.[65] As a result futurism was left some (though very little) agency to further develop its own art-cum-politics. Tragically, too, in the "theater of war" many futurists met with death.

It was only in the final year of the war, on February 11, 1918, that futurism's artistic-political project reemerged with an unexpected twist. *L'Italia Futurista*, a bimonthly journal launched with the aim of propagating futurist work (by women)[66] among the soldiers, and in the editorial of no. 1 (June 1, 1916) announced the "first dynamic Italian newspaper [*giornale*]," became the discursive birthplace of the FPP. That is, before the FPP had even materialized, Marinetti published its program in *L'Italia Futurista*. In part censored by the wartime military regime, the 1918 program proposed to abolish all state institutions (as well as many civil institutions, such as marriage) and portrayed

the FPP as a party that would lead to a new type of society.[67] In its conclusion the program ambivalently distinguished the FPP from the futurist art movement, stating that "all Italians, men and women of all classes and ages, can belong to the Futurist Political Party, regardless of whether or not they have any artistic or literary understanding." This claim far from signaled an unbridgeable gap between futurist art and politics. (A year later, for instance, *Democrazia futurista* opened with a preface entitled "Un movimento artistico crea un Partito Politico.") Rather, this sentence differentiated structural positions or roles. On the one hand, futurist artists could never be just politicians in light of their totalizing *art-action* plan—*art-action* would always include more than just political practices. But the futurists would sustain the FPP's "political program with the élan and courage that hitherto have characterized the Futurist Movement in the theatres and piazzas."[68] On the other hand, and quite in line with futurism's ambition to bring life in its entirety into art, nonartists as well could join the FPP. There was a stultifying simplicity if not naïveté to it all. Indeed, ideally all Italians would become part and partisan of the FPP. The party would then simply come to coincide with civil society, and the suspension of political society or the state, which was also advocated by Gramsci at the time, would subsequently announce itself. Because it was an artistic party, however (and here of course the futurists differed from Gramsci), the whole of civil society, the nation, would then also have come to fall within or under art.

As the futurists began to gather supporters throughout the country and to rope in candidates to figure on their party list, they seized every opportunity to spread their message through actions in the public space, including a widely reported disruption of proceedings in the parliament of Montecitorio, Italy. Their acts of *squadrismo*, in particular, were on occasion extremely violent, and in the run-up to the actual elections of 1919 many futurists, including Marinetti, spent time in prison. Meanwhile, energy also went into refining the FPP's program. The growing grip of communism especially challenged the futurists. In response to the idea of a Marxist or bolshevist revolution they started propagating an "Italian Revolution," in part referring back to the days of the nineteenth-century *Risorgimento*. They thereby closed the gap with the right-wing factions around Mussolini—these factions and the FPP worked together closely—and the relative speed with which futurist ideas were absorbed into fascism should not be underplayed. But the futurists also kept these right-wing factions at some distance by criticizing Mussolini whenever he stepped out of line. Futurism was to remain an uncompromising, open-ended, and independent venture. Accordingly, what the projected "Ital-

ian Revolution" would lead to exactly was not easily pinned down. As the futurists saw it the nation was "nothing other than a vast political party."[69] That party being (becoming) the FPP, futurists would institute a new, futurist democracy: "Our Political Party wishes to create a free Futurist Democracy."[70] As Gian Battista Nazzaro summarizes, that other democracy boiled down to a "Utopian idea of a State founded on art and directed by artists, a kind of technologically equipped and functioning Arcadia."[71]

More energy thus went into negotiating the social role of artists and writers than into producing concrete political solutions to the deep economic and political crisis Italy found itself in. Or, rather, futurism suggested that bringing artists to power was the solution. "Yes, power to the artists! The vast proletariat of geniuses will rule."[72] The phrase "proletariat of geniuses" was yet another of futurism's retorts to the growing popularity of communism. Criticizing what he saw as historical materialism's class essentialism, Marinetti came up with his own "elite" class, endowing it with the prospect and power of government. Just as the proletariat in historical materialism was to be the guide toward a classless society, so too was the "proletariat of geniuses" in futurism to lead to a new artistic society. Futurists thus pitted their own "proletariat" of Italian geniuses against the dictatorship of the majority or working class. The futurist proletariat, interestingly, referred to an oppressed body of artists in need of liberation, a social minority that more or less coincided with what after armistice was often also called the "intellectual proletariat": the thousands of graduates who were destined for unemployment due to shortage of work—Italy was bankrupt. Marinetti estimated that there were, "without doubt, two or three hundred thousand of them throughout the country."[73] Their talents were kept latent or subdued, he claimed, by traditionalism and "institutionalized obstructionism."[74] So for the unemployed of today to become the politicians of tomorrow, the young were to be stimulated (if not forced) to practice art. Great "Open Exhibitions of Creative Talent" had to be organized throughout the country, for example.[75] Here art production and thought were to become fully freed from any outside restrictions and rules—"no matter how absurd, idiotic, mad or immoral [the work] may appear to be."[76] Thus creative talents would be prepared for rule. For, as Marinetti spelled out in *Al di là del comunismo*, "life ... is a *work of art*. Every man will live his best possible novel. ... We will have no earthly paradise, but the economic inferno will be lightened and pacified by innumerable festivals of Art."[77]

The electorate disagreed. In the elections the futurists, supported by fascists and wartime veterans, failed abysmally. In Marinetti's hometown, Milan,

less than 2 percent voted for it. Given the proximity of certain elements in futurism to Marxism, a small number of futurist factions for a while sought alliances with communists. Yet these too had a short life span.

Art of the Impossible

Futurism's aesthetic-cum-political adventure raises a large number of questions, chief among them the question of how, if at all, we are to view politics as art. Commentators at the time, as today, struggled with futurism's political form of *art-action*. Croce, for example, was no admirer of futurism's political "excursions" — which reminds us that he too placed the inaesthetic on the level of contemplation, not action. In 1924 Croce stressed that the seeds of fascism had been able to grow in futurism. The movement's determination to go down on the streets, to impose its desires and moods on others, to shut others with dissenting views up if need be: all of these practices foreshadowed fascist politics, Croce thought.[78] Yet he did not define these practices as distinctly aesthetic. Rather, he distinguished futurism's political actions from its artistic and literary exploits. A decade later, Walter Benjamin did exactly the opposite when he asserted that the fascists (and, by extension, the futurists) had dangerously embarked on an "aestheticization of politics."[79] But whereas Croce put the stress on futurism's public actions, Benjamin in turn restricted his scope to the ideas futurist texts and artworks voiced, placing the movement within a post-Nietzschean and anarchist tradition of representation that glorified *beaux gestes libertaires* and depicted the social masses as a malleable aesthetic object. Only when Croce and Benjamin are read in tandem, by consequence, does the real change entailed by futurism's exploits show itself: quite simply, it introduced *practical* politics *as* artistic practice. In so doing it not so much depicted the electorate as an aesthetic object. Rather, it tried to activate the mass as a body of singular subjects participating in its aesthetic project, and conspicuously refused to settle the future.

One contemporary who looked at futurism's political *art-actions* through the lens of the futurist aesthetic itself was Ferruccio Vecchi, a former Ardito (or First World War storm trooper) who had worked closely together with Marinetti since the end of the Great War. As Vecchi saw it, Marinetti and his followers, at least up to the 1920s, had turned to practical politics as an object of aesthetic play.[80] That such a project entails a complex set of moral and ethical issues goes without saying. Such issues are in fact written into the DNA of all aesthetic revolutions and avant-gardes. Yet the reason futurism is so often recalled in this context is that it came very far in incorporating "ugly" politi-

cal practices into art. This is also why futurism remains of capital significance in any phenomenology of aesthetic revolutions as such, for it pinpoints with relative precision at least two conditions of possibility for them.

First, and most generally, there is the democratic moment I evoked. Futurism's projected alternative Utopian democracy emphasizes that art can only present itself as a social and political model when the dissent and the pluralism typical of liberal democracies is tolerated. Second, futurism more specifically reveals that for an aesthetic revolution to gain a radical *practical* political edge, the structural and discursive confines of the field of art may first have to be fundamentally destabilized by political events. Indeed, futurism's artistic-political project might come with an air of denseness. Yet it was launched in a constellation wherein everything appeared possible. (Gabriele D'Annunzio's concurrent experiment in Fiume need but be recalled here.)[81] If politics is the art of the possible, as it is often called, then futurism for a while at least was politics. As I have argued elsewhere, political crises in Western European countries during the 1910s and 1920s also destabilized the artistic fields in which other canonical avant-gardes experimented. While such crises cannot explain the advent of the so-called historical avant-gardes, they do illustrate that the avant-garde's project of reuniting art and life, as Peter Bürger's seminal *Theory of the Avant-Garde* (1974) defined it, was not entirely of the avant-garde's own design. That project was often facilitated by the avant-garde, but in part also imposed on it by the unstable social and political context. Reading futurism through the lens of its own aesthetic shows us mainly what the movement desired. We only grasp futurism's relatively successful heteronomist attempt to undo the functionally differentiated role and function of art through turning to practical politics, however, by bringing into scope the movement's highly unstable if not functionally and systemically dislocated context.

During the so-called second phase of futurism from the early 1920s onward, when social order was gradually imposed from within the political field on society, the structural and material confines of art gained much clearer definitions. In "Futurism and Fascism" (1924), Marinetti agreed that Mussolini would run the country's politics, provided the leader also respected the autonomy of futurism in the field of art. Marinetti now called art "the unlimited domain of pure fantasy," suggesting that the futurist aesthetic of *art-action* at least in part had encountered its outer limits.[82] Second-wave futurism continued to experiment and enlarge the domain of art by looking for still other ugly forms and practices. (Mussolini's so-called dual state only in the 1930s began to determine art and cultural politics in never entirely

totalitarian ways.) Yet the moment of practical political experimentation—the hope of an Artocracy, as Marinetti often called it—had ceased.

NOTES

This work is made possible by the support of the KULeuven research project MDRN.

1. Benn, "Probleme der Lyrik," 498.

2. Salaris, *Marinetti editore*, 9, 241–63.

3. Boccioni, "Futurist Painting," 150.

4. Ciampi, *Futuristi e anarchisti*; Lista, "Marinetti et les anarcho-syndicalistes."

5. Marino, *L'autarchia della cultura*, 181.

6. Visser, "Fascist Doctrine and the Cult of the Romanità"; Stone, "A Flexible Rome."

7. Gian Battista Nazzaro argues correctly that an "anarcho-individualist utopia" lay at the center of Marinetti's project. See Nazzaro, "L'Idéologie Marinettiène et le fascisme," 122 (my translation).

8. Martin Clark, *Modern Italy*, 172.

9. Translation from Marinetti, *Critical Writings*, 237; hereafter referred to as CW. Italian original from Marinetti, *Teoria e invenzione futurista*, 336; henceforth referred to as *TIF*.

10. Marinetti, "Futurism's First Battles," CW, 151–57, here 151.

11. Marinetti, "Technical Manifesto of Futurist Literature," CW, 107–19, here 113.

12. Not least considering that "the ugly" is a notion frequently associated with the so-called historical avant-gardes as such. See, among others, Greenberg, "Review of Exhibitions"; Jameson, *Postmodernism*; Lesley Higgins, *The Modernist Cult of Ugliness*.

13. This is now generally considered to have been one of Europe's first self-conscious avant-garde movements; see especially Lacoue-Labarthe and Nancy, *L'Absolu littéraire*.

14. For an extensive discussion of Schlegel in this context, see Oesterle, "Entwurf einer Monographie des ästhetisch Hässlichen."

15. Jauss, "Die klassische und christliche Rechtfertigung des Hässlichen."

16. Hugo, *Préface de Cromwell*.

17. Rozenkranz, *Ästhetik des Hässlichen*.

18. For a discussion of the ugly in Baudelaire, consult Hannoosh, *Baudelaire and Caricature*.

19. Croce's notion of intuition, by contrast, had a profound impact on the movement. See Poggi, *Inventing Futurism*.

20. Marinetti, "The Battles of Venice," CW, 164–68, here 167.

21. Ghil et al., "Du futurisme au primitivisme," 170.

22. Marinetti, "The Necessity and Beauty of Violence," CW, 60–72, here 61.

23. Perloff, *The Futurist Moment*, 84.

24. For a survey, see Berghaus, *Italian Futurist Theatre*.

25. Reproductions of some of these can be found in Berghaus, *Italian Futurist Theatre*, 91, 98, 128–29, 141.

26. Martin Clark, *Modern Italy*, 36.

27. See especially *TIF*, 331–32.

28. Marinetti, *Selected Writings*, 234.

29. Marinetti, *Selected Writings*, 148.

30. Marinetti, *CW*, 50.

31. For details, consult Bru, "Morbid Symptoms."

32. Poggioli, *The Theory of the Avant-Garde*, 95.

33. See, among others, Mouffe, *The Democratic Paradox*, 15–16.

34. For a more elaborate discussion of the thorough dislocation of Italian political culture and the *biennio rosso*, consult Whittam, *Fascist Italy*; and Maione, *Il biennio rosso*.

35. Gentile, "From the Cultural Revolt of Giolittian Era." Compare Adamson, "Modernism and Fascism."

36. See Salinari, *Miti e conscienza del decadentismo*, 62–64; Gregor, *The Ideology of Fascism*, 36–54.

37. Marinetti, "Against Sentimentalized Love and Parliamentarianism," *CW*, 55–59, here 56 for both quotes.

38. Marinetti, "Against Sentimentalized," 57.

39. Partridge, *Italian Politics Today*, 8 ff.; Forsyth, *The Crisis in Liberal Italy*, 26.

40. Archivo Centrale della Stato, *Ministerio dell'Interno, Direzione Generale della Pubblica Sicurezza, Casello Politico Centrale*, busta 3066, fasc. 97613, "Marinetti." Quoted, with a slight alteration, in the translation of Berghaus, *Futurism and Politics*, 52.

41. See Bull, "Social and Political Cultures in Italy," 49 ff.

42. Gramsci, *Selections from Cultural Writings*, 389–91.

43. Knight, *Mussolini and Fascism*, 34 ff.

44. See Bru, *Democracy, Law and the Modernist Avant-Gardes*, 41–86. Compare Santarelli, *Fascismo e neofascismo*, 3–50; Zapponi, "La politica come espediente e come utopia"; Berghaus, "The Futurist Political Party." A brief yet interesting historical account is Settimeli, "Storia del partito politica futurista."

45. Tellingly, in his monograph for the exhibition, Joshua Taylor cautioned the viewer that "the nature of the [Italian] Futurist impulse in politics . . . should not influence the assessment of its achievement in art." Joshua Taylor, *Futurism*, 17.

46. Hulten, "Futurism and Futurists" and "Futurist Prophecies," in *Futurism and Futurisms*, 13–21. Renzo de Felice's rather elliptical note titled "Ideology" in the same catalog (pp. 448–91) was the only text to really tackle practical political issues. As many have observed, by linking Italian futurism to its Russian and other counterparts, the exhibition above all depoliticized Italian as well as other futurisms. See, among others, Bowler, "Politics as Art," 790.

47. Ottinger et al., *Le futurisme à Paris*.

48. Marinetti, "Third Futurist Political Manifesto," *CW*, 75–77, here 75.

49. Marinetti, "Third Futurist Political Manifesto," 76, 75.

50. Marinetti, "Third Futurist Political Manifesto," 76.

51. This changed during *Lacerba*'s later years, when it ran at twenty thousand copies, 80 percent going to workers. See Poggi, "*Lacerba*: Interventionist Art and Politics," 19.

52. Miligi, *Prefuturismo e primo futurismo in Sicilia*, 292.

53. Interview by Gubello Memmoli, entitled "Con Marinetti in 'terza saletta,'" *Giornale d'Italia*, October 30, 1913. Quoted in translation from Berghaus, *Futurism and Politics*, 71.

54. Berghaus, *Futurism and Politics*, 71.

55. See the interview in CW, 238–44.

56. See Carpi, *L'estrema avanguardia del novecento*, 27.

57. All quotes from Marinetti, "Against Sentimentalized," 56–57.

58. Marinetti, "Dynamic, Multichanneled Recitation," CW, 193–99, here 194.

59. Marinetti, "Dynamic, Multichanneled Recitation," 194.

60. Marinetti, "Dynamic, Multichanneled Recitation," 195–96.

61. Marinetti, "Dynamic, Multichanneled Recitation," 194. See also Plassard, "Le tecniche di disumanizzazione," 35–64.

62. Claude de Saint-Simon expressed these views in various texts from the early 1820s, but perhaps most adamantly in *De l'organisation sociale* (1825).

63. Marinetti, "In This Futurist Year," CW, 231–37, here 233.

64. Quoted from Berghaus, *Italian Futurist Theatre*, 71.

65. See Bru, *Democracy, Law and the Modernist Avant-Gardes*, 54–63.

66. Salaris, *Le futuriste*.

67. For details see Bru, *Democracy, Law and the Modernist Avant-Gardes*, 63–72.

68. Marinetti, "Manifesto of the Futurist Political Party," CW, 271–75, here 275.

69. Marinetti, "Beyond Communism," in *Selected Writings*, 148–57, here 149.

70. Marinetti, "An Artistic Movement Creates a Political Party," CW, 277–82, here 280.

71. Nazzaro, *Futurismo e politica*, 186.

72. My own translation of a quote from *Al di là del Comunismo* (TIF, 485). In both the *Selected Writings* ("gifted men") and CW ("talented people"), translations mask Marinetti's indebtedness to Marxism.

73. Marinetti, "The Proletariat of Talented People," CW, 304–8, here 305.

74. Marinetti, "The Proletariat," 307.

75. Marinetti, "The Proletariat," 307.

76. Marinetti, "The Proletariat," 308.

77. Marinetti, *Selected Writings*, 157.

78. Croce, "Fatti politici e interpretazioni storiche," *La Stampa*, May 15, 1924, reprinted in Croce, *Cultura e vita morale*, 268–69.

79. I am of course referring here to Benjamin's essay "Das Kunstwerk im Zeitalter seiner technischen Reproduzierbarkeit."

80. Vecchi, *Arditismo civile*, 54.

81. For details on the Fiume colony, see Ledeen, *The First Duce*.

82. Marinetti, *Futurismo e fascismo*, TIF, 498.

5 × 5 = 25?

The Science of Constructivism

JOHN E. BOWLT

5 × 5 = 25

The movement of constructivism, especially as it evolved in Soviet Russia in the 1920s, has become a favorite topic of art historical enquiry. Scholarly books and articles have been written about its genesis, evolution, and premature demise; panoramic exhibitions have been devoted to the subject; and images associated with its practice have become signatures of modernism.[1] In much Western scholarship at least, constructivism has become an integral part of the historiography of the October Revolution and tends to be appreciated almost exclusively as the product of the new political order and to be granted an inordinate primacy in the development of early Soviet culture. All

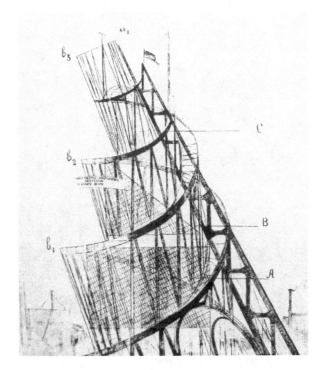

FIGURE 2.1
Vladimir Tatlin,
Drawing for the
*Monument to the
III International*, 1920
(present whereabouts
unknown). The monu-
ment, projected for
Petrograd, was not
built.

the more surprising, then, is the fact that constructivism produced very little of permanence. It was a movement of built-in obsolescence, of ready-to-wear and throw-away, of designs often intended for multiple and mass consumption, of theories, statements, and projects that left behind a precious, but very scant, legacy of material objects. In other words, in remembering the icons of the constructivist process—and Vladimir Tatlin's *Monument to the III International* is an obvious specimen (figure 2.1)—we realize that constructivism is now celebrated more for what it did not create than for what it did.

In September 1921, five members of the Russian avant-garde—Aleksandra Ekster (Exter), Liubov' Popova, Aleksandr Rodchenko, Varvara Stepanova, and Aleksandr Vesnin—represented by five works each—organized the exhibition $5 \times 5 = 25$ at the Club of the All-Russian Union of Poets in Moscow (figure 2.2). This exhibition was the last display of exclusively nonobjective paintings in Russia, a move symbolized by Rodchenko's contribution of three monochrome canvases in red, yellow, and blue, and prefigured the world of constructivist design, with Popova arguing, for example, that her works were "preparatory experiments for concrete constructions" and Stepanova proposing that "technology and industry have advanced the problem of CON-STRUCTION in the face of art."[2] During a lively debate at the Moscow Institute

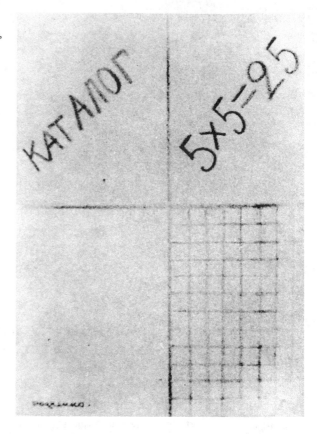

of Artistic Culture (Inkhuk) two months later, the artists then pronounced "studio painting . . . extinct and our activity as mere painters useless" and declared the "absoluteness of industrial art and constructivism as its only form of expression."[3] Although studio art was still being supported at the constructivists' first session within Inkhuk on March 18, 1921, attended by Karel Ioganson, Konstantin Medunetsky, Rodchenko, Stepanova, and Georgii and Vladimir Stenberg, just five months later the critic Nikolai Tarabukin declared that "The Last Picture Has Been Painted," and Aleksei Gan that art had died (figure 2.12),[4] while in December of that year Stepanova lectured on the urgent need to move forward and ally constructivism with industrial design. Bearing such sentiments in mind, therefore, we might be tempted to interpret $5 \times 5 = 25$ not only as a watershed between studio art and applied art or between individualistic contemplation and collective collaboration, but also, more fundamentally, as a dividing line between "intuition" and "analysis" or, in broader terms, between "art" and "science."

Six years after $5 \times 5 = 25$ the constructivist architect Moisei Ginzburg asserted in his survey of Soviet architecture that the ideological impulse of constructivism lay in its aspiration to "reject the metaphysical essence of idealist aesthetics and to embark upon a path of consistent, artistic materialism."[5] The ambitious mission notwithstanding, such a statement could have been made only after the rapid advances that Russian art had achieved by the mid-1920s. As a result of the pioneering investigations of Exter, El Lissitzky, Kazimir Malevich, Popova, Rodchenko, Ol'ga Rozanova, Tatlin, and others, Russian art—between around 1915 and 1925—moved, as it were, from "alchemy" to "chemistry."[6] At the first stage of this development, when Malevich was elaborating his system of suprematism and Tatlin constructing his reliefs, art was still "artistic," but the radical codes compiled by these two artists and their colleagues acted as a vital stimulus to a marked tendency away from the metaphysical toward the physical, the applied or functional arts, and toward the kind of mathematical justification favored by Inkhuk.

Established in Moscow in May 1920, with affiliations in Petrograd, Vitebsk, and other cities, and headed initially by Vasilii Kandinsky, Inkhuk attracted artists and critics who believed that the new art should be mechanical, constructive, and utilitarian. The term "constructivism" was first used in January 1921, in conjunction with the exhibition *The Constructivists* (Konstantin Medunetsky and the Stenberg brothers) (figure 2.3), although the concept of "constructivity" was certainly current in the Russian artistic lexicon well before the October Revolution. With his emphasis on the "spiritual," the psychological, and the occult, Kandinsky seemed ill equipped to supervise a staff of "constructors," and he resigned only after a few months. His replacement, the sculptor and painter Aleksei Babichev, head of the so-called Working Group of Objective Analysis, now tried to promote art as a branch of the sciences, contending that "emotional (and ethical) aspects . . . may be included in the object of research, but they are secondary characteristics . . . and should not be included in the methods of research. . . . As it organizes, art concretizes all concepts and representations. . . . Today's assignment, our social assignment, is to organize the consciousness of the masses."[7]

Championing the reduction of modern movements such as suprematism and Tatlin's "culture of materials" to a scientifically based program that could be used for educational and research purposes, the *inkhukovtsy* were nevertheless quick to conclude that abstract combinations of colors or linear rhythms were of little relevance to the new clientele—the masses—and that art was bound to pursue a more intelligible, accessible purpose. Indeed, the attitude of the new consumer toward abstract and semi-abstract art was well

FIGURE 2.3 Vladimir Stenberg, *KPS 6*. Metal, 766 × 280 × 1570 cm. Reconstruction of the 1921 original. Courtesy of Annely Juda Fine Art, London.

demonstrated in the violent reaction to some of the more provocative statues erected in Moscow in 1918 and afterward in connection with Lenin's Plan of Monumental Propaganda. Some of the experimental contributions were met with angry protests and the cubo-futurist figure of the anarchist Mikhail Bakunin modeled by Boris Korolev, for example, was eventually dismantled because of the public outcry at its schematic forms. As members of the Proletkult (Proletarian Culture) organization, established formally in September 1918, hastened to affirm, art had to be directly relevant to the industrial worker and, therefore, narrative, or at least utilitarian, while Marxist art criticism, according to Yakov Tugendkhol'd in 1926, was to aspire to the "affirmation of a scientific approach to art."[8]

Revolution

Of course, an essential stimulus to this move was the Revolution of October 1917, with its dislocation of all social, political, and cultural axes, even if the avant-garde's engagement lay in a wider philosophical framework and not in a narrow political one. Few of the primary artists were declared enthusiasts of Marxist ideology, although some of them, not least Pavel Filonov, Malevich,

and Rodchenko, did equate artistic innovation with political radicalism, contending that their artistic boldness had in some way anticipated the political spirit of the October Revolution. Still, it would be inaccurate to assume that all radical artists were sympathetic to the new régime, that all its artistic and literary apologists were "avant-garde" or that the cultural ambience immediately after the October Revolution was exclusively "leftist." The institutions which promoted and controlled artistic practice in those years such as the Visual Arts Section of the Commissariat of Enlightenment (IZO NKP), the reformed art schools such as Vkhutemas (Higher State Art-Technical Studios), and the several think tanks such as the Russian (State) Academy of Artistic Sciences (RAKhN) were fluid in their aesthetic proclivities, even if the constructivists did find a secure haven at Inkhuk, turning it into a veritable laboratory of constructivist ideas.

During those years of insurgence, economic blockade, and mass emigration, the Russian populace experienced extreme hardships and deficits at all levels. It was a case of bare survival, not least for the artists, and a principal reason that so many from both the Left and the Right accepted commissions for politicized art forms (Lenin's Plan of Monumental Propaganda, agit-art, mass actions) (figure 2.4) was perhaps more a material than an ideological one. Still, one of the most insistent demands made by the radical artists and critics who supported the early Soviet regime was that the new proletarian society not only transform its political and economic structures, but also undertake a "psycho-physical reform."[9] Much of the experimental art of the 1920s—Malevich's *arkhitektony* and *planity* (figure 2.5), Popova's textile designs (figure 2.6), Lissitzky's typography and photography (figure 2.7)—can be regarded as a direct response to this demand, as, indeed, can the general upsurge of interest in the applied and decorative arts throughout the 1920s.

Immediately after the Revolution particular attention was given to the question of what the new proletarian art should be. Many answers were proposed, but one in particular related directly to the notion of the "science" of art and of constructivist design in the 1920s. Some theorists maintained that revolutionary art must be oriented toward technology and the working class; furthermore, it must be a universal, "anonymous" style, identifiable with international communism, not just with Russia, and, consequently, such a style must dispense with local, ethnic concerns. A logical conclusion here was that the more organized or mathematically sound the work of art, the more universal its appreciation, except that few people liked the new, anonymous style and expressed bewilderment when they were told that a geometric composition was art whereas a nude in a gilt frame was not. Even so, indus-

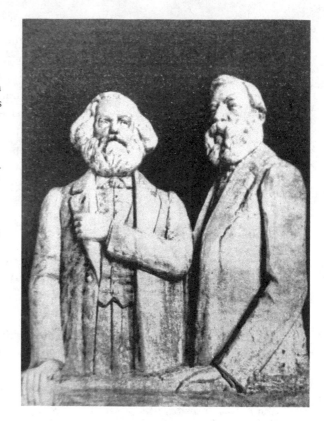

FIGURE 2.6 Liubov' Popova, Textile design, 1923–24. Gouache and pencil on paper, 23 × 35 cm. State Museum of Contemporary Art—Costakis collection, Thessaloniki.

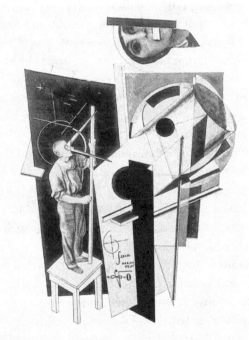

FIGURE 2.7 El Lissitzky, *Vladimir Tatlin at Work on the Monument to the III International*, ca. 1922. Silver print photograph heightened with two areas of India ink, 23 × 16.8 cm. Konstantinov Foundation, St. Petersburg. Courtesy of Nina and Nikita Lobanov-Rostovsky, London.

trial design now became a major, but not the only, area in which the avant-garde artists concentrated their artistic efforts. As the constructivist critic Boris Arvatov argued: "The working class . . . will change its forms of everyday life consciously, rationally, and continuously. . . . But this is only possible if artists will stop decorating or depicting life and start to *build* it."[10] Arvatov even proposed that the artist become an engineer and claimed that this new role would be an "essential condition for the economic system of socialism."[11] Still, Arvatov was developing a concept that had been operative well before the birth of constructivism in 1921 and, to a considerable extent his stance can be regarded as the culmination to a process. In August 1918, for example, IZO NKP opened a special Subsection of Industrial Art under Rozanova to deal precisely with the relationship between "pure" and "applied" art. A year later, at the First All-Russian Conference on Industrial Art, the commissar for popular enlightenment, Anatolii Lunacharsky, declared: "If we are to advance toward socialism, then we must attach more importance to industry and less to pure art," and at the beginning of 1921 the critic David Arkin proposed that after nonobjective painting, the next step was "the creation of objects, of a constructive, productional art."[12]

Nonetheless, for the most part, the constructivists remained "artists" and their sporadic attempts to design buildings, furniture, porcelain, and so on, were often as aesthetic and as fanciful as their studio work. Moreover, with the exception of Stepanova (figure 2.8), none of the constructivists in Moscow/Leningrad received any professional training in industrial design. Despite the assumption that "studio art is of no use to our contemporary artistic culture,"[13] the full transference of "art" into "industrial production" remained a utopian vision. When Tatlin, for example, tried to acquaint engineers with the properties of materials, they completely misunderstood him and suggested that he go and teach people how to "draw nicely."[14]

In March 1918, Moscow replaced Petersburg as the Russian capital to gain an even more forceful position in the evolution of Russian art and literature, dictating government commissions, organizing key exhibitions such as $5 \times 5 = 25$, and restructuring art education. Many of these obligations and reforms fell under the responsibility of Lunacharsky who, himself a writer and critic with long periods of residence in Paris, appreciated or at least tolerated the more extreme manifestations of cultural investigation, inviting Rodchenko, Shterenberg, Tatlin, and other leftists to join IZO NKP. This section, in turn, did much to disseminate the ideas of the avant-garde — by acquiring works for museum inventories, organizing research agencies such as Inkhuk

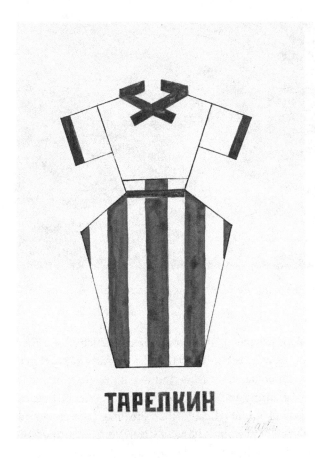

ТАРЕЛКИН

FIGURE 2.8
Varvara Stepanova,
Costume design for
Tarelkin in Vsevolod
Meierkhol'd's production
of the play *The Death
of Tarelkin*, ca. 1922.
Watercolor on paper,
29 × 21 cm. Konstantinov
Foundation, St. Peters-
burg. Courtesy of Nina
and Nikita Lobanov-
Rostovsky, London.

and RAKhN, and supporting major commissions such as Lenin's Plan of Monumental Propaganda (from 1918 onward).

Definitions as to what proletarian or communist art should be were manifold. Indeed, the cultural hierarchy had no rigid policy for the arts and consequently tolerated most artistic directions, which, in turn, allowed for diverse and conflicting interpretations—from the sociological arguments of Vladimir Friche and Leon Trotsky to the intrinsic analyses of Punin and Viktor Shklovsky; on a practical level, too, some artists such as Lissitzky and Tatlin suggested that the broken forms of their pre- and post-Revolutionary works reflected the tension of a social rebirth, while others such as Gabo and Pevsner advocated "space and time" as the only ingredients of art (figure 2.9).[15] To some, constructivism seemed to be the most convincing expression of the new ideology inasmuch as it, too, presented itself as an international and interdisciplinary movement, one oriented toward technology and, evidently,

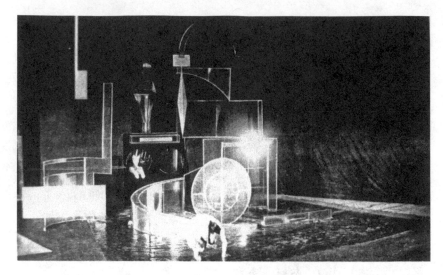

FIGURE 2.9 Naum Gabo and Anton Pevsner, Set for *La Chatte*, 1927. Destroyed.

devoid of national, local, or private justifications. The constructivists argued that the traditional media were moribund and that the new arts of photography, cinematography, commercial advertising, industrial design, sports, and Taylorism should replace painting and sculpture as cultural systems. In turn, they argued that their geometric, analytical forms were linked directly to the world of technological efficiency and mechanical wizardry. Clearly, the consumer would also have to be mechanized and efficient, and just such a development was undertaken and planned at the Central Institute of Labor (TsIT) in Moscow supervised by Aleksei Gastev and supported by Malevich.[16] One of many curious institutions of the postrevolutionary years, TsIT aspired to produce a program of rhythmical, economical movements for the factory floor such as hammering, welding, and working a lathe. TsIT maintained, as the constructivists did, that function determined form and that the communist way of doing things should be the rational, streamlined way that would avoid the capricious gesture of the capitalist, with its unnecessary expenditure of energy. Certainly, one point of derivation was American time and motion studies, but references back to the eurhythmical dancing of Emile Jaques-Dalcroze and perhaps the tango were not too distant. Indeed, Lissitzky's *New Man* (figure 2.10), partnered by the acrobats and Martians that Exter designed for Yakov Protazanov's sci-fi movie *Aelita* (1924) (figure 2.11), seems to be making the opening steps of a Taylorized tango that will shortly turn into the measured steps of a mass gymnastics parade.

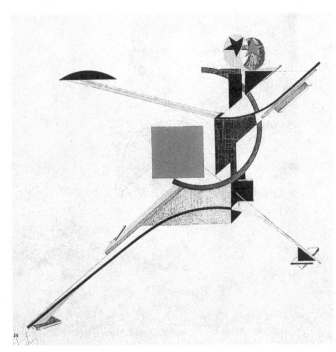

FIGURE 2.10

El Lissitzky, *New Man (Neuer)*. Figure 10 from the album *Die plastische Gestaltung der Elektro-Mechanischen Schau "Sieg über die Sonne"* (Hanover: Leunis and Chapman, 1923). Colored lithograph, 52 × 44 cm. Konstantinov Foundation, St. Petersburg. Courtesy of Nina and Nikita Lobanov-Rostovsky, London.

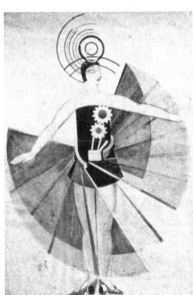

FIGURE 2.11 Aleksandra Ekster (Exter), Costume design for a Martian in the film *Aelita*, 1924. Watercolor and gouache, 53 × 36 cm. Konstantinov Foundation, St. Petersburg. Courtesy of Nina and Nikita Lobanov-Rostovsky, London.

Rejecting competition, the constructivists did not hesitate to impose their views and their leftist dictatorship was a strong precedent to the cultural intolerance of the Stalin era—in word, if not in deed; and, as a matter of fact, for the constructivists the word would seem to have been more important than the deed, not only because their first wish was to destroy the old ("Death to art!" declared their most radical spokesman, Gan [figure 2.12], adding that, in accordance with dialectical materialism, traditional forms would "vanish"),[17] but also because they often lacked the wherewithal to implement their visionary projects, so that slogans, maxims, formulae, and manifestoes remained perhaps their strongest contribution to the new culture. Tatlin's project for the *Monument to the III International* (figure 2.1), Lissitzky's for a Moscow skyscraper (1925), Ivan Leonidov's for his *City of the Sun*, Rodchenko's for newspaper kiosks, Georgii Krutikov's for flying architecture, Stepanova's for sports clothes—not one of these ambitious projects was realized. At the same time constructivism itself was the object of many disparate definitions, and its exponents did not always practice what they preached (Popova and Rodchenko, for example, continued to paint studio paintings)—and, in any case, perhaps the movement was not so new and revolutionary as its enthusiasts maintained.

It is tempting to assume that constructivism, laudatory of the machine and

industrial production, was an ideal aesthetic counterpart to the communist ideology, with its commitment to the international proletariat. In turn, one might assume that those who formulated and practised constructivism such as Klutsis, Lissitzky, and Rodchenko were supporters of the communist doctrine and, without compunction, offered their creative forces to the service of politics. In other words, they responded to, and acted on, the social and political agendas and intentions that followed in the wake of October 1917, such as the nationalization of private property, ethnic and sexual equality, fusion of town and country, mass literacy, and universal political propaganda. Much of the constructivist output, such as Klutsis's propaganda materials, Popova's and Stepanova's clothing and designs (figures 2.6, 2.8), or Vesnin's architecture (figure 2.16), can be associated with these phenomena, and obviously these particular products would not have been projected without the social and political transformation. But the move from studio to street cannot be explained simply by reference to the social aims of the Bolshevik Revolution: the fact that capitalist America, bourgeois France, and postwar Germany also witnessed a boom in industrial art during the 1920s—culminating in the movement known as Art Deco unveiled at the Exposition Internationale des Arts Décoratifs in 1925 in Paris—indicates that other stimuli and motives have to be borne in mind. Tugendkhol'd, one of the most astute critics of the early Soviet period, was perplexed by the similarity of wares, capitalist and socialist, Western and Eastern, at the various national pavilions, and concluded that perhaps constructivism was not so revolutionary after all.[18]

Tradition

Many of the bold experiments in the visual arts that are often associated with the October Revolution had been conducted, or at least anticipated, well before 1917—which is to say, for example, that the formal simplicity of constructivism, with its emphasis on industrial design (the printing arts, architecture), might be regarded as a logical response not necessarily to socialist demands, but rather to preexisting aesthetic movements as well as to the substantial attainments in applied design by artists *before* the Revolution—for example, textile designs by Exter, Malevich, Ivan Puni, and Rozanova (figure 2.13), dresses by Natali'a Goncharova and Rozanova, stage designs by Exter, and so on. In addition, there were rich pre-Revolutionary typographical precedents on which the constructivists could draw, such as asymmetrical commercial advertising in telephone directories; geometric patterns for haute couture; machines and gadgets such as automobiles and vacuum cleaners, cranes and

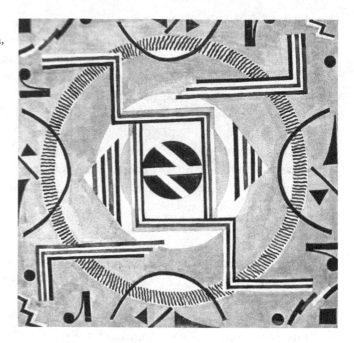

FIGURE 2.13
Ol'ga Rozanova,
Design for a
shawl, 1917.
Watercolor
and black
ink on paper,
32.5 × 32.5 cm.
Courtesy
Rodchenko-
Stepanova
Archive,
Moscow.

electric elevators; and functional architecture such as water towers, natural gas tanks, and silos.

The thick, illustrated trade catalogs of machinery and machine tools issued by international corporations with representatives in St. Petersburg, Moscow, and other Russian cities—such as Bloch's office furniture, supplies, and motors, or Schütte's tools and instruments—offer a plethora of mechanical novelties that must have impressed the average reader (figure 2.14). Here are elevators, cantilevered ceilings, plate-glass surfaces, heating systems, pumps, lamps, cranes, and other industrial paraphernalia—objects of detached harmony and illumination, irrespective of their ultimate destination on a factory floor, in a public sewer or inside a carburetor—and many close formal parallels can be drawn between such precedents and, for example, Lissitzky's Prouns (figure 2.15), Popova's geometric textiles (figure 2.6), Ginzburg's and Vesnin's buildings (figure 2.16), and even ephemera such as Rodchenko's commercial advertisements.

By the late nineteenth century Russia had entered a stage of unprecedented economic acceleration. Capitalism was thriving, cities were expanding rapidly, transit systems were growing at an alarming pace—Russia's advancement from an agrarian to a more urban nation occurred almost within a generation, and there are many references to the astonishment, bewilderment,

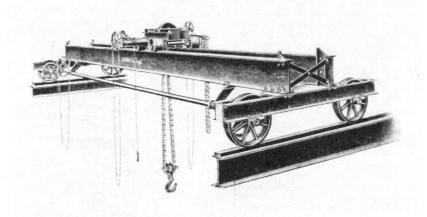

Мостовые краны съ двумя двутавровыми балками

Для движенія телѣжекъ A и B

FIGURE 2.14 Bridge crane with two I-beams for moving carts A and B. Reproduced from Alfred Shiutte (Schüttc), *S. Peterburg: Instrumenty* (Magdeburg: Volkfeld, 1914).

FIGURE 2.15
El Lissitzky, Plate from El Lissitzky's portfolio *Erste Kestnermappe: Proun* (Hanover: Leunis and Chapman, 1923).

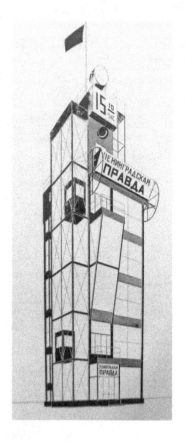

FIGURE 2.16 Aleksandr Vesnin, Design for the *Leningrad Pravda* building in Leningrad, 1925 (not built). Photograph in private collection.

or admiration felt by the witnesses of this process. Wonders of the machine age manifested themselves in St. Petersburg, Moscow, and the provinces in swift succession — the movie house, electric power station, automobile, airplane, motorcycle, telephone, reinforced-concrete building with plate-glass windows, and so forth. The reading public supplemented their translations of Jules Verne and H. G. Wells with optimistic accounts in magazines such as *Zhurnal prikliuchenii* (*Adventure Journal*) or *Vokrug sveta* (*Around the World*), which often carried essays about the city of the future, interplanetary travel, and, in general, the marvels of engineering. These journals also abounded with commercial advertisements for the latest inventions and commodities, many of them European and American, from Osram lightbulbs to Gillette razors, from Waterman fountain pens to 4711 Eau de Cologne.

The basic notion that the function of a man-made object such as a railroad bridge should determine its structure and that this should not be disguised by ornament (a tenet that becomes especially pressing during the period of constructivism) had been evident in Russian architectural practice since at

least the 1830s–40s with the formation of the so-called Rationalist school. Despite the Victorian passion for decorating objects, the idea that "mechanical construction constitutes the only basis of beauty in architecture" gathered increasing support as the nineteenth century advanced.[19] True, Russia could boast no equivalent of the Eiffel Tower or the Crystal Palace, but she did have some remarkable suspension and lattice bridges crossing her great rivers, and the Machine Hall at the "All-Russian Industrial and Art Exhibition" in Nizhnii-Novgorod in 1896 demonstrated her ability to catch up and overtake (figure 2.16).

In examining precedents to the birth of constructivism, we are bound to refer to the genesis of nonfigurative art in Russia. Malevich's invention of suprematism in 1915 marked an abrupt departure from an artistic tradition that had long stressed the reportorial, authorial, and philosophical functions of art and had just experienced the deep influence of nineteenth-century realism. In 1914–15 a major problem facing the Russian avant-garde was how to move from "reproduction" to "production," that is, from the descriptive purpose to a "work of pure, living art";[20] or, as Mikhail Larionov had affirmed in 1912, painting was to depend on the "laws germane only to painting: colored line and texture."[21] The Russian cubo-futurists and suprematists tried to put this theory into practice, but they also drew upon precedents and, in order to comprehend their actions, we must look beyond the avant-garde to the preceding cultural trend, namely, symbolism.

Opposing the nineteenth-century, materialist worldview, the symbolists attempted to transcend concrete reality and to reach the "ulterior" or the "essence." In many cases, the artistic explorations of the Russian symbolists (e.g., of Viktor Borisov-Musatov and Mikhail Vrubel) were accompanied by strong philosophical concerns, and their formal discoveries were side effects rather than primary objectives. However, in modern Russian art it was the symbolists rather than the impressionists (there was never a well-defined school of impressionism in Russia) who forestalled "creation as an end in itself and domination over the forms of nature."[22] Their interpretation of the "real" reality, for example, as a form of movement was a simple and potential idea (one that recurred in both suprematism and constructivism), for, as the symbolist poet and essayist Andrei Bely wrote in 1907: "Movement is the basic feature of reality. It rules over images. It creates these images. They are conditioned by movement. . . . Beginning with the lowest forms of art and ending with music, we witness a slow but sure weakening of the images of reality."[23] It followed that the evocation of movement was, therefore, more important than the description of the material world and that the logical de-

velopment of art was toward "nonobjectivity [where] the method of creation becomes an object in itself."[24]

This was only one of the many prophetic statements that Bely and his fellow writers issued in the early 1900s. Another of particular relevance to the topic under discussion is Bely's description of the two concepts—knowledge and cognition—and his supposition that the former, which had contributed to the construction of a positivist reality, had usurped the latter. Bely felt that technology and other monuments to Western rationality were fallow systems inasmuch as they were the product of science, that is, a static corpus of data, and did not rely on spontaneous, intuitive, or fortuitous qualities. He argued in turn that the art of the later nineteenth century had fallen victim to materialism—which is why realism had become the dominant trend, at least in Russia, and why impressionism in Europe, with its objective laws, was also an extension of the natural sciences rather than of divine inspiration or subjective vision. Bely inferred, therefore, that cognition—the process of finding out, of conceptualizing and imagining—was in danger of being replaced completely by passive knowledge and that the contemporary artist should try to reverse this tendency.

Bely's general interpretation of human progress as a constant clash between cognition and knowledge (in wider terms, between culture and civilization) was repeated and expanded by a number of artists and writers during the avant-garde period. When, for example, in his 1910 article "Content and Form" Kandinsky maintained that the true content of a work of art derived from the spirit, from inner content and not outer form, he was also voicing a plea to retain the cognitive or intuitive moment.[25] The painter and critic Waldemar Matvejs (Vladimir Markov) summarized the position clearly in his important essay of 1912, "The Principles of the New Art": "If we take a broad look at all the world's art, there arise before us clearly and vividly two diametrically opposed platforms, two basic trends hostile to each other. These two worlds are constructiveness and non-constructiveness. The first of these is expressed most vividly in Greece and the second in the East."[26] One of the remarkable properties of the Russian avant-garde was its assimilation of both the constructive and the nonconstructive, that is, of the "West" and the "East." Of the two concepts, the nonconstructive often dominated, and whether we examine studio art or industrial design, we discover not only a repetition of known facts, but also an often distinctive and idiosyncratic interpretation of them.

Formalism

Despite the rhetoric about system, reason, and science, especially in the 1920s, few if any artists of the Russian avant-garde assumed the mantle of the scientist, although Osip Brik, Gan, Popova, Punin, and Tarabukin, in particular, were fascinated by the possibility of perceiving art as an exact aesthetic. Somewhat paradoxically, Kandinsky, with his highly subjective color-form tabulations and color-sound parallels, was also seeking a formulaic common denominator for the practice and appreciation of art, an investigation that he pursued with particular energy at Inkhuk and then at the Bauhaus.

Even a cursory glance at the history of the Russian avant-garde does reveal a more than casual interest in mathematics and formulae. Punin tried to reduce art to an equation: $S(Pi + Pii + Piii + \ldots Pr)Y = T$, where S equals the sum of the principles (P), Y equals intuition, and T equals artistic creation.[27] Arguing in the context, significantly, of steam engines, Punin elucidated the formula by identifying the principle with the basic motivation underlying every invention—for example, in the steam engine the principle or motivation is that water is heated to the boiling point, steam is collected, and its pressure applied to the piston. Punin went on to assert that the only way in which the artist could create a new artistic value (an original work of art) was to apply his intuition not to the systems or constructions already known, but to the mechanical, technical, and aesthetic principles that formed the substructure of any invented phenomenon. As if heeding this command, Velimir Khlebnikov devised elaborate number theories, Lissitzky imported references to higher mathematics into his compositions, and Malevich entitled one of his book illustrations *Arithmetic*, and, with Boguslavskaia and Puni, used a mathematical coordinate to designate his first public showing of suprematism—the exhibition *0.10*.

However, there were few critics who possessed both the intellectual acumen and broad aesthetic tolerance to acknowledge and appreciate the rapid shift from content to form in the painting of Exter, Malevich, Puni, and Rozanova; and the conventional observer regarded their analytical experiments more as symbols of cultural destruction than as the foundation of a new system of artistic ideas. One consequence of the October Revolution was to bring to the fore a group of young art critics who recognized and supported the transvaluation of artistic values and who, recognizing the progress of science and technology, felt at one with the minimalism of Malevich and Puni, Gabo, and Tatlin (figures 2.5, 2.9, 2.1). Art critics such as Arvatov, Nikolai Chuzhak, Erik Gollerbakh, and, above all, Punin represent the flower of this

generation and deserve to stand with their more famous literary counterparts in their propagation of new and revolutionary aesthetic criteria.

Punin's call in 1919 for an art criticism that would be scientific and not, as hitherto, literary served as a challenge to the whole outmoded practice of empirical art criticism.[28] His wish to create a "common form on which the contemporary artistic world-view can base itself"[29] indicated his aspiration to produce an exact theoretical premise for the examination of any work of art, an undertaking in which he was assisted by Brik and Chuzhak, in particular. The main motive underlying this search for a new aesthetics was the general realization that most artistic conventions had become obsolete and, as Arvatov asserted in 1923, "studio art died with the society which begot it."[30] In other words, pre-Revolutionary easel painting and sculpture had been an extension of the painter's ego and for that very reason was alien to a collective society. In the context of a community founded on "tectonics, texture, construction,"[31] the need for a rational and constructed art form and hence for a scientific art criticism was evident: by finding and disseminating the exact laws of a scientific aesthetics, art would become a mass phenomenon intelligible to all.

This sociological factor pointed to a fundamental distinction between the literary and painterly formalists. For the champions of formalism in literature, especially for Shklovsky and the later Bely, the reduction of a literary work to its intrinsic elements or compositional devices was, in a sense, a game that had little to do with a political, materialistic motivation. In other words, the poem or piece of prose was not treated as the product of an individualistic process and therefore as something socially unsympathetic; and although the literary formalists tended to dismiss the significance of the author, they did this for literary reasons and not for Marxist, sociological ones. The critics in the visual arts, however, especially Arvatov, Chuzhak, and to a lesser extent Punin, questioned the relevance of the artist's personality not only to the aesthetic, but also to the sociological value of the work of art. This outlook was also cultivated by Proletkult, which downplayed the importance of the pre-Revolutionary artistic heritage, considering it individualistic and, therefore, alien to a proletarian consciousness; instead Proletkult called for a mechanical and collective art, whether in poetry, music, or the visual arts. This difference in principle might explain why, in their formal analyses, the literary formalists tended to concentrate on classical works of literature or on primitive literary forms and why they turned only occasionally to the problems of contemporary literature. The artistic formalists, however, examined contemporaneous works, often identifying modern art with "futurism," a term that

acquired a new vitality immediately after the Revolution. The painter and sculptor Natan Al'tman, a close colleague of Arvatov and Punin, explained: "A futurist picture lives a *collective* life. . . . Like the old world, the capitalist world, works of the old world live an individual life. Only futurist art is constructed on collective principles. Only futurist art is, at the present time, 'the art of the proletariat.'"[32]

As far as the theoretical construction of constructivism is concerned, the primary critics—Arvatov, Brik, Gan, Punin, and Tarabukin—were united in their rejection of the "bourgeois" art of the past, which for them had been the product of subjective, ritualistic, or commercial motives. The work of art had been created in a single exemplar, often entering into the possession of a single individual and turning into a financial asset, an ego trip, or a status symbol, conditions alien to the essential tenets of the communist—and constructivist—doctrine. At the same time, the concepts of self-expression and private interpretation associated with the work of art impeded not only a collective appreciation, but also the application of the work of art to a multiple manufacture. Art (singular), therefore, had been divorced from industrial design (plural) just as the craftsman, traditionally, had been divided from the studio painter and sculptor. This separation of the media or disciplines had been no more manifest than in the later nineteenth century, when, notwithstanding the Arts and Crafts movement and the affirmation of the Wagnerian *Gesamtkunstwerk*, the high and the low, the élite and the popular rarely intersected. This same contradiction also afflicted enterprises of the best intentions, including the Werkbund and the Bauhaus, which, despite manifest claims to be elevating the aesthetic taste of society at large, produced objects acquired and enjoyed only by the chosen few.

Suffice it to study the history of structural engineering to understand that an item such as a railroad bridge, terminal, or gas tank were rarely regarded as "art" and, if anything, were disguised and aestheticized through the imposition of antique columns and statues. Perhaps the greatest accomplishment of the constructivist artists and critics was to undermine and destroy such divisions and, to promote engineering as art, whereby an automobile or an airplane, for example, was just as "beautiful" as a Rembrandt. Conversely, for Arvatov, Gan, and Tarabukin in particular, if the conventional function of the work of art had been a sentimental, introspective, or at least narrative one, the new art was to leave the studio for the public space, to become practical, objective, and utilitarian.

In December 1915, at the *0.10* exhibition in Petrograd, Malevich declared: "I have destroyed the ring of the horizon and moved out of the circle of ob-

jects."[33] As if to illustrate this sentiment, he displayed canvases in which geometric forms were juxtaposed against a white background, emblematic, according to him, of infinity. Malevich's suprematism did, at first, seem to engage a lucid, "scientific" system in which painting seemed to be obeying precise laws (what Kandinsky, however, would have called "mere ornament").[34] Perhaps Malevich's exercises in displacement, traction, and gravitational pull in his suprematist compositions (figure 2.5), however, marked only a digression from his "nonconstructive," essentially romantic, worldview, and the more Malevich developed the concept of suprematism, the more it came to denote the experience of an ulterior sensation, of fantasy and intuition. He even envisioned the application of suprematist forms to technological ends such as rocket fuel and robotic inhabitants of a suprematist world who cast no shadows — visionary projects more appropriate to scientology than to science.

On the other hand, the relief (Tatlin), the abstract construction (Vasilii Ermilov, Naum Gabo, Gustav Klutsis, Rodchenko, the Stenbergs), the functional design (Exter, Popova) (figures 2.6, 2.9, 2.11) seemed to represent an earnest endeavor to replace content (subjectivity) with form (objectivity). In other words, when Tatlin was "noisily removed" from Picasso's studio in 1914,[35] astounded by his discovery of the Picasso reliefs, he was also borne from mass to volume, or, to quote Lissitzky, from composition, or the "combining of various factors," to construction, or "a substance composed of different parts."[36] Subsequently, Tatlin began to exploit space as a formative element in his assemblages of materials and, as he asserted, "to put the eye under the control of touch" before transferring the principle of the relief to a functional and manifestly rational end,[37] as in the *Monument to the III International* or in his designs for a stove, worker's clothing, a chair, and the airplane *Letatlin* (figures 2.1, 2.17).

One result of the move from composition to construction was the rejection not only of the conventional, narrative purpose of the work of art, but also of the traditional means that had defined that narrative, including color as an associative instrument. The total absence or total presence of color (i.e., black and white) thus became important components of the avant-garde production in the 1910s, as Rodchenko indicated in his *Black on Black* cycle of 1918, before moving on to the medium of black-and-white photography. In this sense, Rodchenko was the constructivists' constructivist, for as a leftist artist, he responded immediately to the political, social, and cultural demands of the new Russia, identifying industrial design and then photogra-

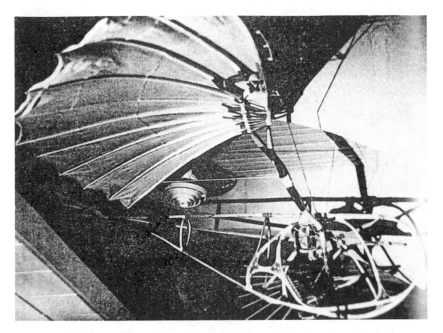

FIGURE 2.17 Vladimir Tatlin, *Letatlin*, ca. 1930. Photograph of the frame of the airplane without the silk covering. Wood. Photograph in private collection.

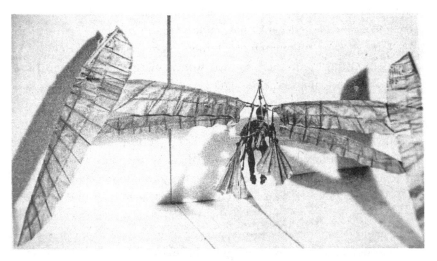

FIGURE 2.18 Petr Miturich, Design for a flying-machine, 1921. Wood and paper. Courtesy Miturich family, Moscow.

phy as primary vehicles of investigation. As early as 1916, Rodchenko had contributed six compass-and-ruler drawings to Tatlin's Moscow exhibition called *The Store* and then went on to execute a series of "minimalist" paintings that relied on the pure interplay of textures, colors, rhythms, and forms, culminating in his triptych at $5 \times 5 = 25$. Rodchenko's engagement with photography (figure 2.12), therefore, denoted a natural progression away from associative color toward a monochromatic reduction as well as toward the substitution of the speculative art of painting with the mechanical accuracy, clarity, and public accessibility of the multiple photographic print. As he declared in 1928: "One should shoot the subject from several different points and in varying positions in different photographs, as if encompassing it—not peer through one keyhole. Don't make photo-pictures, make photo-moments of documentary (not artistic) truth."[38]

In using the camera, Rodchenko maintained that he was documenting objective reality, even though his photographs, with their rapid foreshortening, unexpected viewpoints, and double exposures, might seem just as personal and as "nonconstructive" as a traditional studio painting. For his part, after 1923 Rodchenko focused attention on photography, contending that, with its mechanical precision, anonymity, and verisimilitude, photography would replace lyrical illusion. As he continued in his 1928 declaration: "Every modern individual must wage war against art, as against opium. Photograph and be photographed!" Rodchenko now endeavored to support a "nonartistic," functional method, although he continued to emphasize the purely formal aspects of his new profession, so that "Rodchenko perspective" and "Rodchenko foreshortening" became vogue terms in the 1920s, and there can be no question that his experimental application of light and shadow exerted an appreciable influence on the "constructivist" moviemakers of the time, such as Sergei Eisenstein, Lev Kuleshov, and Dziga Vertov. Just as Rodchenko's spatial constructions demanded an unorthodox viewpoint, so some of his photographs had to be seen "from above" (e.g., the photo-portrait of the writer Nikolai Aseev of 1927), "from below" (e.g., the fir trees in Pushkino of 1927), or parallel to the ceiling (e.g., the shots of glass surfaces of 1928). Even in the later photographs for the propaganda magazine *USSR in Construction* of the 1930s and in the drip paintings of the 1940s Rodchenko expressed this constant wish to destroy the traditional, single, stationary view of the surface. In any case, Rodchenko's belief in black-and-white photography was surely symptomatic of a more universal vogue, coinciding with the monochromatic movies of Eisenstein and Dziga Vertov and, of course, paying homage to Malevich's *Black Square*, *Black Circle*, and *Black Cross* of 1915.

FIGURE 2.19 Pavel Mansurov, *Painterly Formula*, 1918. Oil on wood, 59 × 80.5 cm. Lorenzelli Arte, Milan.

In fact, the late 1910s and early 1920s was especially rich in paintings based on black or white, not least Boris Ender's *Colors of Nature* of 1924, Aleksandr Drevin's painterly compositions of 1921, Vladimir Lebedev's large *Cubism* of 1920, Leonidov's architectural projects on black paper, Pavel Mansurov's white paintings (figure 2.19), some of David Shterenberg's still lifes, and Sergei Yustitsky's *Composition with Wire* (early 1920s). While parallel at least visually to Malevich's black squares ("regal infants")[39] and white-on-white paintings, the monochromes of the younger avant-gardists tended to be more aesthetic or formal, elegant and restrained, lacking the occult connotations of suprematism.

Presence of Absence

At the same time, a number of painters were also interested in documenting invisible phenomena, such as Ivan Kudriashev and Sergei Luchishkin, who with their interpretations of fission and velocity rendered the unseen seen (figure 2.20). Taken as a specific orientation within the avant-garde, this concern with invisibility may thus extend the symbolist idea that reality lies beyond the world of appearances, that all is movement, and that life, therefore, is a chain of my doubles denying each other—a human being "becomes," but never "is."[40]

FIGURE 2.20
Ivan Kudriashev,
Luminescence, 1923–24. Oil
on canvas, 23 × 35 cm. State
Museum of Contemporary
Art—Costakis collection,
Thessaloniki.

In 1910 the Russian symbolist poet and philosopher Viacheslav Ivanov wrote that the artist's mission should be to create a "second nature, one more spiritual, more transparent than the multicolored peplos of nature."[41] Ivanov then went on to explain that only the genuine artist could attain this goal, for the artist was the seer—a sentiment shared by many artists and thinkers of the fin de siècle, not least Kandinsky and Henri Bergson. This search for a "more transparent" reality derived from the widespread conviction, characteristic of the aesthetic and philosophical ambience of the late nineteenth and early twentieth centuries, that the reality of phenomena was a false one; that, as Bely asserted, "reality seen is the enchantress Lorelei"; and that the arts should aspire to "remove material" and penetrate to the ulterior (or perhaps we should say interior), essential source.[42]

In turn, these assumptions connect to two issues vital to the Russian avant-garde in general and to the development of constructivism in particular: the notion of zero or absence, on the one hand (e.g. Malevich's *White on White* series of 1917–18), and the practical application of transparent and translucent

materials, on the other (e.g., Gabo's constructions) (figure 2.9). The aspiration to overcome the false appearances of external nature (false because of our inadequate, "astigmatic" senses) encouraged artists to assume that the essence of life lay "there," not "here." The art historian, mathematician, and Orthodox priest Pavel Florensky summarized the predicament in his 1921 essay "The Analysis of Spatiality," proposing that the essential aim of art was to "overcome sensual visuality" and implying that the less material used in an artistic rendering, the better.[43] In this sense, we can understand why so many thinkers of the modernist age identified artistic primacy with music, the art of the unseen, for, as Bely said, "the smallest quantity of material should express the most content."[44]

Bely's idea of physical economy was expanded most explicitly by the constructivists in the 1920s, not least by the Literary Center of the Constructivists (LTsK) led by Il'ia Selvinsky and Kornelii Zelinsky. Guided by the principle of "loadification," according to which every artistic unit (sound, color, etc.) had to contain maximum formal and thematic power, the Literary Center maintained that "from the airplane engine to the radio transmitter, size and substance have decreased while power has geometrically increased. From Neanderthal man to the nineteenth century, the load of energy per man has increased from 1.4 hp to 6.6 hp. Thus, in the course of tens of thousands of years, this load has scarcely increased, but in the dynamic epoch of the twentieth century the curve of this load has flown dramatically."[45]

One artist whose visual perception and basic aesthetic system evoked the presence of absence or, rather, the concept of transparency was Gabo, sometimes regarded as the founding father of constructivism (figure 2.9). The immediate impression evoked by many of his constructions and sculptures is of luminosity, lightness, translucency, and reflection. Gabo's careful combinations of glass, plastic, wire, and metal assimilate and reprocess light, serving as fragile intermediaries between the viewer and the space or depth beyond: "We renounce volume as a pictorial and plastic form of space; one cannot measure space in volumes, as one cannot measure liquid in yards: look at our space.... What is it if not one continuous depth? We affirm depth as the only pictorial and plastic form of space," wrote Gabo and his brother Anton Pevsner in their *Realist Manifesto* of 1920.[46]

How did Gabo arrive at this particular effect? One answer is to be found in the concurrent interest in glass as a construction material in Russia—from the atriums of the Upper Trading Rows in Moscow to the plate-glass sidings with which Tatlin intended to clothe his *Monument to the III International* of 1919–20 (a "hothouse for growing pineapples") (figure 2.1).[47] The construc-

tivists realized that glass could expose the function of a building, that it could remove divisions, link the inside and the outside, and, as a metaphor for democracy, could emphasize the interconnectedness of human society, and, therefore, undermine the notion of bourgeois privacy and individual space. Vesnin's project for the Leningrad *Pravda* building of 1924, the glass structure of which reveals its inner function, is a case in point (figure 2.16), even if the version of the building erected in Moscow (on Pushkin Square) replaced much of the glass surface with stone.

Gabo's approach to transparency, however, was scarcely influenced by the question of democracy, for he was interested not in reconfirming the concreteness of reality (as Vesnin was) but, rather, in summoning the condition of infinity, as in his translucent sets and costumes for Sergei Diaghilev's production of *La Chatte* in Monte Carlo and Paris in 1927 (figure 2.9). Transparency was obviously a major concern here, but Gabo's constructions also carry opaque elements and occasionally even colors, suggesting contrasts between an epidermic outline and a skeletal arrangement. Similar somatic geometries can be identified with Rodchenko's and the Stenberg brothers' constructions (figure 2.3), in Pavel Mansurov's experiments at Ginkhuk (figure 2.19), and in Tatlin's and Petr Miturich's aerodynamic frameworks (figures 2.17, 2.18). How, then, do these abstract anatomies relate to the condition of transparency?

In 1910, the year of Bely's major treatise on Symbolism (*Simvolizm*) and of Ivanov's "peplos," Gabo's father sent his son to study medicine at the University of Munich. While there (through 1914), Gabo attended lectures by Heinrich Wölfflin, met Kandinsky, and saw examples of French cubism at the exhibitions of the Neue Künstlervereinigung. Still, first and foremost Gabo was studying the natural sciences and mathematics in Munich, where his primary academic encounter may have been not with modern artists, but with Wilhelm Conrad Röntgen, the crystallographer, magnetist, and inventor of the X-ray (1895), who was lecturing in Munich and who in 1901 received the Nobel Prize for his experimental research. Surely, this was of much greater importance to Gabo (and maybe to other artists in Munich at that time such as Kandinsky) than the formal theories of Wölfflin, and he must have been amazed to see those early lantern slides of the interiors of insects, fish, animals, birds, and the human body. No doubt, Gabo discussed these data with scientific colleagues such as Vladimir Chulanovsky and Stepan Timoshenko at the Physics Institute of the University of Munich. By the time Gabo returned to Russia in 1917, X-ray photography was well advanced there, too, thanks especially to the efforts of Röntgen's brilliant assistant Abram Ioffe, a prominent exponent of X-ray application to crystals, especially quartz. With

Mikhail Nemenov, he established the State X-ray and Radiological Institute in Petrograd in 1918 and encouraged the erection of the monument to Röntgen in Leningrad in 1927. X-ray research was so popular in Russia after the October Revolution that Kandinsky, himself recently returned from Munich, ensured that a special position was created for an X-ray specialist (Nikolai Uspensky) at his Russian Academy of Artistic Sciences in Moscow in 1921.

Indeed, a number of Gabo's constructions look like X-rays, with a taut organization of filaments within gelatinous tissue, emphatic articulations and force-lines, and vessels and arteries connecting one member to the next. *Construction in Space: Crystal* (1937–39) and *Linear Construction in Space No. 2* (1949–73) can be regarded as artistic metaphors for Röntgen's photographic plates, and some of Gabo's early pieces even recall specific anatomical structures, for example, the common housefly (*Construction in Space: Soaring*, 1929–30). Nurtured on the sentiments of the symbolists, Gabo was now confronted with a mechanical exposure of the divisions that lay between transparency and eternal depth. That Röntgen chose inductor apparatuses to see beyond, while the symbolist poets often used drugs and alcohol does not matter: both saw the "enchanted shore" of configurations and convolutions invisible to the naked eye.

Rationalization

The stern and ordered physiognomy of constructivism was manifest, above all, in Rodchenko's spatial constructions of 1918–21, some of which were shown at the third exhibition of the Society of Young Artists (Obmokhu) in Moscow in May 1921, together with constructions by the Stenberg brothers (figure 2.3). Rodchenko's constructions, such as the suspended circular one of 1920 (figure 2.21), were built according to principles rather different from those which Tatlin employed in his reliefs. Tatlin, for example, was interested in textural and material contrasts within the work itself and, in any case, never really dismissed the single, frontal viewpoint, whereas Rodchenko was more concerned with the essence of form, attaining lightness and economy of design in his serial treatment of a single form—the rhomboid, the circle, the oval, the hexagon. Rodchenko also argued that the new, revolutionary society demanded not only new "scientific" forms in art, but also new "scientific" media, a sentiment shared by many of his colleagues. Lissitzky looked on photographical and typographical layout in this manner (figures 2.7, 2.10), as Exter did movies (figure 2.11), and Popova textile and stage design (figure 2.6).

Performance played a key role in Popova's advance from "art" to "science."
After assimilating the principles of cubism at the studio of Le Fauconnier
and Metzinger in Paris in 1912–13, as paintings such as *Early Morning* (1914)
demonstrate very clearly, and then of Malevich's suprematism, Popova con-
ducted experiments in a number of three-dimensional media, not least stage
design. Her training in cubism gave her a discipline and rigor that Malevich
sometimes lacked, and it enabled her to experiment rationally and persis-
tently with the organization of forms in the painting, exploring notions such
as rhythm, weight, and symmetry. In her architectonic paintings of 1916 on-
ward, Popova developed the idea of "nonsequences" in color combinations,
attempting to break the usual sequence of cool to warm (a sequence that can
create a sense of depth and, therefore, of illusion). Even so, Popova was not
content to remain a studio painter and, as evidenced by her reliefs of 1915–16,
tried increasingly to use space as a creative element—and to replace compo-
sition with construction.

One of the prominent visitors to 5 × 5 = 25 was theater director Vsevolod
Meierkhol'd, who, seeing the works of Popova and her colleagues, concluded
that they could be used as the basis for stage designs, which "would allow him

to fulfill his long cherished dream of an extratheatrical spectacle."[48] The result was that Meierkhol'd invited Popova to compile a program for a course in material, three-dimensional stage design at his State Higher Producer Workshops, and it was here that Popova developed the basic ideas for her celebrated construction for *The Magnanimous Cuckold* staged by Meierkhol'd on April 25, 1922. True, a certain logic lies in the fact that Popova, Stepanova, and their constructivist colleagues worked with enthusiasm for the theater and the cinema, because the stage or screen acted as their laboratory—confined, concentrated, controlled—for researching the creation of prototypes for the land of the future (figure 2.8). The critic and sculptor Boris Ternovets wrote in his catalog essay for the Soviet pavilion at the Exposition des Arts Décoratifs in Paris in 1925:

> Mais la nouvelle culture s'affirme peut-être plus combative, plus intrépide, plus impitoyable à l'égard des formes périmées que partout ailleurs, dans notre Section théâtrale. Ici le problème n'est pas seulement posé: il reçoit sa solution.

> (But perhaps the new culture is affirming itself in a more combatative, intrepid, and ruthless manner with respect to the necrotic forms which more than anywhere else [are] in our Theater Section. Here the problem is not only posed, but also receives its solution.)[49]

But the "solution" was meaningful only in the theater. Once exported into everyday life, this "modern culture" perished, for there was neither the popular demand nor the technological wherewithal to produce it. As the critic Boris Brodsky observed in the context of Rodchenko's furniture designs for *The Bed-Bug* in 1929: "The sofa-bed was displayed not in a store, but on the stage, as a gibe at everyday life."[50]

The artists of the avant-garde who, by and large, evolved primarily as studio artists and whose practical training in design was minimal found the theater to be an attractive and even comfortable medium. For them it was a haven for experiment protected from the brutal reality outside. An inevitable conclusion, then, is that, to a considerable extent, the artists of the Soviet avant-garde thought more about themselves than about the masses, for they continued their refined, cerebral experiments initiated well before the Revolution, "blocked up the scenic space with abstract objects deprived of any imagistic sense,"[51] and transformed the theater into an esoteric debate when much of the population could neither read nor write. Arvatov issued the following appeal in 1922: "Abandon the stage, the productions. Enter life so as

to relearn and learn. Assimilate not aesthetic methods, but the methods of societal and social construction. Be engineers, be the assemblers of everyday life.The working class does not want illusions, it wants concrete forms scientifically organized. It does not need an imitation of life, it needs the construction of life."[52]

In his important essay, "Overcoming Art," that he wrote in Vitebsk in 1921, Lissitzky argued that artists could overcome the crisis of modern art by replacing the conventional painting with the crafted, tactile object. Like a "tinsmith," Lissitzky writes, the contemporary artist had found an escape from aestheticism in material (paper, chalk, cement, wire) and in this material had now sensed peculiar properties that "were for touching, for the hand, and not just for the eye."[53] In turn, Lissitzky encouraged the new artist to become an engineer by taking up the compasses and executing technical drawings,[54] although the assumption of this role was to be only temporary inasmuch as the "new world will be constructed [and] it will be built with a force that overcomes both art, science, and technology."[55]

The interplay of the symbols of art (hand), science (brain), and technology (compasses) in Lissitzky's famous self-portrait of 1923, *The Constructor* (figure 2.7), or his rendering of Tatlin building the *Monument to the III International*, combines these qualities, indicating that the new creativity, having assimilated all three positions, will pass beyond both "metaphysics" and "mathematics" into a new creativity that will neither apprehend, nor contemplate, nor decorate. The proximity of these concepts to the discipline of engineering (rather than of the fine arts) is manifest, prompting us to recall that Lissitzky trained not at an art school, but at the Riga Polytechnic Institute. Here students were urged to find parallels between nature and artificial forms and to regard the animal and botanical worlds as repertoires of ideal mechanical forms such as a leaf or a butterfly: their function determined their form in the same way that a bridge or crane will fulfill their purpose if their form is economical and efficient, an argument that brings to mind Mansurov's researches at Ginkhuk a few years later (figure 2.19). The faculty of the Riga Polytechnical Institute was responsible for many of the standard textbooks on structural engineering (some of which continued to be republished throughout the Soviet period)[56] and for much of the new industrial architecture and machinery that was changing the urban fabric of Moscow and St. Petersburg/Petrograd, and, during the war, for major defense contracts for the Russian military.

Obviously, this technical and technological environment was of primary importance not only to Lissitzky's general training as a technical draftsman,

but also to the delicate compositions that he applied to his Prouns. Quite literally, the trajectories and configurations of some of the Prouns (figure 2.15) or the compositions in the Proun folios (figure 2.10) extend and elaborate the diagrams for blocks, hooks, hawsers, axles, ball-bearings, and clamps illustrated in textbooks and trade books (figure 2.14). On one level, the Prouns seem to be the same kind of didactic exercises in force, inertia, mass, and resistance, and Lissitzky seems to be responding to the common complaint—on the part of engineers and technicians—that a functional machine can also be beautiful, but that artists, in attempting to be engineers, generally have no understanding of the physical properties of materials such as resistance and durability.[57]

The theme of scientific discovery, invention, and, specifically, aerospace engineering, is a rich and complex topic in the history of twentieth-century Russian culture.[58] Critics have taken note of internal flight (the symbolists' escape from the world of appearances), of Malevich's aerial suprematism, and of the practical manifestations of flying and verticality such as Tatlin's *Monument to the III International* (with its incline symbolizing the continuation of the earth's axis out into space) (figure 2.1) or his glider of 1929–32. However, attention should also be given to the audacious interpretations of cosmic and atomic experiences described by artists such as Kudriashev, Aleksandr Labas, and Kliment Red'ko—all associated with the Moscow group known as OST (Society of Easel Artists), led by Shterenberg.

While some of the *ostovtsy*, including Kudriashev and Red'ko, painted suprematist paintings under the direct influence of Malevich, they moved quickly to a "new objectivity" in the form not of nineteenth-century academic subjects, but of twentieth-century scientific ones—machines, physical phenomena, mechanical processes. The OST artists were united in their enthusiasm for the machine, which they interpreted not as a source of military clangor (as the Italian futurists did), but as a fantastic and benevolent partner of mankind. One explanation for this interest in the machine during the early and mid-1920s, particularly in the air and space machine, derives in part from the popularity of both science fiction (H. G. Wells and Jules Verne were readily available in Russian translation) and scientific discovery, and both concerns were united in the publications of the father of Russian rocketry, Konstantin Tsiolkovsky. That physical and metaphysical flight were, to the Russian mind, tightly interconnected is demonstrated no more clearly than in the close alliance between the scientific formulation of interplanetary space travel and idealist philosophy. Tsiolkovsky, for example, who in his Kaluga workshop in the late 1890s first conceived of a "space elevator" or multistage rocket, came to his bold vision not only through rigorous aero-

nautical deduction, but also through an almost fanatical religious belief in the afterlife: supporting the eschatological ideas of Nikolai Fedorov.[59] Tsiolkovsky proposed that human resurrection was not only possible but also inevitable, and that this resurrection would be comprehensive and collective. In practical terms, the "common cause" would necessitate the mass transportation and redistribution of millions of returnees, whose astronomical number could not be accommodated by the surface of the earth—hence the need to conquer and colonize extraterrestrial sites, and hence the need for multistage rockets.

Less bizarre examples of the marriage between aeronautics and the humanities abound in the Russian Silver Age: the poet Vasilii Kamensky was also a professional pilot, Malevich painted and drew compositions related to flight (e.g., the cubo-futurist *Aviator* of 1914), while in the 1920s, of course, Miturich and Tatlin designed vehicles resembling monstrous birds and hang gliders (figures 2.17, 2.18). Also indicative of this close relationship between technological calculation and artistic fantasy is the poster for the 1909 *International Exhibition of the Latest Inventions* in St. Petersburg, touting a folksy airplane looking more like a neo-nationalist firebird than a functional flying machine. The Soviet Union reinforced and amplified Russia's aeronautical tradition to become one of the most advanced partners in the space race of the later twentieth century.

Of course, it is one thing to conceptualize a scientific phenomenon such as luminescence or atomic decomposition and another to produce an accurate pictorial or sculptural interpretation. One of the most intriguing examples of a "scientific artist" in the 1920s was Krutikov who, in 1928, aged only twenty-nine, compiled an entire scheme for the creation of floating cities (inspired by Tsiolkovsky's proposal for an orbiting space platform). An aerospace buff in high school, Krutikov, for his graduation assignment under Nikolai Ladovsky, produced designs for a floating city. Powered by atomic energy, this city of the future was to serve as living space for workers who worked on the industrial earth and commuted in their own bubble aircraft. Krutikov's flying city was among the last original manifestations of the Russian avant-garde and highly symptomatic of the visionary force of early Soviet architecture.

$2 \times 2 = 5$

By the late 1920s the constructivists were being censured for their "alienation" from the proletarian masses. As Soviet society returned to an autocratic structure, so its art also lost its revolutionary impulse and reverted to

the ease and comfort of the traditional painting in the gilt frame: art moved back from "chemistry" to "alchemy," from "science" to "art." But were the artists of the Russian avant-garde, accused in the Stalin years of coldness and inhumanity, ever scientists? The concept of constructivism, at least, does not have to be confined to the severe geometries of Popova, Rodchenko, and the Stenberg brothers. The vision of transforming the world by engineering and technology cannot be a precise and rational occupation. Perhaps as we envisage Krutikov's flying city or trace the trajectory of Tatlin's *Monument* out into space (figure 2.1), we might conclude that Bely was mistaken and that science cannot exist without art and that knowledge is part of cognition. In other words, five times five does not necessarily equal twenty-five, however forcibly Exter, Popova, Rodchenko, Stepanova, and Vesnin might have argued to the contrary. As Puni declared at the *0.10* exhibition in 1915, "2 × 2 is anything you like, but not four," referring, of course, to what Fyodor Dostoevsky had asserted half a century before: "I admit that twice two makes four is an excellent thing, but if we are to give everything its due, twice two makes five is sometimes a very charming thing."[60]

NOTES

1. Among the primary publications on Russian constructivism special note should be made of the following monographs: Lodder, *Russian Constructivism* and *Constructive Strands in Russian Art 1914–1937*; Allison, *Art into Life*; and Gough, *The Artist as Producer*.

2. Popova, untitled statement in exhibition catalog of 5 × 5 = 25; Stepanova, untitled statement in exhibition catalog of 5 × 5 = 25.

3. Lobanov, *Khudozhestvennye gruppirovki za 25 let*, 101.

4. See Tarabukin, *Opyt teorii zhivopisi*; Gan, *Konstruktivizm*.

5. Ginzburg, "Itogi i perspektivy" (1927), quoted in K. Afanas'ev et al., *Iz istorii sovetskoi arkhitektury 1926–1932 gg*, 82.

6. The analogy belongs to Nikolai Tarabukin (*Ot mol'berta k mashine*, 42).

7. Babichev, "Zapiska k programme," in Sarab'ianov, *Aleksei Vasil'evich Babichev Khudozhnik*, 104, 105.

8. Bliumenfel'd et al., *Na putiakh iskusstva*, 3.

9. Arvatov, "Bezhim . . . bezhim . . . bezhim . . . ," 3. For detailed information on the agitational art of the early Soviet period see Tolstoy, Bibikova, and Cooke, *Street Art of the Revolution*; and Tolstoi et al., *Agitmassovoe iskusstvo Sovetskoi Rossii*.

10. Arvatov, *Iskusstvo i proizvodstvo*, 117.

11. Arvatov, "Iskusstvo v sisteme proletarskoi kul'tury," 25.

12. Lunacharsky, "Rol' Narodnogo komissara prosveshcheniia," 63; Arkin, "Iskusstvo veshchi," 150, 160.

13. Brik, "Ot kartiny k sittsu," 30, 31.

14. Arkin, "Izobrazitel'noe iskusstvo i material'naia kul'tura," 18.

15. Gabo and Pevsner, *Realist Manifesto* (1920), quoted in Read and Martin, *Gabo*, 152.

16. On Gastev and TsiT, see Johansson, *Aleksej Gastev*. Also see Misler, *Vnachale bylo telo.*

17. Gan, "Borba za massovoe deistvo" (1922), in Aksenov et al., *O teatre*, 57.

18. Tugendkhol'd, *Khudozhestvennaia kul'tura Zapada*, 130.

19. From a speech delivered by the architect Nikolai Dmitriev in 1840. Quoted in Kirichenko, "Teoreticheskie vozzreniia na vziamosviaz' formy i konstruktsii v russkoi arkhitekture XIX–nachala XX vv," in Gulianitsky et al., *Konstruktsii i arkhitekturnaia forma v russkom zodchestve XIX–nachala XX vv.*, 44.

20. Malevich, "From Cubism and Futurism to Suprematism" (1916), translation in Andersen, *Malevich*, 1:19.

21. Larionov, "Rayonist Painting" (1913), translation in Bowlt, *Russian Art of the Avant-Garde*, 96.

22. Malevich, "From Cubism and Futurism to Suprematism," 1:20.

23. Bely, "Formy iskusstva," in *Simvolizm*, 165, 166.

24. Bely, "Budushchee iskusstvo," in *Simvolizm*, 452.

25. Kandinsky, "Content and Form" (1910), translation in Bowlt, *Russian Art of the Avant-Garde*, 22.

26. Markov, "The Principles of the New Art" (1912), translation in Bowlt, *Russian Art of the Avant-Garde*, 27.

27. Punin, *Pervyi tsikl lektsii*, 63. Punin delivered these lectures in the summer of 1919.

28. Punin, *Pervyi tsikl lektsii*, 46.

29. Punin, *Pervyi tsikl lektsii*, 46.

30. Arvatov, *Iskusstvo i klassy*, 3.

31. Gan, *Konstruktivizm*, 56.

32. Altman, "'Futurizm' i proletarskoe iskusstvo," 3.

33. Malevich, "From Cubism and Futurism to Suprematism," 1:20.

34. Kandinsky, "On the Spiritual in Art" (1911), translation in Bowlt and Washton Long, *The Life of Vasilii Kandinsky in Russian Art*, 62 ff.

35. According to the artist Georgii Yakulov, Tatlin donned a brightly colored dressing gown and installed himself near Picasso's studio and began to play his bandura (large mandolin). Picasso noticed him and, as Tatlin had hoped, invited him to pose for him. In this way Tatlin gained entry into Picasso's studio, and there he saw the violin reliefs. As soon as Picasso went out, Tatlin started to sketch them, but Picasso came back unexpectedly, saw what Tatlin was doing, and threw him out. The incident is reported in Komardenkov, *Dni minuvshie*, 55.

36. Lissitzky, "New Russian Art: A Lecture," 336.

37. Punin, *Tatlin*, 121, quoted in Strigalev, "O proekte pamiatnika III internatsionala khudozhnika V. Tatlina," 410.

38. Rodchenko, "Puti sovremennoi fotografii" ("The Paths of Modern Photography") (1928), 261.

39. See Malevich, "From Cubism and Futurism to Suprematism," 1:134. The fact that Malevich hung his *Black Square* in the "beautiful corner" of the *0.10* exhibition in Petrograd in December 1915, a space reserved traditionally for the icon, symbolized his identification of suprematism as a new religion.

40. Ivanov, *Po zvezdam*, 140.

41. Ivanov, *Borozdy i mezhi*, 52.

42. Bely, *Lug zelenyi*, 21.

43. Rossina, *P. A. Florensky*, 117.

44. Bely, "Formy iskusstva," 158.

45. Selvinsky et al., "Manifesto of the Literary Center of the Constructivists" (1923), quoted in Weber, "Constructivism and Soviet Literature," 297.

46. Gabo and Pevsner, *Realist Manifesto* (1920), quoted in Read and Martin, *Gabo*, 152.

47. Milashevksy, *Gipertrofiia iskusstva*, 65.

48. Aksenov, "Prostranstvennyi konstruktivizm na stsene," 31.

49. B. T. (Boris Ternovets), "En guise d'introduction," 19.

50. Brodsky, "The Psychology of Urban Design in the 1920s and 1930s," 82. On the presence—or absence—of consumer objects in early Soviet Russia, see Kiaer, *Imagine No Possessions*.

51. Syrkina, *Khudozhniki teatra o svoem tvorchestve*, 254, 255.

52. Arvatov, "Ot rezhissury teatra k montazhu byta," 3.

53. Lissitzky, "Preodolenie iskusstva" (1920), 145.

54. Lissitzky, "Preodolenie iskusstva," 140, 145, 146.

55. Lissitzky, "Preodolenie iskusstva," 149.

56. See Berlov, *Detali mashin*. Like *Detali mashin*, Blakher's treatise on heating engineering (*Teplotekhnika*) also saw many Russian and Soviet editions.

57. Nikolai Tarabukin emphasized this lacuna in his book *Ot mol'berta k mashine*, 40.

58. See, for example, Bowlt, Misler, and Tsantsanoglou, *El Cosmos de la vanguardia rusa*.

59. Fedorov expounded his theory of resurrection in his magnum opus, *Filosofiia obshchego dela*, published in Moscow in 1906. See Gulyga, *Nikolai Fedorovich Fedorov*.

60. Ivan Puni and Kseniia Boguslavskaia, untitled suprematist statement distributed as a leaflet at the *0.10* exhibition, Petrograd, 1915, translation in Bowlt, *Russian Art of the Avant-Garde: Theory and Criticism 1902–1934*, 112; Dostoevsky, "Notes from Underground," 86.

Convulsive Beauty

Surrealism as Aesthetic Revolution

RAYMOND SPITERI

Beauty will be CONVULSIVE or it will not be at all.
—André Breton, *Nadja*, 1928

In the 1934 lecture "Qu'est-ce que le surréalisme," André Breton reviewed surrealism's development since the 1924 *Manifesto of Surrealism*. "Surrealism had been obliged to defend itself almost unceasingly against deviation to the right and to the left," he notes:

> On the one hand we have had to struggle against the will of those who would maintain Surrealism on a purely speculative level and treasonably transfer it onto an artistic and literary plane ([Antonin] Artaud, [Robert] Desnos, [Georges] Ribemont-Dessaignes, [Roger] Vitrac) at the cost of all the hope for subversion we have placed in it; on the other,

against the will of those who would place it on a purely practical basis, susceptible at any moment to be sacrificed to an ill-conceived political militancy ([Pierre] Naville, [Louis] Aragon)—at the cost, this time, of what constitutes the originality and reality of its researches; at the cost of the autonomous risk that it has to run.[1]

Breton located surrealism in an ambivalent position, vacillating between "a purely speculative level" and "a purely practical basis," framed by those who abandoned surrealism's revolutionary political objectives for culture, and by those who sacrificed its cultural dimension in the name of politics. Surrealism, in effect, existed in the contested space between culture and politics, and the instability of this position largely accounted for the fugitive character of the movement's political influence.

This chapter is concerned with mapping this contested space as the terrain of an aesthetic revolution. It focuses on the period between 1925 and 1932, when the surrealists attempted to develop an image-space that would facilitate active engagement with the Parti communiste français (PCF). Here, the provisional status of this image-space is distinctive: it exceeded the institutional confines of the cultural avant-garde that was surrealism's departure point, seeking an oppositional audience engaged in political action; it simultaneously fell short of the degree of commitment expected of a radical political movement. Yet to simply focus on the surrealists' failure to establish a functioning relation with the PCF overlooks the productive nature of this encounter in the elaboration of surrealism. Indeed, surrealism thrived in the contested terrain between culture and politics, employing the tension between these social fields as an integral element of its own stance. This position can be regarded as an example of the heteronomous character of an aesthetic revolution, the importation of concerns from life into the autonomous realm of art; yet the important factor for surrealism is that heteronomy is not conceived abstractly, as the desire to integrate art and life, but in terms of specific political goals.[2]

Given the contested character of the terrain between culture and politics, how is the political scope of surrealism to be understood? This question is at the core of understanding surrealism as an aesthetic revolution. Surrealism is now recognized as a significant artistic and literary movement; its members are artists and writers who have produced a body of notable work now incorporated into art and literary history. As a result, it is easy to assimilate surrealism as a purely artistic or literary movement. However, this assessment considers the reception of surrealism retrospectively, as part of an unfolding

history of which surrealism is only a fragment, and the oppositional character of surrealism is regarded as yet another instance of *épater le bourgeois*. To recognize surrealism as an aesthetic revolution, it is necessary to focus not on the long duration, but rather the immediate reception of the movement, the short-term strategies and alliances surrealism employed to position itself within the social space. In this context what distinguishes surrealism as an aesthetic revolution is its struggle to establish an image-space in which the cultural and political dimensions of the movement could enter into productive dialogue.

The term "image-space" (*Bildraum*) comes from Walter Benjamin, who used it in his 1929 essay "Surrealism: Last Snapshot of the European Intelligentsia."[3] For Benjamin surrealism exceeded the bounds of a literary or artistic movement, consuming all experience as part of its "profane illumination." The techniques of automatism and dream narrative effaced the distinction between "art" and "life," allowing a free exchange between cultural endeavor and the everyday; yet what initially began as a cultural stance very soon assumed a political character, and the surrealists now faced a choice between the anarchic "experience of freedom" and the "constructive, dictatorial side of revolution." If surrealism was to be more than a "praxis oscillating between fitness exercises and celebration in advance," the surrealists had to bind "revolt to revolution" and "win the energies of intoxication for the revolution."[4]

To develop this point Benjamin reconfigures the opposition between art and life in terms of metaphor and image: "Nowhere do these two—metaphor and image—collide so dramatically and so irreconcilably as in politics. For to organize pessimism means nothing other than to expel moral metaphor from politics and to discover in the space of political action the one hundred percent image space."[5] Whereas metaphor preserves the distance characteristic of artistic autonomy, image short-circuits the relation between heterogeneous elements to establish an immediate link. Cultural endeavor and political action converge through the image, for as the artist or writer forsakes the passive contemplative attitude characteristic of autonomous art, he or she is drawn ever more closely into the sphere of action: "In all cases where an action puts forth its own image and exists, absorbing and consuming it, where nearness looks with its own eyes, the long sought image-space is opened, . . . in which political materialism and physical nature share the inner man, the psyche, the individual, or whatever else we wish to throw to them, with dialectical justice, so that no limb remains unrent." The image-space is opened at a moment of political and cultural crisis when hegemonic articulations—the traditional oppositions between action and contemplation, individual

and collective, mind and body, technology and nature, and so on—collapse and the conceptual constellations of technological society are rearticulated through a "space of images and, more concretely, of bodies." Significantly, the image-space performs a double function: it not only constitutes the collective as a political agent, but also furnishes the matrix through which the collective articulates its political struggle to challenge the hegemony of established culture: "The *physis* that is being organized for it in technology can, through all its political and factual reality, only be produced in that image-space to which profane illumination initiates us."[6]

Many strategies developed by surrealism would later be appropriated and theorized by the Situationist International.[7] However, the point here is less to argue priority than to note the fugitive character of an aesthetic revolution as an emergent phenomenon: what the surrealists first enacted in their situated practice would be theorized by the SI in the practices of *détournement*, *dérive*, and unitary urbanism. The lack of an explicit theoretical articulation of these practices in surrealism was a crucial weakness that would facilitate the rapid appropriation of surrealism as a literary and artistic movement. Indeed, Debord and his colleagues identified this shortcoming as a specific failing of surrealism.[8]

From Culture to Politics: The First Steps

There were several attempts to clarify the political position of surrealism during the 1920s. In the 1924 *Manifesto of Surrealism*, Breton already defined surrealism as more than another artistic or literary movement: surrealism was "psychic automatism in its pure state" that could "resolve all the principal problems in life."[9] Similarly, the publication of the first issue of *La Révolution surréaliste* in December 1924 appeared under the caption "We must arrive at a new declaration of the rights of man" (*Il faut aboutir à une nouvelle déclaration des droits de l'homme*) (figure 3.1).

Nonetheless, the initial reception of surrealism conformed to the established pattern of an emergent avant-garde movement. A skeptical public dismissed surrealism's revolutionary claims as little more than the harmless posturing of disenfranchised youth. To counter this reception the surrealists held a meeting on January 23, 1925, to discuss the movement's future direction and examine the relation between surrealist activity, literature, and revolutionary action.[10] The immediate effect was the "Déclaration du 27 janvier 1925," which affirmed the revolutionary character of surrealism and distanced it from literature: "We have attached the word *surrealism* to the word *revolution* solely

FIGURE 3.1
*La Révolution
surréaliste*, no. 1
(December 1924).
Front cover of the
first issue. Three
photographs of the
surrealist group above
the caption "We
must arrive at a new
declaration of the
rights of man."

to show the uninterested, detached, and even entirely desperate character of this revolution."[11]

Although the surrealists welcomed the declaration, it did not diffuse tensions between surrealism's political and aesthetic dimensions.[12] The questions reemerged in April 1925, polarizing the movement between those members content to pursue cultural endeavor and those who wanted surrealism to take a clearly defined political stance, even to the point of forsaking aspects of its strategy of cultural contestation. Could surrealism simultaneously pursue cultural and political goals, or was it necessary to choose one over the other? What weight should be given to revolutionary goals in relation to cultural endeavor? These questions plagued the movement, promoting dissent and tension between the central players—a tendency that increasingly characterized Breton's relation to Pierre Naville.

Naville was determined to distance surrealism from literature and art. His suspicion of the tolerance of surrealism as a cultural movement led him to question the existence of surrealist painting in the April 1925 issue of *La*

Révolution surréaliste: "Everyone now knows that there's no *surrealist painting*. Neither the strokes of the pencil given over to chance gestures, nor the image retracing the figures of a dream, nor imaginative fantasies can, of course, be so described."[13] Although Naville's position has typically been seen as a condemnation of surrealist art, his objections related less to the definition of surrealism as "psychic automatism in its pure state" than the cultural and political significance of the fine arts. In fact, he refocused the argument onto the surrealist potential latent in forms of urban mass culture, which he considered to harbor greater revolutionary potential than what was conventionally recognized as art. Immediately after denying the possibility of surrealist painting, he added: "But there are *spectacles*" (*Mais il y a des* spectacles).[14] In this way Naville attempted to transpose the debate onto the plethora of visual images that constitute the modern urban environment, suggesting that artists actively engage with the broad compass of culture. The target of his criticism was less the production of visual images per se than the autonomy traditionally granted to painting as fine art.

Breton, not surprisingly, responded unfavorably to Naville's article on painting, regarding it as an attempt to undermine his own position.[15] His relationship to Naville deteriorated in early 1925, leading to the formation of a Comité Idéologique to clarify the relation between surrealism and the revolution. The goal of the committee was to "determine which of the two principles, surrealist or revolutionary, was more capable of leading their action"; although it failed to reach a consensus, the participants did agree "the mind [*Esprit*] is an essentially irreducible principle which cannot be located in life nor beyond" and which was dominated by "a certain state of furor."[16] The Comité Idéologique indicated a turning point in the early development of surrealism: although it exacerbated personal tensions in the movement, it represented the first systematic attempt to articulate the relation between cultural endeavor and political action. Breton, who had chosen not to participate in the Comité Idéologique, now seized the initiative, assuming editorship of *La Révolution surréaliste* and injecting new impetus to the movement.[17]

Breton explained his reason for assuming control of *La Révolution surréaliste* in the lead article of the fourth issue.[18] Whereas the Comité Idéologique attempted to unify the surrealists around "a certain state of furor," Breton demonstrated greater awareness of surrealism's ambivalent position between culture and politics. He affirmed his fundamental belief that what united the surrealists was their common opposition to the "ancien régime of the mind," but now asked what form this opposition should take.[19] His solution was one of moderation and mediation: his goal was to create a space where the modes

of active opposition surrealism manifested could interact with the forces that inspired rebellion. He sought to distance the review from purely aesthetic concerns without forsaking the value of cultural endeavor as the means to expand the scope of human experience, and adopted an aggressive, rebarbative editorial policy, where poetry and painting shared the page with articles on politics, abusive replies to unwarranted criticism, or collective declarations on contemporary events. Breton's strategy was to establish a forum in which the otherwise autonomous fields of art and politics were forced to interact, thereby transforming the marvelous into a portal between cultural endeavor and political action.

Turning Points: The Saint-Pol-Roux Banquet

The publication of the fourth issue of *La Révolution surréaliste* occurred during the period of intense controversy that followed the notorious Saint-Pol-Roux banquet held on July 2, 1925.[20] Although Saint-Pol-Roux was one of the few living poets the surrealists held in high regard, their conduct at the banquet caused a riot that provoked almost unanimous condemnation in the press.[21] This was an important event in reinforcing surrealism's oppositional position, coinciding with a decisive turn toward communism, and marking "Surrealism's final break with all the conformist elements of the time."[22]

The day began with the publication in *L'Humanité* of a collective declaration against the Moroccan War, written by Henri Barbusse and signed by seventeen surrealists.[23] Later that day the surrealists received back from the printers copies of a collective declaration, "Lettre ouverte à M. Paul Claudel, Ambassadeur de France au Japon," which they decided to distribute at the banquet, leaving a copy under each place setting to greet the guests.[24]

The pretext for the "Lettre ouverte" was an interview in *Comœdia*, in which Claudel not only vaunted his patriotic activity during the war—he traveled to South America to purchase wheat, preserved meat, and lard for the French army—but also criticized surrealism as having "only one meaning: pederasty."[25] Claudel represented everything the surrealists despised: he was a conservative poet who advanced a Catholic interpretation of Rimbaud's life and writings and was currently the French ambassador to Japan—roles incompatible with the surrealists' own understanding of poetry. In response to Claudel's comments regarding surrealism, the "Lettre ouverte" simply replied: "The only pederastic thing about our activity is the confusion it introduces into the minds of those who do not take part in it."[26] The letter then attacked Claudel's understanding of poetry, stating categorically that "one cannot be

both French ambassador and a poet," and the surrealists seized the opportunity to "dissociate ourselves publicly from all that is French": "We find treason and all that can harm the security of the State one way or another much more reconcilable with Poetry than the sale of 'large quantities of lard' on the behalf of a nation of pigs and dogs."[27] This violently antipatriotic position was guaranteed to alienate the surrealists from the other guests at the banquet: the surrealists not only distanced themselves from the tacit belief that poetry was compatible with French civilization, but through their presence sought to occupy an oppositional position and thereby enact an aesthetic revolution.

The "Lettre ouverte" set the evening's tone. The majority of guests did not know how to respond to the letter or the presence of its authors. To further compound matters, the surrealists had other grievances with Madame Rachilde and Aurélien-Marie Lungé-Poe, who were seated at the table of honor. Rachilde had recently stated that it was not possible for a French woman to marry a German, an opinion repeated at the banquet. In response, Breton reminded Rachilde that his friend Max Ernst, a German national, was present at the banquet, and then proceeded to insult her. Saint-Pol-Roux looked on helplessly as the room erupted in uproar: the surrealists exchanged blows with other guests amid shouts of "A bas la France!," "Vive l'Allemagne!," and possibly "Vive Lénine"; Philippe Soupault knocked over plates on the tables while swinging from the chandelier; and the passing crowd attempted to lynch Michel Leiris after he began shouting seditious comments from a window overlooking boulevard Montparnasse.[28]

The Saint-Pol-Roux banquet coincided with the surrealists' opposition to the suppression of the Rif rebellion in Morocco. This was the first time the surrealists had adopted an explicit position in direct response to a contemporary political event, collaborating with a group of radical intellectuals associated with *Clarté*, a review closely affiliated with the PCF. Over the next few weeks the surrealists would sign several declarations supporting the PCF's opposition to military intervention, culminating in the publication of the tract *La Révolution d'abord et toujours* in September 1925.[29] This support confirmed the belief of the extreme right that surrealism was part of a Soviet conspiracy. *Action française* led the offensive, suggesting that the press greet surrealist works with silence, and even campaigned for their expulsion from France.[30] The cultural establishment ostracized the surrealists, which only impelled them to strengthen their link to communism. According to Breton, "the bridges had been burned between surrealism and all the rest," and henceforth "our shared revolt focused much more on the political sphere."[31] To be associated with surrealism now entailed supporting the movement's political

position; those artists who were not comfortable with this position soon distanced themselves from the movement.[32]

What influence did this position have on the image-space of surrealism? Although the surrealists now agreed with the goals of the communist revolution, there was no immediate transformation in the modes of cultural endeavor they pursued; for example, the October 1925 issue of *La Révolution surréaliste* included Breton's "Lettre aux voyantes" and Antonin Artaud's "Nouvelle lettre sur moi-même," as well as "Textes surréalistes," "Poèmes," and "Rêves." However, politics did influence the presentation of cultural endeavor in *La Révolution surréaliste*, notably through the inclusion of more polemical statements. On the cover, above the title "Le Passé," appeared a photograph of various Dada and surrealist publications, in effect contrasting the movement's past activities to its present position (figure 3.2).[33] The movement's political intransigence was evident under the rubric of "Chroniques," which included Breton's review of Trotsky's *Lénine*, Louis Aragon's review

of the 1925 Exposition des Arts Décoratifs, and republished "La Révolution d'abord et toujours!" The tension between the surrealist texts that opened the issue and the political views expressed in the closing pages defined the movement's new political position.[34]

Yet the balance achieved in the issue between cultural endeavor and surrealism's political position was difficult to maintain. By the time the next issue of *La Révolution surréaliste* appeared in March 1926, the tension between the political and cultural orientations of surrealism was evident. On the inside cover appeared an advertisement for two new initiatives: the opening of the Galerie surréaliste and the launch in April of a new review, *La Guerre civile*. While the Galerie surréaliste would provide an important outlet for the work of artists associated with the surrealist movement, organizing a series of exhibitions until its closure in December 1928, *La Guerre civile* would never progress beyond the planning stage, its publication vetoed by the PCF. Indeed, *La Guerre civile* was an initiative designed to establish a common platform between an avant-garde cultural movement and a radical political group affiliated with the PCF. As such it reveals not only the proximity of the cultural and political ambitions of surrealism, but also the tension that would repeatedly frustrate the surrealists in their political endeavors.

The precarious relation between cultural endeavor and political action was also evident in the second installment of "Le surréalisme et la peinture." In this series of articles Breton discussed the relation between surrealism and the visual arts; the first installment celebrated the work of Picasso, and Breton devoted this installment to Picasso's contemporaries in the prewar generation—principally Georges Braque. Less conciliatory in tone than the previous installment, Breton began by criticizing the failings of Picasso's contemporaries, as well as the "utter bankruptcy" of art criticism and the "usury" of dealers.[35] Yet despite his recent involvement with radical politics, Breton only explicitly broached the question of artists' relation to revolutionary action in one paragraph:

> The Revolution is the only cause on behalf of which I deem it worth while to summons the best men I know. Painters share responsibility with all others to whose formidable lot it has fallen to make full use of their particular means of expression to prevent the domination of the symbol by the thing signified: a heavy responsibility, at the present hour, which seems to have been largely evaded. Yet that is the price of eternity. The mind, as on a piece of orange-peel, slips on this apparently fortuitous circumstance. [*L'esprit, comme sur une pelure d'orange, glisse*

sur cette circonstance qui a l'air fortuite.] Those who prefer to ignore this fact, at the moment when they are least prepared, deprive themselves of a mysterious aid which is the only aid of any value. The revolutionary significance of a work, or quite simply its significance, should never be subordinated to the choice of elements that the work brings into play. Whence the difficulty in setting up a rigorous and objective scale of plastic values at a time when the radical overhaul of all values is about to be undertaken, and when perspicacity obliges us to recognize only those values likely to hasten this overhaul.[36]

This passage articulates the impasse at the center of surrealism's cultural and political ambitions. Breton mobilized the rhetoric of an opposition between an avant-garde "art of conception" and a conventional "art of imitation" to locate the crux of the problem in the relation of the process of symbolization to conventional knowledge, and called on artists to use "their particular means of expression to prevent the domination of the symbol by the thing signified."[37] However, he was unable to articulate clearly the relation between cultural endeavor and political action—other than as a possibility. He located the artwork's revolutionary significance in the slippage (*glissement*) between symbol and thing signified, only to proclaim its fortuitous character: "The mind, as on a piece of orange-peel, slips on this apparently fortuitous circumstance." The agent of revolutionary emancipation appeared in the figure of chance, who transformed the possibility of revolution into actuality. In effect, Breton hypostatized the contingency of the historical process. This represented a significant departure from Marxist belief: the revolution is not the ineluctable result of history, but a possibility to be actualized.[38]

Protestation

The relation of cultural endeavor to surrealism's political position became increasingly problematical during 1926, as can be seen in May when Max Ernst and Joan Miró agreed to collaborate with Sergei Diaghilev's Ballets Russes on the costumes and sets for *Roméo et Juliette*.[39] The commission, however, would come at a high price; despite Picasso's previous work for the ballet, Breton and Aragon signed a declaration entitled "Protestation" to condemn Ernst and Miró for giving "weapons to the worst supporters of moral equivocation."[40] Like the Saint-Pol-Roux banquet, "Protestation" demonstrates the situated nature of surrealism.

What Breton and Aragon described as "moral equivocation" was the aes-

theticism of the Ballet Russes, its assimilation of an avant-garde attitude to a conservative political position. Diaghilev and the Ballets Russes were refugees from the Russian Revolution, and as such opponents of the Soviet regime; similarly, the audience of the Ballets Russes was predominantly bourgeois in character, and while it tolerated the innovation of the modernist avant-garde, it held little sympathy for surrealism's political position. In this context, anyone who collaborated with the Ballets Russes committed a counterrevolutionary act; thus it was necessary to assert the revolutionary dimension of surrealism against aesthetic assimilation:

> It is unacceptable for money to regulate thought. This is not the year, however, for a man—whom one believed incorruptible—to capitulate to powers he previously opposed. Those who concede, citing their current circumstances, do not compromise the ideas they previously held, which continue irrespectively. In this sense, the participation of the painters Max Ernst and Joan Miró at the upcoming performance of the Ballets Russes does not compromise the idea of surrealism. An essentially subversive idea, not to be confused with similar endeavors, which, for the benefit of the international aristocracy, seek to tame the dreams and revolts caused by physical and intellectual famine.[41]

Significantly, Aragon and Breton distinguished between the actions of individuals associated with surrealism and surrealism as an idea; Ernst and Miró's collaboration with the Ballets Russes did not compromise the subversive aspect of surrealism as an idea, only their moral integrity as individuals. On May 18, 1926, a group of surrealists and communist sympathizers disrupted the Paris première of *Roméo et Juliette* by whistling, showering the audience with copies of "Protestation" and shouts of "Vive les Soviets, Vive la Révolution Russe." This was the first collective action undertaken by the surrealist and *Clarté* groups since the failure of *La Guerre civile* in March. An article on the front page of the communist daily *L'Humanité* the following day recognized the political character of the action:

> Once the curtain rose, a broadside of whistles sounded in the room. The Surrealists were keen to prove they were not all "bought" by the vilest form of artistic commercialism. A shower of leaflets (a protest signed Breton and Aragon) came down on the orchestra. The performance stopped.
> Before long, most of the room had turned on a handful of brave young men, calling the police—natural protectors of snobs and privi-

lege. A squad of cops invaded the hall, unceremoniously expelling the Surrealists, who were joined by some Communists. They shout: "Long Live the Soviets, Long live the Russian Revolution."

Fight, brawls, blows rained down. One by one the Communist and Surrealists are expelled. We fight back. One of our staff, Jean Bernier [an editor of *Clarté*], fiercely defends himself. Ten cowards throw themselves on him and the officers take him to the police station.

This vigorous protest will, hopefully, succeed. At least it proves there are a few intellectuals in France brave enough to resist the abject degradation of all forms of this bourgeois art destined to perish with the whole regime, swept out by the great breath of proletarian revolution.[42]

At first glance, "Protestation" appeared to be a resounding success. It not only demonstrated the surrealists' opposition to the Ballets Russes and bourgeois culture, but a communist newspaper had recognized this opposition. The report in *L'Humanité* not only conferred a degree of communist legitimization on "Protestation," but transformed it from a symbolic act limited to the cultural arena into an intervention in the political arena.

Although "Protestation" helped establish a closer relationship between the surrealists and communists, it also exposed the gulf between surrealism's cultural goals and its political orientation. The June 1926 issue of *La Révolution surréaliste* reprinted "Protestation," and Ernst and Miró found themselves temporarily estranged from the movement.[43] However, "Protestation" demonstrated the fragility of surrealism's aesthetic revolution: rather than consolidating the movement, Ernst's and Miró's exclusion polarized the movement between their supporters, and those who agreed with Aragon and Breton. Although the movement soon surmounted these divisions—by December Ernst and Miró were reintegrated into the movement—it remained as a salutary reminder of the risk of dissent within the movement.[44] In future Breton and Aragon would proceed with greater caution, seeking a mandate from the movement before attempting to limit an individual's actions, a strategy adopted to expel Artaud and Soupault in November 1926, and again in 1929 with Leiris and André Masson.[45]

The Naville Crisis

The scandal at the première of *Roméo et Juliette* signaled a period of renewed cooperation between the surrealists and the editors of *Clarté*. *Clarté* would reappear in June 1926, and although individual surrealists contributed to the

new series, collectively they felt frustrated that the PCF viewed their efforts to establish common ground between surrealism and communism with skepticism, merely offering to let them contribute to the literary column of *L'Humanité*.[46] Events finally came to a head in June when Pierre Naville—now an editor of *Clarté*—published *La Révolution et les intellectuels: Que peuvent faire les surréalistes?* Breton responded in September with *Légitime défense* to defend surrealism and condemn the editorial policy of *L'Humanité*.[47] The central issue in the polemic was how best to realize the revolutionary aspirations of surrealism—how, in other words, to translate cultural endeavor into direct political action.

According to Naville, surrealism had derived its original impetus from a particular type of anarchistic revolt inspired by their profound dissatisfaction with established forms of intellectual expression.[48] Surrealism transformed Dada's nihilism into a constructive effort, engendering "a positive current initially translated into literary and artistic works, and various anarchic public protests."[49] Yet surrealism's sphere of action was limited by their inadequate conception of cultural endeavor, which was dependent on the forms of bourgeois art as "autonomous creations of the mind."[50] This argument recalled Naville's earlier critique of surrealist painting, yet Naville now advocated membership of the PCF, rather than the spectacle of mass culture.[51]

Although the surrealists had begun to acknowledge the political limitations of their activity, they still manifested a profound confusion between a metaphysical and a dialectical attitude.[52] The idea of freedom advanced in the *Manifesto of Surrealism* remained on an abstract, metaphysical level with little social basis. They thus faced a choice between two possible courses of action. Philosophically they could choose between metaphysics or materialism; politically, between anarchism or Marxism:

> 1) either persevere in a negative attitude of an anarchic order, an attitude false a priori because it does not justify the idea of revolution it claims to champion, an attitude dictated by a refusal to compromise its own existence and the sacred character of the individual in a struggle that would lead to the disciplined action of the class struggle;
>
> 2) or resolutely take the revolutionary path, the only revolutionary path, the Marxist path, which would mean realizing that spiritual force, a substance which derives from the individual, is intimately linked to a social reality which it in fact supposes. This reality appears for us with class organization. In this case, the fight is directly engaged against the bourgeoisie, the proletarian struggle in all its profundity, controlled by

the mass movements, with the help of intellectuals who decisively re-solve to recognize the land of liberty only where the bourgeoisie will perish.[53]

The surrealists could either maintain a metaphysical stance, which would limit their efficacy to the ideological sphere, or they could embrace Naville's position, join the PCF, and direct their efforts toward political militancy.

Breton responded to *La Révolution et les intellectuels* in *Légitime défense*. Whereas Naville posed a stark choice between two options — metaphysics or materialism, anarchism or Marxism — Breton questioned the validity of the categories Naville used. The opposition between the "interior reality" of the mind and the "factual world" was for Breton a "wholly artificial opposition that does not bear up under scrutiny":

> In the realm of facts, as far as we're concerned there can be no doubt: there is not one of us who does not hope for the passage of power from the hands of the bourgeoisie to those of the proletariat. In the mean-time, we deem it absolutely necessary that inner life should pursue its experiments, and this, of course, without external control, not even Marxist. Doesn't Surrealism, moreover, tend to posit these two states as essentially one and the same, refuting their so-supposed irreconcil-ability by every means possible — beginning with the most primitive means of all, the use of which we would be hard put to defend: I mean the appeal to the marvelous.[54]

Breton attempted to defuse this antinomy through a subtle dialectical turn. The reality of the mind was no less valid than that of facts; moreover, cultural endeavor resolved in this antinomy, since the imagination mediated between the subjective reality of the mind and material facts, a condition realized in the experience of the marvelous. The "appeal to the marvelous" was an appeal to the revolutionary dimension of surrealist experience.

Although Breton and Naville agreed that surrealism needed to adopt a definite position vis-à-vis the PCF, they differed over the role cultural en-deavor would play in the sphere of revolutionary action. Whereas Naville wanted to subordinate cultural endeavor to the discipline of political mili-tancy, Breton considered revolutionary action an *extension* of cultural en-deavor. The image-space uncovered by surrealism played a double role: it provided an intimation of revolutionary transformation — thus political mili-tancy represented a logical development of surrealism — and it embodied an experience of freedom. In this context cultural endeavor was a necessary sup-

plement to the discipline of political militancy; indeed, by manifesting the freedom the revolution was to realize, it constituted the ethical core of surrealism's political position.[55] And it was precisely the vision of the complementary character of cultural endeavor and political action that constituted surrealism as an aesthetic revolution.

Despite the reservations expressed in *Légitime défense*, the surrealists acknowledged the wisdom of joining the PCF, and after a series of meetings in November 1926, they concluded that membership was desirable but a matter of individual conscience. Five surrealists decided that they were ready to join, and in January 1927 Aragon, Breton, Paul Éluard, Benjamin Péret, and Pierre Unik applied for membership. Breton's application was carefully scrutinized, and he was questioned on surrealism's relation to revolution. Although his explanations were accepted, he faced ongoing hostility from his comrades, and soon withdrew from active participation in the PCF.[56]

The problem Breton faced with regard to the PCF was the political legitimacy of the modes of cultural endeavor pursued by surrealism. Up to this point the politicization of surrealism had largely been seen as a negative reaction of more conservative factions of French culture: for the extreme Right, for instance, surrealism was a manifestation of the degeneration of French culture associated with the threat of Bolshevism; for more moderate factions, the relation between culture and politics in surrealism was less straightforward, since the political polemic was neutralized by the value of surrealism as an avant-garde cultural movement. Here, surrealism was received through the prism of modernist culture, which valued the transgression of established cultural conventions in the name of cultural renewal; the innovations of surrealism would assume their place within a history of literary and artistic practice. Whereas the surrealists considered their political position the logical outcome of the experience of freedom harbored in cultural endeavor—an appeal of the marvelous—the PCF associated the cultural modes of surrealism with the decadence of bourgeois society, as evidence of the individual surrealists' class origin.

Images in *Nadja*

Given this context, how can the political physiognomy of surrealism be delineated? Here due weight should be given to Benjamin's exploration of the image-space of surrealism. According to Benjamin, surrealist profane illumination opens an image-space in which technology, body, and image all interpenetrate. One example of this image-space is in the labyrinthine struc-

ture of Breton's *Nadja*, where elements of the quotidian enter into a charged constellation through the confluence of chance and desire, so that the tension between politics and culture animate its construction. On one level the book is an attempt to work through the impasse in surrealism's political position.

Nadja describes Breton's brief liaison with a mysterious woman he met on the streets of Paris, the Nadja of the book's title. But this liaison is framed in such a way to highlight its enigmatic quality, the sense that Breton does not know what had in fact occurred in his encounter with Nadja. When published in 1928 *Nadja* also included forty-four photographic illustrations of places or objects mentioned in the narrative. In contrast to photography employed as a surrealist technique, where distortion and manipulation of the image estranged it from conventional appearances, the illustrations in *Nadja* were remarkably faithful to appearances.[57] Their function was to ground the verisimilitude of the text in the quotidian, simply recording people, objects, or places mentioned. Breton's encounter with Nadja *did* occur in Paris, and the reader can visit the various sites where the narrative unfolded, or may already be familiar with them. It is this proximity to the quotidian that constitutes the image-space of the narrative, since the banality of the everyday resists embellishment as literature, while the surrealist themes of the narrative disclose the marvelous in the ordinary.

As an example of image-space, I want to focus on the illustration of the Boulevard Bonne-Nouvelle that appears toward the end of the *Nadja*, titled *The Illuminated Mazda Billboard*. This billboard is first mentioned in the narrative in relation to Nadja associating herself with the mythological figure of Melusina: "Nadja has also represented herself many times with the features of Melusina, who of all mythological personalities is the one she seems to have felt closest to herself. . . . She enjoyed imagining herself as a butterfly whose body consisted of a Mazda (Nadja) bulb towards which rose a charmed snake (and now I am invariably disturbed when I pass the luminous Mazda sign on the main boulevards, covering almost the entire façade of the former Théâtre du Vaudeville where, in fact, two rams do confront one another in a rainbow light)."[58] The description of the billboard acts as a symbolic portrait of Nadja, echoing her own self-image. Breton also included a photograph of the Mazda billboard, but it does not appear facing this description; rather, it appears forty pages later, in the final section of the book, after Nadja and Breton had ceased seeing each other (figure 3.3).[59] However, the placement of the illustration makes sense in relation to the text on the facing page, in which Breton comments on the illustrations for *Nadja*, which in retrospect he found "quite

nées de pillage dites « Sacco-Vanzetti »
semblé répondre à l'attente qui fut la
mienne, après s'être désigné vraiment
comme un des grands points stratégiques
que je cherche en matière de désordre et
sur lesquels je persiste à croire que me
sont fournis obscurément des repères, à
moi comme à tous ceux qui cèdent de pré-
férence à des instances inexplicables,
pourvu que le sens le plus absolu de
l'amour ou de la révolution soit en jeu et
que cela, naturellement, entraîne la néga-
tion de tout le reste; tandis que le boule-
vard Bonne-Nouvelle, les façades de ses
cinémas repeintes, s'est depuis lors immo-
bilisé pour moi, comme si la Porte Saint-
Denis venait de se fermer, j'ai vu renaître
et à nouveau mourir le Théâtre des Deux-
Masques, qui n'était plus que le Théâtre
du Masque et qui, toujours rue Fontaine,
n'était plus qu'à mi-distance de chez
moi. Etc. C'est drôle, comme disait cet

PL. 43. — L'AFFICHE LUMINEUSE DE MAZDA SUR LES GRANDS BOULEVARDS.
page 165

FIGURE 3.3 Two pages from *Nadja* by André Breton (Paris: Gallimard, 1928). The illustration juxtaposes Jacques-André Boiffard's photograph *The Illuminated Mazda Billboard on the Grands Boulevards* with Breton's description of the Sacco-Vanzetti riots. Digital image courtesy Special Collections Research Center, University of Chicago Library.

inadequate." A digression on the Sacco-Vanzetti riots then interrupts his description of the Boulevard Bonne-Nouvelle:

> While the Boulevard Bonne-Nouvelle, after having, unfortunately during my absence from Paris, in the course of the magnificent days of riot called "Sacco-Vanzetti" seemed to come up to my expectations, after even revealing itself as one of the major strategic points I am looking for in matters of chaos, points which I persist in believing obscurely provided for me, as for anyone who chooses to yield to inexplicable entreaties, provided the most absolute sense of love or revolution are at stake and that this, naturally, involved the negation of everything else; while the Boulevard Bonne-Nouvelle, the façades of its movie-theaters repainted, has subsequently become immobilized for me, as if the Porte Saint-Denis had just closed.[60]

What is significant here is the way a contingent political event—the Sacco-Vanzetti riots—interrupts Breton's discussion of the illustrations in *Nadja*. Viewed in isolation, or in the context of Nadja's earlier portrayal of herself as Melusina, the billboard is not forthcoming as a political image; however, juxtaposed with the riots, the image assumed a greater political value. The image suddenly creates a space where the cultural and political dimensions of surrealism briefly resonate in sympathy. Whereas the illustrations were ostensibly nonpolitical, and thus Breton was addressing the cultural significance of the book, this significance was poised on the threshold of the political. The mere mention of the Boulevard Bonne-Nouvelle opened a convoluted parenthesis on the revolution; Breton's measured prose returned only after he had emphatically stated his political philosophy.[61]

The Sacco-Vanzetti riots erupted after the execution of Nicolas Sacco and Bartolomeo Vanzetti in the United States. The case became a symbol of international proletarian opposition to capitalism after Sacco and Vanzetti were convicted of murdering a guard during a shoe factory robbery, since the court appeared unduly prejudiced by the anarchist political beliefs of the accused. After a series of appeals, the fate of Sacco and Vanzetti was in the hands of the Massachusetts governor, Alvin T. Fuller, who dismissed their final appeal and sent them to the electric chair on August 23, 1927. News of the execution triggered a series of riots by workers in major cities across the world, indicating the political charge assumed by the case. In Paris the execution provoked a major demonstration. The headline for the August 24, 1927, edition of *L'Humanité* celebrated the heroism of the Paris workers, proclaiming: "Paris workers master the street!"[62] *L'Humanité* provided detailed coverage of the evening's events and underlined Communist Party's role in the unfolding of the demonstration.[63]

Breton accepted the Sacco-Vanzetti riots as an article of revolutionary faith, yet these riots also indicate his distance from direct political action. The reason for his absence from Paris was his preoccupation with writing *Nadja*. He had retreated to the Normandy coast, where he slowly wrote the book's first two parts.[64] Although the riots represented a contingent event, Breton's response to them in *Nadja* is telling: the juxtaposition of *The Illuminated Mazda Billboard* with his description of the Boulevard Bonne-Nouvelle and the Sacco-Vanzetti riots opens a place for the appearance of another politics—the convulsive politics of the marvelous—that operates in the interval between event, image, and text.[65] Breton does not attempt to articulate an explicit political strategy in *Nadja*, since his efforts to align surrealism with

communism have already resulted in an impasse; rather, he incorporates the encounter with politics as one coordinate in the construction of *Nadja*.

The Illuminated Mazda Billboard also illustrates the distinction between metaphor and image. As a symbolic portrait of Nadja the illustration was based on a metaphoric of displacement, in which the brand "Mazda" substitutes for the name "Nadja." As an image, however, it is based on the proximity between culture and politics, cultural endeavor and revolution. Breton attempted to collapse the distance between surrealism and revolution by juxtaposing the illustration with the description of the Boulevard Bonne-Nouvelle. Yet here we encounter an impasse in the politics of surrealism. For surrealism to succeed culturally, it had to dress politics in metaphor; yet for it to succeed politically, it had to strip culture of its metaphoric veils. Surrealism never overcame this impasse, which inscribed its political position as an overdetermined subtext in surrealist productions.[66]

This paradox is characteristic of surrealism as an aesthetic revolution. To overcome the impasse in its political position required an audience who would recognize their own condition mirrored in surrealism; surrealism would in effect constitute a political agent's cultural identity. The problem Breton faced in *Nadja* was that his initial attempt to wed surrealism to politics had failed. When he joined the PCF in January 1927, he was greeted with suspicion and hostility, and was soon forced to withdraw; but he did not abandon his belief that surrealism contributed to the revolution. Writing *Nadja* was an attempt to "work through" this impasse, hence the proximity of politics to the narrative.

The success of this strategy in *Nadja* was limited. Despite Breton's efforts to situate the book in the image-space of surrealism, its reception was largely determined by the existing values and standards of the cultural field. A political reading was not forthcoming in France. (Benjamin does provide such a reading in the German context, but this did not influence the immediate French reception of the book.)

L'Age d'Or

Nadja helps identify the provisional and fugitive character of surrealism as an aesthetic revolution. Although images can actualize the convergence of political and cultural interests, as in the Mazda billboard / Sacco-Vanzetti riot example in *Nadja*, the fact that the significance of this convergence has rarely been recognized is testimony to its provisional character. In the final section

of this chapter I look at another instance that exemplifies the tension between cultural endeavor and political action in surrealism: the public controversy generated by the film *L'Age d'Or* and its subsequent suppression by the French state in December 1930.

L'Age d'Or demonstrates the complex interplay of forces involved in any aesthetic revolution: first in terms of the emergence of a conflict between cultural and political values, and second in terms of the neutralization of this conflict within a democratic society. Whereas the political impact of avant-garde culture was limited by its specialized audience — it is difficult for a work that reaches a small audience to assume political value — cinema was by its nature a powerful mass medium, with potential access to a broad audience. For this reason cinema was subject to censorship at the local and national level: before any film (apart from newsreels) could be publicly exhibited, it had to receive a visa from the National Censorship Board (Commission de contrôle des films), which included representatives from the Ministries of Interior, Public Instruction, and Fine Arts, and the film industry. Indeed, the Ministry of the Interior exercised a powerful influence on film censorship during the interwar years; during the late 1920s and early 1930s, the conservative government ensured close scrutiny of any socially disruptive films.

L'Age d'Or exemplifies the way surrealism's image-space operated at the interstices of culture and politics. It was initially able to gain the censor's visa because it did not originally appear as a political statement; indeed, its politics were disguised by its unconventional narrative structure and imagery. However, when the film was released, it was accompanied by a "revue-programme" that sought to make explicit links between the cultural and political dimensions of the film. After a screening was disrupted by a group from the extreme Right who denounced the film as an attack on the institutions of the French state, the film became the focus of a press campaign that resulted in the suppression of the film. Initially this image-space operated below the threshold that marked a politically contentious manifestation, exploiting the liberty given to artistic expression in France; however, once the film became the target of a campaign to suppress it, it exposed not only the limits of artistic freedom, but also the imbrications of cultural and political interests that acted in concert to proscribe certain manifestations of freedom.

L'Age d'Or was written and directed by Luis Buñuel and Salvador Dalí, the team responsible for the short film *Un Chien andalou* in 1929. Whereas *Un Chien andalou* had been a critical and commercial success, *L'Age d'Or* was part of a carefully calibrated campaign to produce a film that more closely exemplified the surrealists' current political position.[67] It assumed a more in-

transigent political position, using the conflict between the film's protagonists and the conventions of bourgeois society to subject that society to a relentless and devastating critique. Although the film succeeded in eliciting a strong response from the Right, who condemned the film as an example of Bolshevik culture, this response was not reciprocated from the Left, particularly the PCF, who did not see proletarian values reflected in the film.

L'Age d'Or was commissioned by the Vicomte Charles de Noaille, an important patron of surrealism and the Parisian avant-garde.[68] It was considerably longer than Un Chien andalou—sixty-three minutes to the former's seventeen—and included a mix of silent and sound sequences filmed in March and April 1930.[69] The film received its "visa" from the Censorship Board in October, and its commercial release commenced on November 28 at an arthouse cinema in Montmartre, Studio 28, the feature film supported by two shorts, Paris-Bestiaux, a documentary on the La Villette abattoir by D. Abric and M. Gorel, and Au Village, a Russian film by Leonid Moguy.[70]

Like Un Chien andalou before, L'Age d'Or did not have a conventional plot: the film begins as a nature documentary on scorpions before shifting to a sequence of bandits (which included several members of the surrealist movement); the main character, played by Gaston Modot, is introduced disrupting an official ceremony. The central episode in the film concerns Modot's liaison with a young woman (Lya Lys), the daughter of an aristocratic family that hosts an elegant evening party at their suburban mansion. The young lovers' attempts to evade scrutiny and consummate their passion are repeatedly frustrated by the obstacles of family, religion, and society. The film concludes with a sequence based on the protagonists of de Sade's *120 Journées de Sodom* leaving the Chateau de Selligny, with one of the protagonists in the orgies, the Comte de Blangis, appearing dressed as Jesus Christ.

If L'Age d'Or lacked the disconcerting concision of Un Chien andalou, it did assume a more political position, replacing the "popular" address of Un Chien andalou with a greater awareness of the class structure of bourgeois society. Although the obstacles to the lovers' passion are the conventions of bourgeois society, the film still falls short of a Marxist analysis. The proletariat is not identified as the agent of revolutionary change. Rather, it is unconditional love that becomes the catalyst for change: the lovers' passion is to vanquish all obstacles. Its surrealism consists in the way it deploys imagery to contravene the mores and values of bourgeois society, yet without articulating a clear alternative to that society. As such it differed from Soviet films, which presented the workers as the hero of the revolution. The hero of L'Age d'Or was the male protagonist, who in no way represented a collective class;

rather, he doubled the ambiguous position of individual surrealists (and the avant-garde writer or artist in general) as an individual who did not identify with the bourgeoisie, but who did not assume a role within the proletariat. It was this ambiguity that would produce the political ambivalence evident in the film's reception.

To accompany the public release of *L'Age d'Or*, the surrealists also issued a "revue-programme" containing a collectively written manifesto signed by thirteen members of the surrealist group.[71] Like the film, the manifesto does not establish a clearly defined political position, apart from acknowledging surrealism's opposition to the values of bourgeois society. Indeed, it acknowledged the socially disparate character of the audience, but claimed that the film could act as a catalyst for change: the audience of "several hundred people" of "very different, not to say contradictory, aspiration covering the widest spectrum," had been brought together to measure "the wing span of this bird of prey so utterly unexpected today in the darkening sky, in the darkening western sky: *L'Age d'Or*."[72]

The "revue-programme" locates the film in the orbit of surrealist concerns, making the case for the film as an expression of the movement's political position. It specifies the relation between artistic endeavor and the broader social and political context, distancing the film from conventional artistic concerns and placing surrealism at the forefront of the attempts at aesthetic revolutions in the twentieth century:

> The problem of the bankruptcy of feelings intimately linked with the problem of capitalism has not yet been resolved. One sees everywhere a search for new conventions that would help in living up to the moment of an as yet illusory liberation. . . . Buñuel has formulated a theory of revolution and love that goes to the very core of human nature, by the most moving of debates, and determined by an excess of well-meaning cruelty, that unique moment when you obey the wholly distant, present, slow, most-pressing voice that yells through pursed lips so loudly it can hardly be heard: LOVE . . . LOVE . . . Love . . . love.[73]

However, the film's position was exposed: in asserting a convergence of artistic and political elements the film was vulnerable to social sanction. The disruption of the screening inscribed the film in a field of contested political values, ranging from the "apolitical" defenders of avant-garde culture to the political condemnation of the film's Bolshevik inspiration.

Ironically, the program for *L'Age d'Or* also celebrated "the gift of violence": "He smashes, he sets to, he terrifies, he ransacks. The doors of love and hatred

FIGURE 3.4 *L'Age d'Or*, directed by Luis Buñuel in 1930. Film still showing a monstrance (used to hold the Eucharist during the Catholic mass) placed in a street gutter as guests arrive for an elegant soirée.

are open, letting violence in. Inhuman, it sets man on his feet, snatches from him the possibility of putting an end to his stay on earth."[74] Although this passage apparently referred to the unpredictable behavior of the male protagonist, who vents his frustration by kicking a pet dog, knocking over a blind man, and slapping his lover's mother, this "gift" would be realized from an unexpected quarter on December 3, when members of two extreme-Right groups associated with Action française, the Ligue des Patriots and Camelots du Roi, disrupted the film. The protest erupted after a scene where elegantly dressed guests arrive for a party at a mansion: as the passengers alight from their limousine, a monstrance containing the Eucharist is placed in the gutter (figure 3.4). Amid shouts of "We will show you there are still Christians in France" and "Death to Jews," the protesters set off smoke and stink bombs, forcing the audience to leave the screening hall; the protesters then destroyed a display of surrealist publications and paintings in the cinema foyer, slashing pictures by Dalí, Ernst, Miró, Man Ray, and Yves Tanguy, and threatened members of the audience.

It is interesting to compare the reporting of the incident the next day in

L'Action française and *L'Humanité*. Both papers included a brief report of the incident on December 4. *L'Action française* did not identify the protesters, merely noting "about fifty spectators protested against a pornographic film," causing a hundred thousand francs' worth of damage to the cinema, and leading to the arrest of eleven protesters.[75] *L'Humanité* clearly identified the protesters as members of the Camelots du Roi and noted the target of the protest as "a surrealist film, *L'Age d'Or*." However, the emphasis in the article was less on the film itself than on the continued activity of the extreme Right, who used this "ridiculous protest" to remind the public that they are not dead, and noted that Action française was holding its congress in Paris.[76] It did not comment on the film, nor promote any identification with the film; the political significance was not the film's surrealism, but the action of extreme-Right groups.

L'Humanité only had limited coverage of the controversy until the banning of the film on December 11, although it did publish an opinion piece by Léon Moussinac in the "Cinéma-Radio" column on December 7. His goal was not to open a debate on surrealism's merits, but to provide an "information sheet" on the scandal. Although he credits the film with giving the institution of bourgeois society a "vigorous kick in the backside," he carefully distinguished between the film as an expression of surrealism, which he considered a manifestation of bourgeois decadence, and the sensibility of the proletariat; for the latter the film held little positive significance.[77] In other words *L'Humanité* did not consider the controversy over the film as an issue of great relevance for its readers, a response typical of the PCF's cautious reception of surrealism.

By contrast, the right-wing press avidly engaged with the controversy. *L'Action française* published a press release issued by the Ligue des Patriots under the title "La censure d'un film bolcheviste":

> For several days a cinema . . . has projected a Bolshevik film that attacks religion, the fatherland and the family.
>
> Wednesday evening, the majority of the crowd, which included several members of the Ligue des Patriots, protested loudly against these insults, resulting in a violent brawl.
>
> Several spectators were arrested. Remarkably, almost all the people held at the police station were detained after they had come to lodge complaints against the film's immorality; they were not released until five o'clock in the morning.
>
> Several municipal councillors, notably M. de Fontenay, have protested against this odious film: the members of the Ligue des Patriots intervened only to prevent a scandal.[78]

Le Figaro also took up the scandal. On December 7 the film critic Richard Pierre-Bodin addressed an open letter to the president of the Censorship Board, Paul Ginisty. He attacked the film for publicly showing "the most obscene, the most repugnant and the most impoverished episodes": "Country, Family, Religion are dragged through the sewer: a monstrance is placed in a gutter, rubbed by the legs of a scantly-dressed woman. Christ is presented, accompanied by a pasodoble, as 'the principal organizer of the most bestial orgies, with eight marvelous girls, eight splendid adolescent boys, etc.'" Pierre-Bodin asked how such a film could receive the censor's visa, and he called on Ginisty to revoke its classification.

The pressure on the government to intervene increased over the next few days. M. Le Provost de Launay, a Paris municipal councillor, issued a public statement on December 10 demanding that the Paris *préfet de police*, Jean Chiappe, suppress the film. This campaign soon bore fruit: the Censorship Board arranged a special viewing of the film to reconsider its classification, and Chiappe banned the film on the grounds that it disrupted public order.

It is evident that for the conservative, right-wing press *L'Age d'Or* was a political issue. It recognized the way that the film opposed the ruling ideology by attacking the social institutions considered fundamental to an ordered society. It was thus able to mobilize the repressive mechanism of the state to suppress the film and limit its audience. By contrast, the radical, left-wing press did not rise to the film's defense, thereby preventing the scandal from assuming a pronounced political character. The PCF failed to perceive the potential of the scandal to advance its own interests: by isolating it as a concern of the bourgeoisie, it failed to capitalize on the way the film exposed the vulnerable underbelly of bourgeois society. Consequently, the film was unable to mobilize an oppositional audience who could read its imagery as a critique of bourgeois society, nor could it promote identification between a proletarian audience and the film.

The surrealists responded to the film's suppression by issuing "L'Affaire de 'L'Age d'Or'" in January 1931.[79] This tract contained an account of the events of December 3, the subsequent press coverage and official response, and a series of excerpts from the program, then posed several questions regarding the suppression of the film. It also included excerpts from the press commentary, and two pages of illustrations (figures 3.5 and 3.6). One page recorded the damage caused by the protest: the ink stain on the cinema screen, destroyed paintings and furnishing in the cinema foyer, and a before-and-after image of Dalí's *Lion, Horse, Invisible Woman*. The other page showed film stills from *L'Age d'Or*: a group of archbishops on the rocks, and an image of a

FIGURES 3.5–3.6 Tract issued by the surrealist group in January 1931 to protest the suppression of the film *L'Age d'Or*. Digital images courtesy Charles Deering McCormick Library of Special Collections, Northwestern University Library.

man and woman, which provoked protest from the Italian ambassador, who recognized the king and queen of Italy in the scene, with the comment "The Italian King and Queen, who massacre the revolutionary workers." This tract was an effort to mobilize a political response to the suppression of the film, claiming it was evidence of the incursion of fascist tactics in France, and suggested the collusion of the extreme-Right groups with factions of the government.

Unfortunately, "L'Affaire de 'L'Age d'Or'" did not generate much response, and the controversy over the film rapidly declined once it was banned. Buñuel attempted to issue a re-edited version of the film under another title, but was not able to negotiate the censorship process, and the ban against the public screening of *L'Age d'Or* remained in force until 1981.[80] All in all, the *L'Age d'Or* scandal demonstrated the impasse reached in surrealism. While it could provoke a response from the bourgeoisie, this did not in itself constitute evidence of its commitment to a Marxist political position. The political character of

surrealism as an aesthetic revolution was located precisely in its repeated efforts to escape the orbit of culture and enter politics, without ever attaining sufficient momentum to escape the gravitational pull of culture. This lack of momentum accounts for the provisional character of surrealism's politics and its inability to enact a full-fledged aesthetic revolution. For the surrealist revolution to assume a real social dimension would require the emergence of a contemporary revolutionary current in French society. In the absence of the latter the political character of surrealism would remain implicit, the subject of speculation and disappointment.

Conclusion

In 1952 Breton responded to André Parinaud's observation that "the difficulties involved in trying simultaneously to pursue internal (surrealist) activities and external (political) ones" did not "end up paralyzing your means of expression" by noting: "No—perhaps just the opposite. The period that ran from 1926 to 1929 saw a flowering of Surrealist works that is often considered to be the most dazzling." Breton then lists publications by Aragon, Artaud, Éluard, Ernst, Péret, René Crevel, Robert Desnos, and himself, and adds, "It was also one of the most outstanding periods visually, being one of extraordinary inventiveness for [Jean] Arp, Ernst, Masson, Miró, Man Ray and Tanguy."[81] Clearly, the vicissitudes of surrealism's political position did not impede the creativity of the artists and writers associated with the movement. On the contrary, its political position appeared to act as a spur to a series of "dazzling" works that have now secured surrealism's reputation as a significant avant-garde cultural movement. Although surrealism's success as a cultural movement has eclipsed its importance as an aesthetic revolution, the latter was not negligible. That the moment of aesthetic revolution in surrealism was provisional simply illustrates the movement's ambivalent position in the social space, suspended in the unstable region between culture and politics; equally, the tension between creative endeavor and political action animates surrealism's image-space. Whereas the avant-garde typically respects the contours of the political field, preserving a minimal distance between art and politics, the surrealists attempted to use the image to collapse the distance between these two modes of social practice.

The legacy of surrealism's attempt to effect an aesthetic revolution would pass to the Situationist International, which recognized both the achievements and shortcoming of the surrealist enterprise. Although Guy Debord noted "the sovereignty of desire and surprise" in surrealism "is much richer

in constructive possibilities than is generally thought," he was critical of the way that surrealism had been co-opted by the art market so that its political convictions had been "moderated by commercial considerations."[82] He would rightly identify the inadequate understanding of the image-space—now renamed spectacle—for the shortcoming of the surrealist revolution.[83] The Situationist International would now define its own project as a reaction against surrealism, and sought to enact the Situationist aesthetic revolution beyond the confines of the artworld in the fabric of everyday life.

NOTES

For Don LaCoss (1964–2011), friend and collaborator. "Existence is elsewhere." Research for this chapter funded by an FHSS Research Grant.

1. Breton, "What Is Surrealism," in *What Is Surrealism?*, 127.

2. This analysis draws on the work of Bourdieu, *Field of Cultural Production*.

3. Benjamin, "Surrealism," 2:207–21. Edmund Jephcott is listed as translator.

4. Benjamin, "Surrealism," 215–16. Benjamin reiterates the alternative posed by Pierre Naville in *La Révolution et les intellectuels*, discussed below.

5. Benjamin, "Surrealism," 217.

6. The image plays a central role in the development of Benjamin's writings during the 1930s. The image-space of the surrealism essay is eclipsed by his notion of the "dialectical image" in the mid-1930s, which in turn is eclipsed by the "Messianic cessation of happening" in the "Theses on the Philosophy of History." For a discussion of this aspect of Benjamin's writings, see Weigel, *Body- and Image-Space*.

7. On the SI, see Ford, *The Situationist International*.

8. Guy Debord, "Report on the Construction of Situations and on the Terms of Organization and Action of the International Situationist Tendency," in McDonough, *Guy Debord and the Situationist International*, 32–34; Debord, *The Society of the Spectacle*, 136.

9. Breton, *Manifestoes of Surrealism*, 26.

10. "Réunion de 23 janvier 1925 au bar Certà," in Thévenin, *Bureau de recherches surréalistes*, 111.

11. Collective, "Déclaration du 27 janvier 1925," in Pierre, *Tracts surréalistes*, 34–35.

12. "Déclaration du 27 janvier 1925," 35.

13. Naville, "Beaux-Arts"; trans., "Beaux-Arts," in Matheson, *The Sources of Surrealism*, 328.

14. Naville, "Beaux-Arts," 328.

15. Apart from the ideological stance of surrealism, Breton had a pecuniary interest in art; since the war he had accumulated a substantial collection of increasingly valuable artworks (which he would sell when required) and from December 1920 until December 1924 was employed as an artistic adviser by the couturier Jacques Doucet. Breton acquired *Les Demoiselles d'Avignon* from Picasso on Doucet's behalf. On Breton's relation to Doucet, see Chapon, "'Une série de malentendus acceptables . . . ,'"

116–20. In 1929 Desnos would accuse Breton of hypocrisy precisely in relation to his activities as an art dealer; see "Troisième manifeste du surréalisme," 472–73.

16. The committee consisted of Aragon, Artaud, Masson, Max Morise, and Naville; Breton, although not an active member, was invited to attend. The resolution was signed by Artaud, Jacques-André Boiffard, Leiris, Masson, and Naville. Thévenin, *Bureau de recherches surréalistes*, 99–101, 128.

17. Naville soon ceased his active participation in the movement. He converted to Marxism during his military service and played an active role in the discussions regarding surrealism's orientation toward communism during 1926.

18. Breton, "Pourquoi je prends la direction de la Révolution surréaliste," 1–3.

19. Breton, "Pourquoi je prends la direction de la Révolution surréaliste," 2.

20. The *Mercure de France* organized this banquet to honor the aging symbolist poet Saint-Pol-Roux on the evening of July 2, 1925, at the Closerie des Lilas in Montparnasse.

21. The surrealists had published their "Hommage à Saint-Pol-Roux" in May 1925. See Pierre, *Tracts surréalistes*, 41–49.

22. Breton, *Conversations*, 89.

23. "Les travailleurs intellectuels aux côté du prolétariat contre la guerre du Maroc," *L'Humanité*, July 2, 1925. The declaration was signed by fifty-seven individuals associated with the reviews *Clarté, Philosophies, L'Humanité,* and *La Révolution surréaliste.* Pierre, *Tracts surréalistes*, 51–53.

24. "Lettre ouverte à M. Paul Claudel, Ambassadeur de France au Japon," in Pierre, *Tracts surréalistes*, 49–50; trans., "Open Letter to M. Paul Claudel," in Matheson, *The Sources of Surrealism*, 348–49.

25. "Open Letter to M. Paul Claudel," 348.

26. "Open Letter to M. Paul Claudel," 348.

27. "Open Letter to M. Paul Claudel," 349.

28. This account is based on a number of sources: Nadeau, *History of Surrealism*, 122–25; Breton, *Conversations*, 87–89; "Déclaration des surréalistes à propos du banquet Saint-Pol-Roux," Pierre, *Tracts surréalistes*, 53–54, 396–97. Pierre Drieu la Rochelle attributed the comment "Vive Lénine!" to one of the surrealists in "La véritable erreur des surréalistes," *Nouvelle Revue française*, no. 143 (August 1925): 166–71.

29. See Pierre, *Tracts surréalistes*, 51–64. The campaign continued into November.

30. Breton, *Conversations*, 88–89. For a detailed analysis of the press reaction to the Saint-Pol-Roux banquet, see Elyette Guiol-Benassaya, *La Presse face au Surréalisme de 1925 à 1938.*

31. Breton, *Conversations*, 89.

32. Georges Malkine and Pierre Roy participated less in the movement during the second half of 1925, while Miró distanced himself from the political position of the movement.

33. The photograph included *Littérature, Dada, Proverbe, La Vie moderne,* and the current issue of *La Révolution surréaliste,* along with a number of surrealist tracts, including the "Lettre ouverte à M. Paul Claudel," "Un Cadavre," "Déclaration du 27 janvier 1925," and "La Révolution d'abord et toujours!"

34. Masson expressed his satisfaction with the issue in a letter to Breton, describing the cover as a "good omen." Masson to Breton, October 21, 1925, *Correspondance*, 107.

35. Breton, *Surrealism and Painting*, 7–9.

36. Breton, *Surrealism and Painting*, 8. Translation modified.

37. This recalled Breton's argument in the *Manifesto of Surrealism*, which linked the epistemological and ethical significance of automatism. Breton, *Manifestoes of Surrealism*, 26; Chénieux-Gendron, *Surrealism*, 116.

38. There are distinct parallels with Benjamin's late writings, particularly "On the Concept of History," in *Selected Writings*, 4:389–400.

39. Ernst and Miró collaborated on the stage sets; Miró produced the costumes, and Ernst the curtain. See Schouvaloff, *The Art of Ballets Russes*, 194–99, 262–65. Ernst's studies for the sets are reproduced in Ernst, *Œuvre-Katalog*, vol. 2, figs. 994–1000.

40. "Protestation," in Pierre, *Tracts surréalistes*, 64.

41. "Protestation," 64. I thank John Finlay for his help in translating this passage.

42. *L'Humanité*, May 19, 1926, 1, cited in Pierre, *Tracts surréalistes*, 407.

43. *La Révolution surréaliste*, no. 7 (June 15, 1926): 31.

44. The December 1926 issue of *La Révolution surréaliste* included reproductions of two works by Ernst and one by Miró. Éluard also published a note defending Ernst beneath the reproduction of *La Belle Saison*.

45. In November 1926 Aragon claimed that "Protestation" was not a collective initiative, but an initiative he and Breton undertook as individuals. Bonnet, *Adhérer au Parti communiste?*, 73.

46. Breton leveled this criticism in *Légitime défense*. See below.

47. For a detailed discussion of the issues involved in the Naville-Breton polemic, see Alan Rose, *Surrealism and Communism*, 209–65.

48. Naville, *La Révolution et les intellectuels*, 65.

49. Naville, *La Révolution et les intellectuels*, 67–68.

50. Naville, *La Révolution et les intellectuels*, 68.

51. Naville, "Beaux-Arts," 328–29.

52. Naville, *La Révolution et les intellectuels*, 69.

53. Naville, *La Révolution et les intellectuels*, 76–77; trans. Nadeau, *The History of Surrealism*, 128.

54. Breton, "In Self-Defense," in *Break of Day*, 34.

55. See Benjamin: "[The surrealists] are the first to liquidate the sclerotic liberal-moral-humanistic ideal of freedom. . . . But are they successful in welding this experience of freedom to the other revolutionary experience that we have to acknowledge because it has been ours, the constructive, dictatorial side of revolution? In short, have they bound revolt to revolution?" "Surrealism," 236.

56. On this point, see my "Surrealism and the Political Physiognomy of the Marvellous," in Spiteri and LaCoss, *Surrealism, Politics and Culture*, 52–72, esp. 59–62.

57. On the role of distortion and framing in surrealist photography, see Krauss, "The Photographic Conditions of Surrealism," 87–118; on the documentary character of the photographs in *Nadja*, see Walker, *City Gorged with Dreams*, 48–67.

58. Breton, *Nadja*, 129–30.

59. The illustration appears in the third section of *Nadja*, which was written some months after the first two sections of the narrative, after Breton had met Suzanne Muzard in October 1927.

60. Breton, *Nadja*, 152–54. Translation modified.

61. Note the repeated use of subordinate clauses in the passage.

62. "Paris ouvrier maître du pavé!" *L'Humanité*, August 24, 1927, 1.

63. The Sacco-Vanzetti riots coincided with the appointment of Jean Chiappe as the *préfet de police* of Paris and prompted him to suppress the PCF. This atmosphere of police repression effectively transformed the PCF into an illegal organization, with little time to accommodate avant-garde intellectuals like the surrealists. On Chiappe, see Zimmer, *Un Septennant policier*, 24–33.

64. On the progress of Breton's writing of *Nadja*, see Polizzotti, *Revolution of the Mind*, 281–91.

65. This strategy goes to the heart of the constitutive role of silence, interval, and failure in the construction of *Nadja*, in which silence acts as an unsurpassable limit against which the narrative unfolds. See Stone-Richards, "Encirclements." Maurice Blanchot has a fascinating discussion of the encounter in "Tomorrow at Stake," 407–21.

66. This is not to say that surrealist productions were necessarily nonpolitical, only that their political content resided in the way the formal construction of surrealist works occasionally refracted the latent political anxieties in French society.

67. Buñuel had described the audience of *Un Chien andalou* as "this imbecilic crowd that has found *beautiful* or *poetic* that which, at heart, is nothing other than a desperate, impassioned call for murder." Buñuel, "Un Chien andalou," in *An Unspeakable Betrayal*, 162.

68. Charles de Noaille commissioned the film as a birthday gift for his wife, Marie-Laure. He also commissioned *Le Sang d'un poète* by Jean Cocteau.

69. A private screening of the film was held on June 30, 1930, followed by a public screening for an invited audience in October.

70. The program misleadingly presented *Paris-Bestiaux* as "Un film comique," and *Au Village* as "Un dessin animé sonore."

71. "L'Age d'Or," in Pierre, *Tracts surréalistes*, 155–84. English trans., "Manifesto of the Surrealists Concerning L'Age d'Or," in Hammond, *The Shadow and Its Shadow*, 195–203. A facsimile of the original program appeared as a supplement to special issue of *Les Cahiers du musée national d'art moderne*, "L'Age d'Or: Correspondence Luis Buñuel-Charles de Noaille, lettres et documents (1929–1976)."

72. "Manifesto of the Surrealists Concerning *L'Age d'Or*," 195.

73. "Manifesto of the Surrealists Concerning *L'Age d'Or*," 199–200.

74. "Manifesto of the Surrealists Concerning *L'Age d'Or*," 199.

75. "Petites nouvelles de la nuit," *L'Action française*, December 4, 1930, 2. The incident was also reported as "Une Violente manifestation dans une cinéma" in *Le Figaro*, December 4, 1930, 3.

76. "Les 'camelots' chahutent le spectacle du Studio 28," *L'Humanité*, December 4, 1930, 2.

77. Léon Moussinac, "Notre point de vue: 'L'Age d'or,'" *L'Humanité*, December 7, 1930, 4.

78. "La censure d'un film bolcheviste," *L'Action française*, December 5, 1930, 2. A different version of this letter appeared in *Figaro*, December 6, 1930, 2. Maurice de Fontenay (1872–1957) was the municipal councillor for the 16th arrondissement in Paris.

79. Pierre, *Tracts surréalistes*, 188–93.

80. It was possible to screen the film before invited audiences, such as cinema clubs and organizations.

81. Breton, *Conversations*, 105.

82. Debord, "Report on the Construction of Situations," 33.

83. Debord, *The Society of the Spectacle*, 136.

4

Aesthetic Avant-Gardes and Revolutionary Movements from Modern Latin America

DAVID CRAVEN

An overarching thesis of my chapter is that in both Mexico to a certain degree (from the 1910s into the 1940s) and in Nicaragua to a far more comprehensive extent beginning in the late 1970s and extending up to 1990, aesthetic avant-gardes were central to the revolutionary process in each of these respective Latin American nations.

During the earliest part of the Mexican Revolution, which began in 1910 while he was in Paris, Diego Rivera became one of the key creators of cubism, and he produced more than three hundred major paintings in this visual language between 1913 and 1917. Viewed with respect to Poggioli's thesis (and subsequent ones by Adolfo Sánchez Vázquez), these works by Rivera qualify

as a manifestation of the aesthetic avant-garde that was emerging in the 1910s and would become crucial to revolutionary cultural policy during 1920s Mexico. Spanish painter Juan Gris (a friend of Rivera in Paris) said of cubism that it was not simply a new style of painting, but rather "a state of mind" connected with "every manifestation of contemporary thought."[1] Similarly, Rivera himself would declare that cubism was a "revolutionary movement, questioning everything that had previously been said and done in art."[2] He then continued: "As the old world would soon blow itself apart, never to be the same again, so cubism broke down forms as they had been seen for centuries, and was creating out of the fragments new forms, new objects, new patterns and—ultimately—new worlds."[3]

Far from being restricted to a reductive exercise in medium purification—the view of normative formalism promoted by Clement Greenberg—cubism was instead an example of *non*-normative formalism. The inception of cubism as a key, perhaps as *the* key, pictorial framework for inaugurating a whole new sensibility was noteworthy for two divergent reasons. As a radically different visual discourse, cubism both *internally* expanded the communicative resources of the medium of painting through the invention of collage and *externally* entailed a contraction of extra-aesthetic claims for European academic art, thus introducing a new non-Eurocentric sensibility open to interchange with popular culture from outside the West, especially among colonies, leading up to the First World War. One painting as important for Mexico as Picasso's *Demoiselles d'Avignon* in 1907 was for Europe was Rivera's landmark *Zapatista Landscape: The Guerrilla* (1915). The latter painting—perhaps the first great avant-garde art from within the Mexican Revolution of 1910—both evoked and contested the conventions of "high art" in the West for constructing one-point perspective, along with the Western cultural assumptions behind this system.[4]

Rivera did so in this painting in several ways: (1) through an abbreviated use of chiaroscuro, (2) through a coy or inconsistent deployment of overlapping, (3) through the suggestion then cancellation of figurative references (as in the camouflaged figure of the guerrilla leader Zapata), and (4) through a deft attack on hierarchical relationships both pictorial and social, whether Western or non-Western. In linking fragments of Mexican culture to those of French culture while connecting elements of European mass culture to Latin American popular culture, Rivera gave us a demotic look at world power from the middle of the Mexican Revolution of 1910—which was at once radically anticolonial and anti-imperialist. In short, this painting was as sweeping in its attack on the traditional distribution of the sensible among the Mexican

popular classes as Zapata's popular-based assault on the inequitable distribution of land in pre-Revolutionary Mexico. Nor is it by chance that Rivera would ultimately depict the campesino (or peasant) leader Zapata more than forty times in public images, whether semifiguratively or figuratively.[5]

By underscoring how the aesthetic avant-garde of revolutionary Mexico, composed of various anticolonial and/or postcolonial modernisms, often provided the visual languages through which a new sensibility and matching ideological values were articulated, we can understand the declaration of two British scholars: "In the 1930s, for many radical artists and intellectuals throughout the world, it was Mexico and not Paris that stood for innovation in the arts. Artists in Mexico were seen to have challenged the authority of a Eurocentric aesthetic [linked to Western European and U.S. imperialism] and asserted the values of self-consciously post-colonial culture.... Diego Rivera was the most prolific and initially the most internationally acclaimed of the muralists, acting as a link between the avant-garde aesthetics of Europe and the growing Mexican debate as to the nature of revolutionary art."[6]

"Three Appeals for a Modern Direction"

In 1921 there was an avant-garde manifesto from Mexico—inspired by the artwork of Diego Rivera and that of the Russian constructivists—that galvanized the aesthetic avant-gardes that would soon emerge in Mexico with the celebrated mural movement and all other complementary developments. Entitled "Three Appeals for a Modern Direction: To the New Generation of American Painters and Sculptors," this manifesto was written by the younger muralist David Alfaro Siqueiros with reference to avant-garde movements elsewhere, including Russian constructivism, cubism, and futurism:

We extend a rational welcome to every source of spiritual renewal born of Paul Cézanne ... the purifying reductionism of Cubism in its diverse ramifications; the new emotive forces of Futurism . . . the absolutely new appraisal of "classic voices" [Dada is still developing]. . . . Let us live fully our marvelous dynamic age! Let us love the machine that provokes unexpected plastic emotions, the contemporary aspects of daily lives, the life of our cities under construction, the sober practical engineering of our modern buildings. . . . Let us dress our human invulnerability in modern clothing: new subjects, new aspects. . . . Let us, the painters, impose the constructive spirit on the merely decorative. . . . The basis of the work of art is the magnificent geometrical structure of

form. . . . Whether ours be dynamic or static, let us first and foremost be constructive.[7]

In concluding with the statement "Let us abandon literary motifs. Let us devote ourselves to *pure art*!," Siqueiros also ignored official nationalism as the wrong road for a progressive art aiming at building a postcolonial culture. Like Diego Rivera, he reminds us of the distinction between an art of national self-definition (or one based on popular nationalism) and one of mainstream nationalism (or, better, "official nationalism"), by using the compelling difference later elaborated by Benedict Anderson in his book on the advent of various types of nationalisms.[8]

The distinction maintained by Siqueiros and Rivera is of crucial significance for grasping why the aesthetic avant-garde in every case, save two—Italian futurism and English vorticism (both of which were driven by a backward-looking "official nationalism" *after* 1919)—conceived of their revolutionary movement as the undying adversary of both Western and U.S. imperialism (whether this meant the Italian government's invasion of Ethiopia or the British occupation of most other colonies elsewhere). Moreover, this ideological attribute helps to explain the incisiveness of the recent work on *cosmopolitan modernisms* by Partha Mitter, Kobena Mercer, Geeta Kapur, and Rasheed Araeen, among many others, concerning why aesthetic avant-gardes—almost necessarily internationalist by definition—drew on the visual languages of *cosmopolitan modernisms* to articulate their militant postcolonial positions. Such a novel chapter would be one where national cultures would not exist in any hierarchical order, or within the orbit of the U.S. imperium. Nor would former colonies remain inferior to the Western nations that previously dictated to them aesthetically, as well as economically and politically—so far from heaven and so bordered by the United States.

What of the artworks in the Mexican Revolution after 1920 that most embodied this new aesthetic avant-garde, even if it existed only as an afterlife in the late 1940s? A test case involves one of the most commanding public spaces in the entire world after 1930, namely, the huge atrium of the Palacio de Bellas Artes (Palace of Fine Arts) in Mexico City. Even now this is perhaps the main cultural matrix of the public sphere in Mexico, with its famed murals of the aesthetic avant-garde by the Mexican Mural Movement of *los tres grandes* (the three great ones)—Diego Rivera in 1934, José Clemente Orozco in 1934, and David Alfaro Siqueiros in 1945 (figures 4.1, 4.2, and 4.3).

In writing how for a revolutionary artwork the key issue was *buen artesano* (good labor or artisanship) and also that for "una expresión revolucionaria no

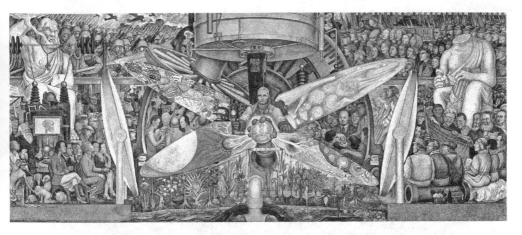

FIGURE 4.1 Diego Rivera, *Man, Controller of the Universe*, 1934. Fresco. Palace of Fine Arts, Mexico City. Photo by David Craven. © 2014 Banco de México Diego Rivera Frida Kahlo Museums Trust, Mexico, DF / Artists Rights Society (ARS), New York Reproduction approved by the Instituto Nacional de Bella Artes y Literatura, 2014.

importa el tema" (for a revolutionary expression the message is not important), Rivera made clear that the two issues of paramount importance were (1) the nurturing of a new multiclass sensibility based on the convergence of competing visual languages linked to different classes and (2) the integrity of the artistic labor that articulated them, as the traditional modes of artistic production were changing.[9] In a society divided by stark class differences within which artistic labor was often perfunctory because of incipient capitalist alienation, this injunction by Rivera was provocative. In short: it was an *avant-garde movement in the most radical sense aesthetically, whose goal was nothing less than a new cross-cultural sensorium within the public sphere.* This point is often lost on those who mistakenly see the murals as didactic rather than dialogical—within an "epic modernism" in which historical narrative plays neither an antimodernist nor an anti-avant-garde role. Let us examine the new aesthetic in these murals by beginning with the above-noted Rivera fresco of 1934. The earliest in the Palacio, it was done during one of the most dynamic phases of the Mexican Revolution—the presidency of Lázaro Cárdenas (1934–40), which featured at least three gains of historic importance: (1) the largest land reform in the history of the Americas, (2) the expropriation of the oil refineries from U.S. capital (including that of Standard Oil, owned by the Rockefellers), and (3) the institution of a secular form of "socialist education" nationally that presupposed a separation of church and state previously unknown to Latin America.[10]

FIGURE 4.2 David Alfaro Siqueiros, *Birth of the New Democracy*, 1945. Mixed media. Palace of Fine Arts, Mexico City. Photo by David Craven. © 2014 Artists Rights Society (ARS), New York / SOMAAP, Mexico City. Reproduction approved by the Instituto Nacional de Bella Artes y Literatura, 2014.

FIGURE 4.3 Diego Rivera, *Zapata*, 1930. Fresco. Palace of Cortéz, Cuernavaca. Photo by David Craven. © 2014 Banco de México Diego Rivera Frida Kahlo Museums Trust, Mexico, DF / Artists Rights Society (ARS), New York. Reproduction approved by the Instituto Nacional de Bella Artes y Literatura, 2014.

Two Murals by Rivera

Man, Controller of the Universe (figure 4.1), the mural by Rivera, was a second version of the notorious wall painting earlier commissioned by the Rockefeller Business Consortium for the Rockefeller Center and then destroyed (it was literally jackhammered off the wall in 1934), owing to Rivera's insistence on painting a portrait of Lenin among the mobilizing crowds. The incident remains one of the most famous cases of censorship in U.S. history. Indeed, the very liberal contract subsequently given to Rivera by the Mexican government was evidently the result of popular militancy in the streets that began during the last year of the Calles Maximato in 1934, while the candidacy of Cárdenas and the mass movement propelling him had begun to accelerate the pace of structural change in Mexico. This work shows how Rivera's mural intersected with the epic theater of Bertolt Brecht, an author he possibly met when he was in Germany in 1927. With its open-ended title, *Man, Controller of the Universe*, the fresco begins with a pictorial question in medias res, as does any epic artwork. What is the epic question of time posed regarding history's overall trajectory, along with its new temporal process? Rivera's question in 1934 about the future was nothing less than this: will fascism succeed in dominating humanity, or will humanity emancipate itself from this immanent threat?

By centering the mural with a postheroic and anonymous worker from Eastern Europe (a Slavic worker from Russia or Central Europe)—*not* a specifically Mexican worker (which one would expect were the mural about "official nationalism" in Mexico)—Rivera depicts a crucial challenge of epic proportions. Moreover, the unusually prominent place of women workers, athletes, and intellectuals in the fresco represented an unprecedented embrace, in Mexico, of "socialist feminism" and a concomitant rejection of the rabid antifeminist forces of fascism. There is also a connection to the Russian position on feminism shortly after the Soviet Union's ambassador to Mexico had been Alexandra Kollontai, a Bolshevik leader and at that time the only woman in the world in such a high diplomatic post. Rivera's 1934 fresco thus posited a degree of parity ideologically between men and women (whatever the artist's own personal tendencies to sexism or machismo), which involved an avantgarde "redistribution" of the sensible in the transformed public sphere.

Like few other public artworks of the period, Rivera's epic depiction represented a key shift in gender relations, however halting and contradictory the movement forward within a society often notorious for machismo. Elena Poniatowska's *Soldaderas* attested to this change, which has been summarized deftly as follows:

There was a real awakening in the period that . . . provided women of the twenties and thirties with space for sexual redefinition, as is evident in several strands of artistic production of the period. If "woman" stood for authenticity and for the land in Diego Rivera's Chapingo murals, she subtly became the subject of sexual desire in María Izquierdo's canvases. If femininity was conventionally figured with tropes of fertility and reproduction, Frida Kahlo's earth mother wore a mask. Along side these expressions of female subjectivity in the arts . . . a feminine public was shaped through radio.[11]

Rivera's mural posits an epic question about shifting gender relations linked to class struggle, rather than giving us an essentializing "destiny" of Mexican men or women and their nation state per se. To view the mural is also to be confronted visually with a cosmopolitan neo-cubist composition overdetermined by the complex forces of Russian constructivist cinema, in which the course of history remained undecided. As such, the fresco demanded active spectator interventions from the popular classes to "complete the picture" at a defining moment in world history. This was literally a moment in 1934 when the outcome of the contest between fascist domination and humanity's liberation hung precariously in the balance. Humanity's answer would not be registered definitively for another decade, in 1944–45. To quote the great Mexican art historian Justino Fernández, this fresco (which uses a polyvalent visual language at odds with "socialist realism" in the Soviet Union) is the "most symptomatic of Rivera's distinctive way of thinking."[12]

A compelling mural, this fresco shares a direct lineage formally with the Anáhuac cubism of Rivera's *Zapatista Landscape: The Guerrilla* from 1915. No longer camouflaged as in earlier paintings, the popular forces and avant-garde leaders in this mural are spliced together indeterminately through compositional stratification, as in Soviet cinema during the 1920s: Dziga Vertov's *Man with a Movie Camera* (1929), on the one hand, or Sergei Eisenstein's *Strike* (1924), as well as his subsequent films such as *Potemkin* (1925) or *October* (1928), on the other. Nor is it irrelevant here that Eisenstein knew and admired Diego Rivera, whose murals he praised in an unpublished article. In 1932 Eisenstein went to Mexico to make a film about the Mexican Revolution, an epic entitled *Que Viva Mexico!* (*Long Live Mexico!*) that he intended to dedicate to Rivera. (The film was never finished, though the footage was assembled in 1933 by Sol Lesser and released in the United States as *Thunder over Mexico* by Eisenstein.) When Eisenstein returned to the Soviet Union in the mid-1930s, however, he was accused of "formalism," that is, of paying too

much attention to formal issues or perceptual concerns in art and not enough to art's "message."

Now, of course, Diego Rivera is falsely accused of "socialist realism," or worse, by almost every U.S. author and a small number of Mexican scholars who currently write about him; this happens even though Rivera's avant-garde mural is in fact an unlikely (and at times unstable) synthesis of various aesthetic languages—including the "formalist tendencies" of Soviet cinema—analogous to Brecht's non-Aristotelian epic theater. Just as Eisenstein defined the fragmenting principle of montage in cinema as one involving the collision of forces or images, so the Rivera mural is based largely on historic counterforces compositionally spliced together so that they collide at class-based flash points along ideological fault lines. To look at the upper zone of the Rivera mural is to see horizontal strata of mobilized women and men from the spectator's right surging to the left (and signifying the left politically), on an immanent collision course with an exclusively male fascist movement surging toward the right from the other part of the picture plane. Significantly, there is no preordained victor indicated in this mural, however sweeping the struggle. Surely one of the most magisterial murals of Rivera's oeuvre, this fresco metaphorically locates humanity at the crossroads of history within a dense network of converging forces whose resolution was as yet undecided in 1934.

The concrete choices demanded of the "emancipated spectator" or dialogical respondent at this historical juncture in the 1930s by Rivera were loaded with implications in the most expansive sense: would modern science and Western technology be used for progressive reasons, that is, for social advances or regressions? In fact, the nondidactic mural by Rivera is more about the necessity of critical thinking than about historical necessity, thus calling for epic thought without leading to dogmatic responses or doctrinaire answers. And whatever the public's rejoinder in 1934, humanity would be making epic choices about its future. Nor is it surprising that the exiled Bolshevik leader Leon Trotsky would find Diego Rivera's dialogical avant-garde murals vastly superior to the entirely message-driven style of Soviet "socialist realism." To quote Trotsky: "In the field of painting, the October Revolution has found its greatest interpreter not in the USSR, but in faraway Mexico. . . . Do you wish to see with your own eyes, the hidden springs of the social revolution? Look at the frescoes of Rivera. Do you wish to know what revolutionary art is like? Look at the frescoes of Rivera."[13]

But what of the pictorial logic and thematic thrust being showcased in this mural?

As I have argued elsewhere, the "epic modernism" of Diego Rivera has an elective affinity with the "epic theater" of Brecht, owing to the painter's particular combination of modernist collage techniques in uneasy alliance with a minority tendency to political didacticism in other murals, which was future-oriented. Indeed, almost all of the key attributes of Brecht's epic theater find a pictorial echo in Rivera's peculiar version of epic modernism, such as one sees in *Man, Controller of the Universe*—from its use of an open-ended or unresolved narrative (vs. a closed plot) and its goal of arousing the spectator's "capacity for action" (vs. encouraging audience passivity) to the presentation of a "picture of the world" in the making (vs. a world already made) along with presenting the "human subject" as still in construction or "man as a process" (vs. "man as a fixed point"). Similarly, Brecht emphasized montage as an authorial principle, while Rivera used collage here as an artistic principle. Likewise, Brecht, as did Rivera in his best murals, underscored the uneven nature of historical development, rather than any linear concept of development. Finally, both Brecht in "epic theater" and Rivera in "epic modernism" gave priority to art with a cerebral challenge over art that foregrounded an emotional appeal.[14]

Some of these observations about Rivera's epic modernism were in fact also registered in Eisenstein's two drafts for texts on Mexican murals. This includes one text in which he contrasted the "Apollonian art" of Diego Rivera with the "Dionysian art" of José Clemente Orozco—who was not a Marxist like Rivera but a nonaligned anarchist and antifascist. To quote the Russian filmmaker: "Perhaps it is both difficult *and* ridiculous, but this trivial antithesis of Apollo [Rivera] and Dionysus [Orozco] has nevertheless materialized in its own paradoxical way in the delirious murals of these two colorful figures."[15]

Intriguingly, Eisenstein found the best analogy with Rivera's compositional approach to murals to be the modernist novels of Irish author James Joyce. To quote Eisenstein:

> Walk another hour in the gallery of [the Ministry of] Education covered with the forms and the faces of Diego Rivera. And, suddenly, do they not seem in some way identical, similar to an uninterrupted current in the monologue—without commas, full stops, without color—in the last chapter of *Ulysses* [by James Joyce]. . . . At some moment they [Rivera's murals] seem to begin to glow in a splendid multi-colored river not destructive like lava, but highly colored like Nature . . . when vitality changes from one form to another and appears again in an infinite diversity of new forms and new creations. . . . To Mother Earth, to

the Mother of all things, I would compare Diego, who peoples his ark with an endless exodus of animals of human image, and human beings subjected to an animal exploitation. The womb [of Rivera's art] could be the symbol of the infinite creative capacity of this man.[16]

Orozco, the Prometheus of Mexican Painting

About the murals of the Dionysian Orozco, such as *Catharsis* (1934)—the awesome fresco facing Rivera's epic work in the Palacio of Fine Arts in Mexico City—Eisenstein was more disturbingly ambivalent. He was thrilled by the raw emotive power of works that, as Octavio Paz and others have noted, were linked to the most apocalyptic strains of German expressionism. Orozco's artworks also seem connected in a conservative vein (as Dawn Ades has observed) to the necessarily tragic discourses of so-called human nature and the doctrine of "original sin."[17] Indeed, Orozco's *Catharsis* is so unremittingly tragic in tone that the apocalyptic direction seems to be about some preordained destiny, whether biblical or otherwise—and in a manner that could easily cancel out all human agency or annul art's relative autonomy. Sweeping everything before it, including rational analysis, the sensory experience offered here by Orozco is more secular and emotionally unconstrained than anything from the baroque era, thus advancing a new type of sensory experience. This is the case even as the revolutionary sensorium conveyed by Orozco is also paradoxically tied at least in part to prerevolutionary conceptions of time and people at the same time. Another premodernist trait is the antifeminist element of unchecked violence against women—who are represented solely as prostitutes here—that anchors the carnage in the foreground of Orozco's powerful painting. Again, the issue is (as it was with Rivera) not how Orozco behaved toward women in his personal life, but whether or not his artwork showcases an ideological commitment to a new role for women in the avant-garde visual language used. In fact, the sheer negativity of his representation would seem to call out for an alternative view of women in the future as the horrors of the present are so exposed.

In his draft for the essay entitled "Orozco: The Prometheus of Mexican Painting," Eisenstein wrote the following notes. They articulate an admiration coupled with alarm at the innovative murals of Orozco, which Eisenstein felt were plagued by political agnosticism concerning revolutionary change, thus potentially delinking his aesthetic avant-garde images from the political avant-garde of the Mexican Revolution. Written in arresting fragments, not sentences, they read as follows:

Orozco's progress: Dartmouth. There it was the most terrible. Super-human passions. Social outcry. . . . Orozco, at least, is not going to compromise. He does not go down to the Stock Exchange in San Francisco like his Apollonian colleague [Diego Rivera]. . . . But I feel apprehension about these surroundings. In the well meaning libraries [of Dartmouth College], . . . Orozco's street cries seem to echo from behind the lenses of his glasses. . . . Here the surroundings are a barrier against the noise in the street where class struggles take place. The bookish spirit of sleeping consciences passes without questioning. . . . In this way Orozco is encased in glass, audiences contemplate and enjoy social horrors as a grand *guignol* (Punch and Judy Show). Horror is neutralized. Orozco's frescoes ought to wage war out there; . . . destroying the old world and directed towards the creating of New Worlds. . . .

The eyes that look at the works of Orozco push them on a level far above that of technique or style — the level that the painter himself transcends. They do for him what Diego does for himself. [He is] a painter outside an audience. Orozco ought to be with us.[18]

This searching assessment by Eisenstein makes several paradoxical points that we cannot avoid in concluding this section. First, he had a clear sense of the contradictory demands of patronage in the United States or Mexico on the avant-garde, and he was apprehensive about exclusive sites like the Stock Exchange in San Francisco or Dartmouth College, each of which stood imposingly against a broader "redistribution of the sensible" on behalf of social change. Second, Eisenstein also grasped the connection between the right-wing censorship and destruction of Rivera's mural in the Rockefeller Center in 1933–34, on the one hand, and, on the other, the Rockefellers' compensatory "liberal" commission shortly afterward of Orozco's mural at an isolated and ultraprivileged educational institution like Dartmouth. Third, the Russian filmmaker noted how a mural like Rivera's *Man, Controller of the Universe* was dialogical in character, while the messianic neo-expressionism of Orozco in his murals (like *Catharsis* or the declarative cycle at Dartmouth) were more monological in character, so as to preclude dialogical intervention by spectators. Fourth, Eisenstein also recognized that the new sensorium of experience for humanity provided by Orozco contradicted the painter's Old Testament "message" and instead linked his art with the transformative language, as well as the thematic open-endedness of the aesthetic avant-garde provided by the Marxist Rivera—Orozco's avowed disbelief in a classless future notwithstanding.

These reflections by Eisenstein bring us back to the broader popular forces sanctioned by the Mexican Revolution—from the intriguing recruitment of Berlin Dada collage by Frida Kahlo in one of her works of the early 1930s through the complicated way in which Tina Modotti used an internationalist photography to introduce a minimalist sensibility based on Rivera's *Zapatista Landscape*, to the highly innovative way in which David Alfaro Siqueiros translated the montages of John Heartfield into his 1939–40 mural for a union hall in Mexico City or recruited the reverberating forms of futurism for his postwar mural in the Palacio de Bellas Artes.

Moreover, despite Orozco's libertarian anti-Marxism, his antifascism somehow inadvertently acknowledged the immense promise of the historical moment embodied by the aesthetic avant-garde in Mexico from the 1910s through the 1930s. In summing up his own life in his autobiography, Orozco also gave us a glimpse into the deferred revolutionary process that he never fully endorsed but still supported aesthetically despite himself: "Naturally, the socialization of art was a project for the distant future, since it implied a radical change in the entire structure of society"—not just groundbreaking murals in the public sphere.[19]

Because of how cultural policy in Cuba (from 1959 to the present) was more tightly linked to a one-party state, so that there was no semiautonomous aesthetic avant-garde in the previously noted sense, we will now move on to look at the Nicaraguan Revolution of 1979, but not before quoting Nicaragua's future minister of culture following his time in Cuba during the early 1970s about the intriguing new cultural pluralism in Cuba. These developments included the rejection of Soviet-style "socialist realism" and a systemic ambivalence about didactic or populist art. As Ernesto Cardenal observed: "In Cuba, as contrasted with Russia [after 1930], there has been no attempt to create a simple art that is immediately understood by the people as they are. Rather, there has been an effort to educate the people so that they understand art in a new and more sophisticated way than they previously did."[20]

Nicaragua: The World Capital in the 1980s
of Dialogical Art and Public Muralism

As part of the broad set of historic cultural changes it triggered, the Sandinista Revolution of July 19, 1979, inaugurated a whole new set of avant-garde cultural policies plus one of the two most important mural movements in the twentieth century—second only to that of the Mexican Mural Renaissance. The revolution itself overthrew the Somoza family's dictatorship, which, with

U.S. government backing, had completely dominated this Central American nation from 1934 to 1979 following the U.S. military occupation of Nicaragua from 1926 to 1934. Perhaps not surprisingly, the Nicaraguan mural movement of the FSLN (Sandinista Front for National Liberation) was at once indebted to the Mexican precedent and also a notable departure from it. The overall significance of this Central American mural movement on behalf of "socialist pluralism," though, was linked less to individual artists in the movement than to the distinctive public locus and popular re-enfranchisement embodied by these innovative murals, as well as to how these images were key to a national process of popular self-empowerment in the visual arts through dialogical cultural policies influenced by Paolo Freire.[21] In that sense, the avant-garde mural movement in Nicaragua indirectly took up the challenge earlier voiced by José Clemente Orozco about how the Mexican mural movement had not always succeeded in its aim to socialize art, though this aim would remain a goal for the future in the Americas.[22]

The aesthetic avant-garde in Nicaragua included many important mural-ists from that country—notably Alejandro Canales, Leonel Cerrato, Róger Pérez de la Rocha, Antonio Reyes, Julie Aguirre, Manuel García, Hilda Vogel, Olga Maradiaga, and Leoncio Sáenz—but few of these painters ever achieved the extraordinary technical skill or imaginative sweep routinely accomplished by the major muralists from Mexico (Diego Rivera, José Clemente Orozco, David Alfaro Siqueiros, and Pablo O'Higgins), each of whom inspired diverse wall paintings for the Sandinista Revolution. Thus, even as the Nicaraguan mural movement became internationally renowned as part of an aesthetic avant-garde during the 1980s, none of the individual muralists ever became world famous in the same way as the most celebrated Mexican mural-ists from a half-century earlier. Conversely, though, the murals of Nicaragua were actually more visible to the popular classes, both rural campesinos and urban labor, within the country, than were the somewhat less physically accessible murals of the Mexican Mural Renaissance, which tended to be done inside major government buildings and educational complexes. (There are of course exceptions to this rule, such as Rivera's mural for the façade of the Theater of Insurgentes and Siqueiros's mural in relief on the façade of the administrative building for the UNAM, the National Autonomous University of Mexico.) In addition, the photographic circulation through the mass media of images of the Mexican murals—particularly via the photos of Tina Modotti—did permit greater popular access in the "age of mechanical reproduction," which perhaps at least partially approached the greater visibility of the public murals in Nicaragua.[23]

Another basic dissimilarity between the mural movements involved the divergent media employed for wall murals in Nicaragua versus those in Mexico. With very few exceptions, the Nicaraguan murals were done by means of acrylic paint especially made for the outdoors, not classic fresco or new synthetic pigments like piroxilina. This means that the major Nicaraguan murals, which were often done on the exterior walls of public buildings, were more ephemeral in character than those in Mexico for the interiors of buildings. The latter were painted in the more durable and technically exacting medium of fresco. Also longer-lasting were the few Mexican murals done in glass-based mosaic on the façades of public buildings, such as *El teatro en México* on Avenida Insurgentes (1953) by Diego Rivera or *El pueblo a la Universidad, la Universidad al pueblo* (1956) by David Alfaro Siqueiros.[24]

Its short-term survival notwithstanding, the Nicaraguan mural movement produced a staggering number of acrylic murals—around 270 in a little over a decade, with 125 of those being put up in or around the capital city of Managua, where one-third of the population was then living. This number compares favorably with the entire number of wall paintings done in all of Mexico, a far larger nation, from 1922 through the 1960s. Tragically, there was an epidemic of counterrevolutionary mural destruction in Nicaragua by the U.S.-backed conservative Arnoldo Alemán, who was mayor of Managua in the early 1990s. This censorship occurred during a period of conservative rule in the early 1990s even though these murals were legally registered as works of national and world cultural patrimony by the United Nations.[25] Such an ultra-right-wing assault on public muralism has of course never succeeded in Mexico, a country that has long protected its cultural patrimony during the postrevolutionary period.

Another similarity between the two movements involved the respective roles of international muralists in each case. Several muralists from other countries painted works of significance in Mexico between 1922 and 1940—such as Jean Charlot from France and the Greenwood sisters (Grace and Marion), who were from the United States, as was the outstanding painter Pablo O'Higgins. Similarly, there was probably an even larger number of accomplished murals in Nicaragua during the 1980s by international artists from other countries, such as those by Sergio Michilini from Italy, Victor Canifrú from Chile, Arnold Belkin from Mexico, and the Felicia Santizo Brigade from Panama, plus the Orlando Letelier Brigade by exiled Chileans in California, in addition to John Weber, Mike Alewitz, Miranda Bergman, and Marilyn Lindstrom from various other parts of the United States.[26]

Alejandro Canales and the Nicaraguan
Mural Movement, 1980–1990

It is significant that the word "modernism" (or *modernismo*) was actually first coined in Latin America during the 1880s by Nicaraguan poet Rubén Darío. He reemerged as a hero of the Sandinistas in the Nicaraguan Revolution of 1979, when the aesthetic avant-garde and the political avant-garde were brought together again in a commanding way. In using the term "modernism," Dario referred to a new discourse for avant-garde movements that implied several innovative traits:

1 A multicultural intertwinement of languages in the arts from different classes.
2 A multilateral sense of historical engagement in the arts featuring both "old things and new things" interwoven.
3 A newly hybrid sense of cultural identity at odds with conventional European views on the subject. (Only much later was modernism defined in normative formalist terms by Greenberg or in postmodernist terms by Rosalind Krauss "as a meta-language.")[27]
4 An anticolonial force of renewal at odds with the classicism of Western colonial art.
5 A new dialogical interplay of the fine arts intertwining modern mass culture and with traditional popular or vernacular culture.[28]

This theoretical precedent of Darío in the 1880s proved invaluable for the aesthetic avant-gardes linked to the Sandinista Revolution in the 1980s. Among the most formally innovative, visually compelling, and physically prominent murals were three major wall paintings done in the early 1980s for building façades in downtown Managua by Nicaragua's leading muralist, Alejandro Canales (1945–90). The earliest one, *Homenaje a la mujer* (*Homage to Women*), measured three by thirty-eight meters and was located in Velásquez Park (figure 4.4). It was executed in 1980 to salute thematically the spectacularly successful literacy campaign of 1980, which saw the rate of literacy rise from 53 percent to 88 percent. Commissioned by the minister of culture, Father Ernesto Cardenal, the mural by Canales and his team of assistants (María Gallo, Genaro Lugo, David Espinoza, Freddy Juarez, and Romel Beteta) celebrated not only the literacy crusade, but also the huge role of women as teachers (*brigadistas*) in this process of national self-transformation. The mural's visual language of buoyant affirmation conceived by Canales aptly synthesized formal elements from a variety of periods throughout history: pre-Columbian, twentieth-century European (the work of Fernand Léger

FIGURE 4.4 Alejandro Canales, *Homage to Women*, 1980. Acrylic. Velásquez Park, Managua, Nicaragua. Photo by David Craven.

and Julio González) and modern Latin American (especially the distinctive depictions of campesinas by Diego Rivera in the 1920s). Perhaps the major historical antecedent for the uncommon iconography and affirmative tone of the Managua mural was the masterful fresco of 1923–24 by Diego Rivera entitled *La maestra rural (The Rural Schoolteacher)* in the Ministry of Education, Mexico City.[29]

The exemplary mural by Canales in homage to the literacy campaign also linked land reform to public education and articulated a novel chord aesthetically. There was in the Nicaraguan mural an unusual sensual rotundity along with broad flat forms that both evoked connections to the volumetric peasant women by Rivera and recalled the marmoreal sculpture of San Juan de Limay in northern Nicaragua, which was linked to a pre-Columbian past. All of these anonymous figures in the Canales mural were deftly placed on a neutral white ground that allowed the figures to hover vibrantly or to somersault exuberantly. Symptomatic here was the striking figure of the leaping teacher holding a copy of the literacy primer *Amanecer del pueblo*, in which it is clearly written: "Las masas hicieron la Revolución" (The masses make the Revolution). The unusual motif of the somersaulting teacher signified "the new woman," as well as the new role of women within a revolutionary society that seemed almost to defy gravity during the 1980s, owing to its remarkable

achievements—achievements that were all out of proportion to the meager material resources at hand in Central America. The net result aesthetically was an airy, almost numinous composition with heavy figures that existed largely in one plane, while imparting a sense of monumental expansiveness to the whole. A tour de force of affirmative art, this mural was without the apocalyptic dread that hung over murals by Orozco or Siqueiros. The Canales mural employed instead the calmly militant charge, the upbeat Apollonian atmosphere that was a hallmark of Rivera's frescoes. (The theme of the painting would come to assume more tragic dimensions because of the war against Nicaraguan educators by the U.S.-backed contras: by the end of the 1980s, the so-called freedom fighters supported by President Ronald Reagan would assassinate at least 189 schoolteachers in Nicaragua.)[30]

Alejandro Canales and his assistants painted two more murals near Velásquez Park. The largest, done in 1985 and titled *Communication of the Past and the Present*, towered above Managua near the lakeshore throughout the late 1980s. It was on a wall almost seven stories high, covering an entire side of the metropolitan Telecommunications Building (Telcor) (figure 4.5). This public painting was easily the most physically commanding mural of the entire decade, since it could be seen from a distance of many square blocks in this part of the capital city. Long before viewers arrived at the site of the mural and it became "readable," this huge mural easily captured their attention. The neocubist collage of competing figurative elements was striking from afar because of the prominent use of primary hues, although they were modified in relation to the surrounding landscape and thus became yellow ochre, bluish green, and burnt orange. The compositional logic of the Telcor image derived from the cosmopolitan modernism of Diego Rivera's cubist paintings, particularly *Zapatista Landscape: The Guerrilla* of 1915, which obviously served as an antecedent for Canales's mural.[31] As such, the Telcor mural was a kaleidoscopic field of considerable visual energy that aptly interwove signs for history, references to nature, and symbols for technology in a series of shifting aesthetic tropes. For all its epic breadth and dense interpenetration of parts, though, the huge wall painting was an aggregate of elements from daily life that were intelligible to the majority of citizens. At the same time, this mural hinged on a fast-paced deployment of quotidian references within a framework that perceptually connected the familiar in an unfamiliar manner, thus *defamiliarizing* the spectator with these individual parts. In this way, the Canales mural both invited identification with easily recognized concrete things and triggered new critical reflections about the historical interconnectedness of these moments of Nicaraguan history.

FIGURE 4.5
Alejandro Canales,
*Communication in the
Past and the Present*,
1985. Acrylic. Telcor
Building, Managua,
Nicaragua. Photo by
David Craven.

Particularly effective in formal terms was the usage by Canales of direc-
tional lines with diagonal paths and a loosely centered but nonstatic compo-
sition that propelled the spectator's glance, as each section flowed into others
through the dialectical interplay of various components in relation to the
whole. Anchoring the center passage of the Telcor mural and surrounded by
anonymous workers were three portraits of revolutionary martyrs from the
forty-five-year struggle to end the U.S.-backed dictatorship of the Somoza
dynasty. These three *guerrilleros* were Augusto Sandino (executed in 1934),
Rigoberto López Pérez (killed in 1956 after he assassinated the first Somoza),
and Carlos Fonseca (shot in 1976 by troops under the last Somoza). The visual
language in this respect, with its boldly flat colors and broadly stenciled out-
lines, owed more to the famous neo-pop posters of Che from the 1960s by
Cuban artists such as Alfredo Rostgaard or Raúl Martínez than to the Mexi-
can muralists. This was also true of a series of *vallas* or painted billboards

from the early 1980s by Antonio Reyes elsewhere in Managua, near the University of Central America.

In the Canales mural, Sandino is at the bottom, Fonseca (with glasses) is in the center, and Lopez Pérez peers out from behind Fonseca. These images of deceased leaders were hardly meant to advance any "cult of personality" on behalf of a living leader such as one saw with Stalin in Soviet Russia or Mao in communist China. During the 1980s, there were no monumental portraits in Nicaragua of living leaders, such as Daniel Ortega, Sergio Ramírez, and Ernesto Cardenal or of any other Sandinista commandante. This point about the antiautocratic nature of the aesthetic avant-garde's images in relation to institutional power in revolutionary Nicaragua needs to be underscored, because of how the U.S. press shamelessly reported the opposite. In 1983, for example, the *New York Times* erroneously claimed, when publishing a billboard showing the triad of martyrs noted previously, that the image represented the "actual leaders" of the FSLN and that these cultlike portraits were seen all over the country.[32]

A signal part of the Telcor mural that encapsulated well the thematic interplay of the entire mural in relation to the contemporary process of social transformation was found in the lower register. Featuring a green tree, the trunk of which terminated in roots that became the antennae of an orbiting satellite, this painting showcased the interrelatedness of technology and nature, mediated anew by a modern revolutionary movement. The iconography here of space-age technology in the context of Third World scarcity had long been a compelling one in Nicaraguan poetry. Among the most famous intertextual references elicited by the Canales mural would have been a poem by the Sandinista combatant Leonel Rugama, entitled "The Earth Is a Satellite of the Moon," that was written shortly before his death in 1970. This poem included a searing contrast of the poverty in rural Nicaragua with the immense wealth needed to launch the Apollo moon flight and ended with the celebrated, if acerbic, line "Blessed are the poor for they shall inherit the moon."

A subsequent poem by Ernesto Cardenal, the minister of culture when the Canales Telcor mural was commissioned, built on the poetic tradition initiated by Rugama. Written in the early 1980s, *Ofensiva final* (*Final Offensive*) by Cardenal developed an analogy between the precariousness of the revolutionary struggle in Nicaragua and a flight into outer space. The famous poem by Cardenal, with its clear link to the iconography of the Telcor mural, ended with the lines: "Now it begins, Rugama, to belong to the poor; this earth (with its moon)."[33] Moreover, a key attribute that makes this mural even more dialogical than many of those situated in Mexico is how the iconography was

arrived at though public dialogues with the members of the popular classes who lived in Managua. Far from featuring an iconographic program devised only by the muralist or the FSLN leadership, the Telcor mural showcases a set of thematic concerns that were literally chosen though dialogical discussions between the resident populace and the artists.

Nicaraguan Murals and *Pintura Primitivista* in the 1980s

Managua's Velásquez Park, which was named after a young FSLN cadre killed by the Somocistas, was the site of two other major murals done in 1980 that showcased quite different avant-garde languages than the one employed by Canales. These impressively divergent murals attested to the "socialist pluralism" that was a hallmark of the revolutionary leadership that repudiated any official "revolutionary style." A theorist of significance to the FSLN in rejecting any "normative art or aesthetic" for the revolutionary process was the Mexican philosopher Adolfo Sánchez Vázquez, who gave seminars at the National School of Art in Nicaragua in 1983. Many artists and critics of Nicaragua were deeply impressed with how Sánchez Vázquez justified avant-garde art (including nonfigurative art or abstract art) from within the Marxist tradition, in opposition to Soviet-style socialist realism.[34] One such Nicaraguan muralist and printmaker was Leonel Cerrato (b. 1946), who was appointed by the FSLN as the director of the National School of Monumental Art at about the same time that Raúl Quintinalla (b. 1954) was made director of the National School of Visual Arts in Managua. In 1980 Cerrato painted a mural entitled *El Encuentro* (*The Reunion*), measuring three by thirty-eight meters, on another exterior wall, the north side of the same building in Velásquez Park (figure 4.6) that displayed Canales's *Homenaje a la mujer* on the south side. The energetic neo-expressionist painting by Cerrato was as densely packed with celebratory, multicolored figures as the Canales mural was leanly composed. The heavily impastoed treatment by Cerrato of the acrylic paint also had a different tactile quality as well from any of the other Nicaraguan murals. There was a strong left-to-right surge of humanity in keeping with the iconographic theme, which represents the reunion of guerrillas from the countryside with their relatives from the cities (as if to imply a revolutionary resolution of the country-vs.-city conflicts endemic to corporate capitalism). The elongation of the figures, their urgent forward movement, and the chalky tonality overlaying the broad palette all recall the more chiliastic œuvre of José Clemente Orozco, as in *Catharsis* (1934), while combining it with an oblique overture to El Greco's manner.

FIGURE 4.6 Leonel Cerrato, *The Reunion*, 1980. Acrylic. Velásquez Park, Managua.
Photo by David Craven.

The shortest of the three murals on the building in Velásquez Park, at three by twelve meters, was *Paisaje con la vida campesina* (*Landscape with Scenes of Peasant Life*) from 1980 (figure 4.7). Three different artists, all from the popular classes, produced this painting: Hilda Vogel (b. 1930), Manuel García (b. 1936), and Julie Aguirre (b. 1954). Among the most original of the entire decade, this mural drew on the rural-based visual language called *pintura campesina* (peasant painting) that was done in places like Solentiname, an island community in Lake Nicaragua. Not surprisingly, this striking example of popular culture in a high-art format and of rural art in an urban space spawned a whole series of murals elsewhere. Such was the case with the *Paisaje Primitivista* (1990) by Olga Maradiaga, which was done for the large retainer wall in front of President Daniel Ortega's private residence in Managua. The considerable interest by FSLN leaders like Ortega and Ernesto Cardenal in this popular-based language (although they were careful not to call it the official "revolutionary" language of Nicaragua) was of course grounded in their understanding of how this visual tradition was created by what Antonio Gramsci termed "organic intellectuals" from the rural popular classes at a time when 65 percent of the workforce came from the agrarian sector. Far from being mere populist images of static scenes, these peculiarly Nicaraguan murals were instead images of the popular classes in transformation and of

FIGURE 4.7 Julie Aguirre, Hilda Vogel, and Manuel Garcia, *Landscape with Scenes of Peasant Life*, 1980. Acrylic. Velásquez Park, Managua, Nicaragua. Photo by David Craven.

a clear advance in socializing the means of artistic production beyond what had occurred in Mexico.

The formal language of these "primitivista" public murals, beginning with the magisterial one in Velásquez Park, often embodied the material texture of campesino life in agrarian areas through a distinctive set of traits: (1) bold tropical hues, (2) artisanal shapes that were both rough-hewn and manually improvised, (3) a marked correspondence between human tools and natural forms, and (4) a pronounced decentering of compositional forces. Moreover, the latter tendency also entailed a nonhierarchical arrangement of figures, a diffused lighting that brought everything into equal relief, and a pictorial structure that was characterized more by imbricated forms, than by the perspectival organization of space. In short, these images were not so much staged representations of peasant life as textural evocations of it with celebratory overtones. Thus, these popular-based *postapocalyptic murals* signified the prospect of general human fulfillment in a society that would be notably egalitarian and ecologically sound should the revolutionary process be successfully consolidated.

The early and mid-1980s saw the proliferation of murals in a wide range of visual languages by artists from other nations, as the Italian contingent

FIGURE 4.8
Arnold Belkin,
The Prometheuses,
1985 [dedicated
in 1987]. Acrylic.
Institute of
Culture, Managua,
Nicaragua. Photo
by David Craven.
© 2014 Artists
Rights Society
(ARS), New York /
SOMAAP, Mexico
City.

of artists led by Sergio Michilini produced such memorable murals as the fifteen-part cycle titled *Historia de Nicaragua* inside the church Santa María de los Angeles, painted from 1982 to 1985. Two things in particular are of note about these murals, which are still in very good condition. First, the unusual iconographic program based on liberation theology was dialogical in the most profound sense. It was derived from public discussions between the urban workers in the surrounding Barrio Riguero and the team of painters led by Michilini, who produced the cycle. Second, the visual language employed by Michilini et al., derived from aesthetic precepts—especially the use of a "polyangular perspective"—advocated by the Mexican muralist David Alfaro Siqueiros. Among the other murals that stand out from the late 1980s was one donated to Nicaragua by the Mexican government in 1987 to mark the seventy-fifth anniversary of the Mexican Revolution and the fifth anniversary of the Nicaraguan Revolution. This is the superb and still well-preserved mural of around forty square meters named *Los Prometeos* (*The Prometheuses*) by Arnold Belkin of Mexico (figure 4.8). Done with an airbrush, it is located inside the old Palacio Nacional in Managua. In this painting, there is a distinctive combination of Léger-inspired "machine aesthetic" figures with the use of Heartfield-like photomontage and some brilliant invocations of artists like Peter Paul Rubens (whose painting *Prometheus* of 1610 is a point of reference). Moreover, the two Promethean figures represented on either side of the struggling Prometheus are Zapata and Sandino. These

two striking revolutionary leaders from Mexico and Nicaragua respectively stand like twin specters haunting the contemporary scene, and they recall a historic moment when art was more than just popular and the public was beginning to become artistic.[35]

The Aesthetic Avant-Garde and Revolutionary Movements

Evidence of an innovative ideological conjunction of art and life within a new polis is manifestly clear in the texts of leading "Third World" Marxists from Latin America—whose emerging "philosophy of liberation" over the last century has often gone beyond a rebellious populism to approach Western Marxism, on the one hand, and the unorthodox Eastern European Marxism of Mikhail Bakhtin, on the other—rather than in the direction of the orthodoxy found in the old Soviet version of Marxism.[36] As I argue, aesthetic avant-gardes have been of central significance to the most noteworthy features of the revolutionary movements during the Mexican Revolution of 1910, the Nicaraguan Revolution of 1979, and to some extent the Cuban Revolution of 1959. Accordingly, Miklós Szabolcsi (and here I am citing an author first invoked by Aleš Erjavec in his introduction) was probably correct when he said, "A revolution without an [artistic] avant-garde is really a pseudo-revolution."[37] To understand theoretically how this has happened, we can recall a reconceptualization of the relationship of art to politics found in the work of Rancière:

> Art is, not, in the first instance, political because of the messages and sentiments it conveys concerning the state of the world. Neither is it political because of the manner in which it might choose to represent society's structures, or social groups, their conflicts and identities. It is political because of the very distance it takes with respect to these functions, because of the type of space and time it institutes, and the manner in which it frames this time and peoples this space.... Politics, indeed, is not the exercise of, or struggle for, power. It is the configuration of a specific space, the framing of a particular sphere of experience.... Politics is the very conflict over the existence of that space.... Politics consists in reconfiguring the distribution of the sensible that defines the commonality of a community, to introduce new subjects and objects.[38]

What is often misnamed "revolutionary art" constitutes a form of backward-looking populism with obvious messages, rather than a movement of future-

oriented avant-gardism in favor of the reconfigured *sensorium* discussed by various theorists from Latin America.[39] In 1979, the street graffiti in León, Nicaragua, famously declared, "The triumph of the revolution is the triumph of poetry," and the Nicaraguan process became justifiably known worldwide as a "revolution of poets."[40] Similarly, the Mexican Revolution had attempted to produce a nation of muralists and public image-makers, along with other types of cultural workers. These revolutionary movements of Latin America asserted that the aim of a revolution should entail not merely economic change or social reconfiguration, but also in tandem with them an aesthetic transformation of the entire public sphere in a way that contradicts conventional populism in the arts. The famous murals of Diego Rivera, for example, always focused on a future resolution, not a contemporary reflection, of existing class divisions—of a working-class unity often unknown to the time in which he worked—except when there were provisional alliances at key moments between rural and urban labor groups to fend off counter-revolutionary uprisings. As such, Rivera's art was intended as the beachhead for a new artistic avant-garde sensibility or aesthetic through a transformative art that broadly affected society in general. As Leticia López Orozco has only recently observed, the first generation of muralists led by Diego Rivera were central to the avant-garde adventure in the art and the culture of Mexico during the 1920s and 1930s.[41] Nor is it unrelated that Rivera's murals were connected formally and otherwise to the Russian films of Sergei Eisenstein and Dziga Vertov—the former of whom saluted Rivera in an essay he wrote while visiting Mexico.[42]

Indeed, the Brechtian terms of engaged spectatorship often demanded by Rivera's artworks entailed what Rancière has recently called interventions by the "emancipated spectator." This meant nothing less than a wholesale redeployment of art by Rivera to encompass aesthetically the "nonaesthetic" aspects of daily life for the popular classes in keeping with the unprecedented literacy campaign policies during the 1920s under Obregón.[43] In the main art institutions of Mexico, a conception of broad artistic engagement for the popular classes was promoted through the National School of Fine Arts under Rivera's direction in 1929–30, even if only for a year.[44] Similarly, an overlooked, but also symptomatic and "utopian" aspect of this artistic movement, was how it at least partially involved what the muralist José Clemente Orozco termed a future "socialization of art."[45]

Here we also need to point out an instructive contrast between Rancière's supposedly self-propelled pedagogy of the "ignorant schoolmaster" and the multipoint "dialogical" pedagogical theory of Paolo Freire about *inter-*

dependent teachers and students. Freire was the Brazilian theorist who co-authored the celebrated literacy crusade primer for the Nicaraguan Revolution, with its photo gallery of "generative images."[46] Freire's work was about self-empowerment through interdependent dialogue, while Rancière's less plausible position is rather more about a presumed self-determination by supposedly independent individuals. It was by means of a dialogical conception—which originated in Latin America, *not* in France or Western Europe—that a theoretical foundation would be constructed for rethinking the diverse *aesthetic avant-gardes* so essential to the revolutionary movements of Latin America, especially in Nicaragua.

From its emergence in Europe during the 1830s until its apparent global demise in the late twentieth century, the avant-garde was concerned less with a new style for art, than with a new style for life through art. As Renato Poggioli noted in his classic book on the subject from the 1960s, the avant-garde involved artistic movements, rather than mere schools of art. At issue was nothing less than a new *Weltanschauung* for the programmatic transformation of society, out of which everything—art and sensory experience included—would be created anew.[47] When Die Brücke, for example, spoke in 1909 of "bridging all the radically new insurgent tendencies in modern life" into an aesthetic capable of connecting all manifestations of modern life, or when the Bauhaus leaders in 1919 wrote of a comprehensive new approach that united all the arts in a "formal engineering principal" for society (so that no difference existed between fine art and craft), or when the surrealist movement claimed in its founding manifesto of 1924 that its members were committed to "solving all the principal problems of life," these avant-garde movements each operated as an advanced guard of social and aesthetic transformation.[48] They supported a view of art as a formative force on behalf of modern society, not a conception of art as a mere passive reflection of traditional society. All new avant-garde movements were thus publicly announced by manifestos—in the futurist tradition first established by Marx and Engels in 1848—that expressed both an alienation from the present and also an affirmation of a dramatically different future that their art was intended to introduce and consolidate.

This latter goal of all the key avant-garde manifestos from 1909 onward is what Poggioli had in mind when he declared that every avant-garde movement was marked by an intense belief in the future, or *futurism*. In sketching the pervasive "futurism of the avant-garde," Poggioli wrote that: "The idea of transition, as a variant of avant-garde futurism, clearly reveals its special function as an antithesis to the historical myth favored by the classical ages

... the myth that consists of the illusory belief that it [the past] had attained to the 'fullness of time.'"[49] Avant-garde cadres, like those of the revolutionary avant-garde, remind us that the future-oriented "spirit of avant-garde movements is that of sacrifice and consecration of the self for those who come after."[50] One of the earliest uses of the term "avant-garde" occurred in 1845 by the French author Désiré Laverdant (a follower of the Utopian socialist Charles Fourier), who wrote: "Art, an expression of society, manifests, in its highest soaring, the most advanced social tendencies: it is the forerunner and the revealer. to know . . . whether the artist is truly of the avant-garde, one must know where Humanity is going."[51] This quotation reminds us of what Poggioli has called the two most frequent themes of the avant-garde, namely (1) an agonistic or sacrificial sense of consecrating oneself through art for the transformed society that will ensue, and (2) an aesthetic desire for a clean cultural slate, so as to create the "primitive" sensibility or primordial sensorium out of which everything will be created or constructed anew, including the human subject.

In his 1974 work *Theory of the Avant-Garde*, Peter Bürger claimed that the "classic" avant-garde movements in Europe could be defined as a transgressive attack on the official status of art in mainstream society, even as these movements posit an alternative vision of the future.[52] What the avant-garde negated was not simply an older style of art, but the established concept of *art* per se, along with the institutional enframement of art as disconnected from the quotidian life of mainstream society. What the avant-gardists in Europe of expressionism, cubism, futurism, constructivism, the Bauhaus, Dada, and surrealism demanded was that art again become "useful" to everyday life. By this, they did not mean that the "content" of their art should be only of practical or instrumental value, since a pragmatic aim entailed resignation to the status quo in society.

Avant-garde art did not use topical messages to address conventional issues; it used a radical new sensibility, a new *Weltanschauung* or ideology, conveyed by innovative visual languages fostering a new sensory experience and aimed at the level of fundamental attitudes prior to any instrumental aim or pragmatic politics. Implicit in all this was a sense of the gap between politics (applied tactics) and ideology (a general strategy). Politics featured a concrete approach to specific situations, whereby ideology would be imperfectly translated into actual and often paradoxical policies.[53] As such, aesthetic avant-garde works—which avant-garde artistic movements used as a critique of the mode of artistic production, rather than just of existing art

objects—always launched a criticism of the social irrelevance of art forms within the pre-revolutionary *status quo*. As Theodor Adorno put it: "Committed [avant-garde] art in the most advanced sense is not intended to generate pragmatic reforms or practical institutions—as is didactic art—but to work instead on the level of fundamental attitudes. . . . The notion of a 'message' in art, even when politically radical, already contains an element of conformity to the world as is."[54]

Conclusion

At issue with the aesthetic avant-gardes of the period under discussion was the paradoxical situation of art's "relative autonomy"—to recall an astute formulation that connects Adorno with Louis Althusser via the recent writings of Jacques Rancière.[55] In the absence of any "relative autonomy," art either dissolves into society by merely reflecting it in an unchanging manner, or conversely, art disconnects from society without being able to bridge the gap separating them.[56] Agentless when conceived without autonomy and nothing but *anti*social agency when seen as absolutely autonomous, art in each binary case would be denied any dialogical path to becoming a developmental force for reconfiguring humanity more broadly, even as art is also produced by humanity. Fortunately, however, the aesthetic avant-gardes interrelated with major revolutionary movements in twentieth-century Latin America sometimes squared social change with the circle of artistic engagement through the relative autonomy of aesthetics. This gain still resounds with enormous potential for the future transformative potential of art in the Americas—when we again experience moments of instability and heightened contingency in the Americas during the next crisis of corporate capitalism.

The great revolutions in Mexico, Nicaragua, and Cuba showed with varying degrees of success that some things do contest the entrenched beliefs of our supposedly "stable and necessary" ordinary times. These few overarching and paradoxical movements of the revolutionary past have demonstrated that the "ignorant schoolmaster," like the "educated illiterate," has a ready counterpart in the "plebian aesthete" and the "patrician peasant," for all of whom art, like life, hinges on a transformative dialogue of previously irreconcilable opposites. Such a dialogue has in a few symptomatic instances even led to a synthesis of prior polarities resulting in a new, if still partially formed, citizen both aesthetically and socially who has embodied a reconfigured "new subject"—even if only for a short period now deferred for the future. Nor is

it by chance that the most widely read book ever written about the Mexican Revolution was *la Revolución interrumpida* (the interrupted revolution), which appeared in the 1960s.[57]

Despite internal contradictions and the subsequent issue of defending "lost causes," the Mexican Mural Renaissance had a profound afterlife throughout the Americas, north and south: from the Works Progress Administration programs of the 1930s in the United States to the public murals in Ecuador of Oswaldo Guayasamín through the Ramona Parra Murals in Allende's Chile to the monumental mural movement of the Sandinista Revolution of 1979. Yet, the deferral of the profound promises found in the accomplishments of these avant-garde artists was hardly without contradictions. To quote Poggioli: "There is a reason why the coinciding of the ideology of a given avant-garde movement and a given political party is fleeting and contingent. Only in the case of those avant-gardes flowering in a climate of continuous agitation, as for example, modern Mexican painting (which one might hesitate to call avant-garde without reservation), does such a coinciding seem to make itself permanent [as was true from 1910 to 1940]."[58]

NOTES

1. Gris, "Response to Questionnaire on Cubism," 276–77.

2. Rivera, *My Art, My Life*, 58.

3. Rivera, *My Art, My Life*, 58.

4. Craven, "The Latin American Contribution to 'Alternative Modernism.'" On the issue of cubist collage, see the related position of Rancière, *Aesthetics and Its Discontents*, 47. Also, for a much longer analysis of Rivera's "Zapatista Landscape," see Craven, *Art and Revolution in Latin America*, 9–14.

5. Híjar, "Los Zapatas de Diego Rivera," 21–32.

6. Baddeley and Fraser, *Drawing the Line*, 80–81. For an example of just how admired these works were in the United States, see Schapiro, "The Patrons of Revolutionary Art," 463.

7. Siqueiros, "Three Appeals for a Modern Direction," 322–23.

8. For an explication of the different types of nationalisms implicit in Benedict Anderson's *Imagined Communities*, see Baackmann and Craven, "Introduction to the Special Issue on Surrealism and Post-Colonial Latin America," ix–xi.

9. For Rivera's complex intertwinement of aesthetics and politics, see Sánchez Vázquez, "Claves de la ideología estética de Diego Rivera," and Híjar, *Diego Rivera*.

10. Meyer, Sherman, and Deeds, "Cárdenas Carries the Revolution to the Left," in *The Course of Mexican History*, 444–54.

11. Lomnitz, "What Was Mexico's Cultural Revolution?," 342–43.

12. Fernández, *El arte del siglo XX*, 33.

13. Trotsky, "Art and Politics in Our Epoch," 116–17.

14. Brecht, "Modern Theater Is Epic Theater," 33–42. For more on this parallel between Rivera and Brecht, see Craven, *Diego Rivera as Epic Modernist*, 119–29.

15. Eisenstein, "Orozco: The Prometheus of Mexican Painting," 68.

16. Eisenstein, "Rivera's Murals in the Ministry of Education," 69.

17. Ades, *Art in Latin America*, 170. The best analysis of Orozco's work remains the monograph by Anreus, *Orozco in Gringolandia*, while the most conservative, or rightwing, reading of Orozco is found in the writings of Renato González Mello.

18. Eisenstein, "Orozco: The Prometheus of Mexican Painting," 69.

19. Orozco, *Autobiografía*, 37.

20. Cardenal, *In Cuba*, 189.

21. The centrality and originality of the "dialogical process" to the Nicaraguan Revolution is a topic that I have discussed at length in a short monograph and two lengthy books. See Craven and Ryder, *Art of the New Nicaragua*; Craven, *The New Concept of Art and Popular Culture in Nicaragua since the Revolution in 1979*; and Craven, *Art and Revolution in Latin America*, chap. 3.

22. Orozco, *Autobiografía*, 66–67.

23. Cruz Manjarrez, *Tina Modotti y el muralismo mexicano*. Other primary sources from the period make clear just how prominent the murals were through such newspapers as *El Machete*. Any serious look at the reception of these murals by the popular classes must discuss the vital role played from the 1920s through the 1940s by the "age of mechanical reproduction" in broadening access to these images.

24. Suárez, *Inventario del muralismo mexicano*; Stein, *Murales de México*.

25. Quintanilla, "La unidad del sector cultural frente a un acto vandálico," 1; Selser, "Odio a la cultura," 33; and Rosenberger, "Nicaragua's Vanishing Sandinista Murals," 27.

26. Craven, *Art and Revolution in Latin America*, chap. 3.

27. Craven, "The Latin American Contribution to 'Alternative Modernism,'" 29–44.

28. Craven, "The Latin American Contribution to 'Alternative Modernism,'" 29–44.

29. Cockcroft, *Mexico*, 132. See also Vaughan, *Cultural Politics in Revolution*.

30. On the horrors of the Reagan-era support for the contras, see, for example, *Oxfam Famine Relief Report on Nicaragua* (1985).

31. Craven, *Art and Revolution in Latin America*, 9–14.

32. John Vinocur, "A Correspondent's Portrait," *New York Times*, August 16, 1983, 1.

33. Cardenal, *Flights of Victory*, 2.

34. See, for example, a very well received paper from these seminars in Nicaragua: Sánchez Vázquez, "La pintura como lenguaje," 115–25.

35. Ernesto Cardenal, prologue to Sheesley and Bragg, *Sandino in the Streets*, xi–xii.

36. Bakhtin and Medvedev, *Formal Method in Literary Scholarship*, part 2, chap. 3.

37. Szabolcsi, "Ka nekim pitanjima revolucionarne avangarde," 14.

38. Rancière, *Aesthetics and Its Discontents*, 23–25.

39. Híjar, *Arte y utopia*; Freire, *Pedagogia do oprimido*.

40. Cardenal, *La Revolución perdida*, 340.

41. López Orozco, "The Revolution, Vanguard Artists and Mural Painting."

42. Concerning Rivera's links with Soviet cinema, see Craven, *Diego Rivera as Epic Modernist*, 124–29, and Begrich, *Der mexikanische Muralismus als Bilderziehung*.

43. Vaughan, *The State, Education, and Social Class in Mexico, 1880–1928.*

44. Craven, *Art and Revolution in Latin America*, 34–37.

45. Orozco, *Autobiografía*, 67.

46. Rancière, *The Ignorant Schoolmaster*, and Freire, *Pedagogia do oprimido.*

47. Poggioli, *The Theory of the Avant-Garde*, 18.

48. Kirchner, "Chronik der Brücke" (1916), 178; Gropius, "Program of the State Bauhaus," 49.

49. Poggioli, *The Theory of the Avant-Garde*, 72–73.

50. Poggioli, *The Theory of the Avant-Garde*, 66–67.

51. Poggioli, *The Theory of the Avant-Garde*, 9. See also Egbert, *Social Radicalism and the Arts*, 117–63.

52. Bürger, *Theorie der Avantgarde*. This celebrated text was in turn a response to an innovative anthology of writings on the topic by key figures of the New Left in Germany: Bredekamp et al., *Autonomie der Kunst: Zur Genese und Kritik einer bürgerliche Kategorie*, with contributions by Bredekamp, Hinz, Müller, and Verspohl, among others.

53. Bürger, *Theorie der Avantgarde*.

54. Adorno, "Engagement," 412, 429.

55. For unexpected agreements on art's internal distance from the established order, see Adorno, "Engagement," 412 ff., and Althusser, *Lènine et la philosophie*, 151–66, plus Rancière, *Aesthetics and Its Discontents*, 1–17.

56. Adorno, "Engagement," 429. See also Marcuse, *Die Permanenz der Kunst*, section 2.

57. Gilly, *La Revolución interrumpida*. The title of the English translation is simply *The Mexican Revolution*.

58. Poggioli, *The Theory of the Avant-Garde*, 96.

All along the Watchtower
Aesthetic Revolution in the United States during the 1960s

TYRUS MILLER

Aesthetic Revolution and Cultural Revolution

This book's sense of "aesthetic revolution," which connects artistic imagination to the accelerated social and institutional changes entailed by political revolution, requires further specification to be applied to the United States of the 1960s. For despite the major upheavals and movements in American politics during the 1960s, there was no manifest overturning of the United States' political order in these years. Throughout the decade, a liberal Cold War consensus characterized most official social policy of the U.S. government, and the defining political "event" of the Vietnam War, begun as an undeclared "police action" during the Kennedy administration, stretched past the resig-

nation of Richard Nixon in 1974 with the fall of Saigon to the People's Army and Viet Cong forces in April 1975.

Nevertheless, I wish to argue, many American artists of the 1960s were strongly informed by a revolutionary "social imaginary," in the sense that Charles Taylor defines that term, as an "implicit grasp of social space," encompassing "the ways people imagine their social existence, how they fit together with others, how things go on between them and their fellows, the expectations that are normally met, and the deeper normative notions and images that underlie these expectations."[1] Taken as an ensemble, their artistic activities can be understood as exemplary expressions of a broader "cultural revolution" in civil society, existing in tension with the absence of major shifts in the official character of governmental power.[2] Already following the failure of the socialist uprisings in Western Europe after World War I, Antonio Gramsci argued for a more nuanced understanding of the role of multiple, heterogeneous points of cultural articulation of power in a socially complex "hegemony" that required long work to transform. In the middle decades of the century, the thinkers of the Frankfurt school, especially Walter Benjamin and Herbert Marcuse, offered novel accounts of how culture, technology, and collective experience were interacting to produce new, unprecedented forms of politics, both reactionary and revolutionary. So too more recent theorizations of the art and revolution relationship, such as Gerald Raunig's Deleuze- and Negri-influenced writings, have displaced the conquest of the state from the center of the model of revolution, in favor of a less linear, less "eventual" understanding of what a revolution might look like.[3]

The term "cultural revolution" as I use it in this chapter in part reflects a construct of the period's own social imaginary, through which a range of heterogeneous phenomena appeared to orient toward the horizon of a coming revolution. In his retrospective essay "The 'Sixties: Crisis and Aftermath (Or the Memoirs of an Ex-Conceptual Artist)," Ian Burn captures well the vague but nonetheless affectively powerful generalization of alternative cultural tendencies into an oppositional, revolutionary "attitude" characteristic of the period: "Since the Second World War, the corporate forces of American capitalism had been making a concerted effort to create an explicit identification of the needs of individuals with the interests of corporations. Hence anything which rejected the basis of that identification was seen as *political*—for example, lifestyles, individual feelings, quality of life, spontaneity, anti-institutionalism, 'free-form' expression, drug-associated cultures. . . . In the broadest sense, these diverse cultural expressions converged on a common attitude of anti-institutionalism."[4]

Moreover, the capillary, multisided shift of heterogeneous social forces that actually did occur within this imaginary complex during the 1960s and early 1970s also demands fresh *theoretical* consideration: a new, culturalized conception of revolution that may diverge significantly from classical political models.[5] Rather than a punctual event leading to the change of personnel in the state, a revolution of this new sort, at least adumbrated by the culturally mediated upheavals of the U.S. 1960s, is a less focalized but nevertheless consequential redistribution of social power throughout the extent of society. Such a broadly construed "cultural revolution," in turn, represents the transformative social background against which the event of the 1960s "aesthetic revolution," comparable to other historical moments explored by the authors of this book, can be comprehended.

Although the U.S. "cultural revolution" of the 1960s was organizationally decentralized and ideologically diffuse by comparison to the socialist upheavals of 1917–20 or the centralized movements of the 1930s in the USSR, the 1950s in East Central and Southern Europe, and the 1960s in China, it was nevertheless marked by an analogous *revolutionary time-sense* characteristic of earlier cultural revolutions. As with these cultural revolutionary moments, in the United States in the 1960s a generalized effervescence of events and actions intensified and accelerated the feeling *that daily life was radically changeable through conscious collective activity in the cultural sphere.*[6] As Hal Foster has noted in reference to the ambiguously critical tendencies within American pop art and minimalism, while it is difficult to characterize the mediating links between art and the imaginary of radical social change in the 1960s—"Somehow the new immanence of art with minimalism and pop is connected *not only* with the new immanence of critical theory ... *but also* with the new immanence of North American capital in the 1960s. Somehow, too, the transgressions of institutional art with minimalism and pop are associated *not only* with the transgressions of sexist and racist institutions by women, African-Americans, students, and others, *but also* with the transgressions of North American power in the 1960s."[7]

In his rather equivocal framing of the "aesthetic revolutionary" character of 1960s artistic radicalism, Foster captures the mediated relations between rapid formal and functional changes in the character of art and equally rapid, contemporaneous if not always causally aligned social changes in the United States. This chapter will seek to examine particular cases in which this mediating "somehow," here evoked as a rhetorical question by Foster, can be fleshed out in somewhat greater theoretical, formal, and cultural historical detail.

In approaching the materials of this chapter, I have drawn on Gerald Raunig's recent "three-dimensional model" of revolution to interpret various instances of U.S. artistic practice in the 1960s as nodal points in this broader process of defining the aesthetic dimension of the "cultural revolution." Raunig argues that "revolution" should be seen as fusing three simultaneously operative "moments" (in the Hegelian rather than temporal sense): *resistance, insurrection, and constitutive power*.[8] Put in somewhat more vernacular terms, we can see Raunig's "resistance" as corresponding to the critical orientations of 1960s art, ranging from a general "refusal" of mainstream social values to specific theoretical and ideological critiques performed by artists. In turn, "insurrection" corresponds to new types of artistic actionism, interventionist cultural activities aiming to precipitate or encourage social change, from politicized performance works to collective protest exhibitions to demonstrations and strikes directed at major art institutions.[9] "Constitutive power" corresponds to the exemplary modeling through art of alternative institutions, spaces, and frameworks for individual and collective experience.

Viewing these three dimensions as overlapping, simultaneously present "moments" discernable to different degrees in individual artistic cases, I will consider three heterogeneous currents in 1960s American art that converge as expressions of a broader "aesthetic revolution," an alternative hegemony implicit in the practices of the arts of the period and also increasingly self-conscious in their social imaginary. These currents include

1 modelings of alternative, anarchistic communities through embodied actions in improvisational performance;
2 liberationist-cathartic collective performance, consonant with the libidinal revolutionary theories of Wilhelm Reich, Herbert Marcuse, and Norman O. Brown; and
3 a populist rapport between commercial culture, subcultural styles, and advanced art practice, in resonance especially with the imaginary of youth counterculture.

Clearly, these three tendencies by no means come close to exhausting the rich field of radical artistic practices that might be conceived to have contributed, more or less consciously and directly, to the 1960s "aesthetic revolution." Recent art historical work by critics such as Julia Bryan-Wilson has documented the emergence of activist groups and currents such as the Art Workers' Coalition, the Guerrilla Art Action Group, the Art Strike, and Women Artists in Revolution, and discusses specific struggles for recognition by African Ameri-

can, Puerto Rican, and women artists and curators in the late 1960s and early 1970s.[10] Similarly, cultural historians such as Robin D. G. Kelley, Fred Moten, John Szwed, and George E. Lewis have drawn a rich picture of the African American activist and avant-garde tendencies constituting what Kelley has characterized as the "black radical imagination" of the period.[11] Various African American groupings, including the Black Arts Repertory Theatre/School in Harlem, the Chicago-based Association for the Advancement of Creative Musicians, Organization for Black American Culture, African Commune of Bad Relevant Artists (AfriCOBRA), the Detroit Arts Workshop, and the St. Louis–based Black Artists' Group arrayed novel configurations of music, literature, performance, visual expression, and politics, toward the end of a holistic black consciousness, cultural self-determination, and social liberation. Between the institutionalized racism they struggled against from the outset, their geographical dispersion in non–New York urban centers such as St. Louis, Detroit, and Chicago, and their uneasy fit in canonical critical paradigms, these movements have only recently begun to receive serious critical and art historical consideration.[12]

An essay such as mine cannot hope to do justice to this rich, diverse ferment of artistic, cultural, and political work, encompassing multiple locations, communities, orientations, and groupings. However, in selecting just three exemplary nodal points in this process, I hope to help illustrate larger and more complex dynamics of cultural change that encompassed a much broader, more variegated field of activity. Considered as an overlapping, inter-referring ensemble of art practices, these three example cases exhibit different ways in which the artistically figured revolutionary moments of "resistance," "insurrection," and "constitutive power" might be intertwined in the 1960s. In turn, they suggest how the broader social imaginary of cultural revolution could help motivate the innovations and orientations of specific neo-avant-garde artworks, ascribing to them—in the minds of artists and their audiences—a general "revolutionary" significance for the society and culture of the U.S. 1960s.

Counterculture and Counterhegemony

These three exemplary cases, I wish to suggest, offer a set of artistic analogues to the 1960s American counterculture that was putting new pressures on the cultural hegemony inherited from the American 1950s and perpetuated in the official Cold War liberalism of the 1960s. The congeries of countercul-

tural phenomena of the U.S. 1960s had already been characterized as a new, unified, alternative "culture" before the decade had even closed, in Theodore Roszak's influential book *The Making of a Counter Culture* (1969). The opening chapter of Roszak's book, entitled "Technocracy's Children," offered a poignant image of youth in revolt against a society regimented along techno-bureaucratic lines and the social roles and values defined by that society. Roszak was, in fact, offering a certain popular refraction of Frankfurt school and other New Left Marxist criticisms, when he wrote: "Capitalist enterprise now enters the stage at which large-scale social integration and control become paramount interests in and of themselves: the corporations begin to behave like public authorities concerned with rationalizing the total economy."[13] Roszak's book vividly recast commonplaces of the New Left, drawn especially from Herbert Marcuse's influential writings, as well as reacting passionately to prominent aspects of American society at midcentury, including the Fordist integration of industry, the development of large-scale corporations in all spheres of business including entertainment and leisure, the development of consumerism and credit, the increasing role of "experts" and expert organizations ("think tanks") in public life, and the logic of Cold War competition with communism everywhere, from the university classroom to the battlefield of Vietnam to the far reaches of outer space. Roszak goes on to discuss several countercultural phenomena as coherent rejections of this growing dominance of technocracy and its ethos. He considers the liberation philosophies of Herbert Marcuse and Norman O. Brown, the allure of Eastern religion in the writings of Allen Ginsberg and Alan Watts, the use of psychedelic drugs, and the anarchist sociology of Paul Goodman, before concluding with an evocation of a new shamanistic, visionary relationship to the earth that anticipates aspects of political ecology and the Green movement. (One clearly notes the similarity of Roszak's chapter topics with the representative list of anti-institutional impulses that Burn retrospectively enumerates.)

If Roszak's notion of technocracy offers one coherent view of the social totality that can be related to various resistant, counterhegemonic positions adopted by individual thinkers and tendencies, another diagnosis is offered by Fredric Jameson in his notable 1984 essay "Periodizing the 1960s." Jameson considers the problem of holding together in any kind of coherent historical construction the highly various, centrifugal tendencies of the 1960s, ranging from Third World revolts and serious challenges to First World power, to new theories of the sign and of language, to the spread of capitalism globally and its development of new powers and means of production. Here I can only cite Jameson's conclusion, in which he ventures this synthetic view of the period:

We have described the 60s as a moment in which the enlargement of capitalism on a global scale simultaneously produced an immense freeing or unbinding of social energies, a prodigious release of untheorized new forces: the ethnic forces of black and "minority" or third world movements everywhere, regionalisms, the development of new and militant bearers of "surplus consciousness" in the student and women's movements, as well as in a host of struggles of other kinds. Such newly released forces do not only not seem to compute in the dichotomous class model of traditional Marxism, they also seem to offer a realm of freedom and voluntarist possibility beyond the classical constraints of the economic infrastructure.[14]

This last point—the possibility of a culturally and existentially situated freedom from infrastructural constraint—is, I would argue, a crucial precondition for the new collective structure of feeling to develop, including the "cultural revolutionary" orientation in the arts. As I have suggested, cultural revolution, in its various versions, involves the sense of an acceleration of historical time through cultural innovation; from the Russian Revolution through the 1960s, the notion of cultural revolution took the form of questioning at first the strong economic determinism of pre-Bolshevist Marxism and eventually also official late communist versions of Marxism. Jameson, however, also holds on to an attenuated Marxist notion of the ultimately determining instance of the economic infrastructure, suggesting that the global economic crisis beginning in the early 1970s put an end to the cultural explosion of the 1960s. "This sense of freedom and possibility," he writes, "may perhaps be best explained in terms of the superstructural movement and play enabled by the transition from one infrastructural or systemic stage of capitalism to another. The 60s were in that sense an immense and inflationary issuing of superstructural credit; a universal abandonment of the referential gold standard; an extraordinary printing up of ever more devalued signifiers. With the end of the 1960s, with the world economic crisis, all the old infrastructural bills then slowly come due once more."[15]

The emergence of contemporary global capitalism, with its attendant forms of postmodern culture and neoliberal ideologies, is the ultimate trajectory that for Jameson seals the historical fate of the 1960s cultural revolution.

Both Roszak and Jameson offer crucial hints for critically understanding the 1960s aesthetic revolution as a specific domain of this broader period of cultural-revolutionary orientation. Roszak suggests that the counterculture—including its more articulate and sophisticated avant-garde manifes-

tations—encompasses diverse but convergent critical responses to a social totality conceived as integrated technocracy. His antitechnocratic "counterculture" provides a way to comprehend the seemingly contradictory relations of artists to technology and media during the period, which range from a kind of ritualistic disavowal to subversive appropriation to almost science fiction, utopian hyperenthusiasm. Jameson's idea that there is a special charging of the whole sphere of culture with social importance during the large-scale transition of the 1960s helps to explain how the exceedingly overoptimistic claims for the revolutionary power of artistic experimentation could be seen to be plausible by intelligent, serious artistic practitioners and theoreticians. Moreover, it suggests, on analogy to the claim by Thierry de Duve that the work of Duchamp legitimated a notion of "art in general" for later artists involved in the 1960s neo-avant-garde,[16] that this special, historically delimited privilege of the superstructure helped to generate a background notion of an alternative hegemony in formation, a "counterculture in general," in which the experimental arts might take sustenance from and position themselves in solidarity with a broad range of cultural phenomena including rock and roll, drug experimentation, erotic exploration, the Black Power and feminist movements, the student antiwar rebellion, and the burgeoning interest in non-Western cultures and spirituality. Insofar as artistic innovation could be seen as a synecdoche of a larger movement of cultural innovation, a given practice of aesthetic revolt could be valued as one among many converging contributions to an indefinable but forward-moving cultural revolution.

Event Scores for a Cultural Revolution:
An Anthology and *Notations*

In 1961, as a special issue of the West Coast magazine *Beatitude West*, the composer La Monte Young and the poet Jackson Mac Low gathered together a number of scores, scripts for Fluxus events, and experimental dance pieces, essays, and poetry. The collection was published in 1963 under the title *An Anthology* (figure 5.1) and was republished in a slightly expanded form in 1971.[17] This work became extremely influential, as it publicized and generalized the interdisciplinary collaboration of artists working across media of visual arts, film, music, literature, dance, and theater, with their work converging not only in common performances in certain gallery spaces and venues, but also in a new interest in scripts and scores requiring substantial interpretation and choice from the performers. Although its genesis was only partially connected to the influence of John Cage, *An Anthology* can nevertheless be legiti-

```
AN ANTHOLOGY AN ANTHOLOGY AN ANTHOLOGY AN ANTHOLOGY AN ANTHOLOGY
AN ANTHOLOGY AN ANTHOLOGY AN ANTHOLOGY AN ANTHOLOGY AN ANTHOLOGY
AN ANTHOLOGY AN ANTHOLOGY AN ANTHOLOGY AN ANTHOLOGY AN ANTHOLOGY
AN ANTHOLOGY AN ANTHOLOGY AN ANTHOLOGY AN ANTHOLOGY AN ANTHOLOGY
AN ANTHOLOGY AN ANTHOLOGY AN ANTHOLOGY AN ANTHOLOGY AN ANTHOLOGY
AN ANTHOLOGY AN ANTHOLOGY AN ANTHOLOGY AN ANTHOLOGY AN ANTHOLOGY
AN ANTHOLOGY AN ANTHOLOGY AN ANTHOLOGY AN ANTHOLOGY AN ANTHOLOGY
AN ANTHOLOGY AN ANTHOLOGY AN ANTHOLOGY AN ANTHOLOGY AN ANTHOLOGY
AN ANTHOLOGY AN ANTHOLOGY AN ANTHOLOGY AN ANTHOLOGY AN ANTHOLOGY
AN ANTHOLOGY AN ANTHOLOGY AN ANTHOLOGY AN ANTHOLOGY AN ANTHOLOGY
AN ANTHOLOGY AN ANTHOLOGY AN ANTHOLOGY AN ANTHOLOGY AN ANTHOLOGY
AN ANTHOLOGY AN ANTHOLOGY AN ANTHOLOGY AN ANTHOLOGY AN ANTHOLOGY
AN ANTHOLOGY AN ANTHOLOGY AN ANTHOLOGY AN ANTHOLOGY AN ANTHOLOGY
AN ANTHOLOGY AN ANTHOLOGY AN ANTHOLOGY AN ANTHOLOGY AN ANTHOLOGY
AN ANTHOLOGY AN ANTHOLOGY AN ANTHOLOGY AN ANTHOLOGY AN ANTHOLOGY
AN ANTHOLOGY AN ANTHOLOGY AN ANTHOLOGY AN ANTHOLOGY AN ANTHOLOGY
AN ANTHOLOGY AN ANTHOLOGY AN ANTHOLOGY AN ANTHOLOGY AN ANTHOLOGY
AN ANTHOLOGY AN ANTHOLOGY AN ANTHOLOGY AN ANTHOLOGY AN ANTHOLOGY
AN ANTHOLOGY AN ANTHOLOGY AN ANTHOLOGY AN ANTHOLOGY AN ANTHOLOGY
AN ANTHOLOGY AN ANTHOLOGY AN ANTHOLOGY AN ANTHOLOGY AN ANTHOLOGY
AN ANTHOLOGY AN ANTHOLOGY AN ANTHOLOGY AN ANTHOLOGY AN ANTHOLOGY
AN ANTHOLOGY AN ANTHOLOGY AN ANTHOLOGY AN ANTHOLOGY AN ANTHOLOGY
AN ANTHOLOGY AN ANTHOLOGY AN ANTHOLOGY AN ANTHOLOGY AN ANTHOLOGY
AN ANTHOLOGY AN ANTHOLOGY AN ANTHOLOGY AN ANTHOLOGY AN ANTHOLOGY
AN ANTHOLOGY AN ANTHOLOGY AN ANTHOLOGY AN ANTHOLOGY AN ANTHOLOGY
AN ANTHOLOGY AN ANTHOLOGY AN ANTHOLOGY AN ANTHOLOGY AN ANTHOLOGY
AN ANTHOLOGY AN ANTHOLOGY AN ANTHOLOGY AN ANTHOLOGY AN ANTHOLOGY
AN ANTHOLOGY AN ANTHOLOGY AN ANTHOLOGY AN ANTHOLOGY AN ANTHOLOGY
AN ANTHOLOGY AN ANTHOLOGY AN ANTHOLOGY AN ANTHOLOGY AN ANTHOLOGY
AN ANTHOLOGY AN ANTHOLOGY AN ANTHOLOGY AN ANTHOLOGY AN ANTHOLOGY
AN ANTHOLOGY AN ANTHOLOGY AN ANTHOLOGY AN ANTHOLOGY AN ANTHOLOGY
AN ANTHOLOGY AN ANTHOLOGY AN ANTHOLOGY AN ANTHOLOGY AN ANTHOLOGY
AN ANTHOLOGY AN ANTHOLOGY AN ANTHOLOGY AN ANTHOLOGY AN ANTHOLOGY
AN ANTHOLOGY AN ANTHOLOGY AN ANTHOLOGY AN ANTHOLOGY AN ANTHOLOGY
```

FIGURE 5.1

La Monte Young and Jackson Mac Low, Cover, *An Anthology*.

mately seen as significant evidence of the generalized impact of Cage's aesthetic and playful anarchism on the art world, and not solely on musicians.

The book itself is designed as a sort of montage work, not only insofar as it juxtaposes work in different media by a range of artists, but also materially: it uses a number of nonstandard typographical formats, incorporates colored construction paper pages and folded inserts, and even contains envelopes holding further formats such as note cards (as in "Composition 1960 #9" by La Monte Young, an event score composition). The suggestion is both whimsical and multidimensional, making the book appealingly playful to page through, as when one suddenly comes across an unexpected insert or foldout or enigmatically formatted page. In one sense, the work is a paradigmatic, early example of what would become known as conceptual art (and one of the Fluxus-associated artists, Henry Flynt, in fact coined the term "concept art"). As with conceptual art, moreover, although graphics and drawing are certainly not absent from *An Anthology*, and while the typography tends to lend its words an ideogrammic, figurative quality, verbal language actually predominates here over the visual. In some cases, the verbal scripting emphasizes the conceptual nature of the work, while in other cases, it highlights the gap between the linguistic materials of the composer's instructions and its embodied realization by the performers. The abstract, even paradoxical or absurd, character of the instructions stands in a productive, ambiguous ten-

FIGURE 5.2
La Monte
Young and
Jackson Mac
Low, Inside
page from
An Anthology.

sion with the need to realize the script in concrete objects, bodily gestures and actions.

The book, too, might be seen as a kind of analogue of a space of artistic activity taking place through the creative play of a community: as a prefigurative instance of what, following Raunig, I would characterize as the juncture between the "insurrectional" moment of action and the "constitutive power" of a new collective. Visual artists, musicians, poets, and dancers communicate and intermingle in its pages, taking inspiration from one another and from their commonalities, which the abstraction of language allows to come to the fore in the virtuality of the anthology, before it has been differentiated and concretized by different artistic practitioners working in their materially distinct media and disciplines. As one of the inner-cover pages (figure 5.2) indicates, the anthology is intended as a space in which "music, poetry, actions, dance pieces, mathematics, stories, diagrams, and essays" interconnect and interact in surprising but productive ways. It prefigures a utopian community to come, a community of an aesthetically transfigured life practice typical of the avant-garde. Yet this passage through language also suggests that this community is traversed by a paradoxical trace, as the utopian community to come will have already happened as an event of language and graphic signs, opening an ontological interval of spacing and deferral between the

text on the page and sounds, movements, and objects occupying real space and duration.[18]

In general, La Monte Young was identified as a musician, developing through his "Theatre of Eternal Music" his characteristic interest in drones and harmonics played for very long durations. This led to collaborations with artists such as John Cale, who went on to cofound the Velvet Underground, and Tony Conrad, who was important both as a musician and as a structuralist filmmaker, with his stroboscopic film *Flicker* (1966). In an essay accompanying the 1996 release of *Four Violins* (1964), one of his early works with Young, Conrad set out three ways in which the challenge to modernist conceptions of the scored composition were being challenged by neo-avant-garde practices of the 1960s that took inspiration from key artists such as Cage, the Fluxus movement, and the Warhol Factory. Conrad's essay also applies broadly to the "cultural revolutionary" dimensions of the field of activities and specific personalities embraced by the Young–Mac Low anthology. One can discern in Conrad's account the interaction of the moments of resistance, insurrection, and constitutive power within the countercultural aesthetic revolt of himself and his friends:

> There were three pathways that made sense to the performers of "Dream Music," or the "Theatre of Eternal Music," or "Dream Syndicate," as I sometimes called it. . . . The first was the dismantling of the whole ediface [*sic*] of "high" cultures. Also around this time, I picketed the New York museums and high-culture performance spaces with Henry Flynt, in opposition to the imperialist influences of European high culture. . . . At the time I was also part of the "Underground Movie" scene, which as I saw it reconstructed the movies as a documentary form—a merging of life-aims with movie production.
>
> Other counter-cultural components of the Dream Syndicate picture were our anti bourgeois lifestyles, our use of drugs, and the joy which John Cale and I took in common pop music. Down this pathway there were other fellow-travellers, like Andy Warhol and Lou Reed; it led straight to the Velvet Underground, and the melting of art music into rock and roll.
>
> The second solution was to dispense with the score, and thereby with the authoritarian trappings of composition, but to retain cultural production in music as an activity. . . . It would . . . be structured around pragmatic activity, around direct gratification in the realization of the moment, and around discipline. . . .

. . . Our work was exercised "inside" the acoustic environment of the music. . . . Much of the time, we sat inside the sound and helped it to coalesce and grow around us.

In keeping with the technology of the early 1960s, the score was replaced by the tape recorder. This, then was a complete displacement of the composer's role. . . .

The third route out of the modernist crisis was to move away from composing to listening, again working "on" the sound from "inside" the sound.[19]

Along with this work with musicians such as Conrad and Cale, La Monte Young was also a pioneer of the sort of event score compositions that were also being explored by Fluxus artists such as George Brecht.[20] Printed on a page of event scores by Young in *An Anthology* are a diversity of event "sub-genres": some of them are Dadaistically theatrical, such as feeding a piano a bale of hay; others are performative in other ways, such as drawing a line and following it; one is unconventionally, but recognizably musical; while others appear more like haikus or Zen koans. The book programmatically suggested the obsolescence of traditional generic and medium designations: textual, visual, sonorous, and performative or gestural elements were all possible elements of poetry, music, dance, and performance, and hence none of these could be defined by reference to a definite sensual material. Implicitly, Young and Mac Low were pointing to the post-Cagean intertranslatability of artistic media into one another and the essentially nominalistic exercise of calling a given work poetry or music as opposed to, say, graphic art or dance. Dieter Rot's contribution was a kind of stencil device for producing a concrete poem from any text on which it might be set—although one could imagine just as easily making a musical composition out of a musical score or a visual selection out of a drawing. The principle is one of an arbitrary, deskilled, and horizontally "populist" interaction with neighboring text or image environments. The new creative "work" derives from erasure, selective extraction, and dynamic choice exercised on the existing cultural legacy, deposited in texts. In analogy to Tony Conrad's idea of replacing composition with listening, as well, Rot's device is a reading machine, producing "readings" rather than composing poems.[21]

In 1969, John Cage and Alison Knowles published an anthology of music manuscripts entitled *Notations*; it was issued by the Something Else Press, directed by Fluxus artist and intermedia theorist Dick Higgins. The collection of the manuscripts was inspired by the Mac Low and Young anthology

and was a benefit for the Foundation for Contemporary Performance Arts. In format, it is more uniform materially—it exhibits none of the ragged collage aspects of *An Anthology*—but it more consistently represents the textual aesthetic that Cage developed in his own books, such as his influential volume, *Silence*. He and Knowles attempted to allow the book to respond to the contingencies of circumstance and helped this process along with injections of arbitrary, nonhierarchical criteria of arrangements such as alphabetics and chance methods.

Thus the manuscripts are not grouped according to notational type, style, or other technical or aesthetic criteria, but solely according to the alphabetic position of the composer's name. The works appear without further informational text other than composer's name, title, and sometimes date. Brief texts do accompany the manuscript scores, but these texts are arbitrarily selected and arranged according to chance methods. Hence, they are not commentaries on the score, but fragments of a larger discourse about notation and composition, which is of equivalent status with the scores, samples of the total musical discourse of the present. To emphasize this independence of the text from any direct, intended commentary function, Cage even subjected typography and other elements of graphic design to chance selection: "Not only the number of words and the author, but the typography too—letter size, intensity, and typeface—were all determined by chance operations. This process was followed in order to lessen the difference between text and illustrations."[22] Here Cage's editorial procedure was consistent with other instances in which he sought to ensure the "non-obstruction and interpenetration"[23] of compositional elements in a complex, nontotalized whole. But an analogous conception in Cage, which indicates more the (potentially anarchist) social analogue of such compositional outcomes, is that of *neighboring*, the free association of different elements in contiguous relationship, but not reduced to a unifying governance by a concept, form, or authority. Thus Cage once indicated, with characteristic humor, that his two passionate pursuits in life, musical composition and mycology, had derived from a contingent neighboring relationship of words: "Music and mushrooms: two words next to one another in many dictionaries."[24] Artistic neighboring offered a model of open, additive, nonreductive patterning through side-by-side relations developing in time. So too, in Cage's anarchistic faith, social neighboring might follow from an extension of the modes of individual free thinking, modeled and stimulated by this sort of art practice, into the realm of everyday life and dwelling.

Mac Low and Young's *An Anthology* had played between presenting its scores and texts as individual works and offering itself as a composite montage work whose medium was print and paper, text and graphics. Its use of different papers and heterogeneous inserts underscores the potential detachability of the individual work from the collective "whole"—or, alternatively, the openness of the whole to further supplementation and change. Indeed, one can imagine someone performing different, singular selections of events out of *An Anthology* in an evolving repertoire of new realizations. Cage's *Notations*, by contrast, tends to become an autonomous and whole work of printed, published art: a book composed of graphics and texts, arranged in a consistent way by chance methods. It is more unified, and in a way more traditional, than *An Anthology*, which more evidently exhibits the insurrectionist impulses of the avant-garde.

Nevertheless, Cage's work also profits by this greater coherence, as an artistic figuration of his social thinking, which emphasized creativity and interaction of individuals within a peaceful, anarchist cooperative relationship. One catches a glimpse of this possibility in Cage's sidelong reference to a social order in the preface, where he offers the following metaphor to explain the lack of explanatory text: "A precedent for the absence of information which characterizes the book is the contemporary aquarium (no longer a dark hallway with each species in its own illuminated tank separated from the others and named in Latin): a large glass house with all the fish in it swimming as in an ocean."[25] Cage combines here, in a witty image of an achieved aesthetic revolution, the idea of community (having overcome their isolation, which derived from their being displayed as individual cases of precious beauty, all the species swim together and create a more open, fluctuating beauty) and the idea of unconstrained freedom (they swim without bumping into glass walls, as in an ocean). Cage even draws on the imagery of the architectural utopia that excited the dreams of modernists from Mies van der Rohe to Walter Benjamin to André Breton: the glass house. The book *Notations*, then, presents itself as a work of utopian architecture where all the beautiful fish of musical creativity can be collectively housed and neighbored: the blank covers, almost untainted by text, figure the transparent walls that exhibit this rich fauna, yet allow it to intermingle freely.

Cage and Knowles's *Notations* is less programmatically interartistic than Young and Mac Low's *An Anthology*, but its practical effect is analogous. It points to the rich intertranslatability of musical, graphic, textual, and performative forms of notation, in essence rendering composition a non-medium-specific form of organizing sensual experience—such as was also represented

in Stan VanDerBeek's appropriately experimental, multimedial film of Cage's *Variations V* (1966). This comprehensive and general approach to *experience* as the object of collective artistic activity—hence too, by extension, the potential for experience to be shaped and transformed by collective action—is, I would argue, the single most important characteristic common to all positions within the U.S. aesthetic revolution of the 1960s.

The artist-composers, performers, and poets collected by Young / Mac Low and Cage/Knowles developed a new medium of polysemiotic notation, mixing images or graphics with text instructions and musical notation, toward a utopian reconception of everyday experience in ordinary spaces. Each work, with its concrete compositional features, implies a singular configuration of score and work, visuality and aurality, simultaneity and sequentiality. However, it is possible to generalize that notations, as these anthologies conceived them, are not merely the abstract precursor form of a performed musical or sound work, but also themselves a medium of imaginative practice and experiment with the grammar, logic, and shape of *holistic aesthetic experiences* and *possible life-situations*. Although actual performances—nominally "music," "dance," "theater," and "poetry"—might be based on notational scores, the scores as graphic materializations also had an autonomous, intensive performative dimension as well, which might even predominate in some cases. As Cornelius Cardew notes in his *Treatise Handbook* about such works, "The sound should be a picture of the score, not vice versa."[26] Hence, as Tony Conrad suggests, these works challenged the hierarchical relation of performance and score characteristic of traditional musical, dance, and theater notation, in favor of a new total aesthetic dialectic of imagination, material practices of *écriture* and drawing, sound, and performance.

This holistic approach to the sensory and sensuous environment of experience is, I would suggest, paradigmatic for the 1960s American avant-garde. In some cases, the intentional pursuit of such experiential holism was the very driving force from which a set of technical artistic implications were derived. This was the case for some of the neo-Dada Fluxus work discussed above, as well as the performance-oriented work of the early 1960s taking place around the Judson Dance Theater and the Living Theatre (these scenes overlapped and interacted with each other to a significant extent). In other cases, in contrast, as with minimalism and the pop art of Andy Warhol's Factory period, this holism was the outcome of an inner-artistic logic: the developmental dynamics of art practices within a medium or in the corpus of a particular artist arriving at a utopian transcendence of medium- and even art-specificity in favor of an aesthetic revolutionary holism.

Aesthetic Revolution and Erotic Liberation

One possible form this transcendence could take was the heightening of artistic multisensuality into a pan-eroticism, in which the aesthetic intensities of an art or performance experience are desublimated into a directly libidinal experience. Artists employed their bodies, along with those of collaborators and audience members, in a double mode: as artistic implements for objectifying the artistic-erotic experience and, simultaneously, as the sensitive recipient of the erotic textures (visual, sonorous, tactile, olfactory, kinesthetic, etc.) of the work. Implicitly, the artwork became paradoxically "intransitive," at once "autonomous" (insofar as eroticism has its own goals and values) and anything but distantiated and disinterested or localizable as a strictly "artistic" experience. Moreover, insofar as eroticism engaged emotionally charged domains of extra-artistic "life," such works could be understood as experimental means for exploring alternative sexualities, gender roles, and forms of communal power and differentiation. Finally, these works emphatically posed the question of affective states such as pleasure and pain with respect to aesthetic experience, which traditionally depended on the sublimation and mitigation of more intense bodily affects.

The 1960s in the United States saw an important convergence between two streams of "avant-garde" thought, both focused on bodily experience and the characteristics of the embodied sensorium. On the one hand, the progressive liberalization of sexual mores, the loosening of rigid gender roles, and a greater degree of social and legal tolerance for a range of erotic expression focused new attention on the sexual experiences of the body.[27] On the other hand, as a result of various new, phenomenologically undergirded artistic practices—performances and happenings, Cagean explorations of nonmusical sound and silence, popular and elite uses of electronic technologies in music, minimalist concerns with specific objects and spatial environments—increasing creative and critical attention was being paid to sensuous bodily sensation as a primary constituent of aesthetic experience. Under the influence of a growing experimentalism in the arts, a social climate of affluence generating countercultural phenomena with accelerating speed, and an increasingly articulate body of theoretical works being read and discussed in artistic and countercultural circles, it was accordingly only a matter of time until bold new interests in sexual expression came to be conjoined with and articulated through the experimental genres of the artistic avant-garde.

Exemplary of this convergence is a single line that performance artist and filmmaker Carolee Schneemann wrote in her notebook in 1963: "Sexual damming is expressive damning."[28] In another entry Schneemann expounds a

bit more, arguing that artistic expressivity and the capacity for a sort of emotional authenticity are, in her view, directly connected: "Capacity for expressive life and for love are insolubly linked; that was my understanding when I taught; saw immediately facing the individuals in a class what their chance for expressive work was and its direct relationship to their social/sexual and emotional life."[29]

In one respect, this is hardly an original observation. It reiterates a view of expressive creativity that dates back to European romanticism, in which, in M. H. Abrams's classic image, the artistic mind as the "mirror" of reality was supplanted by a new metaphor, the mind as "lamp" that projects its illumination onto the artistic canvas or page. Of interest here, however, is the peculiar nature of that romantic lamp for a wide range of artists and aesthetic thinkers in the American 1960s (and, of course, not just in the United States). It is an artistic lamp fueled by libidinal energy, in a desublimated and relatively direct form: a lamp of romantic expressivity shaped by Freudian and post-Freudian theories of the unconscious; touched by the newly disinhibited popular culture of the 1960s, including the youth counterculture and the experience of rock music and drug experimentation; and sparked by sexual liberationist thinking from heterodox intellectuals ranging from the radical psychoanalyst Wilhelm Reich and anarchist Paul Goodman to the Freudo-Marxist philosophers Norman O. Brown and Herbert Marcuse.

I do not wish to linger over whether this is a correct aesthetic theory as such, nor will I be able to survey and evaluate in any serious way the corpus of art that was produced by those holding it. My aim, rather, is narrower: to consider how such an aesthetic came to be formulated, embedded in artistic as well as popular culture, and made productive for a number of artists engaged in the aesthetic revolution of the American 1960s. This conjunction was, of course, part of a much broader tendency challenging the formalist theories of artistic autonomy that constituted the dominant critical framework by which avant-garde artistic practice had been legitimated in the 1950s and through the later 1960s, from the influential writings of Clement Greenberg through the neo-Greenbergian orthodoxy of the early *Artforum*.[30] The dovetailing of transmedial avant-garde artistic practices with cultural revolutionary ideas of sexual liberation offered an emotionally charged way for artists to assert that their work, in transcending the bounded medium—especially painting—had opened onto a utopian threshold of a fully actual new sensibility wider than but also continuous with art.[31] In one respect, the task of this erotic antiformalism was critical and iconoclastic: "I had to get that nude off the canvas, frozen flesh to art history's conjunction of perceptual erotics and an immobi-

lizing social position" (Schneemann).[32] Yet it also projected a radical heightening and extension of the senses in ways that go beyond artistic experience as such, to adumbrate an erotic reconstitution of everyday social experience. Schneemann, for example, described this as a process of entering the image and being activated by it. Her formulation embraces both the popular culture images of the mass media as well as the artistic images she was painting, filming, performing, and installing as spatial-experiential environments: "We were being moved, we were being affected by images bringing information that was startling and taboo and terrible and made you convinced you had to do something. To enter the image itself! Activation as an intervention into the politics behind the revelatory images."[33] "Activation," in Schneemann's sense, entailed a new sort of image-mediated, aesthetic-political implication of the individual in the social, which had, however, been already anticipated in the theoretical reflections of heterodox avant-garde theorists of the 1920s and 1930s, such as Walter Benjamin in his essay on surrealism and his cultural history of nineteenth-century Paris, the *Arcades Project*.[34]

To help put this issue in closer theoretical focus, I will dwell briefly on some motifs in the work of the Frankfurt school philosopher Herbert Marcuse, very much the New Left thinker of the hour in relation to the 1960s countercultural revolt and demands for sexual liberation. Not primarily, in a strict sense, an aesthetician or art critic—as were, for example, his Frankfurt school colleagues Walter Benjamin, Theodor Adorno, and Leo Lowenthal— Marcuse nevertheless wrote important works that touched on the social significance of the "aesthetic" in a broader sense. The question of artistic culture, but still more generally the full social domain of sense and sensibility, of sensuous experience as both a collective and an individual structure, including that of eroticism, were central to Marcuse's thought. The art critic Gregory Battcock, in fact, explicitly claimed Marcuse as *the* aesthetic theorist of the postformalist artistic radicalism of later 1960s and early 1970s: "Just as Clement Greenberg became the major aesthetic definer of Abstract Expressionist and Minimal Art, we discover that a *political* philosopher, Herbert Marcuse, became the major *aesthetic* definer of a new kind of art."[35] Aside from its widespread influence on countercultural thought in the student movements of both the United States and Europe, through the interest of critics such as Battcock and Ursula Meyer, among others, Marcuse's thought thus also had some direct impact on New York–based art scene of the later 1960s.[36]

The motif in Marcuse's work of an erotically transformed sensibility, a revolutionized and re-embodied "aesthetic" of which artistic practice is a

kind of anticipatory recollection, is closely tied to his revisionary reading of psychoanalysis in the mid-1950s in his book *Eros and Civilization*, especially with respect to Freud's speculations on culture and instinctual repression. Marcuse's call in the 1960s to break through the one-dimensional world of commodified experience and to liberate the senses in a new, utopian framework of collective and individual enjoyment was clearly indebted to his ideas of polymorphous perversity and the affirmation of eros expounded in his earlier critique of Freud. Thus, for example, in his 1966 "Political Preface" to his rereleased *Eros and Civilization* (originally published in 1955), Marcuse reiterated his emphasis on the liberation of bodily needs, including the expression of previously repressed or frustrated forms of sexuality: "'Polymorphous sexuality' was the term which I used to indicate that the new direction of progress would depend completely on the opportunity to activate repressed or arrested *organic*, biological needs: to make the human body an instrument of pleasure rather than labor. . . . The emergence of new, qualitatively different needs and faculties seemed to be the prerequisite, the content of liberation."[37]

If one were to ask how these could be actualized as play and just what this play might look like, however, we might easily conclude that Marcuse's ideas resonate with analogous utopian experiments explored throughout the 1960s by the artistic avant-garde, particularly in the sphere of taboo-shattering theater, performance, and experimental film.

Liberationist neo-avant-garde artworks might, in light of Marcuse's liberationist theory, accordingly be seen as offering prefigurative working models of cultural revolutionary resistance to repressive values and structures, outlining new forms of insurrectionary action, and projecting the emergent constitutive power of a new, utopian collective order. Thus Carolee Schneemann, for example, created a number of performance and film works in the mid-1960s that depicted, with a high degree of literal explicitness, acts of individual and group sex. These include, most famously, her performance-dance piece *Meat Joy* (1964) and her film *Fuses* (1965). As Schneemann explained,

> *Meat Joy* has the character of an erotic rite: excessive, indulgent, a celebration of flesh as material: raw fish, chicken, sausages, wet paint, transparent plastic, rope, brushes, paper scrap. Its propulsion is toward the ecstatic—shifting and turning between tenderness, wildness, precision, abandon: qualities which could at any moment be sensual, comic, joyous, repellent. Physical equivalences are enacted as a psychic and imagistic stream in which the layered elements mesh and gain intensity by the energy complement of the audience. . . . Our proximity height-

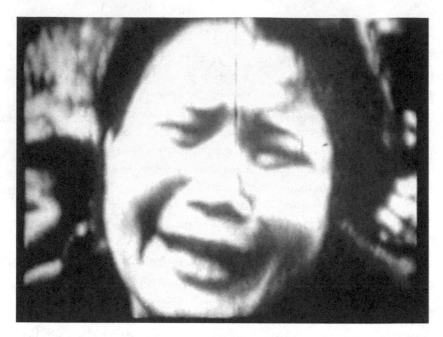

FIGURE 5.3 Carolee Schneemann, Frame from *Viet-Flakes*.

ened the sense of communality, transgressing the polarity between per-
former and audience.[38]

Notably, Schneemann was also a highly politicized artist, especially en-
gaged in resistant protest against the Vietnam War through contemporaneous
works such as her film *Viet-Flakes* (1966) (figure 5.3) and her "kinetic theater"
piece *Snows* (1967), both of which utilized atrocity photographs from the war
in Indochina as image materials. Just as *Meat Joy* encompassed the individual
within an orgiastic mingling of bodies, so too *Snows* was immersive, but in a
frightening and horrifying way: "We were actually frightened in *Snows*. The
experience was all-enveloping, making us aware of the audience as an exten-
sion of ourselves, but not of ourselves in self-conscious presentation. Walking
the planks was dangerous, and the central imagery of *Viet-Flakes*, once fully
apparent as dire and agonizing, confounded our own pleasurable expecta-
tions and collaborations within the glistening white environment."[39]

One can think of these various works as representing complementary, if
antithetical, depictions of the individual female body as the pivot between
collective suffering and pleasure, between resistance and new forms of con-
stitutive power, between the enactment of a critique of repression and vio-
lence on the one hand, and positive utopian projection of a new, liberated

social community on the other.[40] Moreover, if *Viet-Flakes* and *Snows* exhibited the individualized, damaged body suffering the onslaught of military violence, *Meat Joy* and *Fuses* built up a collective image of liberation through the intensities of the body experiencing erotic pleasure: "In the mid-sixties, when I began my film *Fuses* and the performance *Meat Joy*, I was thinking about 'eroticizing my guilty culture.' I saw a cultural task combined with a personal dilemma. My work was dependent on my sexuality—its satisfaction, integrity. I couldn't work without a coherent sexual relationship—that fueled my imagination, my energies. My mind works out of the knowledge of the body."[41]

Similar polarities between the suffering body in protest and the orgiastic body in erotic enjoyment also marked the influential performance works of Julian Beck and Judith Malina's Living Theatre.[42] Works such as *The Brig* (1963), set in a military prison, and *Frankenstein* (1966) subjected audiences to a visceral experience of contemporary culture's repressive sadomasochism. By contrast, *The Mysteries* (1964) and *Paradise Now* (1968) celebrated collective erotic revolt, inviting audiences to experience in a physically participatory way the company's "paradisal" celebration of bodies communing in sexual pleasure (figure 5.4). In a special issue of the *Drama Review* dedicated in 1969 to the return of the Living Theatre from five years in Europe to the United States, critic Stefan Brecht explained the Living Theatre's dialectical, cultural revolutionary project in terms of a psychoanalytically inflected ritual of inducing collective psychic crisis and reconstruction:

> The "ego" of the normal neurotic is to be destroyed, his natural spiritual powers to be liberated. Three schemata seem operative. A chain-reaction is expected from a direct attack on the ego. The destruction of inhibitions is to free creative functions, which then gather their own psychic energies. And/or: the audience's spontaneity is to be triggered, if necessary by provocation into antagonism or defense: the volitional energy mobilized might disintegrate the ego, might mobilize the natural spiritual powers. Or, finally, libido, imagination, love might be attacked directly, their stimulation resulting in de-inhibition and in a mobilization of autonomous energy. The Living Theatre seems to be trying a little of each, not just the last as some gentle admirers might have expected.[43]

Informed especially by a politicized, utopian reading of Antonin Artaud and Wilhelm Reich, the Living Theatre sought to constitute, through a theatricalized communication with their audiences, a new erotic free association of

FIGURE 5.4 Living Theatre, Frame from *Paradise Now.*

liberated individuals, adumbrating the experiences and forms of an anarchistically free society.

Interestingly, however, Marcuse consistently expressed his ambivalence toward those very artworks and artistic tendencies that would appear to actualize his ideas in collective praxis and the production of aesthetically transfigured objects. Even in *An Essay on Liberation*, where he called for a utopian reinvention of society along aesthetic lines, Marcuse at the same time stubbornly defended the autonomy of art: "The wild revolt of art has remained a short-lived shock, quickly absorbed in the art gallery, within the four walls, in the concert hall, by the market, and adorning the plazas and lobbies of the prospering business establishments. . . . Transforming the intent of art is self-defeating—a self-defeat built into the very structure of art. . . . The very Form of art contradicts the effort to do away with the segregation of art to a 'second reality,' to translate the truth of the productive imagination into the first reality."[44]

In a 1969 address at the Guggenheim Museum in New York titled "Art as Form of Reality," Marcuse criticized "antiart" tendencies and singled out the Living Theatre as a mode of art which, though intended to attack ideological illusion, ended up deepening it. By 1972, his criticisms of the Living

Theatre's liberationist spectacle would become even more pointed. Directly referencing Malina and Beck's *Paradise Now: Collective Creation of the Living Theatre*, Marcuse wrote: "The Living Theatre may serve as an example of self-defeating purpose. . . . The radical desublimation which takes place in the theater, *as* theater, is organized, arranged, performed desublimation—it is close to turning into its opposite."[45] Like the Situationist leader Guy Debord, Marcuse harbored a keen suspicion of the possibility that cultural radicalism might be coopted to ("merely") aesthetic ends, that extreme revolutionary sentiments might be ritualized as a pleasurable yet harmless transgression of bourgeois norms, and that spontaneous mass revolt could be frozen in spectacular forms. *Art*, for Marcuse, paradoxically functioned as an apotropaic protection against such socially conservative *aestheticization*. In its deployment of semblance and form, art makes no disguise of its estrangement from reality and hence remains closer to dialectical, critical, or speculative truth (i.e., "two-dimensional" thought) than "antiart" or "living theater." Neo-avant-garde liberationist art collapses the distinction between positive reality and artistic reality, hence lapsing into the complementary errors of positivist immediacy and mysticism.

Notably, Marcuse's most prominent interpreter for the art world, Gregory Battcock, was critical of the philosopher's conservative taste in art, while nonetheless championing the aesthetic revolutionary implications seemingly entailed by his unorthodox Freudo-Marxism. In particular, Battcock played an important role in salvaging Marcuse for an antiformalist and "cultural revolutionary" program that Marcuse himself specifically disavowed. Marcuse rejected "antiart" and "antiform" practices in favor of the "determinate negation" that he discerned in classic art and formalist modernism; he also rejected all attempts of the arts to lower the boundaries of art's specificity with respect to everyday, commercial, and political culture. In doing so, as Battcock puts it, "Professor Marcuse has relegated virtually all contemporary art forms (cinema, literature, art, and music) to the realm of anti-form, thus inhibiting radical revamping of the bourgeois tradition."[46] He also, according to Battcock, fails to see that the forms of the broader culture—such as rock music—"do possess an educational energy that, in some ways, have been [*sic*] the most effective stimulators of the emerging cultural revolution."[47] Battcock was, I would suggest, doing something more here than simply broadening out the canon of artistic taste from Marcuse's rather classical one. Despite his evident lack of theoretical sophistication compared to Marcuse's learned subtlety, Battcock offered an important corrective to the Frankfurt school philosopher's aesthetic theory: embracing the neo-avant-garde, countercul-

tural "living art" Marcuse was not able to accept, Battcock sought to rebridge the theoretical divide that Marcuse had installed between art and insurrection, between art and emerging communal forms of constitutive power.

Cultural Revolution and Culture Industry: Warhol, the Velvet Underground, and the Exploding Plastic Inevitable

This latter nexus, between the broader (counter)cultural sphere and neo-avant-garde arts, was connected to a complex set of factors including the increasing importance of the mass informational and entertainment media, the unleashing of the dynamics of consumer capitalism at an unprecedented scale, and the emergence of new "lifestyle" and existential concerns through the upsurge in affluence and an ever-widening access to higher education in American society. In this respect, although both Marcuse and Battcock were analyzing some of the same cultural trends, one can say that with respect to the arts in the 1960s, Battcock's estimation of the socially transformative force of popular, commercial culture was more attuned to the cultural revolutionary trend of the later 1960s and early 1970s than Marcuse's relatively tame conception of artistic culture's implicit utopian and critical potential. Moreover, as Battcock recognized from his embedded position within the New York art world, the blurring of the line between art and the larger sphere of culture was already a fait accompli. Art practice was already consorting promiscuously with apparently nonartistic culture, and often in *artistically* productive ways. To attempt to reverse this tendency would be both retrogressive and futile.

An exemplary instance of this productive interconnection of avant-garde artistic practice and the mass commercial culture of the American "culture industry" was the rock group the Velvet Underground, which managed to have an important impact in the art world and the rock world, at least retrospectively in the 1970s, when the two converged again in the "punk" aesthetic.[48] The Velvet Underground's recordings, in fact, can be understood as one of the bridges between cultural spheres and, ultimately, from the earlier 1960s scene to emergent tendencies in the 1970s.[49] John Cale, who had taken part in the drone music experiments with La Monte Young and Tony Conrad, joined Lou Reed, Sterling Morrison, and Maureen Tucker to form the legendary band, which took its name from a pulp book on sadomachochism shown to them by Tony Conrad. In 1965, Andy Warhol became their manager and producer, more or less forcing the German-born model and actress Nico on the band as a lead singer; in turn, the Velvet Underground for a time became

something of the house band for Warhol's Factory. This was not just a case of one more group of freaks and hangers-on brought into the Warhol fold, but rather an authentic extension of the more critical and daring impulses of Warhol's pop art aesthetic and ethos. On the one hand, Warhol correctly perceived rock music as an important cultural site where American society was being expressed and transformed in symbolically significant ways—just as earlier, in his *Death and Disaster* series and related works, he had picked up on the photojournalistic reflection of everyday violence in the United States, from car crashes to suicides to capital punishment to racial oppression.[50] On the other hand, the Velvet Underground band members themselves were thoroughly immersed in a countercultural, bohemian, and, especially in the case of Cale, explicitly avant-garde aesthetic environment.

The most consequential convergence of these projects was represented by the multimedia happenings staged by Warhol between 1966 and 1967 called the Exploding Plastic Inevitable. These involved music by the Velvet Underground, lighting and projections of films by Warhol, dancing by Warhol group members such as Gerald Malanga and Edie Sedgwick, and in three interesting cases, further extensions into film, sound recording, and print media. A key document of the Exploding Plastic Inevitable is the short film by Ronald Nameth, which records an event in Chicago but also applies techniques typical of underground filmmakers such as Stan Brakhage—handpainting, optical printing, and other manipulations of the film stock—to simulate in the film medium the sensory assault of feedback, psychedelic lighting, gyrating bodies, and large quantities of mind-altering chemicals.[51] So too, in one of his own films, the epic-length, split-screen *Chelsea Girls* (1966), Warhol juxtaposed the scurrilous, spontaneously violent performance of a gay speed freak, the enraged "Pope Ondine," with the impassive melancholy of "Nico Crying" as Velvet Underground music swirls behind her and Exploding Plastic Inevitable lighting effects play rhythmically across her face and hair (figure 5.5). The incorporation of the Velvet Underground and Nico into the film was more than just a matter of incidental decor of the Warhol Factory. On the one hand, the typically decadent themes of the Velvet Underground's songs—full of drugs and frustration and underground sexuality—resonate with the socially marginal amphetamine users, drug dealers, dominatrixes, transvestites, and homosexual characters who occupy the other "rooms" of the Chelsea Hotel glimpsed in the film. On the other hand, some of the signature formal features of the film—the dramatic lighting of faces lingered over in close-up, including ambient lighting from street signs and passing cars—is elaborated in "Nico Crying" into a gorgeous, full-color, at times nearly abstract por-

FIGURE 5.5 Andy Warhol, Frame from *Chelsea Girls*.

trait of the blond fashion model-singer. Similarly, the Velvet Underground's low-volume cacophony in this sequence represents an artistic correlate of the ambient sound of New York City heard in the background in other segments. *Chelsea Girls* is at once one of Warhol's most psychologically and socially resonant films and one of his most visually accomplished, utilizing his deadpan, amateurish camera style to capture reiterated and extreme disintegrations of personalities on screen. The Velvet Underground and Nico's performance self-reflexively concludes Warhol's film by re-encapsulating all this psychic and affective disintegration in a single, synthetic artistic figuration.

Warhol also created an insert in the pop art issue of the art journal *Aspen*: a one-time, simulated underground newspaper entitled *The Plastic Exploding Inevitable* (figures 5.6 and 5.7).[52] The *Aspen* issue was an unbound collection of items in a hinged box designed by Warhol to look like a laundry detergent box, which also included a text by Velvet Underground singer Lou Reed and a vinyl record insert with a daring noise drone composition called "Loop" by John Cale. Other items in the box included reproductions of pop art paintings by various artists, proceedings of a conference in Berkeley on LSD, and flipbook versions of underground films, including Warhol's own *Kiss*. Although very much a work of Warhol and more generally of the 1960s ambiance, the pop art issue of *Aspen* is also clearly a covert homage and updating of Marcel Duchamp, with the underground publication *The Plastic Exploding Inevitable* replacing Duchamp's *The Blind Man*, and the laundry detergent box being Warhol's version of Duchamp's various boxes and valises containing portable copies of his œuvre.

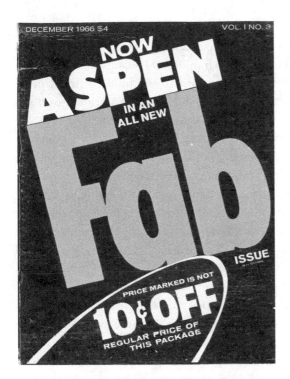

FIGURE 5.6 Andy Warhol, Cover of *Aspen* pop art issue.

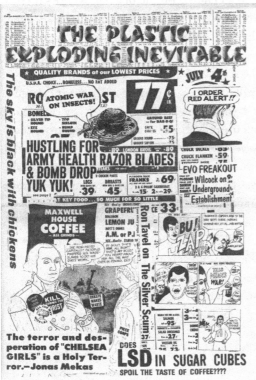

FIGURE 5.7 Andy Warhol, *The Plastic Exploding Inevitable*, insert to *Aspen* pop art issue.

The Velvet Underground also appeared in the so-called electric newspaper *The East Village Other*.[53] This recorded "publication" was released as a record album with cover text and included such things as "Gossip" by Warhol protégés Gerald Malanga and Ingrid Superstar, "Noise" by the Velvet Underground, jazz improvisation by Black Nationalist musician Marion Brown and his group, "Mantras" by Allen Ginsberg and Peter Orlovsky, a text by the Black Nationalist writer Ishmael Reed, and a piece entitled "Silence" (perhaps in homage to John Cage) by Andy Warhol for some reason bearing the improbable copyright date of 1932. Taken as an ensemble, *The East Village Other* represents the convergence of unlikely cultural-political allies—queer, white, and Jewish artists like Warhol and Ginsberg with Black Nationalists like Brown and Reed, free jazz with rock and roll, and so on—in an underground cultural revolutionary hegemony yet to be realized in the above-ground and extra-artistic world.

A later issue of *Aspen*, the minimalism issue, was a white box with materials edited and designed by artist-critic Brian O'Doherty in 1967.[54] This issue, taken together with the Warhol issue, exemplifies the ways in which the mediatization of the arts could establish equivalent relations between otherwise quite distinct neo-avant-garde tendencies: in this case between the "pop" association of art with commercial culture on the one hand, and American minimalism's connection with European historic and contemporary avant-gardes across media on the other. This issue included recordings from Samuel Beckett, Alain Robbe-Grillet, and William S. Burroughs, along with conceptual poetry by Dan Graham, the score for John Cage's *Fontana Mix* along with its recording and a Morton Feldman piece on vinyl record, excerpts from an abstract film by Hans Richter, *Lightplay* by László Moholy-Nagy (which created an abstract light-play from the reflections cast by a rotating metal sculpture), Robert Morris and Carolee Schneemann's dance piece *Site* as filmed by Stan VanDerBeek, a filmed performance by Robert Rauschenberg called *Linoleum*, a recorded set of interviews on vinyl with Merce Cunningham about his dance aesthetic, a recording of Marcel Duchamp's lecture "The Creative Act" and of Richard Huelsenbeck's Dadaist sound poetry, a project description by Sol LeWitt, and several other items. Once again, the image was one of a culturally transformative and promiscuous communication across the arts, accomplished by the gathering of them in a sort of three-dimensional anthology that extended those of Young / Mac Low and Cage/Knowles into fully multimedial environmental and performative assemblages.

Conclusion: Aesthetic Revolution from Action to Exemplarity

In conclusion, I would like to touch on the vexed problem of the *efficacy* of these neo-avant-garde artistic practices with regard to the project of a cultural revolutionary transformation of American society in the 1960s. As already suggested at the outset, the utopian hopes and aspirations attached to these experiments could prove sorely exaggerated. Although we may accept that neo-avant-garde artists modeled, or sought to model, new forms of resistance, insurrectionary action, and constitutive power in artworks of the 1960s — what good could this do, if they could only stand as aging maquettes of a never-constructed utopian city?

I have suggested elsewhere, however, that this way of posing the question, as an issue of political *actualization* of an ideological project, remains indebted to the artistic politics of the first, classical avant-garde and is subject to the same contradictions that doomed it to failure.[55] The utopian force of the 1960s neo-avant-gardes, I would however argue, is not exhausted by their analogy with and conscious reappropriation of the classical, politicized avant-gardes of the earlier part of the century. The neo-avant-gardes did not merely reiterate the classical avant-garde; they also revised it, precisely in the domain of artistic politics. I have characterized this revision as the shift from an artistic politics of ideological actualization to that of presenting "singular examples" of a new hegemony, founded in alternative ways of acting and experiencing our collectively shared worlds. Neo-avant-garde artworks, I suggest, are less likely to be assertive *instantiations* of an ideological position as "unique, one-time, anarchic *occasions* for any given member of the audience to experience a personal, aesthetic, and political awakening. Encouraging individual initiative and choice, they promote variants, deviations, and differences as the very texture of freedom in society."[56]

On the one hand, this entails that we demand too much of neo-avant-garde works if we expect them, like the ideological programs of political parties, to be judged on the criterion of their success in being actualized historically, as new social forms and institutions. On the other hand, requiring of them a mode of political efficacy they cannot but fail to deliver, we blind ourselves to their persistence, long after the 1960s have passed into history, in continuing to bring singular examples of new structures of experience before our present-tense attention, critical reflection, and sensory intuitions. It is this, too, that allows neo-avant-garde artworks of the U.S. 1960s to persist as traces of alterity in a present that seemingly precludes all thoughts of radical political, cultural, sexual, and artistic revolution. It is their very incompletion in the 1960s, I would suggest, that still lends them the deferred force

of singular examples, speaking of missed revolutionary possibilities decades after their original advent in the world.[57]

NOTES

1. Charles Taylor, *Modern Social Imaginaries*, 26, 25.

2. For a survey of the different historical senses of the term "cultural revolution," see Jameson, "Cultural Revolution."

3. See Raunig, *Art and Revolution*.

4. Burn, in Alberro and Stimson, *Conceptual Art: A Critical Anthology*, 393–94.

5. I have already mentioned Raunig's work, which draws from Negri and Hardt and Deleuze: see, e.g., Deleuze and Guattari, *Anti-Oedipus*; Hardt and Negri, *Empire*. An even more significant model, in my opinion, is Ernesto Laclau's work on the politics of populism: see Laclau, *On Populist Reason*.

6. A fascinating account of the complex, anxiously unsettled time sense underlying the innovative artistic creativity of the 1960s is given in Lee, *Chronophobia*. Cf. the characterization of the "long 1960s" (1958–74) as a period of "cultural revolution" in Marwick, *The Sixties*, 7: "The sixties were characterized by the vast number of innovative activities taking place *simultaneously*, by unprecedented *interaction* and *acceleration*." For an account of the reception of the Chinese Cultural Revolution by Western leftists, see Wolin, *The Wind from the East*.

7. Foster, *The Return of the Real*, 68.

8. See Raunig, *Art and Revolution*, 25–66.

9. For discussion of these varied politicized art actions, see, among others, Kozloff, *Cultivated Impasses*, 392–99; Siegel, *Artwords*; Greene, "The Arts and the Vietnam Antiwar Movement"; Frascina, *Art, Politics, and Dissent*; and Bryan-Wilson, *Art Workers*.

10. Bryan-Wilson, *Art Workers*; see also Bryan-Wilson, "Still Relevant," and the essays in Butler et al., *From Conceptualism to Feminism*.

11. See Kelley, *Freedom Dreams* and *Africa Speaks, America Answers*; Moten, *In the Break*; Szwed, *Space Is the Place*; and Lewis, *A Power Stronger Than Itself*.

12. For example, in 2013 AfriCOBRA received a three-part retrospective exhibition and a set of Web-published essays related to the movement. There is still no art historical monograph devoted to the movement. See http://africobra.uchicago.edu /exhibitions/ and http://africobra.uchicago.edu/essays/ (accessed October 27, 2013).

13. Roszak, *The Making of a Counter Culture*, 18.

14. See Jameson, "Periodizing the 60s," 208.

15. Jameson, "Periodizing the 60s," 208.

16. See de Duve, *Kant after Duchamp*. Cf. Rancière, who situates the historical emergence of "art in general" concurrently with the emergence of philosophical aesthetics. In an unpersuasive attempt to displace the category of modernity and discredit the notion of a twentieth-century avant-garde break, Rancière misleadingly elides the concept of art in general with its empirical reflection in art practice; see *The Politics of Aesthetics*, 20 ff., and *Dissensus*, 115 ff. De Duve's thicker art historical account suggests

that Rancière's concept of an aesthetic regime of art instituted in the eighteenth and early nineteenth centuries is itself hermeneutically dependent on the horizon opened by avant-garde practice in the twentieth century; with different philosophical coordinates, Peter Bürger, in *Theory of the Avant-Garde*, makes an analogous argument for the role of the avant-garde in rendering the institution of "art" retrospectively legible.

17. See Young and Mac Low, *An Anthology*.

18. As I have argued in my discussion of the artistic concepts of "situation" and "event" in Miller, *Singular Examples*, 17–41.

19. Conrad, "An EARful: Four Violins and Early Minimalism," 17–20. For further information on Conrad and his associates, see Joseph, *Beyond the Dream Syndicate*; Piekut, "'Demolish Serious Culture!'"

20. For a detailed discussion of such works, see Kotz, *Words to Be Looked At*.

21. For a general account of erasure and related practices as a mode of avant-garde composition, see Dworkin, *Reading the Illegible*. For a relevant theoretical account of the dialectic of deskilling and reskilling, in art making's transition from being primarily a manual labor to being a variety of intellectual work, see Roberts, *The Intangibilities of Form*.

22. Cage and Knowles, preface to *Notations*, n.p.

23. Cage, *Silence*, 36.

24. Cage, *A Year from Monday*, 34.

25. Cage and Knowles, *Notations*, n.p.

26. Cardew, *Treatise Handbook*, iii. For a later, more self-critical discussion of graphic scoring, see Cardew, "Wiggly Lines and Wobbly Music."

27. See, for example, the cultural historical account of this process in Allyn, *Make Love Not War*.

28. Schneemann, *More Than Meat Joy*, 57.

29. Schneemann, *More Than Meat Joy*, 57.

30. Notably, a certain terminus in the history of *Artforum* was the departure of Rosalind Krauss and Annette Michelson to found the journal *October*. A precipitating factor in their departure was the publication in 1974 of a full-page ad by the artist Linda Benglis in which she appears nude with a two-headed dildo protruding from her crotch. Though intended as a cheeky parody of a notorious photograph—taken by Rosalind Krauss herself—of Robert Morris nude and adorned in S&M chains and a German helmet, Benglis's none-too-disguised implication that the artist advertising in *Artforum* was equivalent to a sort of prostitute servicing specialized, exotic sexual tastes was not taken kindly by the deeply serious and rather puritanical *Artforum* critics.

31. For a discussion of this tendency in 1960s art, see Banes, *Greenwich Village 1963*.

32. Schneemann, *Imaging Her Erotics*, 28.

33. Schneemann, *Imaging Her Erotics*, 37.

34. On this point, see Weigel, *Body- and Image-Space*.

35. Battcock, "Herbert Marcuse," 36.

36. See, for example, Battcock, "Marcuse and Anti-Art," and Meyer, "De-Objectification of the Object." *Arts Magazine*, for which Battcock was a special corre-

spondent, carried Herbert Marcuse's speech "Art in the One-Dimensional Society" as the cover page of its May 1967 issue.

37. Marcuse, *Eros and Civilization* (1966), xv.

38. Schneemann, *More Than Meat Joy*, 63.

39. Schneemann, *Imagining Her Erotics*, 76.

40. For a more general treatment of this tendency toward experimental community in U.S. art in the 1960s, see Banes, *Greenwich Village 1963*. In her work on Allan Kaprow, which also emphasizes its underestimated connection with the Living Theatre and other radical performance practices, Judith F. Rodenbeck has framed Kaprow's "Happenings" as "critical" in a philosophical sense, reflecting on both the conditions of validity for participation and on its limits; see Rodenbeck, *Radical Prototypes*. In what follows, I too suggest that the ambivalent dialogue between Marcuse and various radical performative artists of the 1960s was similarly conditioned by this duality within the art practice itself.

41. Schneemann, *Imagining Her Erotics*, 133.

42. On the Living Theatre, see Tytell, *The Living Theatre*, and Biner, *The Living Theatre*.

43. Stefan Brecht, "Revolution at the Brooklyn Academy of Music," 57.

44. Marcuse, *An Essay on Liberation*, 42.

45. Marcuse, *Counterrevolution and Revolt*, 113.

46. Battcock, "Art in the Service of the Left?," 25.

47. Battcock, "Art in the Service of the Left?," 26.

48. Cf. the argument that there is a "secret history" linking three distinct geographical and temporal moments of the avant-garde (Dadaism, situationism, and punk) in Marcus, *Lipstick Traces*.

49. Information about the Velvet Underground can be found in Bockris and Malanga, *Up-Tight*; Heylin, *All Yesterdays' Parties*; Kugelberg, *The Velvet Underground*; and Watson, *Factory Made*.

50. For this social-critical reading of Warhol's work, see Crow, "Saturday Disasters" and *The Rise of the Sixties*; Wagner, "Warhol Paints History, or Race in America"; and Binstock, *Andy Warhol*. Barbara Rose had already anticipated this understanding of Warhol when she greeted Warhol's film *Chelsea Girls* (1966) with the provocative moniker "didactic art" in Rose, "The Value of Didactic Art." For an analogous argument about the social-critical dimensions of James Rosenquist's pop art œuvre of the 1960s, see Lobel, *James Rosenquist*.

51. In a catalog essay for a 1969 exhibition in Amsterdam's Stedelijk Museum, Piero Gilardi directly associated the underground film movement with "cultural revolution": "Although not politically aligned, the underground cinema is a phenomenon that must be linked to the cultural revolution: the New American Cinema, in particular, arose with premises that stamped it as an 'off' phenomenon far superior in range to any other phenomenon of the same type. . . . Today the vital ferments of the underground cinema are the 'newsreel' films prepared by two identically-named co-operatives in New York and San Francisco; their documentary set-up is forming a new creative unit between art and politics" (*Conceptual Art*, 131). Cf. the more pessimis-

tic prognosis of Annette Michelson's 1966 essay "Film and the Radical Aspiration," which, in contrast to Gilardi's emphasis on the dimensions of insurrection and constitutive power, confines the radical potential of underground cinema to resistance or "subversion": "In a country whose power and affluence are maintained by the dialectic of a war economy, in a country whose dream of revolution has been sublimated in reformism and frustrated by an equivocal prosperity, cinematic radicalism is condemned to a politics and strategy of social and aesthetic subversion" (421).

52. "The Pop Art Issue," *Aspen* 3 (1966), published in New York by the Roaring Fork Press. Available at http://www.ubu.com/aspen/aspen3/index.html (accessed March 20, 2011).

53. Available on CD as *East Village Other: Electric Newspaper* (Get Back, 2000).

54. "The Minimalism Issue," *Aspen* 5–6 (1967), published in New York by Roaring Fork Press. Available at http://www.ubu.com/aspen/aspen5and6/index.html (accessed March 20, 2011).

55. Miller, *Singular Examples*, 3–14.

56. Miller, *Singular Examples*, 11.

57. In this conclusion I am indebted to the arguments of Hal Foster that the works of the 1960s neo-avant-garde carry on a rhetorical and affective "deferred action" by inspiring critical postmodernist art practice and theory in subsequent decades. See Foster, *The Return of the Real*, 20–32.

From Unitary Urbanism to the Society of the Spectacle

The Situationist Aesthetic Revolution

RAYMOND SPITERI

Among the small number of things that I have liked and know how to do well, what I have assuredly known how to do best is drink. Although I have read a lot, I have drunk even more. I have written much less than most people who write, but I have drunk much more than most people who drink.
—Guy Debord, *Panegyric*

In a world that *really* has been turned on its head, truth is a moment of falsehood.
—Guy Debord, *The Society of the Spectacle*

The thesis of this chapter is simple: aesthetic revolution was, first and foremost, at the core of the Situationist International. Indeed, this was the principal goal of the movement. However, the Situationists' commitment to the principle of aesthetic revolution entailed an ongoing reformulation of their project. Ten years separate the "Report on the Construction of Situations," the founding document of the Situationist International (sɪ), from *The Society of the Spectacle*; yet in this time the status of art became increasingly marginalized as it was recognized as a facet of the spectacle. If the sɪ was initially able to operate in the margins of the art world, formulating a program of "integral art" based on the construction of situations and unitary urbanism, it was

unable to maintain this stance for long. The tension between the artistic dimension, which could be recuperated as a form of cultural practice, and the political dimension, which sought to transform society and culture, was too great, and a rigorous critique of the society of the spectacle soon eclipsed the artistic phase of the SI.

The SI sought to resume the project of an aesthetic revolution initiated by interwar avant-garde movements like Dada, surrealism, and Russian constructivism.[1] However, the circumstances that facilitated this project during the interwar period—the parallel goals of the cultural avant-garde and the political vanguard—had been transformed by the polarization of the political field into antagonistic factions in the late 1930s, initially between fascism and communism, then, following World War II, between the Soviet bloc and Western capitalism. Any attempt to resume the project of the aesthetic avant-garde, either by established movements like surrealism or by new movements like Cobra, struggled to establish a viable relationship with oppositional political groups, thereby limiting their activities to the cultural field. The Cold War transformed the relation between culture and politics, so now avant-garde art, particularly nonrepresentational styles like American abstract expressionism, were promoted as a symbol of "freedom."[2]

Cobra was the most rigorous attempt to resume the project of the interwar avant-garde after World War II, yet its existence was brief (1948 to 1951).[3] The significance of the SI was that it provided a forum for the elaboration of the avant-garde tendencies that struggled to find an outlet during the post–World War II period. The SI emerged from the convergence of former Cobra artists such as Asger Jorn and Constant, who participated in the International Movement for an Imaginist Bauhaus during the mid-1950s, and the Lettrist International, a group that was initially formed in 1952 by Guy Debord, Gil J. Wolman, Jean-Louis Brau, and Serge Berna as a dissident faction of the Lettrist movement (formed by Isidore Isou and Gabriel Pomerand in 1945).[4]

Unlike previous post–World War II avant-garde movements, the SI did not regard art or literature as the principal focus of its activity. Three principles can be identified as central to the Situationist aesthetic revolution. First, the *dépassement* of art: to pass beyond the production of artworks that would be distributed and consumed within the existing institutions of artistic or literary production in favor of an active, passionate engagement with everyday life. Second, the realization of philosophy: resuming the Young Hegelian project (crystallized in Marx's eleventh *Thesis on Feuerbach*), the SI considered the ultimate goal of philosophy was to transform the world. Third, the abolition of politics: the SI maintained a rigorous critique of organized revo-

lutionary political groups and sought to establish a nonhierarchical political organization based on the model of revolutionary workers' councils.[5]

As a result of this program, the history of the SI was characterized by a series of defections, expulsions, and ruptures. Indeed, in 1972 Debord and Gianfranco Sanguinetti would contrast the attitude of the SI, which had repeatedly displayed the rifts and conflicts of its actual history in the pages of the *Internationale Situationniste*, to that of its followers, the so-called pro-situs, who admired the SI as a body of coherent theory.[6] The SI limited membership to a small group of activists in an effort to preserve the group's integrity and its ability to respond rapidly to events. This did not prevent the SI from collaborating with other groups, yet any such collaboration was provisional and subject to review. On a theoretical level, the SI's critique of contemporary society underwent continual revision and never coalesced into rigid dogma. This chapter focuses on one shift in the elaboration of the SI project: the movement from the initial focus on unitary urbanism to the rigorous critique of the society of the spectacle.

Report on the Construction of Situations

The preliminary groundwork for the establishment of the SI took place under the auspices of the International Movement for an Imaginist Bauhaus. In September 1956 Asger Jorn and Giuseppe Pinot Gallizio organized an "International Congress of Free Artists" in the Italian town of Alba, which brought together representatives from eight countries (Algeria, Belgium, Czechoslovakia, Denmark, France, Great Britain, Holland, and Italy). The Lettrist International was represented by Gil J. Wolman, who presented a statement written by Debord calling for a "precise program for joint action."[7] This statement resulted in "The Alba Platform," published in *Potlatch* in November 1956, which outlined a common program leading to the establishment of the SI the following year:

> Comrades, a general movement determines the parallel crises that are currently affecting all modes of artistic creation, and the fulfillment of the crises can only be reached through a broad perspective. The process of negation and destruction that, with growing speed, has manifested itself against all the old conditions of artistic activity, is irreversible: it is the consequence of the appearance of superior possibilities of action upon the world. . . .
>
> Whatever credit the bourgeoisie wishes today to grant to fragmen-

tary, or deliberately retrograde, artistic efforts, creation can now only be a synthesis aiming at the integral construction of the surroundings, of a style of life. . . . A unitary urbanism—the synthesis, appropriating arts and technologies, that we are demanding—must be built in step with certain new life-values, that it is from the present a question of singling out and spreading.[8]

"The Alba Platform" concluded with a six-point resolution rejecting "art within its traditional limits," and it proposed unitary urbanism to prepare a "future style of life" based on "the perspective of a greater real freedom."[9] Its most far-reaching implication, however, was the recognition that the avant-garde did not exist in isolation; indeed, the problems confronting artistic creation were symptoms of deeper social conflicts that could only be resolved within a broader perspective.

Although the Alba congress did not establish any concrete goals, as a common platform for an activist avant-garde, it set the stage for the SI, which was formally launched at a conference at Cosio d'Arroscia in July 1957. The meeting brought together eight representatives of three avant-garde tendencies: the Lettrist International (Guy Debord, Michèle Bernstein), the London Psychogeographical Society (Ralph Rumney), and the International Movement for an Imaginist Bauhaus (Asger Jorn, Giuseppe Pinot Gallizio, Piero Simondo, Walter Olmo, and Elena Verrone). Debord presented his "Report on the Construction of Situations and on the Terms of Organization and Action of the International Situationist Tendency," a lengthy document that analyzed the current state of contemporary culture and sketched out an initial program for the SI.

The "Report on the Construction of Situations" opened by proclaiming an ambitious revolutionary project:

> First, we believe that the world must be changed. We desire the most liberatory possible change of the society and the life in which we find ourselves confined. We know that such change is possible by means of pertinent actions.
>
> Our concern is precisely the use of certain means of action, along with the discovery of new ones, that may more easily be recognized in the sphere of culture and manners but that will be implemented with a view to interaction with global revolutionary change.[10]

This statement clearly aligned the SI with the revolutionary aims of the interwar avant-gardes, for whom cultural endeavor was always part of a larger

project of social transformation. Thus, at the outset, Debord recognized the limit of cultural endeavor as a self-sufficient end. Although he positioned the SI as heir to radical ambitions of futurism, Dada, and surrealism, he was keenly aware of limitations of these movements. Futurism, for instance, contributed "a large number of formal novelties," but it exhibited an oversimplified "idea of technological progress" that prevented it from "achieving a more complex theoretical vision of its time."[11] Dada "focused mainly on the destruction of art and writing and, to a lesser extent, on certain forms of behavior" and "dealt a mortal blow to the traditional conception of culture"; its "wholly negative definition," however, rapidly ensured its collapse, but not before bequeathing "an aspect of negation" to subsequent avant-gardes.[12]

Surrealism would constitute a prominent beacon for the SI, both as heir to Dada's negation and as an avant-garde movement whose influence was still evident during the 1950s.[13] According to Debord, surrealism was "much richer in constructive possibilities than is generally thought," since it succeeded "in catalyzing for a certain time the desires of an era," asserting the "sovereignty of desire and surprise, offering a new practice of life." The most effective part of surrealism was the brief period during the late 1920s and early 1930s when it embraced dialectical materialism; the decay occurred once its political convictions became "moderated by commercial considerations."[14] Although surrealism's progressive tendencies had declined by the 1950s, the SI recognized its character as an aesthetic revolution during the early years of the movement. Indeed, the SI defined its own project as a reaction against the shortcomings of the surrealist revolution, a strategy that entailed an ongoing critique of contemporary manifestations of surrealism during the 1950s, but also the recovery of aspects of surrealist practice that would be continued by the SI.[15]

Debord described the current state of modern culture as one of "crisis" and "ideological decomposition."[16] To counter this state Debord proposed an experimental avant-garde based on passionate engagement with everyday life exemplified by the "construction of situations": "Our central purpose is the construction of situations, that is, the concrete construction of temporary settings of life and their transformation into a higher, passionate nature. We must develop an intervention directed by the complicated factors of two great components in perpetual interaction: the material setting of life and the behaviors that it incites and that overturn it."[17]

It should be noted that the constructed situations are conceived not as works of art, but as "temporary settings of life" based on the "perpetual interaction" between an environment and the behaviors that respond to this set-

ting. The medium for the construction of situations was the different elements of the urban environment. This led to the practice of unitary urbanism, which called for "the use of the whole of arts and techniques as means cooperating in an integral composition of the environment." Unitary urbanism treated the environment as a totality, incorporating discrete elements—such as the traditional distinction between art and architecture, urbanism and ecology—to form an "integral art" that did not "correspond with any traditional definitions of the aesthetic."[18]

Significantly, this program was presented not as a defined task, but as the provisional basis for a revolutionary cultural avant-garde:

> We deem that today an agreement on a unified action among the revolutionary cultural avant-garde must implement such a program. We do not have formulas nor final results in mind. We are merely proposing an experimental research that will collectively lead in a few directions that we are in the process of defining, and in others that have yet to be defined. The very difficulty of arriving at the first situationist achievements is proof of the newness of the realm we are entering. What alters the way we see the streets is more important than what alters the way we see painting. Our working hypotheses will be reconsidered at each future upheaval, wherever it may come from.[19]

At this stage these theses only formed a provisional program, a point readily conceded by the SI. However, it could call on the example of a number of artists who joined the SI: Jorn, Constant, Gallizio, and later the Gruppe Spur in Germany. Not surprisingly, tension soon emerged within the SI over the balance between the artistic and revolutionary dimensions of the movement. The participation of a number of established artists conflicted with the position of the French section, which steadfastly refused any compromise with the established art world. This conflict reflected the ambiguity at the heart of the notion of the avant-garde: the tension between artistic innovation and sociopolitical transformation.

The ideas in the "Report on the Construction of Situations" were given visual form in a small poster published in early 1958, *New Theater of Operations within Culture* (figure 6.1). The poster boldly announced the arrival of the Internationale Situationniste, describing its mission as "the dissolution of old ideas together with the dissolution of the old conditions of existence." The poster depicted a flowchart of Situationist tactics below an aerial photograph of southeastern Paris: the construction of situations appeared at the apex of the diagram; on the left-hand side, experimental comportment, *dérive*,

FIGURE 6.1 *New Theater of Operations within Culture*, tract by the French section of the Situationist International, 1958. Digital image courtesy Beinecke Rare Book and Manuscript Library, Yale University.

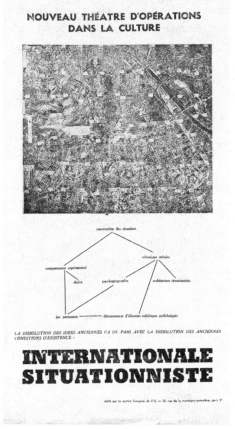

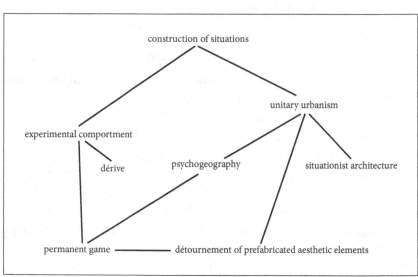

FIGURE 6.2 Detail of figure 6.1, with English translation.

and permanent game; on the right, unitary urbanism, Situationist architecture, and the *détournement* of prefabricated aesthetic elements, with psychogeography in the center, on an axis linking permanent game and unitary urbanism (figure 6.2). The aerial photo functioned not only as an emblem of urbanism—photography had recently been used as an aid for the new field of urbanism—but also described the site for Situationist intervention.[20] The poster thus outlined a program of intervention in the urban fabric, one that would transform "old ideas" and "old experiences" into "a higher, passionate nature."

The focus on unitary urbanism was evident in the early issue of the *Internationale Situationniste*. The first issue published Ivan Chtcheglov's "Formulary for a New Urbanism," initially written in October 1953 in the context of Lettrist International.[21] Although Chtcheglov takes the urban explorations of Dada and surrealism as his starting point, he considers these approaches inadequate; it is now necessary to play with "architecture, time and space."[22] Chtcheglov rejects the urban theories of Le Corbusier (as expressed in the *Athens Charter*) to argue for a new architecture based on a new civilization:

— a new conception of space (whether based on a religious cosmogony or not).
— a new conception of time (numeration starting from zero, various ways for time to unfold).
— a new conception of comportment (in moral nature, sociology, politics, law. The economy is only one part of the laws of comportment to which a civilization agrees.)[23]

The second issue included Abdelhafid Khatib's "Attempt at a Psychogeographical Description of Les Halles" and republished Debord's "Theory of the Dérive" (originally published in the Belgian review *Les Lèvres nues* in 1956).[24] According to Debord, the *dérive* (in English, "drift" or "flow") was a mode of comportment "defined as a technique of swift passage through varied environments" and was "indissolubly linked with the recognition of a psychogeographic nature, and with the assertion of a ludic-constructive comportment." The *dérive* was a technique to reveal the psychogeographic contours of the city as a series of varied "micro-climates."[25]

The *dérive* assumed visual form in the *Psychogeographic Guide to Paris*, which adopted the folded format of a pocket map, but it did not give equal attention to all districts of the city (figure 6.3). The map was a collage of specific areas joined by arrows to exemplify the *dérive* as "a technique of transient passage through varied ambiances."[26] It transformed the traditional function

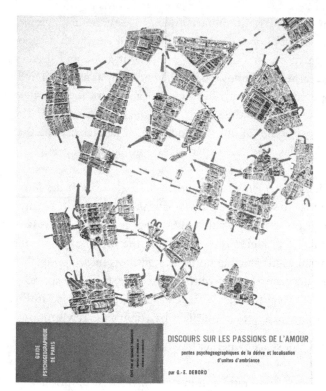

FIGURE 6.3
Guy Debord,
*Psychogeographic
Guide to Paris* (*Guide
psychogéographique
de Paris. Discours
sur les passions
et l'amour. Pentes
psychogéographiques
de la dérive et
localisations d'unités
d'ambiance*). Paris,
Bauhaus imaginiste,
1957. Digital image
courtesy Beinecke
Rare Book and
Manuscript Library,
Yale University.

of the map as the means to navigate an unfamiliar environment, into a means of disorientation that would reveal the "psychogeographical gradients of the *dérive*."[27] The map also serves as an example of détournement: "The integration of present or past artistic productions into a superior construction of a milieu."[28]

Unitary urbanism was central to "The Amsterdam Declaration," an important statement of collective purpose written by Constant and Debord that formulated the sɪ's principles: this document once again discounted the role of the individual arts and affirmed the collective and practical character of participation in Situationist activities as "the development of complete environments, which must extend to a unitary urbanism, and research into new modes of behavior in relation to these environments": "Unitary urbanism, independently of all aesthetic considerations, is the fruit of a new type of collective creativity; the development of this spirit of creation is the prior condition of unitary urbanism."[29]

On a theoretical level Debord sought to refine the position of the sɪ to

distinguish between the progressive and regressive elements of avant-garde practice. Thus he distinguished two temporalities associated with artistic and Situationist goals:

> The traditional goal of aesthetics is to make one feel, in privation and absence, certain past elements of life that through the mediation of art would escape the confusion of appearances, since appearance is what suffers from the reign of time. The degree of aesthetic success is thus measured by a beauty inseparable from duration, and tending even to lay claim to eternity. The situationist goal is immediate participation in a passionate abundance of life, through the variation of fleeting moments resolutely arranged. The success of these moments can only be their passing effect. Situationists consider cultural activity, from the standpoint of totality, as an experimental method for constructing daily life, which can be permanently developed with the extension of leisure and the disappearance of the division of labor (beginning with the division of artistic labor).[30]

Whereas art led to the reification of the temporal flux in the material form of the artwork, the Situationist experience was one of "immediate participation in a passionate abundance of life." One consequence of this position was not only a refusal to produce artworks, but also suspicion toward artists associated with the si who continued to participate in the art world. Another consequence of this position was that art as a form of representation was considered inadequate. Creative endeavor has to aspire to the immediate presentations of sensations: art was no longer a "report on sensations," but a mode of immediate communication based on the "direct organization of higher sensations"—a position Debord would reiterate in later writings.[31]

The emphasis on unitary urbanism in the early si was one effect of this suspicion of art. It had strategic value in that it forced participants to engage directly in ludic actions in the everyday urban environment, rather than produce objects that would circulate as artworks within the art market. The emphasis was on collective action that was "a qualitative leap in culture and everyday life."[32] Indeed, in the course of a debate in September 1958, the claim was advanced that "no painting is defensible from the Situationist point of view": "the construction of ambiances excludes traditional arts like painting and literature, which are threadbare and incapable of any revelation. These arts, which are linked to a mystical and individualist attitude, are useless to us."[33] In other words, the goal of the Situationist aesthetic revolution was to

emancipate imaginative endeavor as a living mode of passionate activity from its reification as artistic form and as commodities within the art market.

Jorn's Modifications

In May 1959, Jorn held the first exhibition of his modification paintings at the Galerie Rive Gauche in Paris. The exhibition consisted of twenty works, based on paintings of conventional landscape and portrait subjects by second-rate artists that Jorn had purchased from flea markets. Jorn overpainted areas of the image to produce paintings that oscillated between kitsch subject matter and Jorn's own vocabulary of painterly gestures and expressionist figures to "erect a monument in honor of bad painting."[34] For instance, in *Paris by Night* he added loose drips of paint to modify a view of a man looking over a balcony onto a nocturnal street scene (figure 6.4). In the catalog, Jorn explained his motivation for the modifications as a way to update the paintings: "Be modern, collectors, museums. If you have old paintings, do not despair. Retain your memories but détourn them so that they correspond with your era. Why reject the old if one can modernize it with a few strokes of the brush?"[35]

For Jorn creation was a method to reinvest or revalorize "the act of humanity"; in this context, the artwork only assumed value "as an agent of *becoming*":

> I want to rejuvenate European culture. I begin with art. Our past is full of becoming. One needs only to crack open the shells. *Détournement* is a game born out of the capacity for *devalorization*. Only he who is able to devalorize can create new values. And only there where there is *something* to devalorize, that is, an already established value, can one engage in devalorization. It is up to us to devalorize or to be devalorized according to our ability to reinvest in our own culture. There remain only two possibilities for us in Europe: to be sacrificed or to sacrifice. It is up to you to choose between the historical monument and the act that merits it.[36]

In holding this exhibition Jorn was testing the toleration of his fellow Situationists. Whereas Debord described Gallizio's recent exhibition of industrial paintings at the Galerie René Drouin as "reactionary buffoonery" and criticized the artist for accepting "the role of a very ordinary artist recognized by his peers," he was more favorably disposed toward Jorn's exhibition of "détourned paintings," which he considered "a very rough break from this milieu [of the art world]."[37]

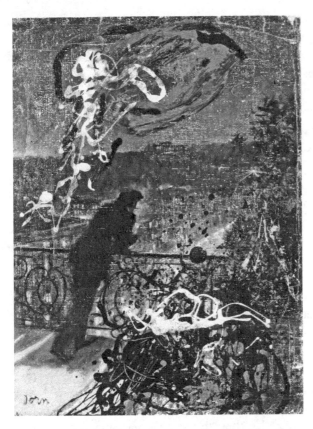

FIGURE 6.4
Asger Jorn, *Paris by Night*, 1959. Modification, oil on canvas, 53 × 37 cm. Collection Pierre and Micky Alechinsky, Bougival, France. © Asger Jorn / COPYDAN, Licensed by Viscopy, 2014.

The Lettrist International first theorized détournement in the mid-1950s, considering it an integral feature of the avant-garde since Dada and surrealism that could be traced to the corrected maxims in Isidore Ducasse's *Poésies*.[38] In 1958 the SI defined détournement as the "integration of present or past artistic productions into a superior construction of a milieu."[39] An article in the third issue of the *Internationale Situationniste* (December 1959) identified the historical significance of détournement as "a constantly present tendency of the contemporary avant-garde": "Détournement is thus first of all a negation of the value of the previous organization of expression. It arises and grows increasingly stronger in the historical period of the decomposition of artistic expression. But at the same time, the attempts to reuse the 'détournable bloc' as material for other ensembles express the search for a vaster construction, a new genre of creation at a higher level."[40]

Détournement would remain a key Situationist technique throughout the history of the movement. It would shift from the initial artistic context to a technique to contest the circulation of images in the society of the spectacle.

The SI would continue to employ détournement after the exclusion of artists in 1962, applying it to aspects of the mass media (cinema, advertising, comics, etc.). Indeed, Debord would describe détournement as "the fluid language of anti-ideology" in *The Society of the Spectacle*—a book itself partly based on détournement.[41]

The place of the avant-garde within contemporary culture was the subject of an editorial note published in the June 1960 issue of *Internationale Situationniste*, "The Use of Free Time."[42] This article is noteworthy for one of the first uses of the term "spectacle" as signifying a specific mode of alienation that separated the passive consumer from the production of culture—a theme that would become increasingly important during the 1960s, culminating in *The Society of the Spectacle*.[43] The emptiness of leisure time "is simultaneously expressed and concealed by the entire cultural spectacle, in three basic forms": the traditional forms of high culture and civil behavior; the new forms of mass entertainment such as televised sport, cinema, novels, consumerism, and so on; and avant-garde art and culture. Whereas traditional culture and mass entertainment simply reinforced the spectacle, the avant-garde was the "only original aspect of present-day culture" and engaged in a "negation of the spectacle." However, this negation was often unconscious and merely assumed the form of impotent "rage against culture." What distinguished the SI from previous avant-gardes was its rejection of criteria of aesthetic quality: works were no longer judged according to "the excellence of their methods and principles," but "the revolutionary praxis of its time." Indeed, the SI was "the first artistic organization to base itself on the radical inadequacy of all permissible works." In this way the avant-garde could realize the *dépassement* of art: "The supersession [*dépassement*] of leisure through the development of an activity of free creation-consumption can only be understood in relation with the dissolution of the traditional arts—with their transformation into superior modes of action which do not refuse or abolish art, but fulfill [*réalisent*] it. In this way art will be superseded, conserved and surmounted [*dépassé, conservé et surmonté*] within a more complex activity. Its traditional elements may still be partially present, but transformed, integrated and modified by the totality."[44]

In other words, the Situationist avant-garde entailed the negation of both previous artistic styles and the spectacle: its goal was to achieve the *dépassement* of art, to pass beyond the limit of art and its institutions. However, this goal could only be realized through the destruction of the social relations maintained through the spectacle: this was the basis of the Situationist aesthetic revolution.

The June 1960 issue of the *Internationale Situationniste* concluded with a manifesto that consolidated the SI's attitude toward art and the spectacle:

Against the spectacle, the realized situationist culture introduces total participation.

Against preserved art, it is the organization of the directly lived moment.

Against particularized art, it will be a global practice with a bearing, each moment, on all the usable elements. Naturally this would tend to collective production which would be without doubt anonymous (at least to the extent where the works are no longer stocked as commodities, this culture will not be dominated by the need to leave traces). The minimum proposals of these experiences will be a revolution in behavior and a dynamic unitary urbanism capable of extension to the entire planet, and of being further extensible to all habitable planets.

Against unilateral art, situationist culture will be an art of dialogue, an art of interaction.[45]

Within capitalist society artists have become separated from one another through competition, and from society as a whole. The goal of the Situationists was to arrive at a higher stage of culture, in which "everyone will become an artist": "a producer-consumer of total culture creation."[46]

Antisituationist Art

The SI never considered any one statement or technique to be definitive: thus its theses were always in a state of continual flux and reformulation. Unlike surrealism, which valorized the principle of "psychic automatism in its pure state" as a reference point throughout its history, the SI constantly redefined its goals. In part this was a strategy to prevent the recuperation of its tactics by nonmembers, and the movement sought to limit membership to a small, committed core. This was evident in its attitude to "discipline" and the frequent exclusions that characterize its history. Exclusion was "the only weapon of any group based on complete freedom of individuals," and it served "to clearly define an incorruptible platform" in the face of "the extreme ambiguity of the situation of artists, who are constantly tempted to integrate themselves into the modest sphere of social power reserved for them."[47] By contrast, for the Situationists, "our actions within culture are all linked to the project of overthrowing this culture itself, and to the formation and development of a new organized situationist instrumentation."[48]

In the early 1960s the SI became increasingly polarized over the relation between the cultural and political dimension of the movement. The Fourth SI Conference, held in London in September 1960, addressed the question "To what extent is the SI a political movement?" The German section, largely composed of artists associated with Gruppe Spur, wanted the SI to collaborate with a broad coalition of avant-garde artists; the French section, represented by Debord and Attila Kotányi, considered participation in avant-garde cultural tendencies an insufficient basis for membership of the SI.[49]

Debate on this issue continued at the Fifth SI Conference, held in Göteborg, Germany, in August 1961. Raoul Vaneigem presented a report that distinguished between the Situationist critique of the spectacle and the cultural avant-garde's participation in the spectacle: "The point is not to elaborate the spectacle of refusal, but to refuse the spectacle. In order for their elaboration to be *artistic* in the new and authentic sense defined by the SI, the elements of the destruction of the spectacle must precisely cease to be works of art. There is no such thing as situationism, or a situationist work of art, or a spectacular situationist."[50]

Jørgen Nash and Dieter Kunzelmann attempted to assume a more moderate position, which provoked Kotányi to respond:

> Since the beginning of the movement there has been a problem as to what to call artistic works by members of the SI. It was understood that none of them was a situationist production, but what to call them? I propose a very simple rule: *to call them antisituationist*. We are against the dominant conditions of artistic inauthenticity. I don't mean that anyone should stop painting, writing, etc. I don't mean that that has no value. I don't mean that we could continue to exist without doing that. But at the same time we know that such works will be coopted by the society and used against us. Our impact lies in the elaboration of certain truths which have an explosive power whenever people are ready to struggle for them. At the present stage the movement is only in its infancy regarding the elaboration of these essential points.[51]

The delegates welcomed Kotányi's intervention. The consensus was that it was becoming increasingly important to distinguish between "would-be avant-garde artists" who erroneously claimed to be "adherents of situationism" and the position of artists who were actual members of the SI. In response, the conference decided to define all art as "antisituationist": "Antisituationist art will be the mark of the best artists, those of the SI, since genuinely situation-

ist conditions have as yet not at all been created. Admitting this is the mark of a situationist."[52]

By 1962 the position of the SI was in danger of being outflanked or assimilated by other "avant-garde" groups. Internally, the SI was polarized over the compatibility of membership of the SI with the pursuit of an artistic career. The established artists who were among the initial members of the SI had either left or been excluded: Walter Olmo, Piero Simondo, and Elena Verrone in January 1958; Ralph Rumney in March 1958, Hans Platschek in February 1959, Giuseppe Pinot Gallizio in July 1960, and Maurice Wyckaert in April 1961. Constant's interest in unitary urbanism led him to focus exclusively on his New Babylon project; he resigned from the SI in the summer of 1960, although he continued to work on plans and models for the utopian city of New Babylon until 1974.[53] Jorn resigned in April 1961 to form the Scandinavian Institute of Comparative Vandalism in Denmark, although he did continue to give financial support to the SI—he financed Debord's 1961 film *Critique de la séparation*, and the publication of *Contre le cinema* in 1964—and he maintained his friendship with Debord until his death in 1973.

In the face of these events the SI sought to distance itself from the art world, which provided the fastest route to disarm its critique of contemporary culture. The first casualties were the German artists associated with Gruppe Spur, who were excluded in February 1962.[54] In March, the Danish faction associated with Jørgen Nash issued *Danger! Do Not Lean Out*, a tract criticizing the exclusion of Gruppe Spur, and split with the SI to establish a dissident group (the Situationist Bauhaus or the Second Situationist International).[55] The SI responded by denouncing the antisituationist Nashist tendency.[56]

Events in Europe and abroad also contributed to a growing sense of crisis. The construction of the Berlin Wall in August 1961 exacerbated Cold War tensions. In France, the Algerian War continued to dominate domestic politics: the government responded to the Front de Libération nationale's terrorist campaign against French targets by limiting the movement of Algerian Muslims in Paris, leading to the massacre of August 17, 1961, and the associated press blackout.[57]

The Destruction of RSG-6

The exclusion of artists from the SI reinforced its opposition to the cultural avant-garde, a position evident in "The Avant-Garde of Presence," published in the January 1963 issue of the *Internationale Situationniste*. This article ad-

dressed recent manifestations of avant-garde activity, such as the Groupe de recherche d'art visuel in France and the emergence of happenings in New York.[58] Happenings emerged in the artistic avant-garde of New York as "a kind of theater dissolved to the extreme, an improvisation of gestures, of a Dadaist bent, by people thrown together in an enclosed space."[59] Unlike the construction of situations as defined by the SI, which were "constructed on the basis of material and spiritual richness" as part of the "serious game" of the "revolutionary avant-garde," happenings were conceived as artistic actions without any explicit social or political dimension.[60] To the degree that they could be seen as critical, it was within the perspective of an artistic critique of society, and followed in the avant-garde tradition of *épater le bourgeois*.

The repeated criticism of the art world notwithstanding, the Situationists did initiate several collaborations with conventional art institutions; however, given their intransigence, these initiatives typically ended in failure. In 1959 Constant attempted to organize an exhibition at the Stedelijk Museum in Amsterdam. Under the directorship of Willem Sandberg, the Stedelijk Museum gained a reputation for its support of experimental avant-garde art — it staged the first major Cobra exhibition in 1949, for instance. Sandberg was sympathetic to Constant's involvement with the SI and agreed to hold an exhibition organized by the SI. The plan was to convert the museum's interior into a labyrinth and construct a number of situations in the city of Amsterdam. However, the SI refused to compromise with the museum's administration, so the exhibition was canceled. Similarly, following the Fourth SI Conference in London, the SI presented a lecture at the Institute of Contemporary Art, in which the Situationists refused to communicate with the audience.[61]

Ironically, the only exhibition organized by the SI to be realized would occur in June 1963, more than a year after the exclusion of professional artists. Yet this exhibition did not include the work of professional artists, and it took place at the Galerie Exi, an alternative space in Odense, Denmark, far from the center of the art world. The exhibition was part of an effort to counter "Nashist tendencies," the breakaway group formed by Jørgen Nash after his expulsion in March 1962.[62] The title of the exhibition, *The Destruction of RSG-6*, was a reference to the Regional Shelters of Government, a series of top-secret nuclear fallout shelters in Britain designed to house government officials in the event of a nuclear war; this network of shelters had recently been disclosed by Spies for Peace, a British antinuclear group.[63] The theme of nuclear conflict was topical. The Cold War had recently entered a new stage with the construction of the Berlin Wall in August 1961, followed by the

Cuban missile crisis in October 1962. The Scandinavian countries bordered the Soviet Union and would be caught in any cross fire between East and West, so the exhibition was designed to engage with Danish government's response to the threat of nuclear war.[64]

The gallery itself, located in the basement of the communal house that also served as the office for several left-wing groups, was divided into three sections: the first room was furnished to create "the atmosphere of an atomic fallout shelter"; the second room contained a series of five *Directives* painted by Debord, as well as a shooting gallery with political leaders as targets (Kennedy, Khrushchev, De Gaulle, the pope, and the Danish foreign minister); the third section contained J. V. Martin's *Thermonuclear Maps* and Michèle Bernstein's *Victories*.[65] Although the second and third rooms contained paintings, these were "employed in a critical fashion." The *Directives* were "political proclamations" directed against the notion of abstraction as incommunicable "pure signs" and "should be understood as slogans that one could see written on walls."[66] The *Thermonuclear Maps* "unite the most liberated procedures of action painting with a representation *that can lay claim to perfect realism* of numerous regions of the world at different hours of the next world war," while the *Victories* series "corrects the history of the past, rendering it better, more revolutionary, and more successful than it ever was."[67]

Although *The Destruction of RSG-6* took place in an art gallery, it was conceived as "a collective manifestation of the Situationist International."[68] Soon after its opening a conflict emerged between the director of Galerie Exi and members of the SI, after the director had allowed visitors to bypass the first two sections of the installation containing the fallout shelter and shooting gallery. In response the SI demanded that the exhibition be closed, since *The Destruction of RSG-6* was not an art exhibition, but "an attack on the society that allowed its ruling powers to expose mankind to deadly dangers through the threat of nuclear war and nuclear tests."[69]

This tension between art and the position of the SI was also evident in Debord's *Directives*. These were a series of slogans painted on five framed canvases: four were crudely written with black paint on a white background; the fifth scrawled the slogan "Abolition of Alienated Labour" on one of Gallizio's industrial paintings. The shooting gallery appears in a photograph documenting the exhibition: we see members of the audience shooting the targets of political leaders, against the backdrop of two of Debord's *Directives*: "The Realization of Philosophy" and "The *Dépassement* of Art" (figure 6.5).[70] *Directive 1* alluded to Marx's eleventh *Thesis on Feuerbach*— "Philosophers have hitherto only *interpreted* the world in various ways; the point is to *change* it"—

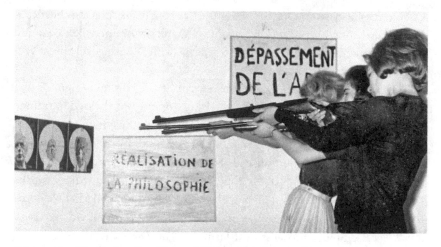

FIGURE 6.5 *The Destruction of* RSG-6, Galerie Exi, Odense, Denmark, June 22–July 7, 1963. Photograph of the shooting gallery in the second room, with Debord's *Directive 1* ("Dépassement de l'art"), 1963, and *Directive 2* ("Réalisation de la philosophie"), 1963. Digital image courtesy Bibliothèque National de France.

while *Directive 2* stated the si's program to pass beyond the limits of art, not in the name of another avant-garde, but as part of the realization of philosophy and the abolition of politics.

The format of a shooting gallery recalled not only fairground distractions, but also the recent series of *Tirages* by Niki de Saint-Phalle—participatory paintings designed to be completed on exhibition by audience members shooting them with a shotgun. Whereas Saint-Phalle's work commented on the gendered conditions of artistic production, it still resulted in works of art; the si's shooting gallery, by contrast, took direct aim at the political figure-heads who were responsible for the state of nuclear terror. And here the full force of Debord's *Directives* appears: to change of conditions of social life in the contemporary world and realize philosophy, it was necessary to move beyond the limited horizon of the art world and act in the world.

The Destruction of RSG-6 was accompanied by a catalog with an essay by Debord, "The Situationists and the New Forms of Action in Politics or Art" (figure 6.6). This essay clearly explained the position of the si and the goal of the current exhibition. Debord commenced by outlining the "unitary approach" of the si, which "indissolubly linked" the movement's activities as "an artistic avant-garde, as an experimental investigation of the free construction of daily life, and finally as a contribution to the theoretical and practical articulation of a new revolutionary contestation."[71] This approach was linked to

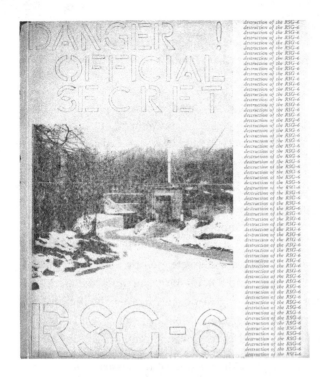

FIGURE 6.6
The Destruction of
RSG-6, Galerie Exi,
Odense, Denmark, June
22–July 7, 1963. Front
cover of exhibition
catalog, illustrated
with a photo of one of
the Regional Shelters
of Government.
Digital image courtesy
Beinecke Rare Book
and Manuscript Library,
Yale University.

"all-encompassing critique" of the "alienation, totalitarian control, and passive spectacular consumption" of contemporary society; against the coherence of this society, the SI opposed a "liberated creativity" that would contribute to "the dominion of all men over their own history."[72] The Situationist perspective was not limited to the artistic domain; rather, it encompassed "an immediate revival of all of the radicalism championed by the workers' movement, by modern poetry and art, and by the thought of the era of the surpassing of philosophy from Hegel to Nietzsche."[73] Indeed, for the Situationists, this project was inseparable from the critique of contemporary society, "since the one implies the other":

> Once it has been grasped that this is the perspective within which the situationists call for the surpassing [*dépassement*] of art, it will become clear that when we speak of a unified vision of art and politics this absolutely does not mean that we recommend any sort of subordination of art to politics whatsoever. For us and for all those who are beginning to view this epoch in a demystified manner, there has been no more modern art anywhere at all — in precisely the same way that there has been no further formation of revolutionary politics anywhere at all — since

the end of the 1930s. The current revival of both modern art and revo-
lutionary politics can only be their *surpassing* [*dépassement*], which is
to say precisely the realization of what was their most fundamental de-
mand.[74]

Although Debord described the SI as an "avant-garde," his use of the term
was quite specific: it did not refer to an artistic movement, but encompassed
political action, artistic or cultural activity, and philosophical critique. In this
context the avant-garde had a responsibility to coordinate these domains:

> The task of the avant-garde wherever it finds itself is to bring together
> these experiences and these people, that is, to simultaneously unify
> such groups and the coherent foundation of their project as well. We
> must make known, explain, and develop these initial gestures of the
> next revolutionary epoch. They are characterized by their concentra-
> tion of new forms of struggle and a new—either manifest or latent—
> content: the critique of the existing world. In this way, the dominant
> society that is so proud of its permanent modernization will finds its
> match, as it has finally produced a modernized negation.[75]

Debord's essay also makes clear the relation of the *Destruction of* RSG-6
exhibition to other political acts of civil disobedience. He described several
examples that met with the SI's "full approval." He noted the action of revo-
lutionary students in Venezuela who attacked an exhibition of French art and
stole five paintings, which they offered to return in exchange for the release of
political prisoners, as "an exemplary way to treat the art of the past."[76] Next,
he cited the actions of Danish comrades who made clandestine radio broad-
casts to protest against the deployment of nuclear weapons and who attacked
travel agencies organizing tours to Spain, not merely because tourism was
"a miserable spectacle that conceals the real countries through which one is
traveling," but because in the case of Spain, it was Franco's police state that
tourism transformed into a "neutral spectacle." These actions were a reaction
against the "comfortable and boring 'socialized' capitalism of the Scandina-
vian countries" and exposed the "violence that is at the foundation of this
'humanized' order: its monopoly on information, for example, or the orga-
nized alienation of leisure or tourism."[77] Finally, Debord cites the actions of
the English group Spies for Peace, who not only revealed the existence of the
Regional Shelters of Government, but also organized acts of civil disobedi-
ence to protest the preparation for a totalitarian state in the case of nuclear
conflict: "the omnipresent threat of thermonuclear war that serves now, in

both the East and the West, to maintain the submissiveness of the masses, to organize the *shelters of power,* and to reinforce the psychological and material defenses of the power of the ruling classes."[78]

In this context *The Destruction of* RSG-6 manifested an expansion of this global struggle and opened a front in the "artistic domain."[79] Given that one motivation behind the organization of *The Destruction of* RSG-6 was to counter the "Nashist tendencies," Debord carefully explains the significance of the current demonstration:

> The cultural activity that one could call situationist begins with the projects of unitary urbanism or of the construction of situations in life. The outcome of these projects, in turn, cannot be separated from the history of the movement engaged in the realization of the totality of revolutionary possibilities contained in the present society. However, as regards the immediate actions that must be undertaken within the framework that we want to destroy, critical art can be produced as of now using the existing means of cultural expression, that is, everything from the cinema to paintings. This is what the situationists summed up in their theory of *détournement.* Critical in its content, such art must also be critical of itself in its very form. Such work is a sort of communication that, recognizing the limitations of the specialized sphere of hegemonic communication, "will now contain *its own critique.*"[80]

The Destruction of RSG-6 did not signal a renewed engagement with art. Indeed, the SI described it as a "protest" (*manifestation*). A brief note in the August 1964 issue of *Internationale Situationniste* recorded its status, and the issue reproduced one of Martin's *Thermonuclear Maps* (figure 6.7) and a detail of Bernstein's *Victory of the Bonnot Gang.*[81] These images were presented as part of the issue's illustrations, not as paintings or artworks.

The Society of the Spectacle

After 1963 the *Internationale Situationniste* devotes more pages to contemporary political issues, while the emphasis on the practical side of Situationist tactics, such as the construction of situations and unitary urbanism, becomes less pronounced. In its place there is a greater emphasis on the practice of détournement and the critique of the spectacle. The August 1964 issue, for instance, makes extensive use of brief newspaper excerpts to produce a commentary on contemporary events (figure 6.8). The tenth issue of *Inter-*

FIGURE 6.7 J. V. Martin, *Europe 4½ Hours after the Start of the Third World War* (*L'Europe 4 heures 30 après le début de la 3ᵉ guerre mondiale*), 1963. Illustrated in *Internationale Situationniste*, no. 9 (August 1964): 32. Digital image courtesy Beinecke Rare Book and Manuscript Library, Yale University.

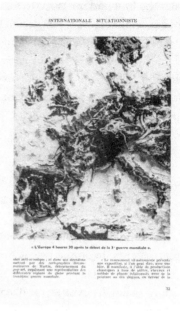

nationale Situationniste (March 1966) opened with commentaries on recent events. "The Decline and Fall of the Spectacle-Commodity Economy" discussed the recent August 1965 Watts Riots as a spontaneous protest by disenfranchised African Americans against the false logic of the spectacle: "A revolt against the spectacle—even if limited to a single district such as Watts—calls *everything* into question because it is a human protest against a dehumanized life, a protest of *real individuals* against their separation from a community that would fulfill their *true human and social nature* and transcend the spectacle."[82] "The Class Struggles in Algeria" discussed the history of Algeria since gaining independence from France in 1962, criticizing the authoritarian character of the regime and advocating self-management.[83] The issue also included a pair of photographs illustrating the different forms assumed by the spectacle under the condition of an authoritarian regime and a liberal consumer society: the former is illustrated with an image of the leader, in this case President Sukarno of Indonesia, who had recently suppressed an attempted coup against his rule, while an image from the men's magazine *Lui* illustrated the latter, showing the commodities associated with the lifestyle of a businessman, including "the economic works of Marx" (figure 6.9).

In "The Situationists and New Forms of Action against Politics and Art," published in the October 1967 issue of the *Internationale Situationniste*, René Viénet suggests ways to extend the Situationist critique beyond the traditional

FIGURE 6.8 *Good Negro / Bad Negro* (*Bon nègre / mauvaise nègre*). Illustrations in *Internationale Situationniste*, no. 9 (August 1964): 8–9. Digital image courtesy Beinecke Rare Book and Manuscript Library, Yale University.

FIGURE 6.9 *Concentrated Spectacle / Diffused Spectacle* (*Le spectacle concentré / Le spectacle diffus*). Illustrations in *Internationale Situationniste*, no. 10 (March 1966): 44–45. Digital image courtesy Beinecke Rare Book and Manuscript Library, Yale University.

COMICS PAR DÉTOURNEMENT (dans « Le retour de la colonne Durruti », d'André Bertrand - 1966).

FIGURE 6.10 *Détourned Comics (Comics par détournement)*. Illustration for René Viénet's essay "The Situationists and New Forms of Action against Politics and Art," *Internationale Situationniste*, no. 11 (October 1967): 33. The text reads: "Thus they hastened to perform sundry tasks required by the defense of student interests . . . / . . . Yes, Marx's thought is truly a critique of everyday life." Digital image courtesy Beinecke Rare Book and Manuscript Library, Yale University.

forms of revolutionary struggle. For Viénet, the technique of détournement provided the key for linking "the theoretical critique of modern society with its critique in acts."[84] He proposed four techniques to advance this goal: "to experiment with the *détournement* of photo love stories and so-called pornographic photographs"; "to promote guerilla warfare in the mass media"; "to perfect situationist comics"; and "to produce situationist films."[85] The techniques Viénet described here were already in use among the Situationists, not only in the pages of the *Internationale Situationniste* but also in the various pamphlets and postcards the SI produced and distributed during the mid-1960s, and they would reach their apogee during the occupation movement of May–June 1968 (figure 6.10). Significantly, détournement was not conceived as an artistic technique, but as a mode of critique directed against both the existing means of artistic expression and the forms of political theory and

organization. This is a clear example of how the SI conceived the role of the avant-garde in an aesthetic revolution.

The October 1967 issue of *Internationale Situationniste* also published the first chapter of Debord's *The Society of the Spectacle*; the book itself followed in November.[86] Unlike the polemical character of the articles in *Internationale Situationniste*, *The Society of the Spectacle* presented a detailed exposition and critique of the spectacle, a notion that played an increasingly important role since 1960. For Debord, the spectacle did not merely refer to the means of communication in contemporary society dominated by mass media; rather it updated the Marxist notion of commodity fetishism for a world in which the circulation of images was a central facet of capitalism. Like the commodity, the spectacle is a "social relation between people, mediated by images."[87]

Debord discussed the fate of art in the penultimate chapter, "Negation and Consumption in the Cultural Sphere," which focused on the fate of community under the conditions of capitalist production. In contrast to the precapitalist community unified through a shared mythology, capitalism disrupted the relation between culture and community, resulting in an antagonism between two demands: "the project of culture's *dépassement* as part of total history, and its management as a dead thing to be contemplated in the spectacle."[88] In this context, the cultural avant-garde had a positive and negative aspect: "The *positive* significance of the modern decomposition and destruction of all art is that the language of communication has been lost. The *negative* implication of this development is that a common language . . . must now be found in a praxis embodying both an unmediated activity and a language commensurate with it. The point is to take effective possession of the community of dialogue, and the playful relationship to time that up till now have merely been *represented* by poetic and artistic works."[89]

Here Debord defines the Situationist aesthetic revolution as a praxis that unifies action and language: "a praxis embodying both an unmediated activity and a language commensurate with it." This praxis could only be manifested at the expense of art as a form of representation. In contrast to conventional art, which distinguished between the roles of the artist who produces the artwork, and the audience who passively consumes the results of the artist's experience embodied in the artwork, the process of production and reception (or consumption) would now coincide. This is the key to the Situationist aesthetic revolution: "the community of dialogue" formed through a language commensurate with unmediated activity.[90]

Historically, Dada and surrealism "marked the end of modern art." Although they coincided with "the proletarian revolutionary movement's last

great offensive," the failure of that offensive "left them trapped in the very artistic sphere that they had declared dead and buried": "For dadaism sought *to abolish art without realizing it,* and surrealism sought *to realize art without abolishing it.* The critical position since worked out by the situationists demonstrates that the abolition and the realization of art are inseparable aspects of a single transcendence [*dépassement*] of art."[91]

In other words, Debord sought to substitute Situationist critical activity for artistic activity. The Situationist aesthetic revolution was no longer to be found in established forms of artistic practice, but in critical activity as "the style of negation."[92] The basis of this critique was détournement: "This style, which embodies its own critique, must express the mastery of the critique in hand over all its predecessors. The mode of exposition of dialectical theory will thus itself exemplify the negative spirit it contains. . . . Such a theoretical consciousness of dialectical movement, which must itself bear the stamp of that movement, is manifested by the reversal of established relationships between concepts and the diversion (or détournement) of all the attainments of earlier critical efforts."[93]

Détournement differed from quotation, since it renounced any claim of "theoretical authority" to become "a fragment torn away from its context." Thus détournement manifested "the fluid language of anti-ideology": "*Détournement* . . . is the fluid language of anti-ideology. It occurs within a type of communication aware of its inability to enshrine any inherent and definitive certainty. This language is inaccessible in the highest degree to confirmation by any earlier or supra-critical reference point. On the contrary, its internal coherence and its adequacy in respect of the practical possible are what validate the ancient kernel of truth that it restores. *Détournement* founds its cause on nothing but its own truth as critique at work in the present."[94]

One characteristic of détournement is the absence of distance. It is not ironic quotation, but something more subversive: it reverses the circulation of thought, introducing contradiction into the ideology of the society of the spectacle. In fact, Debord made extensive use of détournement in writing *The Society of the Spectacle*: the text frequently reworks existing texts on political and social theory to rejuvenate their meaning in light of subsequent historical developments.[95]

Ultimately, the Situationist critique of the avant-garde entailed a critique of society itself. Thus it differed from the postwar neo-avant-garde, which assimilated the strategies of the interwar avant-garde and recuperated them within the canon of art history.[96] The SI not only continued the historical avant-garde's aesthetic revolution, but also recognized that the radical core

of this project could only be realized through an uncompromising critique of all aspects of contemporary society, including the role of the artistic avant-garde—a critique fleetingly realized during the events of May and June 1968.

May 1968 and the Dissolution of the SI

The role of the SI in the events of May–June 1968 remains a topic of scholarly debate. Although the SI played an active part in the occupations movement, the protests of May–June were motivated by underlying historical antagonisms in French society dating back to the Algerian War, and in all likelihood would have occurred without the direct involvement of the SI. René Viénet wrote the official account of the SI's involvement in the occupation movement of 1968, covering the period from controversy over the pamphlet *The Poverty of Student Life* in 1966, the initial collaboration with the Enragés at Nanterre in March 1968, the events leading up to the night of the barricades in May, and the occupation of the Sorbonne and wildcat strikes.[97] Kristen Ross, by contrast, downplays the role of the SI.[98] What the SI did contribute, however, was a language based on détournement through which students and workers could express their discontent (figure 6.11).[99] A slogan such as "Sous la pavé, la plage" (Under the pavement, the beach) written on the wall of the Sorbonne, for instance, perfectly embodied the demands of the SI, realizing with poetic concision the trajectory from unitary urbanism to the dismantling of the spectacle. It also fulfilled the ambition of Debord's *Directives* of 1963 "as slogans that one could see written on walls."

The paradox of the SI is that although it advanced the first thorough critique of the spectacle, it was unable to resist being recuperated by the same spectacle. Indeed, the events of 1968 would hasten the movement's collapse. The media, in its quest to explain the underlying causes for the protests, identified Situationist publications such as Debord's *Society of the Spectacle* or Vaneigem's *Traité de savoir-vivre à l'usage des jeunes générations* as the theoretical justification for the May events. This notoriety, however, would lead to a vulgarization of Situationist ideas, transforming them into an aspect of the spectacle. The SI struggled to respond to this state of affairs, and in the face of police repression, the co-opting of Situationist tactics by other radical groups, and growing internal tensions, the SI became less effective after 1968.

In 1972 the SI would formally dissolve. The final act would be *La Veritable Scission dans l'Internationale*, a pamphlet written by Debord and Gianfranco Sanguinetti, which presented the SI's self-dissolution less as a failure than as a strategy to respect and preserve its legacy.[100] Debord and Sanguinetti ac-

FIGURE 6.11 *The Proletariat as Subject and Representation* (*Le Prolétairat comme sujet et comme représentation*). SI tract based on the text of thesis 123 of Guy Debord's *The Society of the Spectacle*. The text reads: "The proletarian revolution depends entirely on this necessity: for the first time, theory, as comprehended human practice, must be recognized and lived by the masses. It requires that workers become dialecticians and inscribe their thought in practice; similarly, it asks more of the *men without qualities* than the bourgeois revolution asked of the qualified men responsible for its realization (since the partial ideological consciousness constructed by this segment of the bourgeois class already had this central part of social life—the economy—as the base on which to exercise its power). The very development of class society toward the spectacular organization of non-life thus leads the revolutionary project to become visibly what it already was essentially." Digital image courtesy Beinecke Rare Book and Manuscript Library, Yale University.

knowledged the greater renown of the SI in the wake of 1968, but this notoriety came at a cost. Internally, the group was torn between different courses of action, which led to a further series of divisions and exclusions. The SI no longer functioned as a collective, and Debord found himself increasingly responsible for maintaining the movement's activities. The greatest threat, however, was the appropriation of Situationist ideas by individuals and groups not directly associated with the SI. Thus a central part of the *Veritable Scission* addressed the emergence of the "pro-situ" tendencies after 1968.

According to Debord and Sanguinetti the events of 1968 demonstrated the validity of the Situationist critique of modern society, and many revolutionaries have adopted the "theory, the style and the example of the sı."[101] Although they acknowledge the role of the sı in 1968, the "occupations movement was the rough sketch of a 'situationist' revolution . . . both as practice of revolution and as situationist consciousness of history." However, its position at the epicenter of social change presented challenges for the sı: notably the risk that changing circumstances would transform them into mere custodians of an image of Situationist activity.[102]

The pro-situ tendencies posed an even great risk. Although the pro-situ milieu was based on "good intentions" and "hollow claims," it was also "the expression of a deep-seated alienation of *the most inactive* part of modern society becoming vaguely revolutionary." Indeed, for Debord and Sanguinetti, "the pro-situ milieu is *in appearance* the sı's theory become ideology," a "spectacular ideology" that would hinder "the *real situationist movement*: the revolution."[103] They contrasted the attitude of the sı, which was based on the free association of a group of forceful personalities, whose disagreements were frankly recoded in the pages of the *Internationale Situationniste*, to that of the pro-situs, who admired the sı "en bloc" as a body of coherent theory.[104]

The passivity of the pro-situs also afflicted the sı itself. The closing pages of the *Veritable Scission* addressed the internal tensions within the sı. The movement had now reached a crisis point: unlike earlier purges, which served to reinforce the sı, the current purge "aimed at weakening it." Indeed, given the sı's post-1968 notoriety, the relative silence it has maintained since 1970 "constitutes one of its most important contributions to the revolutionary movement": "Now that we can moreover pride ourselves on having achieved the most revolting fame among this rabble, we fully intend to become *even more inaccessible*, even more clandestine. The more famous our theses become, the more shadowy our own presence will be."[105] This paradox would also act as the catalyst for the dissolution of the sı: "The real split in the sı was the very one which must now take place in the vast and formless protest movement currently at work: the split between, on the one hand, all the revolutionary reality of the age, and on the other, all the illusions about it."[106]

This was an indictment of the Situationist aesthetic revolution, which was now besieged on two fronts: it could be either recuperated as a series of empty political slogans or incorporated as part of the cultural avant-garde. Either option represented a profound diminution of the position maintained during the 1960s. In this context the decision to dissolve the sı in 1972 was a way to

protect its legacy, introducing a decisive rupture between the achievements the Situationist aesthetic revolution during 1957–72, and any subsequent effort to recuperate those achievements as spectacular ideology.

Conclusion

The Situationist International now forms an important reference point for many contemporary artists and cultural critics. The movement has been the subject for a number of major exhibitions since 1989, and its writings are frequently cited in discussions of contemporary art.[107] In her recent study of participatory art, for instance, Claire Bishop identified Debord as "the most frequently cited" theorist in "the current literature on participatory and collaborative art."[108] Yet this contemporaneity harbors the risk that the canon of art history will incorporate the Situationist aesthetic revolution as an integral part of the spectacle.

The SI demanded nothing less than an aesthetic revolution, and it perhaps briefly grasped one in the events of May–June 1968. Yet this revolution was fleeting and incomplete; it could only briefly halt the spectacle's relentless advance. Once order was restored, the graffiti removed, and streets repaved, everyday life soon resumed the unrelenting rhythm of spectacular time: the monotonous cycle of work and leisure, production and consumption. The final act was to end the SI: not as a conclusion, or failure, but as an act of unrelenting negation. The individual participants would continue on their own paths—although, it should be noted, unlike other participants in May 1968 they did not succumb to the temptation of political or intellectual careers. Guy Debord would remain faithful to his own particular adventure, continuing to act as an irritant on the social body. Significantly, Debord would always manifest a degree of discretion toward the SI: he would never try to capitalize on his involvement, and his subsequent autobiographical projects—*In girum imus nocte et consumimur igni*, *Panégyrique*, and *Guy Debord, son art, son temps*—focus more on his other activities than his role in the SI. Even the decision to allow Editions Gallimard to republish his works can be seen as an effort to respect the legacy of the SI, introducing a break between the integrity of Debord's personal *œuvre* and the Situationist aesthetic revolution, forever poised at the limit of history.

NOTES

I would like to thank Heinz Paetzold, whose unpublished essay "The Situationist International and Urban Revolution" was the departure point for this chapter. The current version shifts the emphasis from Paetzold's focus on unitary urbanism and urban revolution to a broader consideration of the Situationist avant-garde as a type of aesthetic revolution. I also thank Tyrus Miller for comments on an earlier draft; and Karen Kurczynski and Teresa Østergaard Petersen for information on Asger Jorn and the SI. Illustrations funded by an FHSS Research Grant.

1. For the purpose of clarity, I will distinguish between the literary and artistic programs of a *cultural* avant-garde, which refers to movements whose works have been incorporated into the canon of art and literary history, and the *Situationist* avant-garde, which attempted to resist its recuperation as art or literature.

2. Guilbaut, *How New York Stole the Idea of Modern Art*.

3. On Cobra, see Lambert, *Cobra*; Stokvis, *Cobra*.

4. For an overview of Lettrism, the Lettrist International, and the International Movement for an Imaginist Bauhaus, see Home, *The Assault on Culture*. For relevant primary sources, see Berreby, *Documents relatifs à la fondation de l'Internationale Situationniste*.

5. There is an extensive body of secondary literature on the SI. The initial reception of the SI was mediated by politically engaged writers, such as Ken Knabb, whose *Situationist International Anthology* (1st ed. 1981) remains a key source. The bulk of the critical scholarship in English dates from the catalog for 1989 retrospective, *On the Passage of a Few People through a Rather Brief Moment in Time*, edited by Elisabeth Sussman (which included contributions by Peter Wollen, Thomas Y. Levin, and Greil Marcus), and Marcus, *Lipstick Traces* (1989). Sadie Plant reads the SI as a prefiguration of postmodernism in *The Most Radical Gesture* (1992). In *The Situationist City* (1998) Simon Sadler focuses on the SI's architectural thought and legacy. Tom McDonough has provided a more nuanced account of the SI in *Guy Debord and the Situationist International* (2002), which brings together translation of key SI writings on art, with a number of important essays on aspects of the movement, and *The Situationists and the City* (2009), a collection of writings on the SI's urban thought. As T. J. Clark and Donald Nicholson-Smith have noted, a principal weakness of much scholarly writing on the SI is the tendency to assimilate its political dimension into a conventional art history (see "Why Art Can't Kill the Situationist International," in McDonough, *Guy Debord and the Situationist International*, 467–88). More recently, McKenzie Wark has reconsidered the contribution of members other than Debord in *The Beach beneath the Street* (2011) and the SI's legacy in *The Spectacle of Disintegration* (2013). On Debord, see Ansel Jappe, *Guy Debord* (1999), and the valuable study by Vincent Kaufmann, *Guy Debord: Revolution in the Service of Poetry* (2006).

6. Debord and Sanguinetti, *The Real Split in the Situationist International*, §30, 39.

7. Debord, "Statement by Lettrist International Delegate to the Alba Congress," in McDonough, *The Situationists and the City*, 90–92.

8. "La Plate-forme d'Alba," 247–48. The English translation is based on Debord, "Statement by Lettrist International Delegate to the Alba Congress," in McDonough,

The Situationists and the City, 90–91. For an alternative translation, see "The Alba Platform," in Knabb, *Situationist International Anthology*, 21–23.

9. "The Alba Platform," 22.

10. Debord, "Report on the Construction of Situations and on the Terms of Organization and Action of the International Situationist Tendency," in McDonough, *Guy Debord and the Situationist International*, 29. Translation modified.

11. Debord, "Report on the Construction of Situations," 32.

12. Debord, "Report on the Construction of Situations," 32.

13. On Debord and Surrealism, see Fabrice Flahutez, "L'héritage surréaliste: La lecture de Breton," in Guy and Le Bras, *Guy Debord*, 46–48; on surrealism and the SI, see Rasmussen, "The Situationist International, Surrealism, and the Difficult Fusion of Art and Politics."

14. Debord, "Report on the Construction of Situations," 33.

15. Debord would not only date the end of modern art to the 1930s, but would also consider it in relation to the failure of the revolutionary workers movement. See Debord, "The Situationists and the New Forms of Action in Politics or Art," in McDonough, *Guy Debord and the Situationist International*, 160; Debord, *The Society of the Spectacle*, §191, 136. References by thesis number (§) and page number in the Nicholson-Smith translation.

16. Debord, "Report on the Construction of Situations," 37.

17. Debord, "Report on the Construction of Situations," 44.

18. Debord, "Report on the Construction of Situations," 44.

19. Debord, "Report on the Construction of Situations," 49.

20. McDonough has noted the importance of Paul-Henry Chombart de Lauwe for the SI. See McDonough, *The Situationists and the City*, 16–17.

21. Chtcheglov, "Formulary for a New Urbanism," in McDonough, *The Situationists and the City*, 32–41. The essay appeared under the pseudonym of Gilles Ivain in *Internationale Situationniste*, no. 1 (June 1958): 15–20.

22. Chtcheglov, "Formulary for a New Urbanism," 37.

23. Chtcheglov, "Formulary for a New Urbanism," 36.

24. Khatib, "Attempt at a Psychogeographical Description of Les Halles," in Andreotti and Costa, *Theory of the Derive*, 72–76; Debord, "Theory of the *Dérive*," in McDonough, *The Situationists and the City*, 77–85. "Théorie de la dérive" originally appeared in *Les Lèvres nues*, no. 9 (November 1956): 6–10.

25. Debord, "Theory of the *Dérive*," 78.

26. "Definitions," in Andreotti and Costa, *Theory of the Derive*, 69.

27. The "Guide" was subtitled "pentes psychogéographiques de la dérive et localisations d'unités d'ambriance [*sic*]."

28. "Definitions," in Andreotti and Costa, *Theory of the Derive*, 70.

29. Constant and Debord, "The Amsterdam Declaration," in Andreotti and Costa, *Theory of the Derive*, 80.

30. Debord, "Theses on Cultural Revolution," in McDonough, *Guy Debord and the Situationist International*, 61.

31. "Art can cease to be a report on sensations and become a direct organization of

higher sensations. It is a matter of producing ourselves, and not things that enslave us." Debord, "Theses on Cultural Revolution," 61. For a later statement of this position, see Debord, *The Society of the Spectacle*, §187, 133.

32. "The Dark Turn Ahead," *Situationist International Online*, http://www.cddc .vt.edu/sionline/si/darkturn.html (accessed December 20, 2013).

33. Constant, "On Our Means and Our Perspectives," *Situationist International Online*, http://www.cddc.vt.edu/sionline/si/means.html (accessed December 20, 2013).

34. Jorn, "Détourned Painting," translated by Thomas Y. Levin, in Sussman, *On the Passage of a Few People through a Rather Brief Moment in Time*, 142.

35. Jorn, "Détourned Painting," 140.

36. Jorn, "Détourned Painting," 142.

37. Debord to Constant, May 20, 1959, in Debord, *Correspondence*, 250–51. Gallizio would be excluded from the SI in May 1960.

38. Debord and Wolman, "A User's Guide to Détournement," in Knabb, *Situationist International Anthology*, 14–21. Originally published in *Les Lèvres nues*, no. 8 (May 1956). Ducasse was better known by the pseudonym the Comte de Lautréamont as the author of *Les chants de Maldoror*. He was an important precursor to surrealism.

39. "Definitions," in Knabb, *Situationist International Anthology*, 61–62.

40. "Détournement as Negation and Prelude," in Knabb, *Situationist International Anthology*, 67.

41. Debord, *The Society of the Spectacle*, §208, 145–46. On the use of détournement in *The Society of the Spectacle*, see below, n. 95.

42. "The Use of Free Time," in Knabb, *Situationist International Anthology*, 74–75.

43. Debord briefly used the term *spectacle* in the "Report on the Construction of Situations":

> The construction of situations begins on the other side of the modern collapse of the idea of the theatre [*spectacle*]. It is easy to see to what extent the very principle of the theatre [*spectacle*] — nonintervention — is attached to the alienation of the old world. Inversely, we see how the most valid of revolutionary cultural explorations have sought to break the spectator's psychological identification with the hero, so as to incite this spectator into activity by provoking his capacities to revolutionize his own life. The situation is thus made to be lived by its constructors. The role of the "public," if not passive at least a walk-on, must ever diminish, while the share of those who cannot be called actors but, in a new meaning of the term, "livers," will increase.

Debord, "Report on the Construction of Situations," 47. Spectacle was also used in discussions of the cinema in "Notes éditoriales: Avec et contre le cinéma" and "Notes éditoriales: Le cinéma après Alain Resnais." On this point, see Levin, "Dismantling the Spectacle."

44. "The Use of Free Time," 75.

45. "Situationist Manifesto," translated by Fabian Thompsett, *Situationist International Online*, http://www.cddc.vt.edu/sionline/si/manifesto.html (accessed December 20, 2013).

46. "Situationist Manifesto."

47. "The Adventure," in Knabb, *Situationist International Anthology*, 79.

48. "The Adventure," 81.

49. "The Fourth SI Conference in London," in Knabb, *Situationist International Anthology*, 81–83.

50. "The Fifth SI Conference in Göteborg," in Knabb, *Situationist International Anthology*, 115.

51. "The Fifth SI Conference in Göteborg," 115.

52. "The Fifth SI Conference in Göteborg," 116.

53. On Constant and New Babylon, see Wigley, *Constant's New Babylon*.

54. Dieter Kunzelmann, Heimrad Prem, Hans-Peter Zimmer, Erwin Eisch, Renée Nele, Lothar Fischer, and Gretel Stadler were excluded. "Renseignements situationnistes," 49.

55. *Danger! Do Not Lean Out* was signed by Jørgen Nash, Jacqueline de Jong, and Ansgar Elde. They were joined by Katja Lindell, Steffan Larsson, and Hardy Strid to split with the SI.

56. "Renseignements situationnistes," 53–54.

57. I thank Amelia Barikin for drawing my attention to the influence of press censorship on the emergence of the notion of the spectacle.

58. On the Groupe de recherche d'art visuel, see Bishop, *Artificial Hells*, 87–93.

59. "Editorial Notes: The Avant-Garde of Presence," in McDonough, *Guy Debord and the Situationist International*, 147.

60. "Editorial Notes: The Avant-Garde of Presence," 147.

61. Ford, *The Situationist International*, 84–85.

62. Nash, "Danger, Do Not Lean Out"; "Renseignements situationnistes."

63. Rasmussen, "To Act in Culture While Being against All Culture," 76–77.

64. For a discussion that locates the exhibition in the context of the response by the Danish government and the Campaign for Nuclear Disarmament to the nuclear threat, see Rasmussen, "To Act in Culture While Being against All Culture," 80–85.

65. Debord, "The Situationists and the New Forms of Action in Politics or Art," 164.

66. Debord, "The Situationists and the New Forms of Action in Politics or Art," 165.

67. Debord, "The Situationists and the New Forms of Action in Politics or Art," 165.

68. Rasmussen, "To Act in Culture While Being against All Culture," 82.

69. Rasmussen, "To Act in Culture While Being against All Culture," 108.

70. The text of the *Directives* read: 1. "Dépassement de l'art"; 2. "Réalisation de la philosophie"; 3. "Tous contre le spectacle"; 4. "Abolition du travail aliéné"; and 5. "Non à tous les spécialistes du pouvoir. Les conseils ouvriers partout." Guy and Le Bras, *Guy Debord*, 132.

71. Debord, "The Situationists and the New Forms of Action in Politics or Art," 159.

72. Debord, "The Situationists and the New Forms of Action in Politics or Art," 159.

73. Debord, "The Situationists and the New Forms of Action in Politics or Art," 159–60.

74. Debord, "The Situationists and the New Forms of Action in Politics or Art," 159–60.

75. Debord, "The Situationists and the New Forms of Action in Politics or Art," 161.

76. Debord, "The Situationists and the New Forms of Action in Politics or Art," 161.

77. Debord, "The Situationists and the New Forms of Action in Politics or Art," 162.

78. Debord, "The Situationists and the New Forms of Action in Politics or Art," 162.

79. Debord, "The Situationists and the New Forms of Action in Politics or Art," 164.

80. Debord, "The Situationists and the New Forms of Action in Politics or Art," 164. The final sentence cites "Editorial Notes: Priority Communication," in McDonough, *Guy Debord and the Situationist International*, 147.

81. "Les mois les plus longs (février 63-juillet 64)," 31–33. Martin's *L'Europe 4 heures 30 après le début de la 3ᵉ guerre mondiale* appeared on p. 32, and a detail of Bernstein's *Victoire de la bande à Bonnot* appeared on p. 43.

82. "The Decline and Fall of the Spectacle-Commodity Economy," in Knabb, *Situationist International Anthology*, 194–203. See also McDonough, "The Decline of the Empire of the Visible."

83. "The Class Struggle in Algeria," in Knabb, *Situationist International Anthology*, 203–12.

84. Viénet, "The Situationists and the New Forms of Action against Politics and Art," in McDonough, *Guy Debord and the Situationist International*, 182.

85. Viénet, "The Situationists and the New Forms of Action against Politics and Art," 182–84.

86. Debord, "La séparation achivée"; "Sur deux livres de théorie situationniste," 63.

87. Debord, *The Society of the Spectacle*, §4, 12.

88. Debord, *The Society of the Spectacle*, §184, 131–32.

89. Debord, *The Society of the Spectacle*, §187, 133. Translation modified.

90. On the central role of communication for Debord, see Kaufmann, *Guy Debord*.

91. Debord, *The Society of the Spectacle*, §191, 136.

92. "Critical theory has to be communicated in its own language — the language of contradiction, dialectical in form as well as content: the language of the critique of the totality, of the critique of history. Not some 'writing degree zero' — just the opposite. Not a negation of style, but the style of negation." Debord, *The Society of the Spectacle*, §204, 143–44.

93. Debord, *The Society of the Spectacle*, §206, 144.

94. Debord, *The Society of the Spectacle*, §208, 145–46.

95. On the use of détournement in *The Society of the Spectacle*, see "Relevé provisoire des citations et détournements de *La Société du spectacle*," in Debord, *Œuvres*, 862–72.

96. For an overview of the debate on the neo-avant-garde, see Bürger, "Avant-Garde and Neo-Avant-Garde."

97. Viénet, *Enragés and Situations in the Occupation Movement, France, May '68*.

98. Ross, *May '68 and Its Afterlives*.

99. Kaufmann has noted that the greatest contribution of the SI to the events of May–June 1968 was a form of poetic language that perfectly expressed the demands of the time; see Kaufmann, *Guy Debord*, 183–86.

100. Debord and Sanguinetti, *The Real Split in the Situationist International*.

101. Debord and Sanguinetti, *The Real Split in the Situationist International*, §2, 7.

102. Debord and Sanguinetti, *The Real Split in the Situationist International*, §21, 28.

103. Debord and Sanguinetti, *The Real Split in the Situationist International*, §25–26, 32–33.

104. Debord and Sanguinetti, *The Real Split in the Situationist International*, §30, 39.

105. Debord and Sanguinetti, *The Real Split in the Situationist International*, §57, 71.

106. Debord and Sanguinetti, *The Real Split in the Situationist International*, §58, 71.

107. *On the Passage of a Few People through a Rather Brief Moment in Time: The Situationist International, 1957–1972*, Musée national d'art moderne, Centre Georges Pompidou, Paris, France, February 21, 1989–April 9, 1989; Institute of Contemporary Arts, London, England, June 23, 1989–August 13, 1989; Institute of Contemporary Arts, Boston, Massachusetts, October 20, 1989–January 7, 1990. *Situacionistas: Arte, política, urbanisme*, Museu d'Art Contemporani de Barcelona, Barcelona, 1996. *Situationistische internationale, 1957–1972*, Museum Moderner Kunst Stiftung Ludwig, Vienna, 1998. *In girum imus nocte et consumimur igni: The Situationist International (1957–1972)*, Centraal Museum Utrecht, December 14, 2006–March 11, 2007, Museum Tinguely, Basel, April 4–August 5, 2007. *Guy Debord: Un art de la guerre*, Bibliothèque nationale de France, Paris, March 27–July 13, 2013.

108. Bishop, *Artificial Hells*, 11.

NSK
Critical Phenomenology of the State

MIŠKO ŠUVAKOVIĆ

The First Step: Who, Where, and Why

In the last three decades, the Slovenian and pronouncedly Eastern European art movement NSK (Neue Slowenische Kunst) has responded to a variety of unfolding political situations that range from the crisis of modernism that began in the late 1970s, through the demise of real and self-management socialisms and the commencement of transition in Eastern Europe to globalization and the big economic crisis at the end of the first decade of the twenty-first century.

The primary thesis that I would like to advance in this essay is that the NSK movement has developed a set of complex artistic practices as "aesthetic

symptoms" of social and political breaks and transformations. Social breaks have thus become visible and have then been aesthetically mapped by the artistic practices of the NSK movement.

My other thesis here is that the NSK movement has been in complicity with three great world "aesthetic revolutions" at the end of the twentieth and the beginning of the twenty-first centuries.

First, the NSK foresaw and artistically presented the crisis of real and self-management socialisms in Yugoslavia and Eastern Europe as a crisis of international modernism during the 1980s.

Second, with its artistic activism at the end of 1980s, the NSK movement became complicitous with political movements in Eastern Europe (Polish Solidarity, movements for the national independence of Baltic nations, and the Czech Velvet Revolution) that fought for the end of the Cold War politics and of division of Europe into political East and West. In this way it revealed its nature as an aesthetic avant-garde movement. The members of the NSK played a special and important role of "aesthetic revolutionaries" in the process of achieving the independence of the Republic of Slovenia. In these ways the NSK movement's artistic and aesthetic activities questioned the status of the modern totalitarian state in the 1980s. It then initiated an aesthetic and artistic project relating to the status of the national postsocialist state.

Third, by developing the idea of the NSK state as a "state in time," the NSK has sought to create a global aesthetic event that would represent contemporary global deterritorialization of power as well as the self-organizing practices of social and political global life in the late 1990s and the first decade of the new millennium.

During the postmodern era, in which the end of metalanguage, politics, and ideology were proclaimed,[1] the NSK has unambiguously performed politicized art in its own way.

The NSK Movement—Neue Slowenische Kunst

The NSK movement consists of a network of artistic groups.[2] The name Neue Slowenische Kunst (New Slovenian Art) is a reference to the 1929 thematic issue of Herwarth Walden's avant-garde magazine *Der Sturm* (1910–32) titled "Junge slovenische Kunst."[3] The initial group of what was to become NSK was the music-artistic group Laibach, founded in 1980 in the Slovenian mining town Trbovlje.[4]

Since being formally launched in 1984 by the groups Laibach, IRWIN

(visual art), and Theater of the Sisters of Scipio Nasica, the NSK movement has been involved in various realms of creativity, activism, and confrontation. Other NSK member groups include New Collectivism (graphic design), Retrovision (video and TV), and Department of Pure and Applied Philosophy (theory). According to the members of IRWIN,

> the Neue Slowenische Kunst collective (NSK) was formed by the three founding groups . . . back in 1984, still within the framework of the former Socialist Federal Republic of Yugoslavia. Collaboration, a free flow of ideas among individual members and groups . . . which was not limited even by the indication of authorship, as well as mutual assistance and joint planning of particular moves and actions were crucial for the development and operation of NSK, although the groups were autonomous in their activities. Awareness of the specific conditions for operation in the field of art in the then Yugoslavia, which was largely defined by the closedness of the art system and a valorization system adjusted to local needs, led to the concentration of critical mass and confrontation with the art system.[5]

The NSK movement consists of artistic groups that advocate and practice collective artistic work. Its constitutive groups appeared at the beginning of the 1980s as a postmodern simulacrum of a paradoxical union of early avantgardes (suprematism and constructivism) and totalitarian art (socialist realism, Nazi art). With their works the NSK conducted a critique of fetishized modernist and then postmodernist artistic individualism as found for example in Italian and international trans-avant-garde (Francesco Clemente, Julian Schnabel) and in German neo-expressionism (Georg Baselitz, Anselm Kiefer). Such insistence on the collective and artistic individual anonymity arises from a characteristic Eastern European belief in the supremacy of the collective over the liberal individual. On the other hand, we can recognize today from a historical distance the correspondences between the NSK and the contemporary activist projects of American groups such as Group Material and the collective Critical Art Ensemble, or the Canadian group General Idea, which wanted to overcome the American liberal myth about the individual artist. The teamwork of the NSK movement at this time also anticipated artistic collectives and platforms that were active in the 1990s and 2000s, such as Russian post-Soviet platform Chto Delat?, the international platform Slavs and Tatars (oriented toward Euro-Asian cultures) or the Indian new media and activist platform Raqs Media Collective.[6] The transformation of an artis-

tic group into a free set of authors who mutually cooperate as an artistic collective is driven by transforming artistic activity understood as the "style" of creating art into the "strategy" of acting in culture and society through art.[7]

The NSK movement has long been conceived of as a locus of articulations and rearticulations of the complexity of contemporary social reality. It started in the 1980s by deconstructing modern art, which it then rearticulated into modalities of modern, totalitarian, early avant-garde, and neo-avant-garde art in its movement toward the global art and culture of the 1990s and after. Accordingly, the result of the activities of NSK is not art that comes "after" that of the early avant-garde, the neo-avant-garde, and modern totalitarianisms, but rather art that comes into being due to the postmedia usage and realization of simulations of the "aesthetic revolutions" of these early avant-gardes (Dada, cubo-futurism, suprematism, constructivism), neo-avant-gardes (neo-Dada, Happening, the New Realism, situationism, actionism) and the art of totalitarianisms (socialist realism, fascist and Nazi art) in a conflicting contemporaneity. NSK artists simulated the "aesthetic revolutions" of early avant-gardes, neo-avant-gardes, and modern totalitarianisms because they believed that the ideals, concepts, and methods of modernism have completely lost their political and aesthetical sense in actuality, a point they felt had to be shown in a direct way and made visible in contemporaneity. Characteristic examples are NSK's 1984 reconstruction of Tatlin's *Monument to the Third International* (1917) or the act of paradoxically connecting, in a 2006 photograph, the Dadaist Hugo Ball from 1916 with Macedonian Orthodox bishop Metodii (figure 7.1). On the threshold of the new millennium, the NSK movement represented not a return to the artistic practices of the twentieth century but instead a reconsideration of their aesthetic revolutionary potentialities under contemporary conditions and circumstances.[8]

With its art NSK has shown and served as a witness to social conflicts and antagonisms, such as the wars of the 1990s (the armed disintegration of Yugoslavia), the transitions of modern multinational states (the USSR, the Socialist Federal Republic of Yugoslavia, Czechoslovakia, etc.) into national liberal ones (Slovenia, Croatia, Serbia, the Czech Republic, Slovakia, Estonia, Armenia, etc.), and the global economic crisis of the last decade (figure 7.2). In 2012–13 the IRWIN group appropriated the protests of Slovenian students and citizens against the economic restrictions of the government. By their personal participation in civil protests and gatherings in Ljubljana, they made an ambivalent political statement and carried out an artistic action. In the time of global economic crisis, the IRWIN group became conscious of the political gatherings of citizens and of their protest against the policy of austerity, re-

FIGURE 7.1
IRWIN, *Was ist Kunst
Hugo Ball* (Bishop
Metodii Zlatanov,
Metropolitan of
the Macedonian
Orthodox Church,
with Hugo Ball),
2006–11.

strictions, and the loss of social safety in Spain, Greece, and the United States as well as in Slovenia. IRWIN therefore appropriated the protests of citizens and students in Ljubljana, transforming them from a political event into an artistic and aesthetic presentation of the "new crisis of sociability" connected to the aesthetics of global occupying movements.

Through its simulations of an aesthetic revolution with totalitarian and avant-garde iconography, the NSK movement stood apart from Russian conceptual and perestroika art constructed around fascinations with the iconic similarities and differences between Soviet socialist realism and American pop art. As a postmodern art movement, NSK performed painterly, musical, and theatrical simulations of the aesthetic revolutions of the early avant-gardes and totalitarian states, thereby remaining on the level of alienated (but not completely literary) art practice. NSK prints such as *Die erste Bomardierung* (1983) (figure 7.3) and paintings produced by the groups Laibach and IRWIN, with their pathetic pseudo-totalitarian and pseudo-sublime images,

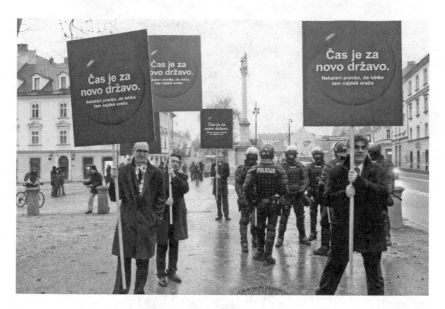

FIGURE 7.2 IRWIN, *Happy New Year 2013*, 2012.

thus profoundly differed from the iconography of perestroika art as featured in the 1970s and 1980s in the skeptical and humorous paintings by Komar & Melamid or in the indifferent paintings-as-commercial-brands of Erik Bulatov. With its antimodern (i.e., "retro") style, NSK also departed from Chinese cynical realism, which emerged as the discovery and articulation of an alienated modernism during the Chinese postsocialist transition.[9] NSK likewise diverged from postsocialist Polish blasphemic art, the visual rhetoric of which confronted the Catholic shaping of everyday life in the new Polish postsocialist state.[10]

The NSK movement arose in socialist Slovenia and Yugoslavia at the end of the Cold War and at the start of the political identity crisis in Yugoslavia. Piotr Piotrowski has highlighted the relation between the NSK movement on the one hand and the end of the Cold War and the disintegration of the socialist Yugoslavia on the other, pointing to the substitution of the dissident critique of socialism with a functional analysis of ideology:

> The history of NSK is closely connected with the fall of the Tito regime and the so-called Slovene syndrome of the 1980s. In the aftermath of Tito's death, the disintegrating Yugoslav federal government attempted to keep separatist tendencies in check by introducing much more rigid internal politics, for instance by eliminating the individual republics'

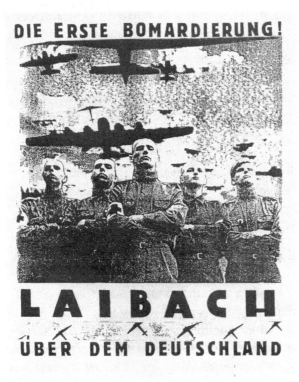

FIGURE 7.3
Laibach, *Die erste bomardierung* [*sic*], poster, 1983.

constitutionally conferred rights to limited autonomy. Because Yugoslavia, unlike Czechoslovakia and Poland, had no organized political opposition or dissident circles, it also lacked art that embraced the values formulated by such circles, in particular those values involved in a moral critique of the Communist regime. The function of the Central European opposition was taken over in the 1980s by groups from alternative culture, such as NSK, which used a very different strategy in dealings with the system of power. They did not engage in a moral critique so much as in a functional analysis of ideology based in the theoretical writing of Slavoj Žižek. . . . "Slovene syndrome" was a result of the fact that this republic enjoyed much greater freedom than other parts of Yugoslavia and that its alternative intellectual and art scene was not only particularly productive, but also created an environment that functioned as a substitute for a politically independent life.[11]

Since the early 1990s, the long-term project of NSK has been to produce a movement that could realize symptoms of contemporary social antagonisms.

In psychoanalytical terms, a symptom may be conceived of as a defect of symbolization and centered in the transparency of a subject. In other words:

> Symptoms are meaningless traces, their meaning is not discovered, excavated from the hidden depth of the past, but constructed retroactively—the analysis produces the truth; that is, the signifying frame which gives the symptoms their symbolic place and meaning. As soon as we enter the symbolic order, the past is always present in the form of historical tradition and the meaning of these traces is not given; it changes continually with the transformation of the signifier's network. Every historical rupture, every advent of a new master-signifier, changes retroactively the meaning of all tradition, the restructured narration of the past, makes it readable in another, new way.[12]

A symptom—and this is its relevance for interpreting NSK—is a performed but nonverbalized antagonistic and critical construct whereby the character of cultural and social ideology in Slovenia, the Socialist Federal Republic (SFR) of Yugoslavia, and, indeed, the Eastern European "really existing socialism" of the 1980s is revealed. For instance, with the totalitarian Nazi iconography of their behavior and the pseudo-Nazi and -Stalinist rhetoric imbuing their industrial rock, Laibach suggested an atmosphere that was incompatible with the official self-identifications of the Yugoslav socialist society and its antifascist traditions. In performing symptoms in their cultural and artistic practices, NSK aimed to evoke and provoke antagonistic situations within the ruling order of the socialist state. The "NSK symptom" thus indicates the breakdown of the rationally established social interpretation that is meant to resolve—or at least neutralize, suppress, or conceal—collective differences and antagonisms within the late socialist self-management SFR Yugoslavia.

During the postsocialist transition, NSK and the IRWIN group initiated the *East Art Map* (1999–), a research and publication project presenting the "Eastern European story of art," thereby complementing the Western or American "story of art." The Czech art theorist Vit Havránek has commented, "One exceptional theoretical manoeuvre was the IRWIN group's *East Art Map* project, which took the ideological homogenization of time as its starting point—as a Trojan horse bearing the fragmented histories of various lands with no pretensions to universality or any sort of homogeneity. *East Art Map* is, *de facto*, a rhizomatic structure in which the positions of individual artistic figures and groups determine the mutual relationships that prevail among artists living in different countries and temporalities."[13]

Fascinations with the State

In 1992 the IRWIN group announced the transformation of the NSK movement into the NSK State in Time. This gesture demonstrated that NSK was in constant change—uninterruptedly transforming the reality of the NSK "spirit" or "mind" (in Hegelian terminology) from one mode to another, from one temporal embodiment to another in a new historical moment. The phenomenality of the NSK State in Time has been undergoing permanent change. In other words, the NSK State in Time appears as an aesthetic response to historical moment when the formation of the modern state has been completed and it has been reduced to a minimum of institutional functions, while neoliberal corporations have become deterritorialized constituents of global power.

The IRWIN group has effected a material turn from painting as a medium of artistic representation to the display of the state apparatuses as an artistic postmedium condition. It has showed the critical dialectical transformation of the potentialities of a state into an artwork and the preconditions for an artwork to be transformed into a state existing in time.[14] The NSK State in Time reveals and realizes political affects within contemporary transitional and global societies. They appear between the discourse of politics and its manifestations, namely between the visible and the invisible (or the real and the fictional) of the state as a form of contemporary sociality.

The NSK State in Time is thus an example of a postmedia artistic practice. The notion of postmedia art practice can be applied to hybrid connections of different artistic and nonartistic phenomena that advocate different political, aesthetic, ethical, or artistic concepts. Postmedia artistic practice denotes artistic or aesthetic events realized as installations or performances, that is, appropriations of nonartistic objects, situations, events, institutions, or forms of behavior.

Contemporary artists are no longer interested in formalist questions about artistic media or in performing innovative "conditions of postmedium" artistic work.[15] They are instead primarily interested in political, social, and cultural discourses, apparatuses, and events that are appropriated and posited as the "postmedia" of their practices. For NSK, especially for the IRWIN group, the issue of the formal relation between the medium and the postmedium in an autonomous system of art is not relevant. What the group finds important instead is the simulation of political, social, and cultural antagonisms and situations simultaneously within and outside the art world.

With its project of the State in Time, NSK has pointed out the modes in which the politicization of the sensible global world is realized through con-

temporary social antagonisms. The NSK has thereby pointed to "the sensible potentialities" of the institutions, discourses and forms of behavior of the contemporary global world that form the "technical support" for the realization of artistic ideas about global social practices as well as for the realization of such ideas within art.[16] Within this "postmedium condition," contemporary artists now work in the complex, open, and flexible field of cultural and social appropriations of life between art and the global world. Contemporary art presented in big international exhibitions, such as the recent Kassel Documenta (especially in 1998–2013), does not resemble modern art based on the idea of autonomous painting and sculpture; rather, it is similar to the documentary practice based on textual, photographic, cinematic, or video presentations of the archives in which are collected documents about everyday life, political and economic crises, social conflicts, or socially useful work in local and regional communities. The NSK movement's postmedium art practice could be compared with the projects of the American group Critical Art Ensemble, the Chilean artist Alfredo Jaar, or the Atlas Group of the Lebanese artist Walid Raad. Boris Groys has identified with precision the primarily documentary character of postmedium art: "In recent decades, it has become increasingly evident that the art world has shifted its interest away from the artwork and toward art documentation."[17]

In the 1980s the NSK movement began to undertake its artistic work under traditional conditions of artistic production (music concerts, theater plays, installations made of paintings, video presentations, lectures, and performances). Since 1992 the NSK State in Time has modified these conditions into the "postmedium practice"—into global cultural and social policies as art. In its work from the 1990s, the group no longer used a single artistic medium (painting, photography) but instead worked with "open and flexible events" based on the appropriation of social practices such as state diplomacy, the issuing of visas and passports, the creation of the state coat of arms, the organization of the national army, or the enacting of national cultural policy. The work of art as a material artifact was thus transformed into segments of society understood as a community wherein the activities and actions of the "state" replaced the usual material artwork.

The NSK involvement with the state as a postmedium practice presupposes the interpretation and use of state apparatuses as instruments of artistic and aesthetic impact in real or fictional sociality or in the institutional effects of the state. Transposing artistic interventions from the realm of autonomous art into the realm of state apparatuses also brings about the politicization of artistic practice, as well as an aestheticization of the social. In this case, con-

trary to some critical and revolutionary Marxist writers (e.g., Leon Trotsky, Georg Lukács, Walter Benjamin), the politicization of art does not imply the uses and abuses of art by a political party or Althusserian state apparatuses.[18] At issue is not art in the service of the state, the party, or the leader but rather the uses of state apparatuses on the part of the artist who abandons the traditional modernist autonomy of art in the name of the new postmedium as an open and flexible condition, that is, of the state itself as an intervening hybrid medium of artistic activity.

The NSK movement thus constructs the State in Time as an instrument of artistic intervention in contemporary transitional and global society. These interventions are based not on expressing political positions but on performing singular events whereby changes of phenomenality in the state are made visible in contemporary forms of life. With the performing of the State in Time, the NSK movement shows how the establishment of a state located between reality and fiction takes place. The NSK movement uses something of reality and something of the fiction and places it within an artistic and cultural frame. This is a fundamental turn that could, following Jacques Rancière, be designated as an aesthetic revolution: "This is precisely what I have called the aesthetic revolution: the end of an ordered set of relations between what can be seen and what can be said, knowledge and action, activity and passivity."[19] The state construed as an open, dynamic, and flexible event reveals the conditions for the implementation of an order of relations between what can be seen and what can be said in relation to the manifestations of the State in Time, whereby a spatial state is transformed into a global temporal one.

The members of the NSK movement have thus launched a multitude of statelike actions both as postmedia and as social aesthetic events: In its first period (the 1980s), the group Laibach and then the NSK operated through a symbolic overidentification with the totalitarian state (Nazi Germany, imperial fascist Italy, Bolshevik Soviet Union). In its second period, immediately after the dissolution of SFR Yugoslavia, the NSK State in Time was created (1992). The NSK State in Time was fashioned as a temporal image of the spatially constituted independent Republic of Slovenia, established after the disintegration of Yugoslavia. As it proclaimed in 1992 by the IRWIN group, the "NSK confers the status of a state not upon territory but upon the mind."[20] The NSK state became a critical manifestation, a symptom of state and territorial fetishisms visible in the 1990s among the postsocialist nation-states of Southeastern Europe.

In the third period—from the late 1990s and into the new millennium—

the dematerialized and deterritorialized NSK State in Time has anticipated and expressed the neoliberal post-Fordist overcoming of territory-specific state institutions.

"Totalitarian State": NSK in the 1980s

Early NSK activities were related to the obsessive symbolic and actual repetition of the affects of European totalitarianisms (fascism, Nazism, Bolshevism) between the 1920s and 1950s. Eastern Europe's recurrent traumas of totalitarianism were implied by syntagms such as retro-garde and retro-avant-garde. Members of the IRWIN group, for example, individually and collectively created paintings in which they included citations or collaged symbols and representations inherent to the art of totalitarianism (characters in Nazi-like uniforms or a "Bavarian" stag, Bolshevik red stars, or figures of workers) or the avant-garde (suprematist cross, constructivist abstract forms) (figure 7.4). One example is an installation of collage-montage paintings from the series *Was ist Kunst* that refer to the iconography of the art of totalitarianisms.

For the NSK movement, the prefix "retro-" related to an active, interventionist, and transgressive eclectic interest in the totalitarian past of Europe. In particular, the prefix bore upon the trauma of the past in the present, implying that the totalitarian past may have gone away but still remained to be played out in the future. For IRWIN especially, the retro principle made it "necessary to analyze the historical procedures of Slovenian fine arts," as well as the history of the European contradictions inherent to modernism defined by the borders of avant-garde anarchism and totalitarian realisms.[21] In the diagrams titled *Retroprinciple* and *Retroavant-garde* (figure 7.5), IRWIN presented the concept of the critical artistic work of the group and pointed to the conditions of its artistic and geopolitical context.

Since the group's first appearance in 1980, the members of Laibach have exploited borderline Nazi imagery in their public and private behavior. I refer not to the neofascist imagery and outfits worn by right-wing youths in the West, but to advocates of identification of twentieth-century totalitarianisms. Accordingly, overidentification with totalitarianism has been their determinant feature.

The idea of "retro" was manifested also as a style in the artificially stylized presentation of the artwork as a universal work of art (*Gesamtkunstwerk*), as elaborated in late romanticism and later by the early avant-gardes. NSK works appeared in a variety of genres and forms: as paintings, pop con-

FIGURE 7.4 IRWIN, *Was ist Kunst?*, Gallery Bess Cutler, New York, installation view, 1989.

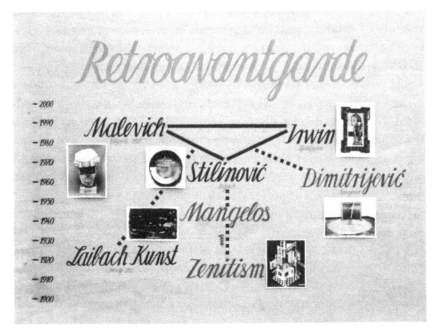

FIGURE 7.5 *Retroavantgarde*, 1996. Mixed media, 120 × 200 cm. First exhibited in January 2007 in Kunsthalle Vienna.

certs, works of graphic design, video art, theoretical lectures, and theater productions. Contrary to radical modernist art's dismissal of oblique, decorative stylizations and its advocacy of minimalism, straightforwardness, and "pure" artistic expression, the NSK movement presented theatrical, decoratively suggestive, and antiformalist stylizations ranging from painterly eclecticism to scenographic fictionalism. For instance, IRWIN paintings were conceived as citational or simulational appropriations of totalitarian (Stalinist and Nazi) iconography and were mounted in rhetorically overemphasized frames that simultaneously implied totalitarian kitsch, the pseudo-romanticist sublime as well as an intentional indexing of paintings as stylized and alienated representations in and of themselves. The retro style of these visual presentations was overdetermined by the authenticity of artistic expression that was of such paramount importance to modernisms of the twentieth century. In their paintings and installations, IRWIN simulated a situation of both the maximum elaboration and simultaneous abolition of truth in a totalitarian society. For example, a series of individually and collectively executed paintings titled *Malevich between the Two Wars* (1984–86) disclosed the eclectic, retro, and ambivalent iconography of Nazi and suprematist (totalitarian and avant-garde) art whose artistic practice related to Boris Groys's claims about the proximities between avant-garde and socialist realist art. Avant-garde artists sought a new human and a new humankind rather than a new art: "The ultimate artistic act would be not the production of new images for an old public to view with old eyes, but the creation of a new public with new eyes."[22] Socialist realism, on the contrary, displayed a tendency to merely represent socialist visions: "Socialist Realism was the attempt to create dreamers who would dream Socialist dreams."[23]

At the outset IRWIN, as well as the NSK movement as such, regarded early avant-gardes as a completed artistic phenomenon. They displayed traces of the avant-gardes with their retro procedures of appropriation, making use, for example, of Malevich's symbols (especially the cross) and Duchamp's forms of alienated and impersonal behavior. At the same time, they transformed the phantasm of the local (Balkan) avant-garde movement around the magazine *Zenit* into a myth about the exceptional nature of the Eastern European artist.[24] Their further appropriations and references ranged from the constructivism of Avgust Černigoj to the experimental theater of Ferdo Delak.[25] They also adopted notions of the collective *Gesamtkunstwerk* and of art pursuing collective identity in its creation of a new world that is always already a retro world. The IRWIN paintings were created by eliminating con-

FIGURE 7.6
IRWIN, *The Enigma
of Revolution*, 1988.
Mixed media.

sistent significations and representations, and by the simultaneous introduction of heterogeneous iconological as well as ideological artistic references, ranging from medieval, Byzantine, Renaissance, and Baroque art, to avant-garde and totalitarian art. For instance, in their 1988 painting *The Enigma of the Revolution* (figure 7.6), different patterns of construction in the pictorial field are present. The socialist realist model in this IRWIN painting is made present by the copying of Isaak Brodsky's painting *Lenin in Smolny* (1930), featuring Vladimir Ilyich in private surroundings. In turn, the avant-garde Suprematist model is referenced by Malevich's black cross on a white surface from the late 1910s. Vertical lateral floral strips and rough wooden frames evoke German expressionism. All of these references are conceived as an eclectic cluster of arbitrary codes.

The design group New Collectivism performed a major subversion with its poster for the 1986 Yugoslav Day of Youth celebration. In socialist Yugoslavia, the Day of Youth was a double celebration. First, it marked the birthday of Josip Broz-Tito (1898–1980), the statesman and political leader of SFR Yugoslavia. Second, this was a festival dedicated to young people and their role in

socialist society. This manifestation possessed all the properties designated by the Russian philosopher Mikhail Riklin as "communism as religion" or "the birth of religion from the spirit of atheism."[26] The Day of Youth celebration was a ritual display of collective faith in the bearers of socialist progress and socialist government—faith inscribed into the empty space vacated by religion. The Day of Youth celebration continued after Tito's death; its central event was a youth and army rally in the Yugoslav capital, Belgrade. In the early 1980s, the celebration was transformed into somewhat formal and pompous festivities dedicated to the preservation of the memory of the revolutionary Yugoslav leader. Graphic design for the propaganda posters increasingly featured abstract representations, such as geometric designs of birds, stars, the sun, and so on. The anonymous graphic design competition for the 1986 celebration received an unusual entry recalling black-and-white socialist realist prints and featuring a nude young man holding a flag in one hand and a torch in the other. After the poster was awarded the first prize, it was discovered that this entry, submitted by New Collectivism, was in fact a remake of a 1936 Nazi image by Richard Klein. The ensuing scandal marked the end of the Day of Youth celebration (figure 7.7).[27] With this symbolic act of patricide, New Collectivism departed from the realm of artistic subversions pertaining to the autonomy of contemporary art and alternative behavior on the margins of society in order to perform an aesthetic intervention simulating a revolutionary social gesture. Thus the culturally and aesthetically oriented revolution of Slovenian "alternative" scene became a symptom of anticipated social changes.

Similarly, Laibach and the Theater of the Sisters of Scipio Nasica employed stage music and a retro theatrical dichotomy between the sublime and the trivial that underlies both traditional romanticist aesthetics and the superficial, kitschy consumer aesthetics of 1980s pop culture. The works of IRWIN represented a fragmented model of a totalitarian state, as documented by numerous manifestoes, programmatic texts and statements. For example, in their "10 Items of the Covenant," Laibach conceived a simulated Hegelian model of the "phenomenology of mind," displaying itself as an industrial mechanism or an artificial organism whose template was the totalitarian state: "Laibach works as a team (the collective spirit), according to the principle of industrial production and totalitarianism, which means that the individual does not speak; the organization does. Our work is industrial, our language political."[28] This was an appropriate context for suggestive paraphrases of statements by Adolf Hitler ("Art is a supreme activity based on fanaticism") or Joseph Stalin (artists as the "engineers of the human soul").

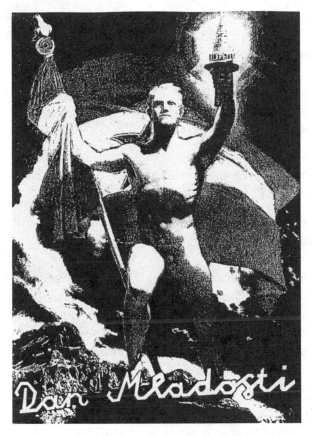

FIGURE 7.7
New Collectivism,
*Design for the Day of
Youth poster, ZSMJ /
Socialist Youth Alliance
of Yugoslavia*, 1987.
Collage from photo-
copies, 35 × 24.5 cm.

One of Laibach's first proclamations launching their totalitarian discourse reads as follows:

> Art and Totalitarianism
> are not mutually exclusive.
> Totalitarian regimes abolish
> the illusion of revolutionary
> individual artistic
> freedom.
> LAIBACH KUNST is the principle
> of conscious rejection
> of personal tastes,
> judgments, convictions . . . ;
> free depersonalization,
> voluntary acceptance

of the role of ideology,
unmasking and
recapitulation of regime,
ultramodernism . . .
He who has material power, has spiritual power, and all art is subject to
 political manipulation, except for that which speaks the language of
 the same manipulations.[29]

A programmatic letter from 1983 by the Theater of the Sisters of Scipio Na-
sica (Dragan Živadinov, Eda Čufer, Miran Mohar) likewise addressed the re-
lationship between the theater and the totalitarian state:

Theater does not exist between the *Spectator* and the *Actor*.
Theater is not an empty space.
Theater is a *State*.
Every theater is a hierarchical, national, economic and ideological orga-
 nization. In defining particular ideological and artistic standpoints,
 the Theater of the Sisters of Scipio Nasica renounces communication
 rituals. All the standpoints of Theater of the Sisters of Scipio Nasica
 are defined by the mode of its *Existence*, that is, by the *Contents* and
 the *Form* of its *Aesthetic* vision.[30]

In the case of NSK, the theater (indeed, every artistic practice) is identified
with the state in a totalitarian sense—with its phenomenal existence as a
ghastly allegorical skeleton of human life, work, and actions. The Theater of
the Sisters of Scipio Nasica thus conceived scenographic images (*Marija Na-
blocka Retro-Garde Happening*, 1985) as parts of a simulated aesthetic regime
of a totalitarian state. The theatrical order mirrored its ideal order.

NSK, Yugoslavia, and the Slovenian National State

Throughout history, the Slovenian national territory was, in part or as a whole,
administered by different states: Austro-Hungary, France, Germany, Italy, or
the South Slavic political project—Yugoslavia.[31] For two centuries Sloveni-
ans depended for their national identity on language and culture, not on an
independent state. From romanticism to twentieth-century modernism, this
national culture was based on the conservation and canonical development
of the national language. Slovenian national identity was thus established
and preserved through spoken and written language (the national literature).
National literature and, more recently, national philosophy (as its subgenre)

written in the Slovenian language have been an important part of the social space where national and, more generally, social identities are forged. During the twentieth century, modern identity constructions of the Slovenian nation manifested themselves in poetry (France Prešeren), prose (Ivan Cankar), art history (Izidor Cankar), essays (Josip Vidmar, Dušan Pirjevec), painting (Ivan Grohar, Rihard Jakopič, Veno Pilon), and so on.

After World War II, the Slovenian national identity was informed by its dual position as a nation: in the federal unit "Socialist Republic of Slovenia" and in the state unit "Socialist Federal Republic of Yugoslavia." In Yugoslavia the decline of the centralized administrative state control in its late socialist era (1980s) brought about the rise of nationalist cultural and, subsequently, independent state agendas in various republics of socialist Yugoslavia. These agendas essentially differed with regard to the status of the federal state and, notably, the relations between federal units.

The Yugoslav conflict and the dissolution of the common state revolved around relations between the central federal government and those of individual republics. The conflict reached its climax in the war operations of 1991, when the independent Republic of Slovenia and the Republic of Croatia were proclaimed, followed by the Republic of Macedonia and the Republic of Bosnia and Herzegovina. Serbia and Montenegro represented the remaining Federal Republic of Yugoslavia. This union of Serbia and Montenegro dissolved with the secession of Montenegro in 2006.

In the Republic of Slovenia, two different cultural and social concepts for overcoming the Yugoslav crisis emerged simultaneously. The first was a typical postsocialist program addressing the national culture and the state, and it was advocated by the nationalist conservative and populist intellectuals assembled around the journal *Nova Revija*. The other concept was associated with the liberal notions of civil society elaborated by the reformist wing of the League of Communists of Slovenia and, in radical forms, by the intellectuals and artists affiliated with alternative culture. These two diverse agendas were brought together briefly—namely, in the period immediately preceding the founding of the independent Republic of Slovenia in 1991, which was the time of broad political support for an independent national state. These events were propelled by a social movement consisting of different groups. This integrative national atmosphere was documented in numerous discourses that manifested themselves in the unique form of a national awakening following the end of communism. *Retro-Garde Event "Baptism under Triglav,"* conceived and performed by the Theater of the Sisters of Scipio Nasica in Ljubljana in 1986 (figure 7.8), was one of the sparks of this awakening and the

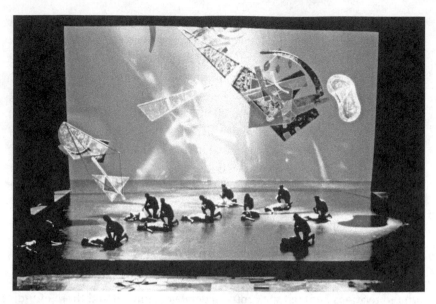

FIGURE 7.8 Theater of the Sisters of Scipio Nasica, *Retrogarde Event "Baptism under Triglav,"* Cankarjev dom Cultural and Congress Center, Ljubljana, 1986.

realization (as well as deconstruction) of Slovenian national identity at the end of the late socialist era. This spectacle was based not on the text of a theater play, but on visual attractions performed in vivid forms that referred simultaneously to one of the central Slovenian national myths expressed both in the romanticist poem *Baptism at the Savica Falls* (1835) by France Prešeren and in a late modernist theater play from 1969 with the same title, written by the Slovenian playwright Dominik Smole. The 1986 postmodern theater production, which featured marked constructivist and suprematist iconography, was thus featured as one of the core elements of Slovenian national identity at the end of the Yugoslav project of self-management socialism.

Art historian Igor Zabel has identified IRWIN's artistic procedures (and indeed those of the NSK movement as a whole) in the following terms: "Right from the start, IRWIN established three main criteria for its work: programmatic eclecticism, the primacy of group identity over personal identity, and affirmation of the local and the national."[32] IRWIN developed its strategic geopolitical mapping by realizing its painterly and imaginative work of artistic appropriation in a carefully elaborated range of sources, comprising Slovenian national art, Slovenian contemporary art, Eastern European postsocialist art, and, subsequently, a globalized transitional artistic identity.

The NSK project *Slovenian Athens* (1991) was an example of the post-

socialist reconstruction of national identity and a manifest sample of the integrative construction and performative unity of the Slovenian postsocialist nation. The term "Slovenian Athens" originated with one of the leading early twentieth-century Slovenian intellectuals, Josip Vidmar, who, with romantic zeal, hoped that the capital of Slovenia, Ljubljana, would become a new Athens or a new Florence, thus inscribing itself in the world and its history as a center of European culture.[33] From their perspective the members of IRWIN proclaimed in their programmatic "Epistle" that *Slovenian Athens is a reconstruction of Slovenian modernism in all its variations. For this reason, painters from all over Slovenia, of different inclinations and generations take only one subject, namely that of the Sower which, particularly at the beginning of the twentieth century, inspired many Slovenian painters. It is a scene which, with its narrative and expressive suggestiveness, goes so far beyond all the boundaries set by imposed aesthetic and ideological patterns, that it remains embodied in myth.*[34]

The group chose the famous painting *The Sower* (1907) by one of the early Slovenian modernists—the impressionist painter Ivan Grohar—to serve as a model for its contemporary versions executed by numerous artists from Slovenia, Yugoslavia, Europe, and the United States, and exhibited in the Museum of Modern Art in Ljubljana in 1991. Adopting the international language of impressionism, Grohar's *Sower* depicts a peasant on his land and is a paramount modernist piece of Slovenian culture. The representational genre of "work in the field" evolved in European painting from the French realists (e.g., Jean-François Millet) to national romanticist painters in the late nineteenth and early twentieth centuries.

The copying of this painting almost a century later had two main purposes:

1 To demonstrate the European horizon of this painting—that is, to present the Slovenian nation as European.
2 To demonstrate the retro-principle: a principle of copying and appropriating that annihilates the original.

What we witness with this project involving Grohar's *Sower* is a simulacrum of national painting after the end of the modern project of Eastern European and Yugoslav socialisms. National painting is thus conceived in terms of visible relations between territory, the nation, and an active pictorial matter.

Another important work dedicated to the independent Slovenia, as perceived through the history of the NSK movement, is the documentary *Predictions of Fire* (1996) by the American film director Michael Benson. The

film was both a documentary and a fictional overview of Slovenian political history in the twentieth century that also depicted the violent dissolution of the SFR Yugoslavia in 1991. The NSK movement was presented as a fictional screen that both generated and eclectically juxtaposed political images of Slovenia and Yugoslavia, thereby becoming a demonstrative sample of the construction of the new Slovenian identity in the independent state created in 1991. As a Yugoslav republic in the 1980s, Slovenia was not only reformist but also one of the most highly developed economic, social, and cultural communities in Eastern Europe. Within fictional productions of the NSK movement, Slovenia became a visible construct of the self-reflecting Eastern European postsocialist identity. This transition from Slovenia as a developed reformist federal unit of the SFR Yugoslavia into the independent Republic of Slovenia is in part an interpretative effect of NSK productions and rearticulations of the symbolic geopolitical identity of Slovenia.

In this way the NSK movement strategically repositioned itself, relocating its activity from that within the space of the alternative culture of Slovenia and the socialist Yugoslavia (1984–92) to one aimed at realizing the universal identity of "Eastern European art."[35] Its aim was to present this European "gray zone" of unidentified and forgotten artistic works and practices as an important and authentic cultural and artistic space in dialogue with the art of the West.[36]

The Anticipation of Free Territory: NSK Embassy in Moscow

The opening of the NSK embassy in Moscow launched a fictional political project announcing the NSK State in Time.[37] The first NSK embassy was located in a private apartment on Leninsky Prospekt 12 from May 10 to June 20, 1992. The event was conceived by IRWIN and Eda Čufer, and the project was realized by the Apt-Art International and Ridzhina Gallery in the form of a live interactive installation. The opening of the embassy was accompanied by a street event: while carrying NSK flags, IRWIN and NSK protagonists mounted state emblems on the façade, impersonating dissidents and revolutionaries who had seized a building and displayed political symbols of a(nother) state created after the fall of socialism (figure 7.9). This was a collectively expressive and, at the same time, staged official ceremony that inaugurated a space promoting the new state—the NSK State in Time—internationally.

Over the course of a week, numerous lectures and discussions suggesting an atmosphere of anticipation and frenzy accompanying the creation of a new state took place. In fact two new states were founded around this time:

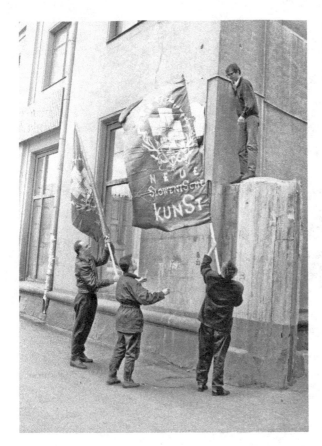

the Republic of Slovenia and the NSK State in Time. The discussions were attended by different NSK groups and numerous guests that included Slovenian, Croatian, and Russian artists and other intellectuals. The topics of the lectures and discussions revolved mostly around the new postsocialist condition and the similarities between the ex-Yugoslav and ex-Soviet political, cultural, and artistic situations. One of the lectures, titled "How the East Sees the East," raised the issue of current Eastern European identity as seen from the position of its inhabitants.[38] Other topics of debate included totalitarian codes, relations between art and culture in the 1980s, and the functions of reality and the effects of reason. The discussions were summed up in the "Moscow Declaration," a collective statement articulating a new reflexive self-consciousness and aimed at implementing the debated and proposed ideas in the new social, cultural, and artistic infrastructures of Eastern Europe. Article D of the declaration reads as follows: "This specific Eastern identity, aesthetical and ethical attitude is common to all of us and has a universal—

FIGURE 7.10 IRWIN and Michael Benson, *Black Square on Red Square*, Moscow, 1992. Photo: Kinetikon Pictures.

not specifically Eastern—importance and meaning."[39] Both the status and the form of the declaration essentially resembled the socialist discourse of resolutions imposing a new social order. One such instance was the earlier "Moscow Declaration," signed on October 30, 1943, by the United States, the USSR, and Great Britain during the Moscow Conference, which served as the basis for the new global concept of state security conceived in the midst of the antifascist world war. References to the 1943 declaration in the 1992 declaration were explicit. With this contemporary "Moscow Declaration" a new postsocialist order was proclaimed in the NSK embassy in Moscow. Article G stated, "This context and developed subjectivity are the real base for our new identity, which is taking a clear shape (also in the form of new social, political, and cultural infrastructures) in the last decades of this century."[40] The most important article of this proclamation concerned the awareness of a world undergoing transformation and the importance of recognizing or constructing a new identity for such a world.

Promotional events for this gathering included a collective performance and installation entitled *Black Square on Red Square* (figure 7.10), realized by IRWIN in Moscow's Red Square on June 6, 1992. In the historical and political center of Moscow, the NSK members in this participatory (or "complicitous") performance interacted with the public, mostly made up of numerous

passersby, who thus became its participants. NSK members placed a black square canvas (twenty-two meters square) in the center of Red Square. Kazimir Malevich's painting *Black Square* (1914–15) served as a referential symbol of the NSK revolution: Black Square confronted Red Square. At the same time, the Red Square was a part of Malevich's suprematist vision (as in his painting *Red Square: Visual Realism of a Peasant Woman in Two Dimensions* [1915]), while the actual Red Square marked the social and political center of the Soviet universe. IRWIN's gesture involved an identification with the revolutionary symbolic potentials of the Red Square and, at the same time, a counterrevolutionary negation of the Bolshevik identity by the Black Square.

The Moscow *Black Square on Red Square* was preceded in 1991 by an installation that consisted of a black cross on the roof of a New York skyscraper. There the canvas with Malevich's cross induced a plurality of relations between the East and the West, both in geographic and political terms. In the new global order, absolute and static relations were no longer possible. For IRWIN the contemporary human world was becoming an increasingly dynamic and flexible set of political situations that they aestheticized.

NSK State in Time as a New State

NSK state building represented and at the same time followed the phenomenology of political and social revolutions that took place in Eastern Europe between 1989 and 1991 (including the Slovenian break with Yugoslavia). With their early questioning of liberal collective postsocialist identities, NSK groups anticipated the political and social revolutions that occurred after 1989.

Their artistic projection of state building started as a manifestation of critical interest in the creation of a national state from the Baltic states to Slovakia and Slovenia, and in the aesthetic and political exploration of the potentialities and limits of civil society. The NSK State in Time thus represented an aesthetic example of the post-1989 revolutions and constitutions of new national states in Eastern Europe, including the Republic of Slovenia. But the new "aesthetic state" established with the project State in Time was not a utopian one toward which we should strive and which was to be realized in social reality as the final fulfillment of political dreams; instead it was an aesthetic state in flux and undergoing transformation, or—in the words of Terry Smith—a "traveling state."[41]

Ceremonies celebrating the foundation of the fictional NSK State in Time took place in the Volksbühne in Berlin on November 8–11, 1993, and in the National Theater in Sarajevo on November 20–21, 1995 (figure 7.11). The

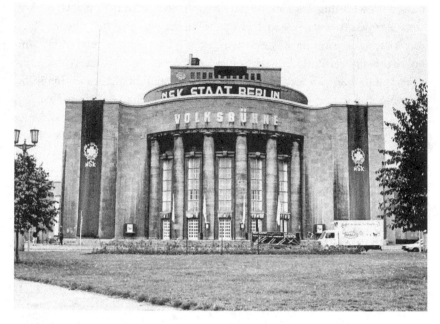

FIGURE 7.11 NSK, NSK *State Berlin*, Volksbühne, Berlin, installation, 1993.

foreign policy of the NSK State in Time required consulates and embassies throughout the world (Moscow 1992, Ghent 1993, Florence 1993, Venice 1993, Umag 1994, Beijing 1994). Notably, diplomatic missions of the NSK State in Time were established before or at the same time as the network of diplomatic missions of the Republic of Slovenia.

Institutions, artifacts, and acts proving the legitimacy of the NSK State in Time included diplomatic missions, postage stamps, symbols of sovereignty (flag, coat of arms, military guards), citizenship, passports, and so on. Various activities related to this new state and its public visibility were realized through their transference from the autonomous institutions of the art world into the public spheres of everyday life and culture. Existing between social reality and fiction, NSK created a system of fictionally constructed institutions of the State in Time.

The NSK movement inverted the agendas of "normal" postsocialist states obsessed with identity within their borders and with the ensuing territorial state-building fetishism so very common in these transitional circumstances. Instead of a political geography based on the partitioning of the globe, NSK proposed a partitioning of context, situating their state in the "geography of time."

Like most NSK concepts, "geography of time" was multilayered and multi-referential. The NSK movement first transformed itself from a network of artistic groups into a State in Time, turning the politicization of art into the aestheticization of politics. The concept of the geography of time evolved between the literally sensuous manifestations of constructed fiction and an aura of conspiracy, secrecy, or mystery as forms of manipulation surrounding NSK projects. This was their response to the postsocialist (nation-centered) state-building territorializations of the ex-Yugoslav geographic and geopolitical space. The same went for their dematerialization of the state as a physical territory through transformations from spatial into temporal fictional social relations and state-building efforts that were symbolically indexed by official institutions rather than by physical locations. As a modified postmedium practice (project, structure, situation, event or effect), the NSK state has thus become attractive for exploring and displaying state apparatuses as constructions in time.

Transitional State and the Critical Appropriation of the Global Order

The neoliberal order is based on the restructuring of the Western space of political and economic power. The power centers developing within the national state apparatuses are opposed by new global networks and power mechanisms of global capital. The capitalist overcoming of the territorial state has resulted in a post-Fordist mutation of commodity exchange into communicational practice. The world economy has mutated into the transnational production, exchange and consumption of information—that is, of "cognitive packages" and their economic equivalents. This mutation of the world economy has occurred simultaneously with the neoliberal dematerialization of traditional state power. The NSK's dematerialization of the territorial national state—of the Republic of Slovenia, for example—into a State in Time thus represents changes in the world order before 2008; that is, the neoliberal decomposition and deterritorialization of the Western democratic national state system into suspended global networks of transnational markets.

The NSK testing of the state as a new medium has been exemplified by the group's projects involving the hiring of national guards in Tirana (1998), Prague (2000), Zagreb (2000), Graz (2001), and Cetinje (2002). Such acts bore witness to the destabilized nature of state power: in a sovereign state, the national guard is an elite unit of the national army (figure 7.12). By hiring and thus appropriating members of the national guard, NSK fictionally and

FIGURE 7.12
IRWIN in collabora-
tion with Monte-
negrian Army, *NSK
Guard Cetinje*, Cetinje
Biennial, June 22,
2002. Iris print,
70 × 50 cm.

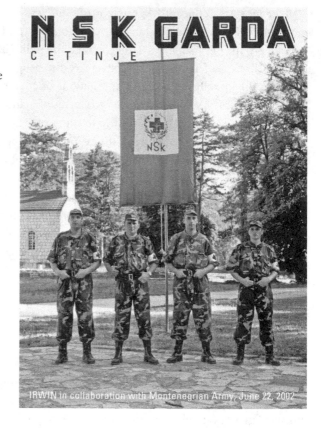

symbolically annulled representations of the sovereignty of respective na-
tional states. The state gave the semblance of a corporation, while its national
army unit appeared as a disposable piece of symbolic capital in the demateri-
alized contexts of global disseminations. For example, on the Slovenian TV
program *Studio City*, the then–Slovenian minister of foreign affairs, Zoran
Thaler, made an ironic statement about how the Republic of Slovenia should
establish diplomatic relations with the NSK State in Time.

NSK has also tested the state as a new medium with its project involving
the passport as a legal document. The issuing of the passports of the NSK State
in Time started in the early 1990s. Such a passport was a proof of someone's
identity as well as of his or her citizenship in the NSK state. Owing to the tur-
bulent circumstances surrounding the creation of the independent Slovenia,
it was actually possible to produce the NSK passports with the support of the
Slovenian ministry of foreign affairs. Passports of the NSK State were thus
printed in the same facilities, on the same paper, and with the same standards

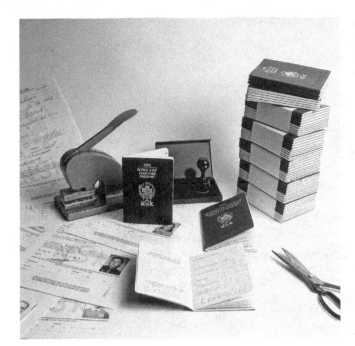

FIGURE 7.13
IRWIN, *NSK State in Time Passport*, installation, 1993.

of quality and protection as official Slovenian passports. Through its passport policy, the NSK state simulated its sovereignty, legitimacy and indeed existence, including the legal status of its citizens (figure 7.13). The passport as such was both a unique cultural artifact and an interactive artwork engaging and involving exhibition viewers, art lovers, artists and fans of NSK. At the time of issuing the first NSK passports, the citizens of the NSK State in Time were mostly people from the art world, with the number of the NSK passport holders reaching some two thousand persons in the 1990s.

In the war-afflicted regions of the former Yugoslavia at that time, a passport was not only a symbol of state sovereignty and a document of citizenship but also a means of granting mobility and enabling departure from countries such as Serbia, Bosnia and Herzegovina, or Macedonia. The NSK passport was thus not a forgery but a simulacrum of the ordinary document demonstrating personal belonging to an entity of statehood—a provocative placebo allowing its owner to circumvent bureaucratic nightmares. This replacement of the symbolic order of identification of the citizen (of a real state) with a fictional order of identification demonstrated a symbolic void at the core of the ordering and the classification of human lives by the state.

Another instance of the communicational and identificational potentialities of the NSK State in Time was its website. In 1994 the NSK Electronic Em-

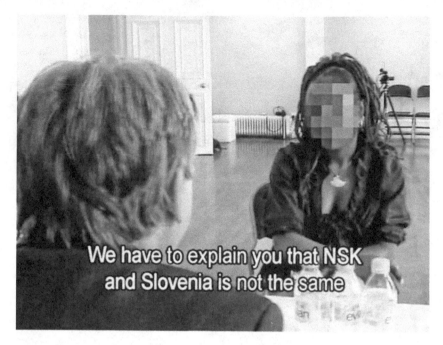

FIGURE 7.14 IRWIN, *NSK Passport Holders*, film, 2007. Filmed by Esben Hansen and Julie Boticello.

bassy Tokyo was launched; in 2001 a citizen of the NSK State in Time, Haris Hararis from Athens (Greece), started another website (www.nskstate.com), an unofficial NSK presentation that nevertheless became an important means of communication among the citizens of the NSK state. Through online communication and real-life situations, they soon started to organize themselves. The NSK State in Time thus began to evolve independently of its founders, although the latter encouraged these novel activities.

Applications for NSK passports began to arrive online from all over the globe. Requests from a thousand Nigerian citizens also came from London. Needless to say, for citizens of Third World countries, the NSK passports represented anything but artistic artifacts and were instead perceived as extremely useful documents.

As of 2012, NSK passports are owned by some fourteen thousand persons. In London (May 5–7, 2007) (figure 7.14), Vienna (December 12–13, 2007), and Taipei (August 26–28, 2008), the members of IRWIN participated in a series of lectures documented by video footage titled *NSK Passport Holders*. The lecture in London came about due to the massive interest of Nigerian immigrants in the NSK passports.

The recent self-organization of the citizens of the NSK State in Time has also resulted in other activities. They have started to create a new type of artistic work—NSK folk art. Its creators are citizens of the NSK state who, at their own initiative, have produced artifacts mostly dedicated to their identification with the NSK state. Instances of such spontaneous artistic work abound. For example, the American filmmaker Christian Matzke has opened an NSK library; Reykjavik-based citizens of the NSK State in Time launched the Icelandic NSK Guard and Embassy; and Charlie Krafft from Seattle has made a set of porcelain objects decorated with NSK motives. Hararis's website has begun to feature NSK folk artifacts. Dape Didier Quebecor has made drawings with sealed NSK symbols (2003), Armin Zerbe NSK photo collages, Peter Blase paintings, and Avi Pachon *Gesamtkunstwerk* body installations.

In addition, the NSK citizens' world congress was held in the Haus der Kulturen der Welt in Berlin on October 21–23, 2010. The NSK website issued the following proclamation:

> In the globalization process that's occurring right now, every person is a global citizen. . . . We as global citizens can communicate and interact with each other and the [NSK] passport is a medium or tool for us to re-imagine what we can do. Created in 1992, the NSK State in Time has become a unique entity which now has several thousand citizens across numerous countries and all continents. In 2010 the state will examine itself through its citizens and discuss its past, present and future. At a time when national (market) state financial and political systems are tested as never before, the First NSK Citizens Congress will test the ambiguous realities and potentialities of "the first global state of the universe."[42]

This unique event brought together citizen delegates (figure 7.15) and NSK members to explore, debate, and develop the NSK state and to negotiate the shared and contradictory interpretations and visions of its citizens. The congress was intended to establish lively dialogue that would show that the NSK State in Time is permanently creating new forms of life in a contemporary world of crisis; or, as Alexei Monroe writes, "A State of Emergence is almost inevitably messy, contradictory and hard but it is also dynamic and catalysing."[43] This "State of Emergence" is here proclaimed to be a characteristic of NSK State in Time, pointing to the ideal of permanent changes in society.

For IRWIN and NSK in general, systems and practices of the instrumental functions of the state have become their media. The NSK movement demonstrates how the political and economic substance of global contemporaneity

FIGURE 7.15 IRWIN, *First NSK Citizens' Congress*, Berlin, October 2010, Participants. Color photo, 165 × 216 cm.

has become a fictional realm for the artistic appropriation of the state as a new artistic medium.

However, the NSK State in Time is not a postmedium presentation or representation of apparatuses of the real state by means of artistic work; rather, it is a performance of singular state apparatuses that become (through their "State of Emergence") aesthetic revolutionary events under the conditions of transnational and global sociality. These events are artistically construed through political fictions that are conceived in the manner of real subversive events introduced into the realm of visibility via individual and collective subjectivization. In its aesthetic phenomenality, the politics of NSK has retained all the properties of real politics in the contemporary world—indeed, even the difference between "the political" and "politics" that Chantal Mouffe insists on: "By 'the political' I mean the dimension of antagonism which I take to be constitutive of human societies, while by 'politics' I mean the set of practices and institutions through which an order is created, organizing human coexistence in the context of conflictuality provided by the political."[44]

It turns out that a transition did not occur only in the countries of the Second and Third Worlds, but that the leading political, military, and economic powers of the West were also increasingly affected by certain processes that

could be termed "transitional." For the United States or Great Britain, for instance, after the end of the Cold War this transition signified the weakening of the role of the state, its economy and culture, and the transfer of the active socioeconomic capacity of intervention to global corporate capital and its transnational institutions, which are independent from individual states. The transitional character of the societies of the First World has become manifest in the global financial crisis, unresolved by the self-regulated global neoliberal markets. The need for the state to interfere within global and national financial crises has revealed the contradictions and antagonisms of neoliberalism, such as the irreconcilable differences between property rights and social rights. State intervention has also demonstrated the limits of the increased neoliberal suspension of the welfare state after the Cold War. The recent economic crisis has emerged as a political conflict between the social interests represented by the liberal capitalist state and the apparently independent formations of neoliberal transterritorial capital.

Past and present attempts at overcoming the modern state—in the political East, with the project of direct democracy as in self-management socialism, and in the West, with the projects of neoliberal self-regulated global markets—have experienced a practical defeat once again. Antagonistic confrontations within the current global neoliberal world were already emphasized by Mouffe back in 1993 when she concluded that the fall of the Eastern bloc and the triumph of the liberal democracy did not result in a new, "antagonism-free" universal society:

> Not long ago we were being told, to the accompaniment of much fanfare, that liberal democracy had won and that history had ended. Alas, far from having produced a smooth transition to pluralist democracy, the collapse of Communism seems, in many places, to have opened the way to a resurgence of nationalism and the emergence of new antagonisms. Western democrats view with astonishment the explosion of manifold ethnic, religious and nationalist conflicts that they thought belong to a bygone age. Instead of the heralded "New World Order," the victory of universal values, and the generalization of "postconventional" identities, we are witnessing an explosion of particularism and increasing challenge to Western Universalism.[45]

Mouffe demonstrates that the essential human condition remains the multiplicity of social antagonisms and contradictions and that these should be taken into consideration without pluralist idealizations.

NSK artists have carried out an aesthetic revolution as a complex interdisciplinary procedure of cognitive mediations and mappings of the relations between the discursive, phenomenological, semantic, and affective events of the construed and conceptualized State in Time and the real transformations of neoliberal states undergoing transition and globalization. The aesthetic revolution of NSK started to take place with the emergence of the NSK State in Time. It has consisted in developing a Schillerian aesthetic state that exists neither geographically nor materially, but only symbolically and symptomatically. Its development has consisted of the following gestures.

First, the project of the NSK state was transposed from the realm of artistic creative practices into the realm of the effects of the apparatuses of a fictional state. There it has functioned as a reality, although it does not exist within the order of recognized and legitimate territorial states. It exists instead as a network of apparatuses, interpellating their subjects through their operations and interactions between NSK artists and accidental participants or collaborators who have eventually acquired citizenship in the NSK State in Time. Over time, these accidental or external collaborators of the NSK state have tended to become its subjects; they have become active participants with rights, expectations, investments, and partnerships appertaining to the formal and social relations of the NSK state. This state and its actions have not been something that exists virtually in some kind of artistic Second Life but have instead appropriated social modes that exist in the gap between concrete social reality and the offered visual social project.

Second, the NSK State in Time has started to operate as a communicational practice based on protocols of the state, especially through sensuously visible and representable apparatuses of human relations. In 2010, for example, they started a promotional campaign offering the message: "Time for a new state. Some say you can find happiness there" (figures 7.16 and 7.17).

Third, the project of the NSK state has been created by procedures appropriating the traces of the effects of real states and their cognitive rearticulations. Accordingly, characteristic (and globally established) procedures of postmedium relations between fictional and real constituents and the operations of the State in Time have included appropriation, participation, complicity, self-organization, self-management, cognitive rearticulation, and globalization. Changes in the role of the local state in NSK projects have been influenced by transitional processes that no longer possess merely an Eastern European character, but one that is global and planetary.

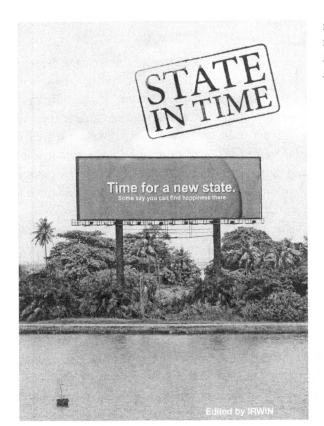

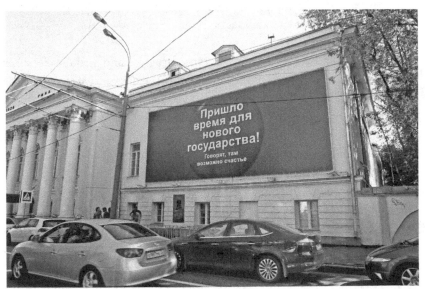

FIGURE 7.17 IRWIN, *State in Time*, billboard, Moscow, 2011.

A Comparative Conclusion: NSK and the
Borders of an Aesthetic Revolution

Between 1980 and 2012, the groups forming the NSK movement demonstrated that the relations they established between subversive artistic and revolutionary aesthetic activities follow the dominant political paradigms of the twentieth and twenty-first centuries. In an aesthetic and artistic context, they created political paradigms of alternative culture, of dissident acting, of revolutionary participation in the creation of a national postsocialist state, of transitional globalism and the desire for new sociability expressed by participants in the "Occupy movements" from New York to Ankara (via London, Ljubljana, and Cairo) during 2011 and 2012.

At the beginning of 1980s, the NSK movement deconstructed the characteristic modernist ideological representations of revolutionary and totalitarian systems. It explored relations between avant-garde (futurist, suprematist, constructivist) totalitarian representations of power and those in socialist realism and in Nazi and fascist art. It demonstrated that the artistic, political, and aesthetic modalities of the early avant-gardes and of the art of totalitarian regimes appeared to be over, for they had been transformed into consumable cultural texts and thus into "aesthetic commodities" on postmodern markets. The groups of the NSK movement were both witnesses to and active participants in the final stage—in the late 1980s and early 1990s—of the projects of "really existing" and "self-management" socialisms. By simulating dissident public behavior, as in the project of the NSK embassy in Moscow, the NSK movement pointed to potentialities of the anti-Soviet revolutions in what was then still East Europe.

The project of the NSK State in Time was conceived and then developed as analogous to the formation of the Slovenian national state. Later, during the first decade of the new millennium, the NSK state was being developed as a transitional fictional society or a set of communities. It countered the neoliberal concepts of global depoliticization and economic determinism with the idea of self-organization. Global self-organization was thus comprehended as a new form of politicization of quotidian life in the NSK State in Time.

In these ways, the NSK movement and especially the IRWIN group have shown that the social models and mechanisms of totalitarian as well as liberal states can become first the artistic postmedia and then the flexible conditions with which potentialities for political, aesthetic and artistic revolutions can be made visible in our world today.

In its artistic work, the NSK movement has created various modalities of avant-garde transgressive actions in relation to the state. Through the appro-

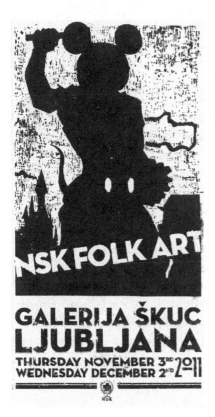

FIGURE 7.18 First NSK Folk Art
Biennale, poster, 2013.

priation of some of the concepts of the early avant-gardes, especially those of
a new world and a new life, their activity in the 1980s led to an early stage of
a totalizing aesthetic revolution that materialized with the project of the NSK
State in Time. The activity of the NSK has also revealed its fascination with
totalitarian regimes, thereby supporting the transformation of an aesthetic
revolution into a Benjaminian ritualization of politics in totalitarian regimes.
At the same time, the NSK movement was an accomplice in the process of
eliminating the socialist revolutionary order, supporting and representing its
liberal overcoming.

NSK was one of the first symptoms of the liberal Eastern European revo-
lutions against the ossified and bureaucratized "really existing" and self-
management socialisms (figure 7.18). The liberal revolutions from the end
of the 1980s and the early 1990s possessed all the characteristics of antirevo-
lutions insofar as they negated those revolutionary socialisms that in a uto-
pian manner still envisioned the possibility of a classless community. In such
a context, the NSK state has continued its critical provocative actions against

the neoliberal appropriation and restructuring of our contemporaneity. In the first years of the new millennium, the structure of the NSK state has been analogous to contemporary neoliberal deterritorialized corporative power as well as its subversion (and thereby resistance) through self-organized artists, cultural workers, and citizens from global cultures. Contrary to the neoliberal economic postpolitical order, the NSK state presents itself today as a self-organized form of the direct democratic restructuring of contemporary sociality.

With the possibilities offered by open and flexible postmedia devices, NSK has for the last two decades explored the potentialities of its State in Time, creating and expanding ("peopling") what started as a community of the mind—Friedrich Schiller's "aesthetic state," but with an avant-garde twist—into a temporal and increasingly visible community that exists, on the one hand, as a simulated state, and, on the other, as any other self-evolving and self-organized community. The NSK State in Time exists halfway between fiction and reality, between art and the real world. As such, it is broadening and expanding the territory of art, striving in its own unique way—in this, it paradoxically resembles the dream of many early avant-gardes—to interpolate the sensible between art and life.

NOTES

1. See Lyotard, *The Postmodern Condition*; Bell, *The End of Ideology*.

2. For overviews of NSK, see Marina Gržinić, "Neue Slowenische Kunst," in Djurić and Šuvaković, *Impossible Histories*, 246–69; Aleš Erjavec, "Neue Slowenische Kunst—New Slovenian Art: Slovenia, Yugoslavia, Self-Management and the 1980s," in Erjavec, *Postmodernism and the Postsocialist Condition*, 135–74; Arns, "IRWIN Navigator"; Smith, "Russia and (East of) Europe," in *Contemporary Art*, 98; and Thompson et al., *The Global Contemporary and the Rise of New Art Worlds*.

3. Aleš Erjavec, "The Three Avant-Gardes and Their Context: The Early, the Neo, and the Postmodern," in Djurić and Šuvaković, *Impossible Histories*, 46; Živadinov, *Der Sturm*.

4. For an analysis of Laibach, see Monroe, "Laibachization," in Monroe, *Interrogating Machine*, 154–76.

5. IRWIN, *Država v času*, 2.

6. See Holert, "Joint Ventures"; Block and Nollert, *Kollektive Kreativität = Collective Creativity*.

7. The idea that a collective transforms style into strategy is developed by Angelika Nollert in "Art Is Life, and Life Is Art," in Block and Nollert, *Kollektive Kreativität = Collective Creativity*, 29.

8. Laibach started early with international concerts and acquired the status of a

cult postpunk group. IRWIN has held solo exhibitions and realized 150 projects across Europe and the United States. Since its beginnings, IRWIN has taken part in international exhibitions such as *After the Wall: Art and Culture in Post-Communist Europe* at Moderna Museet in Stockholm in 1999; *Aspect/Positions: 50 Years of Art in Central Europe 1949–99* at the Museum of Contemporary Art in Budapest; at the first Manifesta in Rotterdam in 1996 and at Manifesta 09 in Ghent. IRWIN participated at the Fiftieth Venice Biennale in 2003, the Ninth Istanbul Biennial in 2005, at *Eye on Europe* in the Museum of Modern Art in New York in 2006, at *A Bigger Splash: Painting after Performance* at the Tate Modern in London in 2013, etc.

9. See Wu Hung, "Artistic Trends in the Early 1990s (1990–93)," in Wu Hung, *Contemporary Chinese Art/Primary Documents*, 154–84. See also Gao Minglu, "Post-Utopian Avant-Garde Art in China," in Erjavec, *Postmodernism and the Postsocialist Condition*, 247–83.

10. See Brent Plate, "Defining and Delimiting Blasphemy," in *Blasphemy/Art That Offends*, 31–61.

11. Piotrowski, "Epilogue: The Spectres Haunting Europe in the 1980s," in *In the Shadow of Yalta*, 431.

12. Žižek, "From Symptom to *Sinthome*," in *The Sublime Object of Ideology*, 55–56.

13. Havránek, "The Post-Bipolar Order and the Status of Public and Private under Communism," 27.

14. On the ways in which the state is conceived as an artwork, see Mastnak, "The State as a Work of Art." Mastnak discusses the NSK State in Time in relation to the philosophico-aesthetic concept of the "aesthetic state" in German idealist philosophy of the nineteenth century, as well as in relation to contemporary reactualizations of these ideals.

15. The term I am using ("postmedia art practice") is derived from "postmedium condition" as developed by Krauss in *"A Voyage on the North Sea,"* 32, 45; and the introduction and the chapter titled "Art Criticism" in Krauss, *Perceptual Inventory*, xii, 89. My term differs from her usage of "postmedium condition" by not being involved in her polemics regarding the significance and value of media and postmedia. Instead, its function is to describe contemporary hybrid artistic practices that no longer use traditional media such as painting and sculpture. These practices are hybrid and underlie different artistic and aesthetic concepts. Compare also Joselit, "Image Explosion," in *After Art*, 2.

16. Cf. Rancière, *The Politics of Aesthetics*, 12–19, 85.

17. Boris Groys, "Art in the Age of Biopolitics: From Artwork to Art Documentation," in *Art Power*, 53.

18. See Althusser, "Ideology and Ideological State Apparatuses," in *Lenin and Philosophy and Other Essays*, 141.

19. Rancière, *The Aesthetic Unconscious*, 21.

20. Eda Čufer and IRWIN, "NSK State in Time" (1992), in Hoptman and Pospiszyl, *Primary Documents*, 301.

21. *Neue Slowenische Kunst*, 114.

22. Groys, *Art Power*, 147.

23. Groys, *Art Power*, 148.

24. Zenitism was an eclectic avant-garde movement characterized by postexpressionist proclamations of the "Balkanization" of Europe. Founded by Ljubomir Micić (1895–1971), the movement operated in Zagreb and Belgrade between 1921 and 1926. Micić published the avant-garde magazine *Zenit* (1921–26), which featured contributions by Malevich, Tatlin, Karel Teige, Ivan Goll, etc.

25. Avgust Černigoj (1898–1985) studied at the Bauhaus (1924). In 1927 he founded the Trieste constructivist group and was a contributor to the Slovenian avant-garde magazine *Tank*. Černigoj was a leading representative of the leftist constructivist avant-garde in Slovenia and northern Italy. Ferdo Delak (1905–68) was a theater director, writer, and publisher of the avant-garde magazine *Tank* (1927). A disciple of Erwin Piscator, in 1925 he founded the theater *Novi oder* in Ljubljana.

26. Riklin, *Komunizam kao religija*, 13.

27. See Erjavec, *Postmodernism and the Postsocialist Condition*, 168–69.

28. Laibach, "Ten Items of the Covenant," in Bradley and Esche, *Art and Social Change*, 251.

29. *Neue Slowenische Kunst*, 21.

30. *Neue Slowenische Kunst*, 163.

31. The Yugoslav state went through several political phases: Kingdom of Serbs, Croats, and Slovenians (1918–29), Kingdom of Yugoslavia (1929–41), Democratic Federal Yugoslavia (1943–45), Federal People's Republic of Yugoslavia (1945–63), and Socialist Federal Republic of Yugoslavia (1963–91).

32. Zabel, "Icons by IRWIN," in Arns, *IRWIN Retroprincip*, 77.

33. See Erjavec, *Postmodernism and the Postsocialist Condition*, 135, 171n2.

34. Gržinić, *Slovenian Athens*, n.p.

35. IRWIN, "General Introduction," in *East Art Map*, 11–15.

36. Piotrowski, "The Grey Zone of Europe," 203.

37. See "Neue Slowenische Kunst (NSK): Embassy in Moscow, 1992," in Thompson, *Living as Form*, 196–97.

38. See Čufer, *NSK Embassy Moscow*, 1.

39. Čufer, *NSK Embassy Moscow*, 46.

40. Čufer, *NSK Embassy Moscow*.

41. Smith, *Contemporary Art*, 98.

42. Available at http://congress.nskstate.com/index.html (accessed August 11, 2011).

43. Monroe, "Declaring a State of Emergence / The Logic of Congress," in *State of Emergence*, 13.

44. Mouffe, *On the Political*, 9.

45. Mouffe, *The Return of the Political*, 1.

Conclusion. Avant-Gardes, Revolutions, and Aesthetics

ALEŠ ERJAVEC

I will start this conclusion by presenting reasons for not paying more atten-
tion to the Dada movement within the European avant-garde. I will then
turn to revolution, and will finally discuss the recent avant-garde movements.

The Avant-Gardes

In the nineteenth century one doesn't often encounter avant-garde art; rather,
one encounters revolutionary art, much of which remains within the frame
of traditional representational art and involves "content-based commitment"
(as opposed to the formal "commitment" exemplified by the specific use of

collage, montage, etc.). An instance of the former would be works by an artist such as Gustave Courbet (1819–77), who produced realist paintings such as *The Stonebreakers* (1849). Courbet became a politician during the siege and the Commune of Paris in 1870–71 and, in his own words, a member of "four of the most important offices in Paris." He was imprisoned during the political persecution of the Communards, only to return later to the life of an artist. His artistic activities were related to his political beliefs and were interdependent with them in a direct way, as in social and critical realism—that is, via content. Nonetheless, his art was neither "revolutionary" in a formal artistic sense—by its style and technique—nor avant-garde in the sense that his painterly work extended beyond the confines of autonomous art. In other words, "Courbet as an exemplary artist-revolutionary thus does not exemplify the overlapping of art and revolution, but rather the rapid succession of the roles of artist and revolutionary politician."[1] Consequently, nineteenth-century socially critical art probably can be called "avant-garde" only with some reservations—an additional reason being that it involves individuals (such as Rimbaud) and not movements. The existence of the avant-garde in the contemporary sense thus remains a characteristic of the twentieth century.

Avant-garde artists form movements (not "schools"), are anti-bourgeois, provoke the public, are active in different artistic and extra-artistic domains, and are oriented toward the future. They ridicule the idea of progress but identify with a political project and support it. Some turn from revolution to war. They also write manifestos and, in the words of Polish aesthetician Stefan Morawski, "theorize endlessly."[2] These characteristics don't appertain to all the avant-gardes, but they do to the aesthetic ones. These may be artistically, socially, or politically revolutionary and radical, whether in relation to class, nation, state, biopolitics, or some other agenda that requires essential transformative efforts.

Especially in the 1920s in Russia, Italy, and France, the early aesthetic avant-garde movements attempted to build alliances with radical or revolutionary social and political movements. Although relations between them and their political avant-gardist contemporaries may have frequently resembled "a meeting on a dissecting table of a sewing machine and an umbrella," in some instances—such as Italian futurism or constructivism—they have produced tangible results and periods of creative avant-garde activity. Even if the actual results of such cooperation may have often been meager, it is an exaggeration to claim that "the 'historical' avant-gardes never fulfilled their promise nor achieved their project."[3]

Italian futurism and post-1917 Russian avant-gardes are exemplary cases of the aesthetic avant-gardes. Italian futurists were well aware of the need for their mostly artistic revolution to be complemented by the political one. They knew well that "a revolutionary political movement had to strive for an avant-garde art."[4] They saw in the rise of fascism and temporarily in rapprochement with the Left (1920–24) a way to accomplish such purpose: Although it might be safe to say that the *general direction* of futurism pointed toward fascism and that with the passing of time this orientation became increasingly pronounced, we should not overlook either the numerous dissenting voices or more recent research which shows that the relationship between Mussolini and Marinetti (as well as certain futurists and futurist groups) was much more precarious than previously thought.[5] Due to their artistic revolutionary ambitions, the aesthetic avant-gardes in Russia—such as Kom-fut (communists and futurists, 1919, 1921) and Marxist-oriented constructivists—were especially predestined to be supportive of the Bolshevik government and to be supported by it.

With the unfolding of the twentieth century, "as revolutions have been suppressed or betrayed, radical fusion has given way to fission; both Marxism and modernism have congealed into orthodoxies and gone their separate and mutually distrustful ways."[6] Modernism here designates the avant-gardes: "Symbolism, expressionism, cubism, futurism or constructivism, surrealism—there were perhaps five or six decisive currents of 'modernism' in the early decades of the [twentieth] century."[7] All such terms form a constellation that is continuously being modified.

The early or classical avant-gardes were initially often called simply "the new schools," with their designations frequently left to chance. Futurism, for example, "was a term used very loosely in Russia in the immediate post-revolutionary years to denote all avant-garde artists and poets."[8] In the early 1920s, it started to be called "left art" because of its commitment to the ideas of communism, and the name "futurism" was finally dropped in 1925 due to its association with "its Bohemian temperament and its history of postrevolutionary monopolistic efforts."[9]

In his "Surrealism" essay from 1929, Walter Benjamin mentions in passing the "avant-garde," "whether it is called Futurism, Dadaism, or Surrealism," thereby demonstrating that in that year at least these three movements not only were known under their specific names but also were perceived as belonging to the "avant-garde."[10] According to Matei Calinescu, "By the second decade of our century, avant-garde, as an artistic concept, had thus become comprehensive enough to designate not one or the other, but all the

new schools whose aesthetic programs were defined, by and large, by their rejection of the past and by their cult of the new."[11] Calinescu has further noted that "the avant-garde proper did not exist before the last quarter of the nineteenth century, although every epoch had its rebels and negators. . . . So the avant-garde, seen as a spearhead of aesthetic modernity at large, is a recent reality, like the word that, in its cultural meaning, is supposed to designate it."[12]

Throughout the twentieth century, presentations, analyses, evaluations and the choice of meanings of the avant-gardes were strongly dependent on political, artistic, and even linguistic choices and affinities, thereby signifying that these avant-gardes were (and apparently still are) pregnant with meanings, the weight of whose import hardly ever diminishes; instead, it remains both a long-lasting theoretic currency and a continuous source for the "imaginary museum" and art historical archive. Many of the debates and opposing views regarding the avant-gardes can be ascribed to this "destiny" of avant-garde art. Since especially in recent decades different Western cultures have started to increasingly communicate with each other, the linguistic differences regarding different terms have accordingly become progressively obvious: "avant-garde," "modernism," and "art" were among the more obvious candidates for semantic ambiguity, especially when they were being translated to or from various languages.

In 1968 the English translation of Renato Poggioli's *The Theory of the Avant-Garde* appeared. Erudite and comprehensive, it represented the first relatively systematic presentation of a phenomenon that has captivated cultural, political, and artistic discussions of the twentieth century, but its key term, *avanguardia*, did not signify the same thing as the French, German, or English "avant-garde" did; rather, it denoted high modernism.[13] The other early influential study, Peter Bürger's *Theory of the Avant-Garde* (published in English in 1984), employed the terms "historical avant-gardes" and "neo-avant-gardes," which took on Bürger's specific meaning. In the same way Bürger's use of the term "post avant-gardiste" has helped make further development of the historicized concept of avant-garde difficult, especially in conjunction with the rise of postmodernism and its critics' onslaught against the "antimodern" nature of the post-avant-garde. The 1984 publication of Bürger's study in the United States was accompanied by Benjamin Buchloh's criticism of his interpretation of the neo-avant-gardes, and later by Hal Foster's "rereading" of Bürger.[14] The difference between the views of Bürger and his American critics has been summed up by Branden W. Joseph as follows: "Bürger viewed the situation from the perspective of the avant-garde rather than the traditional

arts, and he therefore judged success not according to lasting aesthetic potential but according to radical political effect."[15] This schism, which remains alive even today, is partly dependent on the difference between the Anglo-American and the still prevalent Continental understanding of what authentic art is: in Europe it is predominantly that of avant-garde art as opposed to mass culture, the culture industry, popular culture, and kitsch. Such a view is not limited to Theodor Adorno and his followers; it also finds resonance in more recent discourse.[16] In this regard Jacques Rancière took a very unorthodox stance, for he—especially with his aesthetic regime of art—has ignored such exclusivist labels and proclaimed them all a part of the same *dispositif.*

Rancière saw the actual avant-garde as split between avant-garde as innovation (the "modernist" interpretation of the avant-garde) and "the invention of sensible forms and material structures of a life to come," such as practical and everyday objects created especially in post-October Russia, whether works of productivism or constructivism.[17] What art does is to serve as a vehicle of subjectivization and thus of politics (in Rancière's interpretation of the term), which is always emancipatory as such; what it also does is take part in the process of emancipation that builds on the anticipation of a community to come. With such views Rancière reopened the discussion of the relation between artistic, social, and political avant-gardes within the frame of his "aesthetic regime of art."

The Case of Dada

In this volume three of the early avant-gardes are discussed—Italian futurism, Russian constructivism, and Surrealism—but not Dada. Why? Because in spite of numerous similarities with the mentioned movements, Dada lacks one essential feature that they possess, and this lack dissociates it (like cubism or expressionism) from the aesthetic avant-gardes. In this respect its paradigmatic creator and representative was and remains Marcel Duchamp, who started another time line in the history of art of the previous century, and, as an ideal type, it is neither that of art as representation nor that of art as transformation of the world.

From the perspective advanced in this book, Dada was artistically radical—it was, as Peter Bürger claimed, "the most radical movement within the European avant-garde"[18]—but was not an instigator of an aesthetic revolution, for it negated such a revolution rather than affirmed it.

As long as Dada was active "within the framework of the strongest attacks on art and under threat of beatings or forced labor for artists specifi-

cally within the manageable and limited spaces of art, it remained successful. Yet when it attempted to transgress the boundaries into the political field, it failed."[19] There doesn't remain much to be added to this last assessment by a recent critic, for although Dadas aspired "to move from representing to transforming the world," they usually bordered on their own negation. Moreover, as a movement Dadaism was too fragmented either to programmatically and consistently pursue the conflation of art and life or to be oriented toward the future, for its radical nature prevented it from fully embracing any determined historical trajectory—not even "anti-art." When it apparently followed and promoted ideas inspired by revolutionary developments such as "the new machine art of Tatlin," that is, of Russian constructivism, its individual members often considered politics and art "two different things."[20] Among the Dadas only the Berlin representatives of the movement (Huelsenbeck, Raoul Hausmann, John Heartfield, Georg Grosz, Hannah Höch) were pronouncedly political, and they perceived their support of the radical communist party Spartacus as an activity contributing to a socialist revolution. A recent commentator thus noted "an almost seamless continuity between dada and Spartacus."[21] While such a remark immediately brings to mind Miklós Szabolcsi's observation, discussed in the introduction, that a revolution without an avant-garde in art is really a pseudo-revolution, it should be added that among Dada members such gestures were few, and when they existed, they were often in the same breath countered by their negation. The well-known statement "Dada is German Bolshevism" implies historic proportions of Dadaist actions, but its tentative revolutionary significance diminishes immediately, for it is followed by the claim that a Dadaist "is a man who loves wine, women and advertising."[22] Hardly any self-respecting communist would want to be described in such a manner.

One should thus not be surprised that, as Leah Dickerman points out, Dada's depiction of the revolutionary project of the "New Man" was actually a parody, consisting of various characteristics of adherents to other avant-garde movements.[23] It was to "life" that Dada—in the words of Richard Huelsenbeck from 1918—established "the most primitive [i.e., the most direct] relation."[24] Dadaism thus often represented an eclectic and undifferentiated matrix, wherein identifiable and stable distinctions—whether artistic or political—were rare or nonexistent. Provocative, semantically polyvalent, and publicly omnipresent, Dada from its inception appropriated ideas from and even the names of other avant-garde movements, thus in the end—in an attempt to commercially harvest its early achievements—it rewrote its own history. At least from an aesthetic point of view, Dada, with its apolitical an-

archism, appeared less "a spearhead or an avant-garde of the avant-garde" and more "its odd man out."[25]

Dada formed a constellation of individuals and groups without the pronouncedly shared positive agendas typical of Italian futurism. As Hans Richter wrote, "Futurism had a programme and produced works to 'fulfill' this programme. Whether the result was a work of art or a mere illustration of the programme depended on the talent of the artist. Dada not only had *no* programme, it was against all programmes."[26] Or, in the pointed words of Thierry de Duve, Dada was "the absolute whatever: . . . Dada never consisted of a group marching in step to the same ideology."[27]

This point can be further illustrated by another telling difference between Italian futurism and Dadaism. The futurists "destroyed, destroyed and destroyed, without worrying whether their creations will be better than those they destroyed . . . they had a precise and clear view that our epoch . . . must have new forms of art, philosophy, customs, language: this was a totally revolutionary understanding and a completely Marxist one."[28] At the same time, but in contradistinction even to the early futurism which issued its first "Political Manifesto" as early as 1913, Dadaism was characterized by its complete absence of any vision of the future and thus represented, in the words of Claire Bishop, only an "anarchic negation of the political."[29] Its evolution was without a goal, though it was not without an effect.[30] From the standpoint of the aesthetic avant-gardes, Dadaism lacked the "positive" designation characteristic of Italian futurism, constructivism, surrealism, and the later avant-garde movements.[31]

Moreover, the efforts of Dada "to abolish art, whether they were based on some social theory, met with unexpected difficulties. Hausmann preached anti-art, and yet most of his works were very close to the same abstract art that Huelsenbeck and Grosz so despised."[32]

Some Dadaists—George Grosz, Wieland and Johann Herzfelde (John Heartfield), and Franz Jung—supported the Bolshevik revolution, while some futurists were temporarily communists (Boccioni was also a Marxist). But here political similarities ended. Although Marinetti may have harbored sympathies for the October Revolution, in his 1920 essay "Al di là del communismo" he made his position clear: "Humanity is marching toward an anarchic individualism, the dream and the goal of all strong spirits. Communism, on the other hand, is an outdated exponent of mediocrity, which the exhaustion and terror caused by the war have today given a new lease of life and turned into an intellectual fashion."[33]

Yet another feature that may have distinguished Italian futurism from

Dadaism was its approach to art as an institution. Bürger interprets Dadaism as anti-institutional, but van den Berg describes it in an opposite way: "Contrary to the conventional image of dada as anti-art, the Zurich Dadaists (but the same holds true for dada elsewhere) did not reject art (as an institution). Instead, the Dadaists tried hard to be admitted to the institutions of art, to conquer a place in the cultural field of their own, pleased and delighted by any form of recognition, by any opportunity to establish themselves in the cultural field."[34]

The closing words here should go to Sascha Bru's telling summary of the whole matter: "It is quite silly to claim that Dada as a whole shared an interest in sublating art into life, or, for that matter, into practical politics; nor did those who took an interest in politics find themselves in agreement."[35]

Revolutions

The "bare" classical definition of a revolution runs as follows: "Revolution is a term with a precise meaning; the political overthrow from below of one state order, and its replacement with another. . . . Revolution is a punctual and not a permanent process. That is: a revolution is an episode of convulsive political transformation, compressed in time and concentrated in target, that has a determinate beginning . . . and a finite end."[36]

The opposite interpretation is that of revolution as a continuous process (a permanent revolution). Such a revolution unfolds in a way that transgresses the "end as a necessary failure" paradigm. A revolution can also be conceived "as an irreducible duality oscillating between process and event."[37] Its nature as a temporal process causes it to remain unfinished and a failure: "Self-criticism *of* the revolution . . . is the very condition for its reactivation, the condition for the 'inversion' of the void into a new opening on to the event."[38]

It was the Croatian literary historian Aleksandar Flaker who has attempted to resolve the issue of the end of a revolution, part of which also concerns the almost standard question of the realization and materialization of political and aesthetic utopia. When discussing the utopian nature of the avant-garde, Flaker took as his starting point Yuri Lotman's notion of the "'optimal variant' as the principle characterizing science and art in the epoch of the avant-garde" and transformed it into "optimal projection" in the etymological sense of *proiectio*, namely throwing forward, into the distance.[39] Flaker argued that the self-designation of individual avant-garde movements such as futurism, constructivism, zenitism, and ultraism contained a projection toward the future. In such instances at stake was not a "utopia," insisted

Flaker, but rather movement: "The notion of the 'optimal projection' does not signify for us the same as the notion of 'utopia.' 'Utopia' already with its original semantics designates a nonexistent 'place' or 'land,' while the texts that formed utopia regularly designate it as a closed, delimited space with an ideal social structure."[40] In its representative discourse, the avant-garde is the *opposite* of utopia and opposes the "reification of the ideal, incessantly realizing its proper, individual, and poetic selection."[41] Utopia is a *static* entity and therefore the opposite of a movement: "The utopian project is a structure projected into the future, while optimal projection is only the direction of the movement. When we say: utopian project we by that very designation disqualify it as unrealizable while when speaking of optimal projection, we speak of a movement, which is realizable."[42] When it comes to aesthetic avant-gardes, Flaker's description very appropriately presents their process of affirmation and "success." It is for the very same reason that a statement of Giovanni Papini from 1913, quoted shortly, appears so authentic and easy to believe in its enthusiasm—it describes the experience of a movement, a personal but nonetheless shared experience that persuasively expresses the transformation that the author himself underwent since becoming a futurist.

Let me paraphrase the insightful observation from 1845 by Fourierist Gabriel-Désiré Laverdant, the validity of which stretches into the twentieth century: for a movement to be truly of the aesthetic avant-garde, one must know where humanity is going. The "place" toward which such movement is oriented is not really a place—utopia—but rather a direction: Flaker's "optimal projection."[43]

In this way a series of avant-garde activities acquires sense: manifestos, public statements, political agendas, their "endless theorizing" (Morawski), and imagined representations of the future all result in materializations of a movement. Instead of claiming that manifestos are but poetic creations of avant-garde artists, to which no special importance should be ascribed, we are to understand them as a given movement's discursive materializations and imagined realizations that have attained public visibility.

The commonplace idea about the failure of the aesthetic avant-gardes (and hence of the aesthetic revolutions they have engendered) appears to be unfounded: the "transformations of the world" by art and its sublation are always partial and temporary and, if successful, end up being integrated into common life. "Artists are those whose strategies aim to change the frames, speeds and scales according to which we perceive the visible, and combine it with a specific invisible element and a specific meaning. Such strategies are intended to make the invisible visible or to question the self-evidence of

the visible; to rupture given relations between things and meanings and, inversely, to invent novel relationships between things and meanings that were previously unrelated."[44] The specificity of aesthetic avant-gardes is in this respect in making present and accentuating the "common" facet of art and in foregrounding the heteronomous experience of art.

While appearing to be only goal-oriented, the aesthetic avant-gardes cause both punctual events *and* continuous processes within a revolution. These are materialized in attempts to profoundly change sense perception and to effect a redistribution of the sensible, engendering new visions of the world and life, and leading to a transformation not only of the expressive means of art, but also of life both as it has already been lived and as it might yet be in an imagined and projected future. Here is how these visions and experiences were expressed by the futurist Giovanni Papini in an article in the journal *Lacerba* on December 1, 1913:

> I am a futurist because futurism signifies a total appropriation of the modern civilization with all its gigantic wonders, its fantastic possibilities and its terrifying beauties.
>
> I am a futurist because I am tired . . . of Byzantine tapestries, false intellectual depth, . . . of harmonious rhymes, pleasant music, pretty canvases, photographic painting, decorative, anecdotic, and ambiguous painting. . . .
>
> I am a futurist because futurism signifies love for risk-taking, for danger, for what didn't attract us, for what we have not tried, for the summit that we didn't expect and for the abyss that we haven't measured. . . .
>
> I am a futurist because futurism signifies an ambition for a greater civilization, for a more personal art, for a richer sensibility and for a more heroic thinking.
>
> I am a futurist for futurism signifies Italy larger than it was in the past, worthier of its future and its future place in the world, more modern, more developed, more avant-garde than other nations. The liveliest fire of such Italy burns today among the futurists and I like it and I am boasting that I am and remain among them.[45]

Statements such as these show that a transformation of the world doesn't have to be deferred to an imaginary and distant future or utopia, but is already here. The success or failure of a social or political revolution can be measured by the implementation of its aims or by counterrevolution, fall into totalitarianism, and so on. The success of an artistic revolution can be measured by its

proliferation, its reconfiguration of the realm of art history, and its influence on the future of art. What can be assessed is its success and not its failure. An aesthetic revolution falls into the shared space of the art and aesthetics: Italian futurism had its artistic moments and its aesthetic ones, but often they did not occur simultaneously.

Let me approach the issue of "failure" from yet another vantage point. Although an aesthetic revolution may be announced by an event—the founding manifestos of various movements would count as such events—it necessarily involves a process whereby the extant, assimilated (and therefore often unnoticed) kinds of sensibility are replaced by other kinds, are reconfigured or redistributed, with this change constituting and affecting different spheres of life. An aesthetic revolution thus always involves a profound change or transformation of perspective, which necessarily exceeds the limits of art as "pure" (autonomous) art—especially art whose ambition is to research its proper expressive means (or "language") or one that possesses no function except that of having no function at all. If one compares the provocative and disorderly *serate* of the early Italian futurists or Giacomo Balla's 1914 *il vestito antineutrale* (with "shoes ready to deliver merry kicks to all neutralists") on the one hand and the pastoral artifacts of the developed cubism (even though its early phase influenced the emergent futurism) from across the globe on the other, then one senses the difference between the aesthetic and the artistic avant-gardes and therefore between different facets of art.

Difference in these two kinds or states of "art"—one designated by the notion of "art" and the other negating it precisely by considering such a notion of art in its effervescent phenomenal form as produced by the aesthetic avant-gardes—may result in the following paradoxical and aporetic comparison of cubism and futurism: the former "exerts an indisputable influence on later artistic movements while Futurism leaves no trace."[46] Such a statement, dependent on regarding success according to lasting aesthetic potential, causes its author to exclaim: "We could almost say that futurism was an artistic movement . . . without art!"[47]

Rancière on Aesthetic Revolution

The reason for Rancière's frequent presence in this essay is that he has developed a persuasive interpretation of the ways in which art functions within a broad historical and human framework and how it serves human emancipation—all while avoiding the many traps of contemporary aesthetic and of critical discourse. He has also proposed innovations, some of which arose

from his previous works in which he discussed democracy, politics, education, and so on. In recent decades he has increasingly dealt with aesthetic issues even though he has formulated them in a specific way. In this he took as his starting point and key point of reference Friedrich Schiller (especially his treatise *On the Aesthetic Education of Man, in a Series of Letters*), who developed an aesthetic theory which diverged from that of Kant for it involved also politics in its relation to art, thereby questioning or subverting the usual apartness (autonomy) of artworks.

In Rancière's opinion autonomy and heteronomy in art are always present together and are a feature of the aesthetic regime of art—a regime that has replaced what he calls "representative regime of art." This change occurred around the time of the French Revolution when a new sensibility arose in art and when art and aesthetics became a precondition for each other's existence. Rancière's Schillerian conflation of the sensual with the rational, which are united in beauty and art, and his discussion of the avant-gardes seem a good starting point for conceptualizing the "aesthetic avant-garde movements."

Rancière conceived of aesthetic revolution in terms of a singular and unique event that appeared at the end of the eighteenth century with the emergence of autonomous aesthetics and autonomous art.[48] In the present volume aesthetic revolution is, on the contrary, interpreted as a repeating occurrence and as a successful response to the demand "that art move from representing to transforming the world."

In Rancière's work the "aesthetic revolution" concerns a hitherto unrecognized move from the representative regime of art (which is normatively based on representational criteria of veracity applied to the depicted referent) to the aesthetic regime of art (which is more democratic and transforms the extant relations between the visible and the invisible). In this regime, a work does not draw its property of being an artwork from its conforming to the representational rules but from its belonging to a specific sensorium.[49] This new sensorium is based on "aesthetic free play"—in Rancière's eyes a feature essentially characteristic of the novel regime of art that emerged two centuries ago.

According to Rancière the "Kantian revolution" engendered an aesthetic "silent revolution" that created the conditions of possibility for perceiving works as art. Aesthetic free play thus "ceases to be a mere intermediary between high culture and simple nature, or a stage of the moral subject's self-discovery. Instead, it becomes the principle of a new freedom, capable of surpassing the antinomies of political liberty."[50]

An "aesthetic revolution" is realized by spontaneous collective action—

contrary to a political revolution, which is realized by a directed political action. The former involves not individuals but movements: cases where the discursive, practical, and material activity and creativity of a group (or sporadic singular instances thereof) eventually generate an "enthusiasm" that transforms solitary cases into historically recognizable and mutually related events realized by movements that are today displayed in material and discursive repositories of culture and art history or have been retained as material cultural artifacts. Italian futurism, Surrealism, the Situationist International, or Neue Slowenische Kunst and other aesthetic avant-garde movements are not "just" a series of artistic phenomena that have been political and politicized simply by coincidence. Their political aspects effected historical innovations and consequences. As "aesthetic" avant-garde movements, they have intentionally attempted to unify the artistic and political components of human social existence in a "futurist moment" or an "optimal projection."

Aesthetics

After Alexander Baumgarten coined the word "aesthetic" in the 1730s and presented it in his *Aesthetica* (1750–58), the term and the discipline of "aesthetics" swiftly spread throughout Europe. What started off as an ambiguous term was clarified by Immanuel Kant. Although Baumgarten and Kant differed in many respects regarding the notion of the aesthetic (for instance, Kant accentuated the judgment of taste), they both interpreted aesthetics as a broad concept connected to a specific relation between subject and object concerning a specific experience and mode of perception. Since it was a new coinage, aesthetics "could easily be given several significations, and there has been an equivocation from the beginning between the broad use of 'aesthetic' for any sort of value system having to do with art and beauty and 'the aesthetic' as a special form of disinterested knowledge, uniting feeling and reason."[51]

This ambiguous term was what Kant employed in his notion of "aesthetic experience," which designated the harmonious free play of our imagination: "So long as understanding and imagination remain in this aesthetic mode they simply explore and enjoy the world contemplatively."[52] Works of the fine arts (poetry, music, painting, sculpture, and architecture) were to be objects of disinterested contemplation, pleasurable in themselves and thus a form of free "play."

In early romanticism the relation between art and the aesthetic was essentially modified: early romanticism established a symmetrical alliance be-

tween art and the aesthetic. This change was articulated in the "Oldest System Programme of German Idealism" (1796), attributed to Hegel, Hölderlin, and Schelling. In this brief fragment the idea of beauty attained a very particular position: "Finally the idea which unites all, the Idea of *beauty*, the word taken in the higher platonic sense. I am now convinced that the highest act of reason, which embraces all Ideas, is an aesthetic act, and that *truth and goodness* are brothers *only in beauty*—The philosopher must possess just as much aesthetic power as the poet."[53] In the brief remaining passage in the "System," poetry was raised to the highest position, surpassing sciences and the other arts, with philosophy requiring the "monotheism of reason of the heart."[54] The same document proclaimed the state to be "something mechanical," for "every state must treat free people as a piece of machinery; and it should not do this; thus it must *come to an end*."[55] This revolutionary statement was complemented by the proclamation that the object of freedom be an *Idea*. And here we return to the beginning of the discussion of this fragment, for the "Idea" which unites all subordinate ideas is that of beauty, the latter thereby unifying the true and the good.

In the Enlightenment and romanticism the criterion of beauty shifts from the object to the subject. The idea of beauty is replaced by the *sentiment* of the beautiful. From now on it is taste that is capable of carrying out a judgment of beauty—a judgment that depends on the sensible and not on the intelligible. Until the nineteenth century the idea of beauty was the only basis of the aesthetic criterion. With romanticism the object of art "vanishes," that is, it is no longer clear and self-evident that the object of art as representation is erected upon the foundations of beauty. Now it is instead increasingly erected on categories such as the sublime, the interesting, and the ugly.

When discussing Schiller, we should note that that the "art" he had in mind was different from the art of today. This "art" stretched in a fairly continuous line from Greek antiquity and the Renaissance to that of the eighteenth century, when (according to Rancière) the "aesthetic regime of art" emerged.

In Schiller's time the art of antiquity served as the exemplary form of art. Today, however, "the occupation with the timeless value of a work of art in its classical sense of perfection has been all but replaced by the consideration of its function within society and . . . the classical model of the predominance of the work of art over its contemplator has been substituted by the pre-eminence of its experience through the recipient."[56] Or, in the words of a contemporary critic, today "political, moral, and ethical judgments have come to fill the vacuum of aesthetic judgment in a way that was unthinkable

forty years ago."[57] It is for this reason that the criteria of the romantic art of the "beautiful," despite many similarities, are only with difficulty applicable to the art of today, of much of the twentieth century or even that of the nineteenth. As a rule, aesthetic avant-gardes of the twentieth century criticized the notion of timeless beauty, seeing in it the main reason for the autonomy, institutionalization, and therefore passivity of bourgeois art. Nevertheless, in the early avant-garde poetics the category of "beauty" was not a redundant category: Marinetti, for example, claimed in the 1909 "Futurist Manifesto" that "a racing car . . . is more *beautiful* [my italics] than the Winged Victory of Samothrace."[58]

Between 1793 and 1795, Friedrich Schiller wrote his philosophical inquiry *On the Aesthetic Education of Man*. In twenty-seven letters to the reader, Schiller, an opponent of the French Revolution, described the relation between art, beauty, and human freedom. His main point—related to the ongoing events in France—was that freedom without chaos can be procured through the aesthetic experience of fine art, and not through a political revolution. Although he based many of his views on Kant's philosophy, Schiller at the same time felt unease with Kant's dualism between the spiritual and the sensual, for in his view, this dualism had dire consequences for society. He therefore defended a "union" of the "spiritual drive" with the "sensuous drive" that he called "play." Fine art never strives for particular results of practical value and consequence, renounces all such instrumentality, and practices a disinterested and unconditional appreciation. For Schiller, art possessed the capacity to draw each person toward a harmonious life from which goodwill arises out of natural inclination.

As in the "Oldest System," Schiller's "letters" also propose that truth lives on in "the illusion of Art." The aesthetic impulse, or the "play drive" (*Spieltrieb*), mediates between the "formal drive" (the rational) and the "material drive" (the sensual), or the spiritual and the physical, thereby uniting reason and feeling.

Nevertheless, Schiller's ideas went a step further when compared to the "Oldest System," which completely denigrated the state. According to Schiller, what had to be erected was the "aesthetic state." Taking as his starting point the *Spieltrieb*, Schiller's "letters" expressed hope for a future ideal state in which, due to the free play of the play drive, everyone would be content and everything would be beautiful. This idea found resonance in Herbert Marcuse's *Eros and Civilization* (1955) and more recently in Rancière, who proclaimed this "aesthetic state" to be one of the constituents of his "aesthetic regime."[59]

The *Communist Manifesto* (1848) contains some thoughts that resemble Schiller's, while Marx's positions in his *Economic and Philosophic Manuscripts* of 1844 resemble them even more closely. Marx's "idea of man's alienated senses finding objects appropriate to them, the attempt to form a connection between freedom and aesthetic activity, the picture of the all-round man—all these occur in Schiller's *On the Aesthetic Education of Man*."[60]

In what is today referred to as avant-garde art, the important and explicit influences in the nineteenth and early twentieth centuries are anarchist political and aesthetic ideas promoting ephemeral art and the elimination of its institutions. The other important influence is the utopian socialist Saint-Simon (1760–1825), who promoted a strong connection between the artist and the engineer, the latter idea later recurring in Russian constructivism and productivism—particularly in Rodchenko, El Lissitzky, Tatlin and others who in the 1920s attempted to build a bridge between art and industry.

Rancière on Aesthetics

In the preface to *The Order of Things*, Michel Foucault raises an issue on which that work is based: "Between the already 'encoded' eye and reflexive knowledge there is a middle region which liberates order itself. . . . This middle region, then, in so far as it makes manifest the modes of being of order, can be posited as the most fundamental of all."[61] What Foucault is attempting to bring to light in the epistemological field are the conditions of possibility of history as a discourse and a form of knowledge.

These thoughts of Foucault's may aid us in understanding the position of Rancière, who himself states, "If the reader is fond of analogy, aesthetics can be understood in a Kantian sense—re-examined perhaps by Foucault—as the system of *a priori* forms determining what presents itself to sense experience."[62] In Rancière's endeavor aesthetics is what historically causes the constitution of the general notion of art, an event that in his opinion occurs toward the end of the eighteenth century. It is such aesthetic practices that make visible and "disclose artistic practices, the place they occupy, what they 'do' or 'make' from the standpoint of what is common to the community."[63] Or as Rancière phrases this thought elsewhere, "Aesthetics is not the fateful capture of art by philosophy. It is not the catastrophic overflow of art into politics. It is the originary knot that ties a sense of art to an idea of thought and an idea of the community."[64] In this way Rancière establishes aesthetics as a discourse that not only creates the transcendental conditions for the emergence of a unified and general notion of art, which in his view stretches

into our contemporaneity and beyond, but also connects art with community and reciprocally with politics. The latter is proximate to the notion of "the political," for it relates to democracy and to making visible those who were previously disregarded and mute.

To develop his political notion of aesthetics and of the related "aesthetic revolution," Rancière turns to Schiller and his specific reading of Kant:

> Kant assigned the aesthetic a special position between sensuousness and reason, and defined judgment of taste as free and disinterested. For Schiller, these Kantian reflections become a point of departure from which he can proceed toward something like a definition of the social function of the aesthetic. The attempt strikes one as paradoxical, for it is precisely the disinterestedness of the aesthetic judgment and, it would seem at first, the *functionlessness* of art as an implicit consequence that Kant had emphasized. Schiller attempts to show that it is on the very basis of its autonomy, its not being tied to immediate ends, that art can fulfill a task that cannot be fulfilled in any other way: the furtherance of humanity.[65]

Confronted with the terror inherent to French Revolution, Schiller was of the opinion that class society cannot be eliminated by a political revolution because the men who are to carry out this feat are themselves stained, "contaminated," and determined by class society. Schiller therefore suggested that under such circumstances only art—because it doesn't intervene in reality and has nothing to do with practical life—can reestablish the previous unity and put together humankind's torn halves. It is in this way that art can form the basis for a human revolution.

In Schiller's theory Rancière discerns a premonition of the future development of art, namely two basic trends in the art of the twentieth century: one is characterized by turning art into the sociopolitical project of a cultural revolution of historic dimensions (Stalin's attempt to erect an "aesthetic state"), while the other sees Schiller's "play" as the contemporary dominance of consumer culture and the culture industry.

"Schiller says that aesthetic experience will bear the edifice of the art of the beautiful *and* of the art of living. The entire question of the 'politics of aesthetics'—in other words, of the aesthetic regime of art—turns on this short conjunction. . . . It grounds the autonomy of art, to the extent that it connects it to the hope of 'changing life.' . . . Schiller says that the 'play drive'— *Spieltrieb*—will reconstruct both the edifice of art and the edifice of life."[66] What is "life"?—It is "a concept designating all material being and all that is

immediately present to the senses."[67] Life can also designate the shared life of individuals, of a social class or of a community. It is what they all have "in common," with "art" being at the same time a means of their expression and an experiential object of their perception.

Rancière's "aesthetic regime of art" extends not only in temporal terms, but also in an epistemological sense: it concerns the "distribution of the sensible" that "determines a mode of articulation between forms of action, production, perception, and thought. This general definition extends aesthetics beyond the strict realm of art to include the conceptual coordinates and modes of visibility operative in the political domain."[68] Rancière's "aesthetics" is therefore concerned with art as a form of emancipation, as a way of "becoming truly human"—a position related both to Schiller's political interpretation of art and of the aesthetic and to Rancière's own specific interpretation of politics as a form of subjectivization. In this framework art and politics work hand in hand: the images of art "help sketch new configurations of what can be seen, what can be said and what can be thought and, consequently, a new landscape of the possible."[69]

Rancière's interpretation of aesthetics and the specific role of art in Schiller allow us to situate the avant-gardes, with their frequently heteronomous nature, firmly within the art of the previous century, constituting one possible relation between art and life, namely that of transforming the former into the latter. An aesthetic revolution may lead also to the human revolution as envisaged in the 1840s by Karl Marx: "The coming Revolution will be at once the consummation of and abolition of philosophy; no longer merely 'formal' and 'political,' it will be a 'human' revolution. The human revolution is an offspring of the aesthetic paradigm."[70] In this way the aesthetic avant-gardes represent in art a particular parallel and complement to the revolutionary political avant-gardes: they both strive to transgress the borders between the relatively autonomous spheres of life that were erected in modernity and that art, by its very nature, transgresses incessantly. What sometimes prevents the aesthetic avant-gardes from viewing ancient Greece as an apotheosis of a lost (but perhaps in the future regained) humanity and community within which art too is integrated is not only their aversion to classical culture, which they regard as a part of the bourgeois universe, but also their frequent realistic understanding of the future, which is not to be perceived as a state of static bliss, but instead as an "agonistic struggle."[71]

Postwar Avant-Gardes

The early avant-gardes were followed predominantly by the neo-avant-gardes—"a loose grouping of North American and Western European artists of the 1950s and 1960s who reprised such avant-garde devices of the 1910s and 1920s as collage and assemblage, the readymade and the grid, monochrome painting and constructed sculpture."[72]

Tyrus Miller suggests in his contribution to this volume that the utopian force of the American neo-avant-gardes of the 1960s was not exhausted by their analogy with and conscious reappropriation of the early aesthetic avant-gardes. The neo-avant-gardes did not merely reiterate early twentieth-century avant-gardes; they also revised them, precisely in the domain of artistic politics. He sees such a revision as the shift from an artistic politics of ideological actualization to that of presenting "singular examples" of a new hegemony, founded in alternative ways of acting and experiencing our communities, our collectively shared worlds.

The post–World War II avant-garde movements differed from those around World War I in making their political plans more focused on specific issues. Some were concerned less with world revolution and more with processes of subjectivization that resulted in emancipation. Among these were AIDS activism, feminism or gay movements and their biopolitical aims, or cultural movements such as Tropicália (1967) in Brazil, which, while voicing political dissent, transformed elite and folk culture into popular culture. Its agenda was carried out in paintings, objects, and installations by Helio Oiticica, in music by Caetano Veloso and Gilberto Gil, in cinema by Glauber Rocha, and by others in theater and fashion.[73] In 1969 Oiticica elaborated the concept of "creleisure," which combined the senses of creativity, faith, leisure, and pleasure, and was related to the aesthetics of Schiller, Marcuse, and Che Guevara's *foquismo* theory. Oiticica then proposed a "revolution in the idea of aesthetic revolution," but he did not pursue this idea further.[74] These movements are isolated, time- and place-specific, and often short-lived. Nonetheless, they represent cases of aesthetic avant-gardes that—while neither numerous nor particularly influential—redistribute the sensible in communities of sense, making their presence felt out of temporal synchrony or out of proportion when compared to the central avant-gardes.

Also deserving mention is the art of the apartheid era in South Africa and of the independence struggles and revolutions in various parts of the world. This art was critical, oppositional, politically revolutionary, and at the same time often artistically innovative—although not exactly avant-garde in Western terms.

What about socially engaged contemporary art such as that of Critical Art Ensemble or Critical Mass—of "participatory art" in short? "Socially engaged art is not an art movement. Rather, these cultural practices indicate a new social order—ways of life that emphasize participation, challenge power, and span disciplines ranging from urban planning and community work to theater and the visual arts."[75]

Avant-garde artists from the Soviet bloc countries and Yugoslavia, most of whom practiced conceptual art, formed loose groupings in the 1960s and 1970s, and their art served as an unexpected launching pad for postsocialist avant-gardes. Such artists and groups developed ideas and created works often made as solitary endeavors or "missions," unconnected to other similar groups around them—and as a rule isolated from the West. Thus Czech conceptual artist Milan Knížák stated that in 1964, when he first encountered Western magazines presenting work of modern artists that resembled his, he was very happy, for he saw "there were people in the world similar to me."[76]

Yet another kind of postwar avant-garde consisted of radical avant-garde artists, groups, and movements, some of which were clustered around the revolts of the late 1960s and early 1970s. Paramount among them was the Situationist International, whose theoretical analyses, novel devices of *détournement* and *dérive*, and actual political impact added up to a veritable aesthetic revolution resembling those of the early avant-gardes—also by questioning the need for and existence of art itself. Its less analytic versions were groups and movements such as Subversive Aktion in West Germany and Viennese actionism.

The 1968 events in Paris revealed the abyss separating the youthful rebels from the French Communist Party (PCF): it was not the PCF but surrealism and the Situationist International that became the influential ideological ingredients of the Paris revolts. In the United States, the same period was witness to the radical but less visible revolution by alternative culture groups that caused the rift between Herbert Marcuse and his traditionalist criticism of alternative culture and the latter's unorthodox lifestyles and new forms of sensibility. Adorno in Frankfurt was similarly annoyed and refused to join the students, a situation that soon led to the conflict between some of the protagonists of the old "critical theory" and the German New Left. These failed encounters attested to the widening gap between the youth and the political and intellectual authorities.

Third-Generation Avant-Gardes

According to Perry Anderson, "Since the seventies, the very idea of an avant-garde, or of individual genius, has fallen under suspicion."[77] The immediate reason is obvious: if the avant-gardes no longer know "where Humanity is going," can no longer know "what the destiny of the human race is," then they have lost their raison d'être.[78] Within this framework avant-gardes are not "just" a marginal segment or an irrelevant feature of modernity but rather its essential and constitutive characteristic. As Jürgen Habermas claimed in his 1980 Frankfurt speech, modernity "unfolded in various avant-garde movements and finally reached its climax in the Café Voltaire of the Dadaists and in surrealism."[79]

Although there were many good reasons for the idea of a recent avant-garde to fall under suspicion, I wish to argue (as I did in the introduction) that recent art in the former socialist countries underwent a specific development, and one of its features was the emergence of a specific type of avant-garde art that usually existed only for limited time—from the beginning of the disintegration of socialism in a particular country until its actual demise. I have designated such avant-gardes as "postsocialist" or as "third-generation" avant-gardes. Hopefully, today this idea will seem more plausible and perhaps easier to accept than in the 1980s and 1990s, when the gap between modernism and postmodernism excluded any possibility of a shared history or future. With the demise or diminution of the role and place of postmodernism and its frequent reduction to an element of modernity (and of postmodernity to "late modernity," "altermodernity," or "second modernity"), the notion of "contemporary art" has acquired a new significance: "The concept of 'contemporary art' is in everyday usage as the general term for today's art taken as a significant whole, and understood as distinct from modern art—the art of the historical period that is substantially complete, however resonant it may remain in the lives and values of many. If used at all, the term 'postmodern' recalls the moment of transition between these two eras, an anachronism from the 1970s and 1980s. These presumptions became the norm in art throughout the world during the 1990s."[80]

It is within such an interpretative framework that the "third-generation" avant-gardes may be able to find their place.[81] Additional support for such an interpretation is to be found in Rancière's notion of the "aesthetic regime of art," for it questions the usual division into modernism and postmodernism and not only replaces it with the aesthetic regime of art but also ascribes to it an opening onto a continuous future devoid of historical closure.

When suggesting that the "third-generation avant-gardes" from the epoch of postsocialism contain or even exist as a new version of radical avant-gardes, it has to be admitted that they represent their watered-down form. This statement has to be comprehended within the contemporary capitalist system, wherein the market supports, exhibits, and proliferates contemporary art—directly through the art market and indirectly through the cultural institutions of the state. In the 1970s and 1980s, this had not yet occurred—the world was still divided into two systems of which only one functioned according to the logic of commodity market—which is why it was possible for the emergent avant-garde art in socialist or postsocialist countries to have politically or socially radical aspirations as well as aesthetic effects that (for some time at least) exceeded those of the neo-avant-gardes. I should explain that in saying this I am not referring primarily to Soviet and post-Soviet Sots Art and conceptualism but rather to simultaneous or somewhat later art that has been discussed in detail elsewhere:[82] the Neue Slowenische Kunst movement in Slovenia, and certain groups and movements in the former Eastern Europe (especially in Hungary, Poland, and Romania), the Cuban Generation of the Eighties, and the Chinese artists of the '85 Movement.

Although only a segment of the Chinese art from the 1980s and 1990s can be called "aesthetic" in the sense employed in this book, some observations have to be made regarding cultural revolution, which in some aspects resembles aesthetic revolution. The Great Proletarian Cultural Revolution in China (1966–76) attempted to change not only the property of the means of production (and thereby the class composition of the Chinese society), but also the essential subjective and existential conditions of the Chinese people: Mao Zedong sought to transform norms, values, and culture as such, subsuming all forms of social and private lives to the aims of the revolution. In brief, he aimed at realizing a revolution from above, in which from its very beginning propaganda art played a central role. (Such was Weng Rulan's poster from February 23, 1967, titled *A Parade of Clowns*, on which the first thirty-nine high-ranking targets of the Cultural Revolution to be purged from the government were depicted.)

The influence of Cultural Revolution stretched well into the 1980s and was the precondition for the emergence of the third-generation avant-gardes in China—in fact, the first authentic and indigenous avant-garde in that country: "The post–Cultural Revolution innovators in Chinese art, literature and culture generally shared a common attitude with Cultural Revolution artists and their managers. This was the abiding conviction in the power of art and literature to transform lives."[83]

A substantial part of the third-generation avant-garde movements, whether in China or Cuba, soon started to visibly lose the dynamic urgency associated with radical avant-gardes and often successfully joined the emergent art market. The 1980s in most cases represented their creative apogee as well as the pinnacle of broader political and social transition.

The Neue Slowenische Kunst (NSK) movement's contemporary project of the State in Time is unique—also in the sense that it deals with global issues and behaves unlike typical "critical" art (the Perestroika Movement, Sots Art, etc.) or existential art (such as that of Krzysztof Wodiczko), which are both instances of art from the "East." This is possible because the existence of the NSK State in Time no longer rests on the materiality of its factual history. Instead its fictional existence has swallowed it up and replaced it: traces of a factual state and its institutions are being transformed into an aesthetic "state in time," thereby effecting a unique aesthetic revolution that is—with the support of numerous artifacts, documents, events, NSK embassies, and gatherings—spreading across the globe.

Art Transforming the World

Earlier I suggested that the avant-garde movements constitute a spectrum wherein the extreme positions represent two possible purposes of every emergent art: "art as a radical change in style and technique" or art that possesses transformative ambitions. In the former case, the avant-gardes effect a change in art, while in the latter they attempt to partake in a political revolution and contribute to a change in society.

The avant-garde movements of the twentieth century—whether the "early" activities in the first two decades, the transformations of the 1950s through the 1970s, or the third-generation (postsocialist) avant-gardes—have been characterized by revolt against art, tradition, the bourgeois, society, or all of these. Revolt has not been bound to revolution in each case, however: the often individual and always counterreactive action and discourse of revolt was opposed to the often programmatic and always collective and future-oriented project of revolution. Avant-garde artists appear to have lost the struggles that they experienced and that are inherent to political struggles: they seem not to have been successful in welding the individual experience of freedom to the collective revolutionary experience. From the viewpoint of autonomous art, the political aspirations and involvements arising from their striving for the marriage of artistic and social revolution fall victim to the charge either of the co-optation of art by politics or of the willful desire to

turn its revolt into revolutionary action, as in the case of Russian constructivism.

Earlier I spoke of the failure and success of the aesthetic avant-gardes; let me once more return to failures. The early aesthetic avant-gardes seem to have failed in their efforts to continuously revolutionize life and society: in the 1920s Marinetti and the Italian futurists mostly abandoned any ambitions to lead an independent and progressive politics and started to support or coexist with fascism, sharing the latter's nationalist affinities; Russian futurists—soon to be identified with the radical journal *Lef*—became increasingly exclusivist and in 1925 finally lost the support of Lunacharski, who proclaimed the Lef group to be "already an almost obsolete thing";[84] although Rodchenko and Lissitzky in the 1930s turned to publication design, making the propaganda magazine *USSR in Construction* (1930–41) the means of their constructivist research, the institutional framework for group activity was gone with the dismantling of independent art organizations in 1932; and surrealists in the 1930s were transforming from a movement into a school, slowly losing or abandoning their special role of "adoptive children of the revolution."[85]

From these events and declines, it is obvious that the aesthetic avant-gardes operated in a highly contested space between art, culture, and especially politics; in the late 1920s such a position was productive for surrealism, but it was much less so for the other early avant-gardes or, later, for the postwar neo-avant-gardes, which only in the 1960s acquired a position of some strength and thus were able to act as agents of transformation in the domains of the sensible human conditions of life.

Such outcomes led to the assessment that "the avant-garde project is predisposed to failure, with the sole exception of movements set in the midst of revolutions."[86] Such were Russian constructivism, the Mexican Mural Revolution of the 1920s, and—conditionally—Italian futurism.

Yet in the decades after World War II, the majority of the early avant-gardes underwent an unexpected change: "The failure of the avant-garde utopia of the unification of art and life coincides with the avant-garde's overwhelming success within the art institution."[87] Should the fact that the radical among the early avant-gardes ended up progressively influencing other art the same way the nonradical did be considered failure or success? It could also be said that some avant-garde movements have, after undergoing an "aesthetic" period, ended up as avant-gardes that realized the value of artistic innovations.

In Rancière's writings there are frequent but elusive references to antiquity.

For Schiller and his epoch, it would have been surprising if ancient Greece was not regarded as the essential point of reference and an unattainable ideal from the perspective of modern times. (It was Friedrich Schlegel who suggested that modern art can be on an equal footing with the Greek art.) In the sixth letter of his *Aesthetic Education of Man*, Schiller writes of "the natural humanity of the Greeks" and how the "Greeks combined the first youth of imagination with the manhood of reason in a glorious manifestation of humanity."[88]

For Schiller antiquity represents the opposite of his own epoch and its division into Reason and Nature. Rancière apparently shares such an opinion, although not very explicitly. He thus writes about "art's forms [that] will again be what they once were—or what they are *said* [my italics] to have been: the forms of unseparated collective life."[89] Despite this doubt about the Greek "Golden Age," in numerous places he refers to an ancient sense of community, of the "common," and of the artistic tradition that brings together the art of that ancient community with that of Russian constructivism. The latter implicitly awaits the same destiny as Greek sculptures and temples: to be integral constituents of everyday shared life. But there is no guarantee that such an epoch will be attained again, which is why Rancière obviously accepts the continuation of the same path of art—as existing under the aesthetic regime of art.

Conclusion

"The avant-gardes saw the artistic and the social revolutions as an interdependent process, as one continuum. That is why artists and critics often described the October Revolution as a continuation of the revolutionary process started in cubism and futurism in the early 1910s. They believed that artistic and the social revolutions complement each other."[90] It is along these lines that Miklós Szabolcsi's 1978 statement—that "a revolution without an avant-garde [in art] is really a pseudo-revolution"—is to be understood, and it is such connection that illustrates the meaning of the aesthetic avant-garde movements and their aesthetic revolutions.

Artists were aware of the capacity of art to transform our perception of the world and perhaps even the world itself. In Diego Rivera's opinion, "cubism broke down forms as they had been seen for centuries, and was creating out of the fragments new forms, new objects, new patterns, and—ultimately— new worlds."[91] A related point was made by Herbert Marcuse in his *Aesthetic Dimension* (1977): "Art can be called revolutionary in several senses. In

a narrow sense, art may be revolutionary if it represents a radical change in style and technique. Such change may be the achievement of a genuine avant-garde, anticipating or reflecting substantial changes in the society at large."[92] Nevertheless, both statements also imply that the "revolutionary" gesture of cubism is essentially that of a novel form of *representation* as opposed to that of *transformation* by a movement such as Italian futurism, which as early as its initial 1909 manifesto announced its intent not only to change the established representation of the world, but also to transform the world itself, by art or by action: "With futurism the poet, the artist, climbs the stage, descends into the street, fights for his ideas with the blows of his fists. . . . He no longer demands from History to register his words and his witnessing, it is he who *makes* History."[93]

The two kinds of avant-gardes—the artistic and the aesthetic—and the two kinds of revolutions they engender were frequently inextricably intertwined and interdependent with political (and often also social) avant-gardes. To some extent these avant-gardes always overlapped, with avant-garde art per se representing not only an essential but an almost "existential" precondition for an authentically radical political revolution. The example of cubism bears witness to art's political "surplus": although it is a novel form of representation, it at the same time exceeds that classification and often borders on the aesthetic avant-gardes.

I introduced the "aesthetic" avant-gardes so as to segregate radical avant-garde movements from those that engendered novelties in style and representation. For this purpose I employed Schiller's interpretation of aesthetics, which—contrary to Kant's or Hegel's—carries overt political implications. In the fifteenth letter of his *Aesthetic Education of Man* Schiller makes the following argument:

1 "The beautiful is to be neither mere life, nor mere form, but living form, i.e., Beauty."
2 "With beauty man shall *only play*, and it is *with beauty only* that he shall play."
3 "Man only plays when he is in the fullest sense of the word a human being, and *he is only fully a human being when he plays*."[94]

As Schiller points out a little earlier, the reason for using the word "play" is that he relates it to ancient Greece (and not ancient Rome): life is to resemble noble feats of Greek sports, and not the violent and cruel games of the Romans. It is this type of play that also informs Schiller's interpretation of art and consequently of life. If life is, as Schiller explains in the same letter,

"a concept designating all material being and all that is immediately present to the senses," and art is linked to "Beauty" that is "living form," then art (with its dependence on play) is both the "art of the beautiful" and the "art of living." Together they represent two facets of the same desirable aesthetic "state." Schiller—like Rancière—did not expect an "aesthetic state" in which this ideal would take place to arise any time soon.

Although Marx was unfamiliar with Schiller's *Aesthetic Education of Man*, claims such as these informed Marx's early works and resembled Schiller's earlier interpretation of aesthetics and its relation to "the art of the beautiful and of the still more difficult art of living."[95] Nevertheless, Schiller saw art as putting back together the "torn halves of man" (reason and the senses) *only in some few chosen circles* (my italics) and almost *in opposition* to the social and political upheaval called the French Revolution, while Marxism considered a radical revolution in sociohistorical and material circumstances a necessary precondition for an authentic social revolution. In the view of Schiller and German idealism—a view apparently shared by Rancière—art was "the transformation of thought into the sensory experience of the community. It is this initial programme . . . that laid the foundation for the transformation of thought and practice of the 'avant-gardes' in the 1920s: abolish art as a separate activity, put it back to work, that is to say, give it back to life and its activity of working out its own proper meaning."[96]

Within such a setting, art and politics remain two fundamental categories, with the aesthetic project of unifying the beautiful of art with the beautiful of life offering a *promesse de bonheur*—whether in the form of artistic creative projects, social and artistic visions, or agendas of various master narratives. That is why "a juncture emerged between the Marxist vanguard and the artistic avant-garde in the 1920s, since each side adhered to the same programme."[97] In a similar way, Italian futurists in 1918 founded the Futurist Political Party, which for a short period of time had visible political consequences in Italy, and muralist artists in Mexico and Nicaragua created abundantly in cooperation with the state; the Situationist International crucially influenced the 1968 events in Paris; the alternative culture and critical social theory in the United States in the 1950s and 1960s contributed importantly to essential changes in the American way of life and mentality; and the Neue Slowenische Kunst movement was pivotal in the symbolic, material, and political affirmation of an independent Republic of Slovenia.

If it can be agreed that avant-garde movements stretch beyond the neo-avant-gardes into the third-generation avant-gardes, then the path is open for admitting a further development of aesthetic avant-garde movements. Such

a thought is perhaps echoed in the following recent statement: "The desire to merge art and life resonates throughout the avant-garde movements of the twentieth century and then multiplies across the globe at the beginning of the twenty-first."[98]

IS THERE A FUTURE for the avant-gardes, the aesthetic ones included? Perhaps, if only they succeed in imagining a future and creating a vision that will outweigh the atemporality of contemporary historical circumstances. A second condition may already be present: the avant-garde emerges "in times of *instability* and heightened contingency."[99] Yet another necessary condition remains the same as a century ago: a viable political avant-garde with which the artistic historical projection can converge. After all, it was the absence of a sympathetic political avant-garde that hindered the posthistorical avant-garde movements from becoming as visible and as effective as the early ones.

Of course we cannot look into the future, so probably such assessments are erroneous or premature. Perhaps the avant-gardes really are a phenomenon limited by modernity and authentically exist only within the twentieth-century time frame. Or perhaps somewhere on the globe at this very moment a fourth-generation aesthetic avant-garde has just been brought into the world.

NOTES

1. Raunig, *Art and Revolution*, 98.
2. Morawski, "The Artistic Avant-Garde," 88.
3. De Duve, *Kant after Duchamp*, 442.
4. Berghaus, *Futurism and Politics*, 65.
5. See Berghaus, *Futurism and Politics*, chap. 6.
6. Berman, *All That Is Solid Melts into Air*, 121–22.
7. Perry Anderson, "Modernity and Revolution," 103.
8. Lodder, *Russian Constructivism*, 49.
9. Stephan, *"Lef" and the Left Front of the Arts*, 54.
10. Benjamin, "Surrealism," 212.
11. Calinescu, *Five Faces of Modernity*, 117.
12. Calinescu, *Five Faces of Modernity*, 119.
13. See Bäckström, "One Earth, Four or Five Words."
14. Buchloh, "Theorizing the Avant-Garde"; Foster, *The Return of the Real*.
15. Joseph, *Random Order*, 12.
16. See, for example, Turowski, *Existe-t-il un art de l'Europe de l'Est?* (1986), in which the art discussed is exclusively avant-garde art.

17. Rancière, *The Politics of Aesthetics*, 29.

18. Bürger, *Theory of the Avant-Garde*, 22.

19. Raunig, *Art and Revolution*, 24.

20. Hugo Ball, quoted in van den Berg, "From a New Art to a New Life and a New Man," 140.

21. Puchner, *Poetry of the Revolution*, 156.

22. "Richard Huelsenbeck, "En Avant Dada," 44.

23. See Dickerman, *Dada*, 10.

24. Quoted in van den Berg, "From a New Art to a New Life and a New Man," 142.

25. Cf. van den Berg, "From a New Art to a New Life and a New Man," 148.

26. Richter, *Dada*, 34.

27. De Duve, *Kant after Duchamp*, 333.

28. Antonio Gramsci, "Marinetti rivoluzionario?," quoted in Gherarducci, *Il futurismo italiano*, 183.

29. Bishop, "Participation and Spectacle," 37.

30. Jones, "'Jeder kann Dada,'" 356.

31. Claire Bishop argues that "in the first phase of this orientation towards the social, participation has no given political alignment: it is a strategy that can be equally associated with Italian Fascism, Bolshevik communism, and an anarchic negation of the political" (Bishop, "Participation and Spectacle," 37). Such an assessment is questionable with respect to Italian futurism, where it is conditionally valid only for the 1918–22 period when futurists disseminated their political alliances among fascists, communists, anarchists, and socialists. See Carpi, *Bolscevico immaginista*.

32. Richter, *Dada*, 112.

33. Marinetti, "Beyond Communism," in *Critical Writings*, 339.

34. Van den Berg, "From a New Art to a New Life and a New Man," 138–39.

35. Bru, "Dada as Politics," 297.

36. Perry Anderson, "Modernity and Revolution," 112.

37. Kouvelakis, *Philosophy and Revolution from Kant to Marx*, 27.

38. Kouvelakis, *Philosophy and Revolution from Kant to Marx*, 341.

39. Flaker, *Poetika osporavanja*, 68.

40. Flaker, *Poetika osporavanja*, 68.

41. Flaker, *Poetika osporavanja*, 69.

42. Flaker, *Poetika osporavanja*, 336.

43. Flaker, *Poetika osporavanja*, 336.

44. Rancière, *Dissensus*, 141.

45. Quoted in Lista, *Futurisme: Manifestes, documents, proclamations*, 91–92.

46. Albini, *Les arts plastiques en Italie de 1860 à 1943*, 120.

47. Albini, *Les arts plastiques en Italie de 1860 à 1943*, 121.

48. Such character of the aesthetic revolution has encountered some criticism. As a commentator argues, Rancière doesn't offer a reason why "the only fundamental transformation since the Greeks, i.e. a transformation that has given birth to a new partition of the sensible, occurred approximately at the end of the eighteenth century" (Rockhill, "The Silent Revolution," 72).

49. Rancière, *Aesthetics and Its Discontents*, 29.

50. Rancière, *Aesthetics and Its Discontents*, 99.

51. Shiner, *The Invention of Art*, 146.

52. Shiner, *The Invention of Art*, 147.

53. Quoted in "Appendix: The So-Called 'Oldest System Programme of German Idealism,'" in Bowie, *Aesthetics and Subjectivity from Kant to Nietzsche*, 334.

54. Bowie, *Aesthetics and Subjectivity from Kant to Nietzsche*, 335.

55. Bowie, *Aesthetics and Subjectivity from Kant to Nietzsche*, 334.

56. Behler, "Origins of Romantic Aesthetics in Friedrich Schlegel," 52.

57. Bishop, "Antagonism and Relational Aesthetics," 77.

58. Marinetti, *Critical Writings*, 13.

59. Rancière, *The Politics of Aesthetics*, 23–24.

60. Margaret Rose, *Marx's Lost Aesthetic*, 74.

61. Foucault, *The Order of Things*, xxi.

62. Rancière, *The Politics of Aesthetics*, 13.

63. Rancière, *The Politics of Aesthetics*, 13.

64. Rancière, "What Aesthetics Can Mean," 33.

65. Bürger, *Theory of the Avant-Garde*, 44.

66. Rancière, *Dissensus*, 116.

67. Schiller, *On the Aesthetic Education of Man*, 101.

68. Rancière, *The Politics of Aesthetics*, 82.

69. Rancière, *The Emancipated Spectator*, 103.

70. Rancière, *Dissensus*, 120.

71. Mouffe, *On the Political*, 21.

72. Foster, *The Return of the Real*, 1.

73. See Basualdo, *Tropicália*.

74. Cf. Skrebowski, "Revolution in the Aesthetic Revolution."

75. Thompson, *Living as Form*, 19.

76. Milan Knížák, "Milan Knížák: Kill Yourself and Fly," 37.

77. Perry Anderson, *The Origin of Postmodernity*, 93.

78. Laverdant, quoted in Poggioli, *The Theory of the Avant-Garde*, 9.

79. Habermas, "Modernity—an Incomplete Project," 5.

80. Smith, *What Is Contemporary Art?*, 242.

81. See Erjavec, "The Three Avant-Gardes and Their Context," in Djurić and Šuvaković, *Impossible Histories*, 36–62.

82. See Erjavec, *Postmodernism and the Postsocialist Condition*.

83. Paul Clark, *The Chinese Cultural Revolution*, 260.

84. Lunacharski, quoted in Stephan, *"Lef" and the Left Front of the Arts*, 53.

85. Benjamin, "Surrealism," 209.

86. Foster, *The Return of the Real*, 15.

87. Bürger, "Avant-Garde and Neo-Avant-Garde," 705.

88. Schiller, *On the Aesthetic Education of Man*, 31.

89. Rancière, *Aesthetics and Its Discontents*, 100.

90. Andel, "The Constructivist Entanglement," 225.

91. Quoted in Craven, *Art and Revolution in Latin America, 1910–1990*, 11.

92. Marcuse, *The Aesthetic Dimension*, x–xi.

93. Lista, *Futurisme: Manifestes, documents, proclamations*, 17.

94. Schiller, *On the Aesthetic Education of Man*, 107.

95. Schiller, *On the Aesthetic Education of Man*, 107, 109.

96. Rancière, *The Politics of Aesthetics*, 44–45.

97. Rancière, *The Politics of Aesthetics*, 38.

98. Bishop, "Participation and Spectacle," 21.

99. Bru, *Democracy, Law and the Modernist Avant-Gardes*, 34.

Bibliography

Adamson, Walter L. "Modernism and Fascism: The Politics of Culture in Italy, 1903–1922." *American Historical Review* 95, no. 2 (1990): 359–90.

Ades, Dawn. *Art in Latin America*. New Haven, CT: Yale University Press, 1989.

Adorno, Theodor. "Engagement" (1962). In *Noten zur Literatur: Gesammelte Schriften*, 11, 409–30. Frankfurt am Main: Suhrkamp Verlag, 1997.

Agamben, Giorgio. *"What Is an Apparatus?" and Other Essays*. Translated by David Kishik and Stefan Pedatella. Stanford, CA: Stanford University Press, 2009.

Aksenov, Ivan. "Prostranstvennyi konstruktivizm na stsene." *Teatral'nyi Oktiabr'*, no. 1 (1926): 31–37.

Alberro, Alexander, and Blake Stimson, eds. *Conceptual Art: A Critical Anthology*. Cambridge, MA: MIT Press, 1999.

Albini, Carla. *Les arts plastiques en Italie de 1860 à 1943*. Translated from Italian by Maria Brandon-Albini. Paris: Editions Entente, 1985.

Allison, Nicholas H., ed. *Art into Life: Russian Constructivism 1914-1932*. New York: Rizzoli, 1990.

Allyn, David. *Make Love Not War: The Sexual Revolution: An Unfettered History*. New York: Routledge, 2001.

Althusser, Louis. *Lenin and Philosophy and Other Essays*. Translated by Ben Brewster. New York: Monthly Review Press, 1971.

———. *Lénine et la philosophie*. Paris: Librairie François Maspero, 1970.

Al'tman, Natan. "'Futurizm' i proletarskoe iskusstvo." *Iskusstvo kommuny*, no. 2 (December 15, 1918): 3.

Andel, Jaroslav. "The Constructivist Entanglement: Art into Politics, Politics into Art." In *Art into Life: Russian Constructivism 1914-1932*, edited by Nicholas H. Allison, 223-39. New York: Rizzoli, 1990.

Andersen, Troels, ed. *Malevich: Essays on Art*. Vol. 1. Copenhagen: Borgen, 1968.

Anderson, Benedict. *Imagined Communities*. London: Verso, 1983.

Anderson, Perry. "Modernity and Revolution." *New Left Review*, no. 144 (March–April 1984): 96–113.

———. *The Origin of Postmodernity*. London: Verso, 1998.

André Breton: La beauté convulsive. Paris: Centre Georges Pompidou, Musée national d'art moderne, 1991. Published in conjunction with the exhibition of the same name, Centre Georges Pompidou, Musée national d'art moderne, April 25–August 26, 1991.

Andreotti, Libero, and Xavier Costa, eds. *Theory of the Derive and Other Situationist Writings on the City*. Translated by Paul Hammond and Gerardo Denis. Barcelona: Museu d'Art Contemporani de Barcelona, 1996.

Anreus, Alejandro. *Orozco in Gringolandia*. Albuquerque: University of New Mexico Press, 2001.

Aragon, Louis. "Au bout du quai, les Arts Décoratifs!" *La Révolution surréaliste*, no. 5 (October 1925): 26-27.

Arkin, David. "Iskusstvo veshchi." In *Ezhegodnik literatury i iskusstva na 1929 god*, edited by Pavel Novitsky, 150-60. Moscow: Ogiz-Izogiz, 1932.

———. "Izobrazitel'noe iskusstvo i material'naia kul'tura." *Iskusstvo v proizvodstvo*, no. 1 (1921): 428-71.

Arns, Inke. "IRWIN Navigator: Retroprincip 1983-2003." In *IRWIN Retroprincip*, edited by Inke Arns, 9-14. Frankfurt am Main: Revolver, 2003.

———, ed. *IRWIN Retroprincip*. Frankfurt am Main: Revolver, 2003.

———. *Laibach, IRWIN, Gledališče sester Scipion Nasice: Eine Analyse ihrer künstlerischen Strategien im Kontext der 1980er Jahre in Jugoslawien*. Regensburg: Museum Ostdeutsche Galerie, 2002.

Art into Life: Russian Constructivism 1914-1932. Introduction by Richard Andrews and Milena Kalinovska. New York: Rizzoli, 1990.

Arvatov, Boris. "Bezhim . . . bezhim . . . bezhim . . ." *Zrelishcha*, no. 16 (1922): 6.

———. "Iskusstvo v sisteme proletarskoi kul'tury." In Valerian Bliumenfel'd et al., *Na putiakh iskusstva*, 13-25. Moscow: Proletkul't, 1926.

————. *Iskusstvo i klassy*. Moscow: Gosizdat, 1923.

————. *Iskusstvo i proizvodstvo*. Moscow: Proletkul't, 1926.

————. "Ot rezhissury teatra k montazhu byta." *Ermitazh*, no. 11 (1922): 3.

Aspect/Positions: 50 Years of Art in Central Europe 1949–99. Edited by Lóránd Hegyi. Vienna: Museum moderner Kunst Stiftung Ludwig; Budapest: Ludwig Museum, 1999.

Atkins, Guy, and Troels Andersen. *Asger Jorn, the Crucial Years, 1954–1964: A Study of Asger Jorn's Artistic Development from 1954 to 1964 and a Catalogue of His Oil Paintings from That Period*. London: Lund Humphries, 1977.

Avila, Theresa. "Zapata: Figure, Image, Symbol." MA thesis, University of New Mexico, 2005.

Baackmann, Susanne, and David Craven. Introduction to Special Issue on Surrealism and Post-Colonial Latin America, *Surrealism and the Americas e-Journal* 3, no. 1 (2009): ix–xi.

Babichev, Aleksei. "Zapiska k programme." In Dmitrii Sarab'ianov, *Aleksei Vasil'evich Babichev: Khudozhnik, teoretik, pedagog*, 104. Moscow: Sovetskii khudozhnik, 1974.

Bäckström, Per. "One Earth, Four or Five Words: The Peripheral Concept of 'Avant-Garde.'" *ACTION YES Online Quarterly* 1, no. 12 (Winter 2010). http://www.actionyes.org/issue7/backstrom/backstrom1.html.

Baddeley, Oriana, and Valerie Fraser. *Drawing the Line: Art and Cultural Identity in Latin America*. London: Verso, 1989.

Badiou, Alain. *The Century*. Translated by Alberto Toscano. Cambridge: Polity, 2007.

————. *The Communist Hypothesis*. Translated by David Macey and Steve Corcoran. London: Verso, 2010.

————. *Handbook of Inaesthetics*. Translated by Alberto Toscano. Stanford, CA: Stanford University Press, 2005.

————. *Logiques des mondes: L'être et l'événement 2*. Paris: Seuil, 2006.

————. *Théorie du sujet*. Paris: Seuil, 1982.

Bakhtin, Mikhail, and M. M. Medvedev. *The Formal Method in Literary Scholarship* (1928). Translated by Albert J. Wehrle. Baltimore: Johns Hopkins University Press, 1991.

Banes, Sally. *Greenwich Village 1963: Avant-Garde Performance and the Effervescent Body*. Durham, NC: Duke University Press, 1993.

Barthes, Roland. "Photogénie électorale." In *Mythologies*, 160–63. Paris: Éditions du Seuil, 1957.

Basualdo, Carlos, ed. *Tropicália: A Revolution in Brazilian Culture (1967–1972)*. São Paulo: Naify, 2005.

Battcock, Gregory. "Art in the Service of the Left?" In *Idea Art: A Critical Anthology*, edited by Gregory Battcock, 18–29. New York: E. P. Dutton and Co., 1973.

————. "Herbert Marcuse." In *Why Art: Casual Notes on the Aesthetics of the Immediate Past*. New York: E. P. Dutton and Co., 1977.

————. "Marcuse and Anti-Art." *Arts Magazine* 43, no. 8 (1969): 17–19.

Baudrillard, Jean. *Fatal Strategies*. Translated by Philip Beitchman and W. G. J. Niesluchowski. New York: Semiotext(e); London: Pluto, 1990.

————. *In the Shadow of the Silent Majorities, or, The End of the Social*. Introduction

by Sylvère Lotringer, Chris Kraus and Hedi El Kholti. Translated by Paul Foss et al. Los Angeles: Semiotext(e), 1983.

———. *Life: Selected Interviews 1982–1993*. Edited by Mike Gane. London: Routledge, 1993.

———. *The Vital Illusion*. Edited by Julia Witwer. New York: Columbia University Press, 2000.

———. "The Year 2000 Will Not Take Place." In *Futur*Fall: Excursions into Post-Modernity*, edited by Elizabeth A. Grosz et al., 18–29. Sydney: Power Institute of Fine Arts, University of Sydney and Futur*Fall, 1986.

Begrich, Aljoscha. "Der mexikanische Muralismus als Bilderziehung." MA thesis, Humboldt Universität zu Berlin, 2007.

Behler, Ernst. "Origins of Romantic Aesthetics in Friedrich Schlegel." *Canadian Review of Comparative Literature* (Winter 1980): 47–66.

Bell, Daniel. *The End of Ideology: On the Exhaustion of Political Ideas in the Fifties*. Cambridge, MA: Harvard University Press, 1988.

Bely, Andrei. *Lug zelenyi: Kniga statei*. Moscow: Altsion, 1910.

———. *Simvolizm*. Moscow: Musaget, 1910.

Benjamin, Walter. "Das Kunstwerk im Zeitalter seiner technischen Reproduzierbarkeit." In *Gesammelte Schriften I*, 2, edited by Rolf Tiedemann and Hermann Schweppenhäuser, 471–508. Frankfurt am Main: Suhrkamp Verlag, 1980.

———. *Selected Writings*. 4 vols. Edited by Marcus Bullock, Howard Eiland, Michael W. Jennings, and Gary Smith. Translated by Rodney Livingstone and others. Cambridge, MA: Harvard University Press, 1996–2003.

———. "Surrealism: The Last Snapshot of the European Intelligentsia." In *Selected Writings, 1927–1934*, vol. 2, edited by Michael W. Jennings, Howard Eiland and Gary Smith; translated by Rodney Livingstone and others, 207–21. Cambridge, MA: Harvard University Press, 1999.

———. "The Work of Art in the Age of Mechanical Reproduction." In *Illuminations: Essays and Reflections*, edited and with an introduction by Hannah Arendt, 217–51. New York: Schocken, 1985.

Benn, Gottfried. "Probleme der Lyrik." In *Gesammelte Werke*, vol. 1, edited by Dieter Wellershoff, 494–532. Wiesbaden: Limes, 1959.

Berghaus, Günter. *Futurism and Politics: Between Anarchist Rebellion and Fascist Reaction, 1909–1944*. Providence, RI: Berghahn Books, 1996.

———. "The Futurist Political Party." In *The Invention of Politics in the European Avant-Garde, 1906–1940*, edited by Sascha Bru and Gunther Martens, 153–82. Amsterdam: Rodopi, 2006.

———. *Italian Futurist Theatre, 1909–1944*. Oxford: Clarendon, 1998.

Berlov, M. *Detali mashin*. Riga: Rizhskii politekhnicheskii institut, 1902–3; St. Petersburg: Rikker, 1909–11.

Berman, Marshall. *All That Is Solid Melts into Air: The Experience of Modernity*. New York: Penguin, 1988.

Berreby, Gérard, ed. *Documents relatifs à la fondation de l'Internationale Situationniste*. Paris: Allia, 1985.

———, ed. *Textes et documents situationnistes, 1957–1960*. Paris: Allia, 2004.

Biner, Pierre. *The Living Theatre: A History without Myths*. Translated by Robert Meister. New York: Grove, 1972.

Binstock, Jonathan, ed. *Andy Warhol: Social Observer*. Philadelphia: Pennsylvania Academy of the Fine Arts, 2000.

Bishop, Claire. "Antagonism and Relational Aesthetics." *October*, no. 110 (Fall 2004): 51–79.

———. *Artificial Hells: Participatory Art and the Politics of Spectatorship*. London: Verso, 2012.

———. "Participation and Spectacle: Where Are We Now?" In *Living as Form: Socially Engaged Art from 1991 to 2011*, edited by Nato Thompson, 34–45. New York: Creative Time Books, 2012.

Blanchot, Maurice. "Tomorrow at Stake." In *The Infinite Conversation*, translated by Susan Hanson, 407–21. Minneapolis: University of Minnesota Press, 1993.

Bliumenfel'd, Valerian, et al. *Na putiakh iskusstva*. Moscow: Proletkul't, 1926.

Block, René, and Angelika Nollert, eds. *Kollektive Kreativität = Collective Creativity: Kunsthalle Fridericianum Kassel*. Frankfurt am Main: Revolver, 2005.

Boccioni, Umberto. "Futurist Painting: Technical Manifesto." In *Art in Theory, 1900–2000: An Anthology of Changing Ideas*, edited by Charles Harrison and Paul Wood, 150–53. Oxford: Blackwell, 2000.

Bockris, Victor, and Gerard Malanga. *Up-Tight: The Velvet Underground Story*. New York: Cooper Square, 2003.

Bonnet, Marguerite, ed. *Adhérer au Parti communiste? Septembre–décembre 1926*. Archives du surréalisme, vol. 3. Paris: Gallimard, 1992.

———, ed. *Vers l'action politique, juillet 1925–avril 1926*. Archives du surréalisme, vol. 2. Paris: Gallimard, 1988.

Bouhours, Jean-Michel, and Nathalie Schœller, eds. *L'Age d'Or: Correspondence Luis Buñuel–Charles de Noaille, lettres et documents (1929–1976)*. Special issue of *Les Cahiers du musée nationale d'art moderne*. Paris: Centre Georges Pompidou, 1993.

Bourdieu, Pierre. *The Field of Cultural Production*. Translated by Randal Johnson. Cambridge: Polity, 1993.

Bowie, Andrew. *Aesthetics and Subjectivity: From Kant to Nietzsche*. 2nd ed. Manchester: Manchester University Press, 2003.

Bowler, Anne. "Politics as Art: Italian Futurism and Fascism." *Theory and Society* 20, no. 6 (1991): 763–94.

Bowlt, John E., ed. *Russian Art of the Avant-Garde: Theory and Criticism, 1902–1934*. London: Thames and Hudson, 1988.

Bowlt, John, Nicoletta Misler, and Maria Tsantsanoglou, eds. *El Cosmos de la vanguardia rusa*. Catalog of exhibition at the Fundacion Marcelino Botin, Santander, and the State Museum of Contemporary Art, Thessaloniki, December 11, 2010–March 27, 2011.

Bowlt, John E., Rose-Carol, Washton Long. *The Life of Vasilii Kandinsky in Russian Art*. Newtonville, MA: Oriental Research Partners, 1980.

Bradley, Will, and Charles Esche, eds. *Art and Social Change—a Critical Reader*. London: Tate Publishing and Afterall, 2007.

Brakhage, Stan. *Essential Brakhage: Selected Writings on Filmmaking.* Edited by Bruce R. McPherson. Kingston, NY: Documentext, 1997.

Braun, Emily. *Mario Sironi and Italian Modernism: Art and Politics under Fascism.* Cambridge: Cambridge University Press, 1999.

Brecht, Bertolt. "Modern Theater Is Epic Theater" (1930). In *Brecht on Theater,* translated by John Willet, 33–42. New York: Hill and Wang, 1964.

Brecht, Stefan. "Revolution at the Brooklyn Academy of Music." *Drama Review* 13, no. 3 (1969): 47–73.

Bredekamp, Horst, and Michael Müller, with Berthold Heinz and Franz Verspohl. *Autonomie der Kunst: Zur Genese und Kritik einer bürgerlichen Kategorie.* Frankfurt am Main: Suhrkamp Verlag, 1972.

Brent Plate, S. *Blasphemy / Art That Offends.* London: Black Dog, 2006.

Breton, André. *Break of Day.* Translated by Mark Polizzotti and Mary Ann Caws. Lincoln: University of Nebraska Press, 1999.

———. *Conversations: The Autobiography of Surrealism.* Translated by Mark Polizzotti. New York: Marlow, 1993.

———. *Manifestoes of Surrealism.* Translated by Richard Seaver and Helen R. Lane. Ann Arbor: University of Michigan Press, 1969.

———. *Nadja.* Translated by Richard Howard. New York: Grove, 1960.

———. *Œuvres complètes.* Edited by M. Bonnet et al. 4 vols. Paris: Gallimard, 1988–99.

———. "Pourquoi je prends la direction de la Révolution surréaliste." *La Révolution surréaliste,* no. 4 (July 1925): 1–3.

———. *Surrealism and Painting.* Translated by Simon Watson Taylor. Boston: MFA Publications, 2002.

———. *What Is Surrealism? Selected Writings.* Edited and with an introduction by Franklin Rosemont. London: Pluto, 1978.

Brik, Osip. "Ot kartiny k sittsu." *Lef,* no. 2 (1923): 27–34.

Brodsky, Boris. "The Psychology of Urban Design in the 1920s and 1930s." *Journal of Decorative and Propaganda Arts,* no. 5 (1987): 76–89.

Bru, Sascha. "Dada as Politics." *Arcadia* 41, no. 2 (2006): 296–312.

———. *Democracy, Law and the Modernist Avant-Gardes: Writing in the State of Exception.* Edinburgh: Edinburgh University Press, 2009.

———. "Morbid Symptoms: Gramsci and the Rhetoric of Futurism." *Variations* 13, no. 13 (2005): 119–32.

Bryan-Wilson, Julia. *Art Workers: Radical Practice in the Vietnam War Era.* Berkeley: University of California Press, 2009.

———. "Still Relevant: Lucy Lippard, Feminist Activism, and Art Institutions." In *Materializing Six Years: Lucy R. Lippard and the Emergence of Conceptual Art,* 71–93. Cambridge, MA: MIT Press / Brooklyn: Brooklyn Museum of Art, 2012.

B.T. (Boris Ternovets). "En guise d'introduction." In *Exposition de 1925: Section URSS.* Catalog of *Exposition des Arts Décoratifs et Industriels.* Paris, 1925.

Buchloh, Benjamin H. D. "From Faktura to Factography." *October,* no. 30 (Autumn 1984): 82–119.

———. "Theorizing the Avant-Garde." *Art in America,* November 1984, 19–21.

Bull, Anna Cento. "Social and Political Cultures in Italy from 1860 to the Present Day."

In *The Cambridge Companion to Modern Italian Culture*, edited by Zygmunt G. Baranski and Rebecca J. West, 35–62. Cambridge: Cambridge University Press, 2001.

Buñuel, Luis. *An Unspeakable Betrayal: Selected Writings of Luis Buñuel*. Translated by Garrett White. Berkeley: University of California Press, 2000.

Bürger, Peter. "Avant-Garde and Neo-Avant-Garde: An Attempt to Answer Certain Critics of *Theory of the Avant-Garde*." *New Literary History* 41, no. 4 (Autumn 2010): 695–715.

———. *Theorie der Avantgarde*. Frankfurt am Main: Suhrkamp Verlag, 1974.

———. *Theory of the Avant-Garde*. Translated by Michael Shaw. Minneapolis: University of Minnesota Press, 1999.

Burn, Ian. "The 'Sixties: Crisis and Aftermath (Or the Memoirs of an Ex-Conceptual Artist)" (1981). In *Conceptual Art: A Critical Anthology*, edited by Alexander Alberro and Blake Stimson, 392–408. Cambridge, MA: MIT Press, 1999.

Butler, Cornelia, et al. *From Conceptualism to Feminism: Lucy Lippard's Numbers Shows 1969–74*. London: Afterall Books, 2012.

Cage, John. *Silence*. Middletown, CT: Wesleyan University Press, 1961.

———. *A Year from Monday: New Lectures and Writings*. Middletown, CT: Wesleyan University Press, 1969.

Cage, John, and Alison Knowles. *Notations*. New York: Something Else, 1969.

Calinescu, Matei. *Five Faces of Modernity*. Durham, NC: Duke University Press, 1987.

Cardenal, Ernesto. "Cultura revolucionaria, popular, nacional, anti-imperialista." In *Hacia una política cultural*, edited by Daisy Zamora and Julio Valle-Castillo. Managua: Ministry of Culture, 1982.

———. *In Cuba* (1972). Translated by Donald Walsh. New York: New Directions, 1974.

———. *La Revolución perdida: Memorias III*. Mexico City: Fondo de Cultura Económica, 2005.

———. *Vuelos de Victoria / Flights of Victory*. Translated by Marc Zimmerman. Maryknoll, NY: Orbis, 1985.

Cardew, Cornelius. *Treatise Handbook*. London: Edition Peters, 1971.

———. "Wiggly Lines and Wobbly Music." *Studio International* 192, no. 984 (1976): 249–55.

Carpi, Umberto. *Bolscevico immaginista: Communismo e avanguardie artistiche nell' Italia degli anni venti*. Naples: Liguori Editore, 1981.

———. *L'estrema avanguardia del novecento*. Rome: Editori Riuniti, 1985.

Chapon, François. "'Une série de malentendus acceptables . . .'" In *André Breton: La beauté convulsive*, 116–20. Paris: Centre Georges Pompidou, Musée national d'art moderne, 1991. Published in conjunction with the exhibition of the same name, Centre Georges Pompidou, Musée national d'art moderne, April 25–August 26, 1991.

Chénieux-Gendron, Jacqueline. *Surrealism*. Translated by Vivian Folkenflik. New York: Columbia University Press, 1990.

Chytry, Josef. *The Aesthetic State: A Quest in Modern German Thought*. Berkeley: University of California Press, 1989.

Ciampi, Alberto. *Futuristi e anarchisti: Quali rapporti?* Pistoia: Archivo Famiglia Berneri, 1989.

Clark, Martin. *Modern Italy: 1871–1995*. London: Longman, 1996.

Clark, Paul. *The Chinese Cultural Revolution: A History*. Cambridge: Cambridge University Press, 2007.

Cockcroft, James. *Mexico: Class Formation, Capital Accumulation and the State*. New York: Monthly Review, 1983.

Coffey, Mary K. *How a Revolutionary Art Became Official Culture: Murals, Museums, and the Mexican State*. Durham, NC: Duke University Press, 2012.

Conrad, Tony. "An EARful: Four Violins and Early Minimalism." In *Early Minimalism*, vol. 1. Atlanta: Table of the Elements, 1997.

Cooper, Douglas. *Picasso: Theater*. New York: Abrams, 1968.

Craven, David. *Art and Revolution in Latin America, 1910–1990*. New Haven, CT: Yale University Press, 2002.

———. *Diego Rivera as Epic Modernist*. Boston: G. K. Hall, 1997.

———. "Fri(e)da Kahlo and Hannah Höch: A Trans-Atlantic Dialogue in the Arts." Paper presented at the Centre of Latin American Studies, University of Cambridge, February 23, 2009.

———. "The Latin American Contribution to 'Alternative Modernism.'" *Third Text*, no. 36 (Autumn 1996): 29–44.

———. *The New Concept of Art and Popular Culture in Nicaragua since the Revolution in 1979*. Lewiston, NY: Edwin Mellen, 1989.

Craven, David, and John Ryder. *Art of the New Nicaragua*. Cortland: New York Council for the Humanities, 1983.

Croce, Benedetto. *Cultura e vita morale*. Bari: Laterza, 1955.

Crow, Thomas. *The Rise of the Sixties: American and European Art in the Era of Dissent*. New York: Harry N. Abrams, 1996.

———. "Saturday Disasters: Trace and Reference in Early Warhol." In *Modern Art in the Common Culture*. New Haven, CT: Yale University Press, 1996: 49–65.

Cruz Manjarrez, Maricela. *Tina Modotti y el muralismo mexicano*. Mexico City: Instituto de Investigaciones Estéticas, 1999.

Čufer, Eda, ed. *NSK Embassy Moscow*. Koper, Slovenia: Loža Gallery, 1992.

Davis, Oliver. *Jacques Rancière*. Cambridge: Polity, 2010.

Debord, G.-E. *Mémoires: Structures portantes d'Asger Jorn: Suivi de Origine des détournements*. Paris: Allia, 2004.

Debord, Guy. *Comments on the Society of the Spectacle*. Translated by Malcolm Imrie. London: Verso, 1998.

———. *Complete Cinematic Works: Scripts, Stills, Documents*. Translated by Ken Knabb. Oakland: AK Press, 2003.

———. *Correspondence: The Foundation of the Situationist International (June 1957–August 1960)*. Translated by Stuart Kendall and John McHale. Los Angeles: Semiotext(e), 2008.

———. *Internationale situationniste, 1958–1969*. Édition augmentée. Edited by Patrick Mosconi. Paris: Librairie Arthème Fayard, 1997.

———. *Œuvres*. Edited by Jean-Louis Rançon and Alice Debord. Paris: Gallimard, 2006.

———. *Panegyric*. 2 vols. Translated by James Brook and John McHale. London: Verso, 2004.

———. *Potlatch (1954-1957)*. Édition augmentée. Paris: Gallimard, 1996.

———. "La séparation achivée." *Internationale Situationniste*, no. 11 (October 1967): 43–48.

———. *The Society of the Spectacle*. Translated by Donald Nicholson-Smith. New York: Zone, 1994.

Debord, Guy, and Gianfranco Sanguinetti. *The Real Split in the Situationist International: Theses on the Situationist International and Its Time, 1972*. Translated by John Hale. London: Pluto, 2003.

de Duve, Thierry. *Kant after Duchamp*. Cambridge, MA: MIT Press, 1998.

Deleuze, Gilles, and Guattari, Félix. *Anti-Oedipus: Capitalism and Schizophrenia*. Translated by Robert Hurley, Mark Seem, and Helen R. Lane. Minneapolis: University of Minnesota Press, 1983.

Desnos, Robert. "Troisième manifeste du surréalisme." In *Nouvelle Hébrides et autres textes: 1922-1930*, edited by Marie-Claire Dumas, 472–73. Paris: Gallimard, 1978.

Dickerman, Leah. *Dada*. Washington: National Gallery of Art in association with DAP / Distributed Art Publishers, Inc., 2006.

Djurić, Dubravka, and Miško Šuvaković, eds. *Impossible Histories: Historical Avant-Gardes, Neo-Avant-Gardes, and Post-Avant-Gardes in Yugoslavia, 1918-1991*. Cambridge, MA: MIT Press, 2003.

Dostoyevsky, Fyodor. "Notes from Underground." In *The Best Short Stories of Fyodor Dostoyevsky*, edited and translated by David Magarschack. New York: Modern Library Imprint, 1985.

Drieu la Rochelle, Pierre. "La véritable erreur des surréalistes." *Nouvelle Revue française*, no. 143 (August 1925): 166–71.

Durozoi, Gérard. *History of the Surrealist Movement*. Translated by Alison Anderson. Chicago: University of Chicago Press, 2002.

Dussel, Enrique. *Philosophy of Liberation*. Translated by Aquilino Martinez and Christine Morkovsky. New York: Orbis, 1985.

Dworkin, Craig. *Reading the Illegible*. Evanston, IL: Northwestern University Press, 2003.

East Art Map: Contemporary Art and Eastern Europe. Edited by IRWIN. London: Afterall, 2006.

Egbert, Donald Drew. *Social Radicalism and the Arts*. New York: Knopf, 1970.

Eisenstein, Sergei. "Orozco: The Prometheus of Mexican Painting." In *Orozco! 1883-1949*, 68–69. Oxford: Museum of Modern Art, 1980.

———. "Rivera's Murals in the Ministry of Education." In *Orozco! 1883-1949*, 69. Oxford: Museum of Modern Art, 1980.

Ellul, Jacques. *Propaganda*. New York: W. W. Norton, 1965.

Enwezor, Okwui. "The Postcolonial Constellation: Contemporary Art in a State of Permanent Transition." In *Antinomies of Art and Culture: Modernity, Postmodernity, Contemporaneity*, edited by Terry Smith, Okwui Enwezor, and Nancy Condee, 207–34. Durham, NC: Duke University Press, 2008.

Erjavec, Aleš, ed. *Postmodernism and the Postsocialist Condition: Politicized Art under Late Socialism*. Berkeley: University of California Press, 2003.

———. "Umetnost in politika." *Filozofski vestnik* 1 (2008): 77–89.

Erjavec, Aleš, and Marina Gržinić. *Ljubljana, Ljubljana: The Eighties in Slovene Art and Culture*. Ljubljana: Mladinska knjiga, 1991.

Ernst, Max. *Œuvre-Katalog*. 5 vols. Edited by Werner Spiers, Sigred Metken, and Günter Metken. Houston and Cologne: Menil Foundation / Du Mont, 1976.

Estivals, Robert. "De l'avant-garde esthétique à la revolution de mai." *Communications*, no. 12 (1968): 84–107.

Fernández, Justino. *El arte del siglo XX: Arte moderno y contemporáneo de México*. Vol. 2. Mexico City: UNAM, 1994.

Fillon, Jacques. *"New Games!": Programs and Manifestos on 20th-Century Architecture*. Edited by Ulrich Conrads. Cambridge, MA: MIT Press, 1975.

Flaker, Aleksandar. *Poetika osporavanja*. Zagreb: Školska knjiga, 1982.

Ford, Simon. *The Situationist International: A User's Manual*. London: Black Dog, 2004.

Forsyth, Douglas J. *The Crisis in Liberal Italy*. Cambridge: Cambridge University Press, 1993.

Foster, Hal. "For a Concept of the Political in Contemporary Art." In *Recodings: Art, Spectacle, Cultural Politics*, 139–55. New York: New Press, 1999.

———. "Some Uses and Abuses of Russian Constructivism." In *Art into Life: Russian Constructivism 1914–1932*, 241–53. Introduction by Richard Andrews and Milena Kalinovska. New York: Rizzoli, 1990.

———. "Who's Afraid of the Neo-Avant-Garde." In *The Return of the Real: The Avant-Garde at the End of the Century*, 1–32. Cambridge, MA: MIT Press, 1996.

Foucault, Michel. *The Order of Things: An Archeology of Human Sciences*. New York: Columbia University Press, 1994.

Frascina, Francis. *Art, Politics, and Dissent: Aspects of the Art Left in Sixties America*. Manchester: Manchester University Press, 1999.

Freire, Paolo. *Pedagogia do oprimido*. Rio de Janiero: Paz y Terra, 1967.

Fried, Michael. "Art and Objecthood." *Artforum* 5 (June 1967): 12–23.

Gabo, Naum, and Anton Pevsner. *Realist Manifesto* (1920). In Herbert Read and Leslie Martin, *Gabo*. London: Lund Humphries, 1957.

Gan, Aleksei. "Bor'ba za massovoe deistvo" (1922). In *O teatre*, edited by Ivan Aksenov et al. Tver: Tverskoe izdatel'stvo, 1922.

———. *Konstruktivizm*. Tver: 2-oe tverskoe izdatel'stvo, 1922.

Gao Minglu. *Total Modernity and the Avant-Garde in Twentieth-Century Chinese Art*. Cambridge, MA: MIT Press, 2011.

Gentile, Emilio. "From the Cultural Revolt of Giolittian Era to the Ideology of Fascism." In *Studies in Modern Italian History: From the Risorgimento to the Republic*, edited by F. J. Coppa, 103–19. New York: Lang, 1986.

Gherarducci, Isabella. *Il futurismo italiano*. Rome: Editori Riuniti, 1984.

Ghil, René, et al. "Du futurisme au primitivisme." *Poésie* 5, nos. 31–33 (1909): 162–204.

Gilardi, Piero. "Politics and the Avant-Garde" (1969). In *Conceptual Art: A Critical Anthology*, edited by Alexander Alberro and Blake Stimson, 128–34. Cambridge, MA: MIT Press, 1999.

Gilly, Adolfo. *The Mexican Revolution*. Translated by Patrick Camiller. London: Verso, 1971.

Gilman, Claire. "Asger Jorn's Avant-Garde Archives." *October*, no. 79 (Winter 1997): 32–48.

Ginzburg, Moisei. "Itogi i perspektivy" (1927). In *Iz istorii sovetskoi arkhitektury 1926–1932 gg*, edited by K. Afanas'ev et al., 82–86. Moscow: Nauka, 1970.

Gladston, Paul. *Contemporary Chinese Art: A Critical History*. London: Reaktion, 2014.

Gombrich, Ernst. *The Image and the Eye*. Oxford: Phaidon, 1982.

Gough, Maria. *The Artist as Producer: Russian Constructivism in Revolution*. Berkeley: University of California Press, 2007.

Gramsci, Antonio. *Selections from Cultural Writings*. Edited by David Forgacs and Geoffrey Nowell-Smith. Translated by William Boelhower. London: Lawrence and Wishart, 1985.

Gray, Camilla. *The Russian Experiment in Art: 1863–1922*. New York: Abrams, 1971.

Greenberg, Clement. "Modernist Painting" (1965). In *Art in Theory, 1900–2000: An Anthology of Changing Ideas*, edited by Charles Harrison and Paul Wood, 773–79. Oxford: Blackwell, 2000.

———. "Review of Exhibitions of Mondrian, Kandinsky and Pollock; of the Annual Exhibition of American Abstract Artists and of the Exhibition *European Artists in America*" (1945). In *The Collected Essays and Criticism*, vol. 2, 14–18. Chicago: University of Chicago Press, 1986.

Greene, Alexis. "The Arts and the Vietnam Antiwar Movement." In *Sights on the Sixties*, edited by Barbara L. Tischler, 149–61. New Brunswick, NJ: Rutgers University Press, 1992.

Gregor, James A. *The Ideology of Fascism: The Rationale of Totalitarianism*. New York: Free Press, 1969.

Griffin, Roger. *Modernism and Fascism: The Sense of a Beginning under Mussolini and Hitler*. Basingstoke, UK: Palgrave Macmillan, 2007.

Gris, Juan. "Response to a Questionnaire on Cubism." In *Theories of Modern Art*, edited by Herschel B. Chipp, 276–77. Berkeley: University of California Press, 1968.

Gropius, Walter. "Program of the State Bauhaus in Weimar" (1919). Translated by Michael Bullock. In *Programs and Manifestoes of 20th Century Architecture*, edited by Ulrich Conrads, 49–51. Cambridge, MA: MIT Press, 1964.

Groys, Boris. *Art Power*. Cambridge, MA: MIT Press, 2008.

———. *The Total Art of Stalinism: Avant-Garde, Aesthetic Dictatorship, and Beyond*. Translated by Charles Rougle. Princeton, NJ: Princeton University Press, 1992.

Gržinić, Marina, ed. *Slovenian Athens*. Ljubljana: Moderna galerija, 1991.

Guilbaut, Serge. *How New York Stole the Idea of Modern Art: Abstract Expressionism, Freedom and the Cold War*. Translated by Arthur Goldhammer. Chicago: University of Chicago Press, 1983.

Guiol-Benassaya, Elyette. *La Presse face au surréalisme de 1925 à 1938*. Paris: CNRS, 1982.

Gulyga, A., ed. *Nikolai Fedorovich Fedorov: Sochineniia*. Moscow: Akademiia nauk SSSR, 1982.

Guy, Emmanuel, and Laurence Le Bras, eds. *Guy Debord: Un art de la guerre*. Paris: Bibliothèque nationale de France / Gallimard, 2013.

Habermas, Jürgen. "Modernity—an Incomplete Project." In *Postmodern Culture*, edited and introduced by Hal Foster, 3–15. London: Pluto, 1985.

Hadjinicolaou, Nicos. "The Ideology of Avant-Gardism." *Praxis*, no. 6 (1982): 39–196.

Hammond, Paul, ed. *The Shadow and Its Shadow: Surrealist Writings on the Cinema.* Edinburgh: Polygon, 1991.

Hannoosh, Michele. *Baudelaire and Caricature: From the Comic to an Art of Modernity.* University Park: Penn State University Press, 1992.

Hardt, Michael, and Antonio Negri. *Empire.* Cambridge, MA: Harvard University Press, 2000.

Havránek, Vit. "The Post-Bipolar Order and the Status of Public and Private under Communism." In *Promises of the Past—a Discontinuous History of Art in Former Eastern Europe*, edited by Christine Macel and Nataša Petrešin-Bachelez, 26–30. Paris: Centre Georges Pompidou, 2010.

Hegel, G. W. F. *The Phenomenology of Mind.* Introduction by George Lichtheim. Translated by J. B. Baillie. New York: Harper Colophon, 1967.

Hewitt, Andrew. *Fascist Modernism: Aesthetics, Politics, and the Avant-Garde.* Stanford, CA: Stanford University Press, 1993.

Heylin, Clinton. *All Yesterdays' Parties: The Velvet Underground in Print, 1966–1971.* New York: Da Capo, 2006.

Higgins, Hannah. *Fluxus Experience.* Berkeley: University of California Press, 2002.

Higgins, Lesley. *The Modernist Cult of Ugliness: Aesthetic and Gender Politics.* New York: Palgrave Macmillan, 2002.

Híjar, Alberto. *Arte y utopía.* Mexico City: INBA, 1999.

———. *Diego Rivera: Contribución Política.* Morelia: Universidad Autónoma, 2004.

———. "Los Zapatas de Diego Rivera." In *Los Zapatas de Diego Rivera*, 21–32. Mexico City: INBA, 1984.

Hinderliter, Beth, et al., eds. *Communities of Sense: Rethinking Aesthetics and Politics.* Durham, NC: Duke University Press, 2009.

Holert, Tom. "Joint Ventures: The State of Collaboration." *Artforum*, February 2011, 158–61.

Home, Stewart. *The Assault on Culture: Utopian Currents from Lettrism to Class War.* London: Aporia, 1988.

Hoptman, Laura, and Tomaš Pospiszyl, eds. *Primary Documents: A Sourcebook for Eastern and Central European Art since the 1950s.* New York: Museum of Modern Art, 2002.

Huelsenbeck, Richard. "En Avant Dada: A History of Dadaism." In *The Dada Painters and Poets: An Anthology*, edited by Robert Motherwell, 21–47. New York: Wittenborn, Schultz, 1951.

Hugo, Victor. *Préface de Cromwell.* Paris: Larousse, 2006.

Hulten, Pontus, ed. *Futurism and Futurisms.* Translated by Asterisco et al. New York: Abbeville, 1986.

IRWIN. *Država v času.* Novo Mesto: Dolenjski muzej, 2010.

Ivanov, Viacheslav. *Borozdy i mezhi.* Moscow: Musaget, 1916.

———. *Po zvezdam.* St. Petersburg: Ory, 1909.

Jameson, Fredric. "Cultural Revolution." In *Valences of the Dialectic*, 267–78. London: Verso, 2009.

———. *Marxism and Form: Twentieth-Century Dialectical Theories of Literature*. Princeton, NJ: Princeton University Press, 1974.

———. "Periodizing the 60s." In *The 60s without Apology*, edited by Sohnya Sayres, Anders Stephanson, Stanley Aronowitz, and Fredric Jameson, 178–209. Minneapolis: University of Minnesota Press, 1984.

———. *Postmodernism, or, the Cultural Logic of Late Capitalism*. Durham, NC: Duke University Press, 1993.

———. *Valences of the Dialectic*. London: Verso, 2009.

Janco, Marcel. "Dada at Two Speeds." In *Dadas on Art*, edited by Lucy Lippard, 36–37. Englewood Cliffs, NJ: Prentice-Hall, 1971.

———. "Dada at Two Speeds." In *Dada*, edited by Rudolf Kuenzli. New York: Phaidon, 2006.

Jappe, Anselm. *Guy Debord*. Translated by Donald Nicholson-Smith with a foreword by T. J. Clark and a new afterword by the author. Berkeley: University of California Press, 1999.

Jauss, Hans Robert. "Die klassische und christliche Rechtfertigung des Hässlichen in mittelalterischer Literatur." In *Alterität und Modernität der mittelalterischen Literatur*, 143–68. Munich: Fink, 1977.

Jay, Martin. *Songs of Experience: Modern American and European Variations on a Universal Theme*. Berkeley: University of California Press, 2005.

Jencks, Charles. *The Language of Post-Modern Architecture*. London: Academy Editions, 1984.

Johansson, Kurt. *Aleksej Gastev: Proletarian Bard of the Machine Age*. Stockholm: University of Stockholm Press, 1983.

Joll, James. *Intellectuals in Politics (Three Biographical Essays: Léon Blum, Walther Rathenau, F. T. Marinetti)*. London: Weidenfeld and Nicolson, 1960.

Jones, Dafydd. "'Jeder kann Dada': The Repetition, Trauma and Deferred Completion of the Avant-Gardes." In *Neo-Avant-Garde*, edited by David Hopkins. Amsterdam: Rodopi, 2006.

Joselit, David. *After Art*. Princeton, NJ: Princeton University Press, 2013.

Joseph, Branden W. *Beyond the Dream Syndicate: Tony Conrad and the Arts after Cage*. New York: Zone Books, 2008.

———. *Random Order: Robert Rauschenberg and the Neo-Avant-Garde*. Cambridge, MA: MIT Press, 2003.

"Junge slovenische Kunst." *Der Sturm* (Sonderheft), 19 (January 1929).

Kandinsky, Vasilii. "Content and Form" (1910). In *Russian Art of the Avant-Garde*, edited by John Bowlt. London: Thames and Hudson, 1988.

———. "On the Spiritual in Art" (1911). In John E. Bowlt and Rose-Carol Washton Long, *The Life of Vasilii Kandinsky in Russian Art*. Newtonville, MA: Oriental Research Partners, 1980.

Kaufmann, Vincent. *Guy Debord: Revolution in the Service of Poetry*. Translated by Robert Bononno. Minneapolis: University of Minnesota Press, 2006.

Kelley, Robin D. G. *Africa Speaks, America Answers: Modern Jazz in Revolutionary Times*. Cambridge, MA: Harvard University Press, 2012.

———. *Freedom Dreams: The Black Radical Imagination*. Boston: Beacon, 2002.

Kiaer, Christina. *Imagine No Possessions: The Socialist Objects of Russian Constructivism*. Cambridge, MA: MIT Press, 2005.

Kirchner, Ernst Ludwig. "Chronik der Brücke" (1916). In *Theories of Modern Art*, edited by Herschel B. Chipp, 174–78. Berkeley: University of California Press, 1968.

Kirichenko, Evgeniia. "Teoreticheskie vozzreniia na vziamosviaz' formy i konstruktsii v russkoi arkhitekture XIX–nachala XX vv." In *Konstruktsii i arkhitekturnaia forma v russkom zodchestve XIX–nachala XX vv*, edited by N. Gulianitsky et al. Moscow: Stroiizdat, 1977.

Knabb, Ken, ed. *Situationist International Anthology*. Rev. ed. Berkeley: Bureau of Public Secrets, 2007.

Knight, Patricia. *Mussolini and Fascism*. London: Routledge, 2003.

Knížák, Milan. "Milan Knížák: Kill Yourself and Fly: An Interview by Johan Pijnappel." *Art and Design: New Art from Eastern Europe*, no. 35 (1994): 37.

Komardenkov, Vasilii. *Dni minuvshie*. Moscow: Sovetskii khudozhnik, 1972.

Köppel-Yang, Martina. *Semiotic Warfare: The Chinese Avant-Garde, 1979–1989. A Semiotic Analysis*. Hong Kong: Timezone, 2003.

Kotz, Liz. *Words to Be Looked At: Language in 1960s Art*. Cambridge, MA: MIT Press, 2010.

Kouvelakis, Stathis. *Philosophy and Revolution from Kant to Marx*. Preface by Fredric Jameson. Translated by G. M. Goshgarian. London: Verso, 2003.

Kozloff, Max. *Cultivated Impasses: Essays on the Waning of the Avant-Garde, 1964–1975*. New York: Marsilio, 2000.

Krauss, Rosalind E. *Perceptual Inventory*. Cambridge, MA: MIT Press, 2010.

———. "The Photographic Conditions of Surrealism." In *The Originality of the Avant-Garde and Other Modernist Myths*, 87–118. Cambridge, MA: MIT Press, 1985.

———. *"A Voyage on the North Sea": Art in the Age of the Post-Medium Condition*. London: Thames and Hudson, 1999.

Krauss, Rosalind, and Jane Livingston. *L'Amour fou: Photography and Surrealism*. New York: Abbeville, 1985.

Kristeva, Julia. *Revolution in Poetic Language*. Translated by Margaret Waller. New York: Columbia University Press, 1984.

Kugelberg, Johan, ed. *The Velvet Underground: New York Art*. New York: Rizzoli, 2009.

Kunzle, David. *The Murals of Revolutionary Nicaragua, 1979–1992*. Berkeley: University of California Press, 1995.

Kurczynski, Karen. "Expression as Vandalism: Asger Jorn's 'Modifications.'" *RES: Anthropology and Aesthetics*, nos. 53/54 (Spring/Autumn 2008): 293–313.

———. "No Man's Land." *October*, no. 141 (Summer 2012): 22–52.

Laclau, Ernesto. *On Populist Reason*. London: Verso, 2005.

Lacoue-Labarthe, Philippe, and Jean-Luc Nancy. *L'Absolu littéraire: Théorie de la littérature du romantisme*. Paris: Seuil, 1978.

Laibach and Neue Slowenische Kunst. *Problemi* 22, no. 6 (1985).

Laibach Kunst. "Akcija v imenu ideje." *Nova revija*, nos. 13–14 (1983): 1460–69.

Lambert, Jean Clarence. *Cobra*. Translated by Roberta Bailey. New York: Abbeville, 1983.

Larionov, Mikhail. "Rayonist Painting" (1913). In *Russian Art of the Avant-Garde*, edited by John Bowlt, 91–100. London: Thames and Hudson, 1988.

Laverdant, Gabriel-Désiré. *De la mission de l'art et du rôle des artistes.* Paris: Aux Gureaux de la Phalange, 1845.

Ledeen, Michael. *The First Duce: D'Annunzio at Fiume.* Baltimore: Johns Hopkins University Press, 1977.

Lee, Pamela M. *Chronophobia: On Time in the Art of the 1960s.* Cambridge, MA: MIT Press, 2004.

Lefebvre, Henri. *Writings on Cities.* Selected, translated, and introduced by Eleonore Kofman and Elizabeth Lebas. Oxford: Blackwell, 1996.

Levin, Thomas Y. "Dismantling the Spectacle: The Cinema of Guy Debord." In *On the Passage of a Few People through a Rather Brief Moment in Time: The Situationist International 1957–1972*, edited by Elisabeth Sussman, 72–123. Cambridge, MA: MIT Press, 1989.

Les Lèvres nues: No. 1 (avril 1954) à 12 (septembre 1958). Paris: Editions Allia, 1995.

Lewis, George E. *A Power Stronger Than Itself: The AACM and American Experimental Music.* Chicago: University of Chicago Press, 2008.

Lippard, Lucy R. *Six Years: The Dematerialization of the Art Object from 1966 to 1972.* London: Studio Vista, 1973.

Lissitzky, El. "New Russian Art: A Lecture." In Sophie Lissitzky-Kappers, *El Lissitzky: Life, Letters, Text.* London: Thames and Hudson, 1968.

———. "Preodolenie iskusstva" (1920). *Experiment*, no. 5 (1999): 138–49.

Lissitzky-Kappers, Sophie. *El Lissitzky: Life, Letters, Text.* London: Thames and Hudson, 1968.

Lista, Giovanni. *Futurisme: Manifestes, documents, proclamations.* Zurich: L'Âge d'homme, 1973.

———. *Le Futurisme.* Paris: Hazan, 1985.

———. "Marinetti et les anarcho-syndicalistes." In *Présence de F. T. Marinetti*, edited by Jean-Claude Marcadé, 74–78. Lausanne: L'Âge d'homme, 1985.

Lobanov, Viktor. *Khudozhestvennye gruppirovki za 25 let.* Moscow: AKhR, 1930.

Lobel, Michael. *James Rosenquist: Pop Art, Politics, and History.* Berkeley: University of California Press, 2009.

Lodder, Christina. *Constructive Strands in Russian Art 1914–1937.* London: Pindar, 2005.

———. *Russian Constructivism.* New Haven, CT: Yale University Press, 1983.

Lomnitz, Claudio. "What Was Mexico's Cultural Revolution?" In *The Eagle and the Virgin: Nation and Cultural Revolution in Mexico, 1920–1940*, edited by Mary Kay Vaughan and Stephen Lewis, 335–50. Durham, NC: Duke University Press, 2006.

López Orozco, Leticia, ed. *Influencias del muralismo mexicano en otras latitudes: Crónicas*, no. 12 (October 2006).

———. "The Revolution, Vanguard Artists and Mural Painting." *Third Text* 28, no. 3 (2014): 256–68.

Lukács, Georg. "Die Gegenwartsbedeutung des kritischen Realismus." In *Essays über Realismus: Probleme des Realismus I*, vol. 4, 457–603. Neuwied: Luchterhand, 1971.

———. *History and Class Consciousness.* Translated by Rodney Livingstone. Cambridge, MA: MIT Press, 1968.

Lunacharsky, Anatolii. "Rol' Narodnogo komissara prosveshcheniia." In *Pervaia*

Vserossiiskaia konferetsiia po khudozhestvennoi promyshlennosti, edited by Anatolii Lunacharsky et al., 63–69. Moscow: IZO, 1920.

Lütticken, Sven. "Guy Debord and the Cultural Revolution." *Grey Room* 52 (2013): 108–27.

Lyotard, Jean-François. *The Lyotard-Reader*. Edited by Andrew Benjamin. Oxford: Basil Blackwell, 1989.

———. "On the Strength of the Weak." Translated by R. McKeon. *Semiotext(e)* 3, no. 2 (1978): 204–14.

———. *Political Writings*. Translated by Bill Readings and Kevin Paul Geiman with a foreword by Bill Readings. London: UCL Press, 1993.

———. *The Postmodern Condition: A Report on Knowledge*. Translated by Geoff Bennington and Brian Massumi with a foreword by Fredric Jameson. Manchester: Manchester University Press, 1991.

Maione, Giuseppe. *Il biennio rosso: Autonomia e spontaneità operaia nel 1919–1920*. Bologna: Il Mulino, 1975.

Malevich, Kazimir. "From Cubism and Futurism to Suprematism: The New Painterly Realism" (1916). In *Malevich: Essays on Art*, edited by Troels Andersen, vol. 1. Copenhagen: Borgen, 1968.

Marcus, Greil. *Lipstick Traces: A Secret History of the Twentieth Century*. Cambridge, MA: Harvard University Press, 1989.

Marcuse, Herbert. *The Aesthetic Dimension: Toward a Critique of Marxist Aesthetics*. Boston: Beacon, 1978.

———. "Art as Form of Reality." In *Art and Liberation*, edited by Douglas Kellner, 140–48. London: Routledge, 2007.

———. *Counterrevolution and Revolt*. Boston: Beacon, 1972.

———. *Eros and Civilization: A Philosophical Inquiry into Freud*. Boston: Beacon, 1955.

———. *Eros and Civilization: A Philosophical Inquiry into Freud*. Boston: Beacon, 1966.

———. *An Essay on Liberation*. Boston: Beacon, 1969.

———. *Five Lectures*. Boston: Beacon, 1970.

———. *Die Permanenz der Kunst*. Munich: Carl Hanser Verlag, 1977.

Mariátegui, José Carlos. *Siete ensayos sobre la realidad peruano*. Lima: Amauta, 1928.

Marinetti, Filippo Tommaso. *Critical Writings*. Edited by Günter Berghaus. Translated by Doug Thompson. New York: Farrar, Straus and Giroux, 2006.

———. *Selected Writings*. Edited and translated by R. W. Flint. New York: Farrar, Straus and Giroux, 1971.

———. *Teoria e invenzione futurista*. Edited by Luciano de Maria. Milan: Mondadori, 2001.

Marino, Giuseppe Carlo. *L'autarchia della cultura: Intellettuali e fascismo*. Rome: Editori Riuniti, 1983.

Markov, Vladimir. "The Principles of the New Art" (1912). In *Russian Art of the Avant-Garde*, edited by John Bowlt, 23–38. London: Thames and Hudson, 1988.

Marwick, Arthur. *The Sixties: Cultural Revolution in Britain, France, Italy, and the United States, c. 1958–c. 1974*. Oxford: Oxford University Press, 1998.

Marx, Karl, and Friedrich Engels. *The German Ideology* (1846). Edited by C. J. Arthur. New York: International, 1970.

Masson, André. *Les années surréalistes: Correspondance 1916–1942*. Edited by Françoise Levaillant. Paris: La Manufacture, 1990.

Mastnak, Tomaž. "The State as a Work of Art." In *State in Time*, edited by IRWIN, 45–49. Ljubljana: Društvo NSK informativni center; Novo Mesto: Dolenjski muzej, 2012.

Matheson, Neil, ed. *The Sources of Surrealism*. Aldershot: Lund Humphries, 2006.

McDonough, Tom. "The Decline of the Empire of the Visible or, the Burning of Los Angeles." *AA Files*, no. 62 (2011): 40–46.

———, ed. *Guy Debord and the Situationist International: Texts and Documents*. Cambridge, MA: MIT Press, 2002.

———, ed. *The Situationists and the City*. London: Verso, 2009.

Mello, Renato González. *Orozco: Pintor revolucionario?* Mexico City: UNAM, 1995.

Merleau-Ponty, Maurice. "Cézanne's Doubt." In *The Merleau-Ponty Aesthetics Reader: Philosophy and Painting*, edited and with an introduction by Galen A. Johnson. Evanston, IL: Northwestern University Press, 1993.

Meyer, Michael C., William L. Sherman, and Susan M. Deeds. *The Course of Mexican History*. Oxford: Oxford University Press, 1999.

Meyer, Ursula. "De-Objectification of the Object." *Arts Magazine* 43, no. 8 (1969): 20–22.

Michalski, Sergiusz. *Public Monuments: Art in Political Bondage 1870–1997*. London: Reaktion, 1998.

Michelson, Annette. "Film and the Radical Aspiration." In *Film Culture Reader*, edited by P. Adams Sitney, 404–21. New York: Cooper Square, 2000.

Milashevksy, Konstantin. *Gipertrofiia iskusstva*. Petrograd: Akademiia, 1924.

Miligi, Giuseppe. *Prefuturismo e primo futurismo in Sicilia*. Messina: Sicania, 1989.

Miller, Tyrus. "No Man's Land: Wyndham Lewis and Cultural Revolution." In *Time Images: Alternative Temporalities in Twentieth-Century Theory, Literature and Art*, 82–103. Newcastle: Cambridge Scholars, 2009.

———. *Singular Examples: Artistic Politics and the Neo-Avant-Garde*. Evanston, IL: Northwestern University Press, 2009.

Milner, John. *The Exhibition 5 × 5 = 25: Its Background and Significance*. Budapest: Helikon, 1992.

Misler, Nicoletta. *Vnachale bylo telo*. Moscow: Iskusstvo XXI vek, 2011.

"Les mois les plus longs (février 63–juillet 64)." *Internationale Situationniste*, no. 9 (August 1964): 31–33.

Monroe, Alexei. *Interrogating Machine: Laibach and NSK*. Cambridge, MA: MIT Press, 2005.

———, ed. *State of Emergence: A Documentary of the First NSK Citizens' Congress*. Leipzig: Poison Cabinet, 2011.

Morawski, Stefan. "The Artistic Avant-Garde: On the 20th Century Formations." *Polish Art Studies* 10 (1989): 79–107.

Moten, Fred. *In the Break: The Aesthetics of the Black Radical Tradition*. Minneapolis: University of Minnesota Press, 2003.

Mouffe, Chantal. *The Democratic Paradox*. London: Verso, 2000.

————. *On the Political*. London: Routledge, 2005.

————. *The Return of the Political*. London: Verso, 2005.

Nadeau, Maurice. *The History of Surrealism*. Translated by Richard Howard. Cambridge, MA: Harvard University Press, 1989.

Nash, Jørgen, Jacqueline de Jong, and Ansgar Elde. *Danger, Do Not Lean Out*. Tract published in Paris, February 13, 1962, reprinted in *Situationist Times*, no. 1 (1962): 48. Available online at http://www.editions-allia.com/files/pdf_73_file.pdf (accessed September 2, 2014).

Naville, Pierre. "Beaux-Arts." *La Révolution surréaliste*, no. 3 (April 1925): 17.

————. *La Révolution et les intellectuels*. Rev. ed. Paris: Gallimard, 1975.

Nazzaro, Gian Battista. *Futurismo e politica*. Naples: JN Editore, 1987.

————. "L'Idéologie Marinettiène et le fascisme." In *Marinetti et le futurisme: Études, documents, iconographie*, edited by Giovanni Lista, 122–29. Lausanne: L'Age d'Homme, 1977.

Negt, Oskar, and Alexander Kluge. *Experience and Public Sphere: Toward an Analysis of the Bourgeois and Proletarian Public Sphere*. Translated by Peter Labanyi, Jamie Owen Daniel, and Assenka Oksiloff. Minneapolis: University of Minnesota Press, 1993.

Neue Slowenische Kunst. Zagreb: Grafički zavod Hrvatske, 1991.

"Notes éditoriales: Avec et contre le cinema." *Internationale Situationniste*, no. 1 (June 1958): 8–9.

"Notes éditoriales: Le cinéma après Alain Resnais." *Internationale Situationniste*, no. 3 (December 1959): 8–10.

Núñez Soto, Orlando, and Roger Burbach. *Fire in the Americas*. London: Verso, 1987.

Oesterle, Günter. "Entwurf einer Monographie des ästhetisch Hässlichen: Die Geschichte einer ästhetischen Kategorie von Friedrich Schlegels *Studium*-Aufsatz bis zu Karl Rosenkranz' *Ästhetik des Hässlichen* als Suche nach dem Ursprung der Moderne." In *Literaturwissenschaft und Sozialwissenschaften 8: Zur Modernität der Romantik*, edited by Dieter Bänch, 217–97. Stuttgart: Metzler, 1977.

Orozco, José Clemente. *Autobiografía*. Mexico City: Ediciones Era, 1945.

Ottinger, Didier, et al. *Le futurisme à Paris: Une avant-garde explosive*. Paris: Editions du Centre Pompidou, 2008.

Oxfam Famine Relief Report on the Americas Nicaragua: The Threat of Good Example? Oxford: Oxfam, 1985.

Partridge, Hilary. *Italian Politics Today*. Manchester: Manchester University Press, 1998.

Pejić, Bojana, and David Elliot, eds. *After the Wall: Art and Culture in Post-Communist Europe*. Stockholm: Moderna Museet, 1999.

Perloff, Marjorie. *The Futurist Moment: Avant-Garde, Avant Guerre and the Rupture of Language*. Chicago: University of Chicago Press, 1986.

Piekut, Benjamin. "'Demolish Serious Culture!': Henry Flynt and Worker's World Party." In *Sound Commitments: Avant-Garde Music and the Sixties*, edited by Robert Adlington, 37–55. New York: Oxford University Press, 2009.

Pierre, José, ed. *Tracts surréalistes et déclarations collectives, 1922–1939*. Vol. 1. Paris: Le Terrain vague, 1980.

Piotrowski, Piotr. "The Grey Zone of Europe." In *Contemporary Art in Eastern Europe*, edited by Nikos Kotsopoulos, 199–206. London: Black Dog, 2010.

———. *In the Shadow of Yalta: Art and the Avant-Garde in Eastern Europe, 1945–1989*. London: Reaktion, 2009.

Plant, Sadie. *The Most Radical Gesture: The Situationist International in a Postmodern Age*. London: Routledge, 1992.

Plassard, Didier. "Le tecniche di disumanizzazione nel teatro futurista." *Teatro contemporaneo* 4, no. 2 (1983): 35–64.

"La Plate-forme d'Alba." *Potlatch*, no. 27 (November 2, 1956): 247–48.

Poggi, Christine. *Inventing Futurism: The Art and Politics of Artificial Optimism*. Princeton, NJ: Princeton University Press, 2009.

———. "*Lacerba*: Interventionist Art and Politics in Pre–World War I Italy." In *Art and Journals on the Political Front, 1910–1940*, edited by Virginia Hagelstein Marquardt, 17–62. Gainesville: University Press of Florida, 1997.

Poggioli, Renato. *The Theory of the Avant-Garde*. Translated by Gerald Fitzgerald. Cambridge, MA: Belknap Press of Harvard University Press, 1968.

Polizzotti, Mark. *Revolution of the Mind: The Life of André Breton*. London: Bloomsbury, 1995.

Popova, Liubov. Untitled statement. In exhibition catalog of 5 × 5 = 25. Moscow, 1921.

Puchner, Martin. *Poetry of the Revolution: Marx, Manifestos, and the Avant-Gardes*. Princeton, NJ: Princeton University Press, 2006.

Punin, Nikolai. *Pervyi tsikl lektsii*. Petrograd: 17-ia Gosudarstvennaia tipografiia, 1920.

———. *Tatlin: Protiv kubizma*. Petersburg: IZO NKP, 1921.

Quintanilla, Raúl. "La unidad del sector cultural frente a un acto vandálico." *Barricada*, November 11, 1990, 1.

Rancière, Jacques. *Aesthetics and Its Discontents* (2004). Translated by Steven Corcoran. Cambridge: Polity, 2009.

———. *The Aesthetic Unconscious*. Translated by Debra Keates and James Swenso. Oxford: Polity, 2010.

———. *Aisthesis: Scenes from the Aesthetic Regime of Art*. Translated by Zakir Paul. London: Verso, 2013.

———. *Dissensus: On Politics and Aesthetics*. Translated by Steven Corcoran. London: Continuum, 2010.

———. *The Emancipated Spectator*. Translated by Gregory Elliott. London: Verso, 2009.

———. *The Future of the Image*. Translated by Gregory Elliott. London: Verso, 2007.

———. *The Ignorant Schoolmaster* (1987). Translated by Kristin Ross. Palo Alto: Stanford University Press, 1991.

———. *The Politics of Aesthetics: The Distribution of the Sensible*. Translated by Gabriel Rockhill. London: Continuum, 2004.

———. "What Aesthetics Can Mean." In *From an Aesthetic Point of View: Philosophy, Art and the Senses*, edited by Peter Osborne, 13–33. London: Serpent's Tail, 2000.

———. "You Can't Anticipate Explosions: Jacques Rancière in Conversation with Chto Delat." *Chto Delat*, April 7, 2007.

Rasmussen, Mikkel Bolt. "The Situationist International, Surrealism, and the Difficult Fusion of Art and Politics." *Oxford Art Journal* 27, no. 3 (2004): 367–87.

———. "To Act in Culture While Being against All Culture: The Situationists and the 'Destruction of RSG-6.'" In *Expect Anything, Fear Nothing: The Situationist Movement in Scandinavia and Elsewhere*, edited by Mikkel Bolt Rasmussen and Jakob Jakobsen, 75–113. Copenhagen: Nebula, 2011.

Raunig, Gerald. *Art and Revolution: Transversal Activism in the Long Twentieth Century*. Translated by Aileen Derieg. Los Angeles: Semiotext(e), 2007.

"Renseignements situationnistes." *Internationale Situationniste*, no. 7 (April 1962): 49–54.

Reszler, André. *L'esthétique anarchiste*. Paris: PUF, 1973.

Richter, Hans. *Dada: Art and Anti-Art*. Translated by David Britt. London: Thames and Hudson, 1978.

Riklin, Mihail. *Komunizam kao religija*. Zagreb: Fraktura, 2008.

Rivera, Diego. *Arte y política*. Edited by Raquel Tibol. Mexico City: Editorial Grijalbo, 1978.

———. *My Art, My Life* (with Gladys March). New York: Dover, 1970.

Roberts, John. *The Intangibilities of Form: Skill and Deskilling in Art after the Readymades*. London: Verso, 2007.

Robson, Mark. "Jacques Rancière's Aesthetic Communities." *Paragraph* 28, no. 1 (March 2005): 77–95.

Rockhill, Gabriel. "The Silent Revolution." *SubStance* 33, no. 1, issue 103 (2004): 54–76.

Rockhill, Gabriel, and Philip Watts, eds. *Jacques Rancière: History, Politics, Aesthetics*. Durham, NC: Duke University Press, 2009.

Rodchenko, Aleksandr. "Puti sovremennoi fotografii" ("The Paths of Modern Photography") (1928). English translation in *Photography in the Modern Era*, edited by Christopher Phillips. New York: Metropolitan Museum of Art, 1989.

Rodenbeck, Judith F. *Radical Prototypes: Allan Kaprow and the Invention of Happenings*. Cambridge, MA: MIT Press, 2011.

Rose, Alan. *Surrealism and Communism: The Early Years*. New York: Peter Lang, 1991.

Rose, Barbara. "The Value of Didactic Art." *Artforum* 5, no. 8 (1967): 32–37.

Rose, Margaret. *Marx's Lost Aesthetic*. Cambridge: Cambridge University Press, 1984.

Rosenberger, Jack. "Nicaragua's Vanishing Sandinista Murals." *Art in America*, July 1993, 27.

Ross, Kristen. *Fast Cars, Clean Bodies: Decolonization and the Reordering of French Culture*. Cambridge, MA: MIT Press, 1995.

———. *May '68 and Its Afterlives*. Chicago: University of Chicago Press, 2002.

Rossina, N., ed. *P. A. Florensky: Analiz prostranstvennosti i vremeni v khudozhestvenno-izobrazitel'nykh proizvedeniiakh*. Moscow: Progress, 1993.

Roszak, Theodore. *The Making of a Counter Culture: Reflections on the Technocratic Society and Its Youthful Opposition*. Berkeley: University of California Press, 1968.

Rozenkranz, Karl. *Ästhetik des Hässlichen*. Stuttgart: Reclam, 1996.

Rubin, William S. *Dada and Surrealist Art*. New York: Abrams, 1985.

Rupel, Dimitrij. "Tipologija slovenskih intelektualcev." *Nova revija* 61–62 and 63–64 (1987): 923–38 and 1196–211.

Russell, John. *Max Ernst: Life and Work*. New York: Abrams, 1967.

Russian Samizdat Art, assembled by Rimma Gerlovin and Valery Gerlovin. New York: Willis Locker and Owens, 1986.

Sadler, Simon. *The Situationist City*. Cambridge, MA: MIT Press, 1998.

Saint-Simon, Claude de. *De l'organisation sociale* (1825). In *Œuvres complètes*, vol. V. Paris: Anthropos, 1966.

Salaris, Claudia. *Le futuriste: Donne e letteratura d'avanguardia in Italia, 1909–1944*. Milan: Edizione della Donne, 1982.

———. *Marinetti editore*. Bologna: Il Mulino, 1990.

Salinari, Carlo. *Miti e conscienza del decadentismo italiano*. Milan: Feltrinelli, 1960.

Sánchez Vázquez, Adolfo. "Claves de la ideología estética de Diego Rivera." In *Diego Rivera Hoy*, 205–28. Mexico City: INBA, 1986.

———. "Diego Rivera: Pintar y Militancia." *El Universal*, December 12, 1977, 6.

———. *Las ideas estéticas de Marx*. Mexico City: Biblioteca Era, 1965.

———. "La pintura como lenguaje." *Nicaráuac*, no. 10 (August 1984): 115–25.

Santarelli, Enzo. *Fascismo e neofascismo: Studi e problemi di ricerca*. Rome: Editori Riuniti, 1974.

Schapiro, Meyer. "The Patrons of Revolutionary Art." *Marxist Quarterly* 1, no. 3 (October–December 1937): 462–66.

Schiller, Friedrich. *On the Aesthetic Education of Man, in a Series of Letters*. Edited and translated by Elizabeth M. Wilkinson and L. A. Willoughby. Oxford: Clarendon, 1967.

Schneemann, Carolee. *Imaging Her Erotics*. Cambridge, MA: MIT Press, 2002.

———. *More Than Meat Joy: Performance Works and Selected Writings*. Edited by Bruce R. McPherson. Kingston, NY: Documentext, 1997.

Schouvaloff, Alexander. *The Art of Ballets Russes: The Serge Lifar Collection of Theater Designs, Costumes, and Paintings at the Wadsworth Atheneum*. New Haven, CT: Yale University Press, 1998.

Schulte-Sasse, Jochen. Foreword to Peter Bürger, *Theory of the Avant-Garde*, translated by Michael Shaw, vii–xlvii. Minneapolis: University of Minnesota Press, 1984.

Selser, Gabriela. "Odio a la cultura." *Barricada Internacional*, November 17, 1990, 33.

Settimeli, Emilio. "Storia del partito politica futurista." *Oggi e domani* 23, no. 3 (1931): 27.

Shattuck, Roger. *The Banquet Years: The Origins of the Avant-Garde in France, 1885 to World War I*. New York: Vintage, 1968.

Sheesley, Joel, and Wayne C. Bragg. *Sandino in the Streets*. Prologue by Ernesto Cardenal. Bloomington: Indiana University Press, 1991.

Shiner, Larry. *The Invention of Art: A Cultural History*. Chicago: University of Chicago Press, 2001.

Siegel, Jeanne. *Artwords: Discourse on the 60s and 70s*. New York: Da Capo, 1985.

Siqueiros, David Alfaro. "Diego Rivera: Pintor de América." *El Universal Illustrado*, July 7, 1921, 1–2.

———. "Three Appeals for a Modern Direction." In *Art in Latin America*, edited by Dawn Ades, 322–23. New Haven, CT: Yale University Press, 1989.

Situationist Texts on Visual Culture and Urbanism: A Selection. Translated by John Shepley. *October*, no. 79 (Winter 1997).

Skrebowski, Luke. "Revolution in the Aesthetic Revolution." *Third Text* 26, no. 1 (January 2012): 65–78.

Smith, Terry. *Contemporary Art—World Currents.* London: Laurence King, 2011.

———. *What Is Contemporary Art?* Chicago: University of Chicago Press, 2009.

Sontag, Susan. "Posters: Advertisement, Art, Political Artifact, Commodity." In *The Art of Revolution*, edited by Dugald Stermer. New York: McGraw Hill, 1970.

Spiteri, Raymond, and Donald LaCoss, eds. *Surrealism, Politics and Culture.* Aldershot: Ashgate, 2003.

Stein, Philip. *Murales de México.* Mexico City: Editur, 1991.

Stepanova, Varvara. Untitled statement. In exhibition catalog of 5 × 5 = 25. Moscow, 1921.

Stephan, Halina. *"Lef" and the Left Front of the Arts.* Munich: Verlag Otto Sagner, 1981.

Stokvis, Willemijn. *Cobra: The Last Avant-Garde Movement of the Twentieth Century.* Aldershot: Lund Humphries, 2004.

Stone, Marla. "A Flexible Rome: Fascism and the Cult of Romanità." In *Roman Presences: Receptions of Rome in European Culture, 1789–1945*, edited by Catherine Edwards, 205–20. Cambridge: Cambridge University Press, 1999.

Stone-Richards, Michael. "Encirclements: Silence in the Construction of *Nadja*." *Modernism/Modernity* 8, no. 1 (2001): 127–57.

Stracey, Frances. "Destruktion RSG-6: Towards a Situationist Avant-Garde Today." In *Neo-Avant-Garde*, edited by David Hopkins. Amsterdam: Rodopi, 2006.

Strigalev, Anatolii. "O proekte pamiatnika III internatsionala khudozhnika V. Tatlina." In *Voprosy sovetskogo izobraziteľnogo iskusstva i arkhitektury*, 408–52. Moscow: Sovetskii khudozhnik, 1973.

Suárez, Orlando. *Inventario del muralismo mexicano.* Mexico City: Editur, 1972.

"Sur deux livres de théorie situationniste." *Internationale Situationniste*, no. 11 (October 1967): 63.

Sussman, Elisabeth, ed. *On the Passage of a Few People through a Rather Brief Moment in Time: The Situationist International, 1957–1972.* Cambridge, MA: MIT Press, 1989.

Syrkina, Flora, comp. *Khudozhniki teatra o svoem tvorchestve.* Moscow: Sovetskii khudozhnik, 1973.

Szabolcsi, Miklós. "Ka nekim pitanjima revolucionarne avangarde." *Književna reč* 3, no. 101 (1978): 14.

Szwed, John F. *Space Is the Place: The Life and Times of Sun Ra.* New York: Da Capo, 1998.

Tanke, Joseph J. *Jacques Rancière: An Introduction. Philosophy, Politics, Aesthetics.* London: Continuum, 2011.

Tarabukin, Nikolai. *Opyt teorii zhivopisi.* Moscow: Vserossiiskii proletkuľt, 1923.

———. *Ot moľberta k mashine.* Moscow: Rabotnik prosveshcheniia, 1923.

Taylor, Charles. *Modern Social Imaginaries.* Durham, NC: Duke University Press, 2003.

Taylor, Joshua. *Futurism.* New York: Museum of Modern Art, 1961.

Taylor, Kendall. "Propaganda." In *The Dictionary of Art*, 650–54. London: Macmillan, 1996.

Thévenin, Paule, ed. *Bureau de recherches surréalistes: Cahier de la permanence, octobre 1924–avril 1925*. Archives du surréalisme, vol. 1. Paris: Gallimard, 1988.

Thompson, Nato, ed. *Living as Form: Socially Engaged Art from 1991 to 2011*. New York: Creative Time Books, 2012.

Thompson, Nato, Hans Belting, Andreas Buddensieg, and Peter Weibel, eds. *The Global Contemporary and the Rise of New Art Worlds*. Cambridge, MA: MIT Press, 2013.

Tisdall, Catherine, and Angelo Bozzolla. *Futurism*. London: Thames and Hudson, 1977.

Tolstoi, Vladimir, et al., eds. *Agitmassovoe iskusstvo Sovetskoi Rossii: Materialy i dokumenty*. Moscow: Iskusstvo, 2002.

Tolstoy, Vladimir, Irina Bibikova, and Catherine Cooke. *Street Art of the Revolution: Festivals and Celebrations in Russia 1918–1933*. New York: Vendome, 1990.

Trotsky, Leon. "Art and Politics in Our Epoch" (1938). In *Art and Revolution*, 116–17. New York: Pathfinder, 1970.

Tugendkhol'd, Yakov. *Khudozhestvennaia kul'tura Zapada*. Moscow-Leningrad: GIZ, 1928.

Turowski, Andrzej. *Existe-t-il un art de l'Europe de l'Est?* Paris: Editions de la Vilette, 1986.

Tytell, John. *The Living Theatre: Art, Exile, and Outrage*. New York: Grove, 1995.

Van den Berg, Hubert F. "From a New Art to a New Life and a New Man: Avant-Garde Utopianism in Dada." In *The Invention of Politics in the European Avant-Garde (1906–1940)*, edited by Sascha Bru and Gunther Martens, 133–50. Amsterdam: Rodopi, 2006.

Vaneigem, Raoul. *The Revolution of Everyday Life*. Translated by Donald Nicholson-Smith. Welcombe, UK: Rebel, 1983.

Vaughan, Mary Kay. *Cultural Politics in Revolution: Teachers, Peasants, and Schools in Mexico, 1930–1940*. Tucson: University of Arizona Press, 1997.

———. *The State, Education, and Social Class in Mexico, 1880–1928*. DeKalb: Northern Illinois University Press, 1982.

Vecchi, Ferruccio. *Arditismo civile*. Milan: L'Ardito, 1920.

Viénet, René. *Enragés and Situationists in the Occupation Movement, France, May '68*. Translated by Richard and Helene Potter. New York: Autonomedia, 1992.

Virno, Paolo. *A Grammar of the Multitude: For an Analysis of Contemporary Forms of Life*. Translated by Isabella Bertoletti, James Cascaito, and Andrea Casson. New York: Semiotext(e), 2004.

Visser, Romske. "Fascist Doctrine and the Cult of the Romanità." *Journal of Contemporary History* 1, no. 27 (1992): 5–22.

Wagner, Anne M. "Warhol Paints History, or Race in America." *Representations* 55 (1996): 98–119.

Walker, Ian. *City Gorged with Dreams: Surrealism and Documentary Photography in Interwar Paris*. Manchester: Manchester University Press, 2002.

Wark, McKenzie. *The Beach beneath the Street: The Everyday Life and Glorious Times of the Situationist International*. London: Verso, 2011.

———. *Fifty Years of Recuperation of the Situationist International*. New York: Temple Hoyne Buell Center for the Study of American Architecture, Princeton Architectural Press, 2008.

———. *The Spectacle of Disintegration*. London: Verso, 2013.

Watson, Steven. *Factory Made: Warhol and the Sixties*. New York: Pantheon, 2003.

Weber, G. "Constructivism and Soviet Literature." In *Soviet Union*, vol. 3, part 2, 294–310. Pittsburgh: Charles Schlacks, Jr., 1976.

Weigel, Sigrid. *Body- and Image-Space: Re-reading Walter Benjamin*. Translated by Georgina Paul with Rachel McNicholl and Jeremy Gaines. London: Routledge, 1996.

Whittam, John. *Fascist Italy*. Manchester: Manchester University Press, 1995.

Wigley, Mark. *Constant's New Babylon: The Hyper-Architecture of Desire*. Rotterdam: Witte de With, Center for Contemporary Art / 010 Publishers, 1998.

Wilde, Oscar. "The Soul of Man under Socialism" (1891). In *The Artist as Critic*, edited by Richard Ellman. Chicago: University of Chicago Press, 1982.

Wolin, Richard. *The Wind from the East: French Intellectuals, the Cultural Revolution, and the Legacy of the 1960s*. Princeton, NJ: Princeton University Press, 2010.

Wollen, Peter. *Raiding the Icebox: Reflections on Twentieth-Century Culture*. Bloomington: Indiana University Press, 1993.

Wu Hung, ed. *Contemporary Chinese Art / Primary Documents*. New York: Museum of Modern Art, 2010.

Wye, Deborah, and Wendy Weitman, eds. *Eye on Europe: Prints, Books and Multiples / 1960 to Now*. New York: Museum of Modern Art, 2006.

Young, LaMonte, and Jackson Mac Low, eds. *An Anthology*. New York: Young and Mac Low, 1963.

Zabel, Igor. "Icons by IRWIN." In *IRWIN Retroprincip*, edited by Inke Arns, 77–83. Frankfurt am Main: Revolver, 2003.

Zapponi, Niccolò. "La politica come espediente e come utopia: Marinetti e il Partito Politico Futurista." In *F. T. Marinetti futurista: Inediti, pagine disperse, documenti e antologia critica*, edited by S. Lambiase and G. B. Nazzaro, 221–39. Naples: Guida, 1977.

Zimmer, Lucien. *Un Septennant policier: Dessous et secrets de la police républicaine*. Paris: Fayard, 1967.

Živadinov, Dragan, ed. *Der Sturm in slovenska historična avantgarda / Der Sturm and the Slovene Historical Avant-Garde*. Ljubljana: Muzej in galerije mesta Ljubljane, 2011.

Žižek, Slavoj. *Filozofija skozi psihoanalizo*. Ljubljana: Analecta, 1984.

———. "From Symptom to *Sinthome*." In *The Sublime Object of Ideology*, 55–84. London: Verso, 1989.

Contributors

JOHN E. BOWLT is a professor of Slavic languages and literatures at the University of Southern California, Los Angeles, where he is also director of the Institute of Modern Russian Culture. He has written extensively on Russian visual culture, especially on the art of symbolism and the avant-garde.

SASCHA BRU teaches literary theory at the University of Leuven. He has published extensively on the European avant-gardes, including *Democracy, Law and the Modernist Avant-Garde* (2009).

DAVID CRAVEN was Distinguished Professor of Art History and Visual Culture at the University of New Mexico in Albuquerque. He is author of numerous books on Latin American modern and contemporary art and modernism, among them *Art and Revolution in Latin America, 1919–1990* (2002).

ALEŠ ERJAVEC is research professor in the Institute of Philosophy, Scientific Research Center of the Slovenian Academy of Sciences and Arts. His areas of interest are aesthetics, contemporary art history, and critical theory. He is the editor and coauthor of *Postmodernism and the Postsocialist Condition* (2003).

TYRUS MILLER is professor of literature and vice-provost / dean of graduate studies at the University of California at Santa Cruz. His books include *Late Modernism* (1999) and *Singular Examples* (2009). He edited and translated G. Lukács's post–World War II Hungarian writings, *The Culture of People's Democracy* (2013).

RAYMOND SPITERI teaches art history at Victoria University of Wellington, New Zealand. In his research and publications he focuses on the culture and politics of surrealism. He is the coeditor (with Don LaCoss) of *Surrealism, Politics and Culture* (2003).

MIŠKO ŠUVAKOVIĆ teaches aesthetics and art theory in the Faculty of Music, Belgrade. He has published twenty-seven books on art and philosophy of art and culture. With Dubravka Djurić he edited *Impossible Histories: Historical Avant-Gardes, Neo-Avant-Gardes and Post-Avant-Gardes in Yugoslavia, 1918–1991* (2003).

Index

Aristotle: *Poetics*, 2
Arkin, David: and productional art, 50
Arp, Jean, 107
art: abstract expressionist, 162; American pop art, 219; "antiart," 166–67; antisituationist, 191, 193; *art-action*, 10, 21, 25–27, 35, 37; art criticism in Russia, 62; artocracy (Marinetti), 39; autonomous, 2; baroque, 229; Chinese, 17n20; Chinese cynical realism, 220; classic, 167; dialogical, 117; didactic, 117; Eastern (East) European, 236; expressionist, 140; fascist, 250; historical, 256; introducing new styles and techniques, 2; of living, 16; Marxist art criticism, 46; minimalist, 147, 162, 228; modern, Dada and surrealism as its end, 203; Nazi, 218, 250; perestroika, 235; postsocialist avant-garde, 2, 9; productional, 50; pure, 116; revolutionary, 47, 115; Russian, from "alchemy" to "chemistry," 45; Russian conceptual, 219; socialist realism, 219, 228
Artaud, Antonin, 80, 92, 107, 165
Arts and Crafts, 5, 26, 63
Art Strike, 148
Art Workers' Coalition, 148
Arvatov, Boris, 50, 61–63, 73
autonomy of art, 147, 166; alleged, 20; relative, 141
avant-garde, 50, 57; aesthetic, 2–5, 9, 123, 128–40, 280–81; American, 159; artistic, 280; "classical," 2; cultural, 203; early futurist, 14; historical, 2, 27, 38; movements, 1; and NSK state, 250; political, 24; politicized, 2; postsocialist, 2–4, 7–8, 275; retro, 242–43; Russian, 17n11, 257; Situationist, 206; suprematist, 266; third-generation, 3, 7, 275–76

Babichev, Aleksei, 45
Bakhtin, Mikhail, 137
Ball, Hugo, 46, 218–19
Balla, Giacomo, 20, 265
Barbusse, Henri, 86
Baselitz, Georg, 217, 233
Battcock, Gregory, 162, 167–68
Baudelaire, Charles, 24, 39n18; and *Fleurs du mal*, 40
Baudrillard, Jean, 15

Bauhaus, 5, 61, 63, 139–40
Baumgarten, Alexander, 267–68, 283
beautiful: art of the, 2, 16; Croce's defense of, 10; Marinetti on "a racing car," 269
beauty: in Hugo, 24; idea of, in the "Oldest System Programme," 268; as "living form," 280–81; Marinetti on, 269; pure, 2; in Rozenkranz, 24; in Schiller, 268; in Schlegel, 23; and sentiment of the beautiful, 268; of the ugly, 24
Beckett, Samuel, 172
Belkin, Arnold, 127, 136
Bely, Andrei, 59–60, 62–63, 68–69
Benjamin, Walter, 37, 108, 146, 158, 162, 225, 257; and the glass house, 158; and image-space, 82, 95; on *Nadja*, 96–99; opposition between art and life, 82
Benn, Gottfried, 19
Benson, Michael, 235
Berghaus, Gunter, 26–27
Bergson, Henri, 68
Bernstein, Michèle, 181, 195, 199
biennio rosso (red biennium), 29, 40n34
Bishop, Claire, 208, 261
Bishop Metodii Zlatanov (Metropolitan of the Macedonian Orthodox Church), 218
"black radical imagination," 149
Boccioni, Umberto, 21, 31, 261
Boguslavskaia, Kseniia, 61
Bolsheviks, 6, 119, 257
Bolshevism, 95, 226; Bolshevik inspiration in *L'Age d'Or*, 102
Bowlt, John E., 10–11
Brakhage, Stan, 169
Braque, Georges, 89, 156
Brecht, Bertolt, 119, 121; "epic theater," 121–22
Brecht, George, 156
Brecht, Stefan, 165
Breton, André, 80–83, 85–89, 92, 95–96, 98, 158; celebration of Picasso, 89; condemnation of Ernst and Miró, 90–91; convulsive politics of the marvelous, 98; and the glass house, 158; marvelous as portal between cultural endeavor and political action, 86; and Marxist belief, 106; and PCF, 99
Brik, Osip, 61–63
Brodsky, Boris, 73
Brodsky, Isaak, 229

Brown, Norman O., 148, 150, 161
Bru, Sascha, 9–10, 262
Buchloh, Benjamin, 11; criticism of Bürger, 258
Bulatov, Erik, 220
Buñuel, Luis, 100, 102, 106; on the audience of
 Un Chien andalou, 111n67
Bürger, Peter, 4, 7, 17n11, 140; on Dadaism, 259
Burn, Ian, 146, 150
Burroughs, William S., 172

Cage, John, 152, 155–58, 172
Cale, John, 155–56, 168, 170
Calinescu, Matei: on avant-garde history,
 257–58
Canales, Alejandro, 126, 128–31, 133
Canifrú, Victor, 127
Cardenal, Ernesto, 125, 128, 132, 134
Cárdenas, Lázaro, 117, 119
Cardew, Cornelius, 159
Carrà, Carlo, 21, 31
Černigoj, Avgust, 228, 254n25
Cerrato, Leonel, 126, 133
Cézanne, Paul, 2, 115
Chien andalou, Un, 100–101, 111n67
China: avant-garde of the '80s, 8; and cultural
 revolution, 13, 147, 174n6, 276
Chtcheglov, Ivan, 185
Chto Delat?, 217
Chuzhak, Nikolai, 61–62
Clark, T. J., 209
Clarté, 87, 91–93
Claudel, Paul, 86
Clemente, Francesco, 217
Cobra, 14, 179, 194
commodity fetishism, 203
communism, 86–87, 93, 233, 247
communists, 37, 92
community: to come, 154; move from repre-
 sentation to transformation of, 2, 6; as seg-
 ments of society, 224; of sense, 6, 8
Conrad, Tony, 155–56, 159, 168
Constant, 179, 183, 186, 193–94
construction of situations, 14, 179, 182–83, 199
constructivism, 140, 217–18; Russian, 4–5, 9,
 10, 14, 42, 51, 54, 77, 115, 179, 256, 260; and
 NSK, 250
constructivists, 52, 76, 115

contemporary art, 275–76
Corradini, Enrico, 22
Courbet, Gustave, 256
Craven, David, 12–13
Crevel, René, 107
Critical Art Ensemble, 274
Critical Mass, 274
critical theory: Debord on, 213n92; Foster on,
 147
Croce, Benedetto, 22, 24–25, 37; and *terza
 pagina*, 21
Cuba, 7, 13, 23, 29; rejection of socialist real-
 ism, 125; revolution in, 141
cubism, 2, 5, 17n11, 72, 115, 140, 259, 279, 280;
 cubist collage, 142; introducing new styles
 and techniques, 2; Rivera on, 278; Siquei-
 ros on, 115
cubo-futurism, 59, 218
Čufer, Eda, 232, 236
Cunningham, Merce, 172

Dada, 13–14, 88, 115, 182, 185, 189, 203, 218; Ber-
 lin, 125, 140; Dadaism, 17n11, 204, 249, 257,
 259; Dadaists, 6; nihilism of, 93; neo-, 159
Dalí, Salvador, 100, 103
D'Annunzio, Gabriele, 38
Darío, Rubén, 128
Debord, Guy, 167, 179, 181–82, 186–87, 190, 192,
 196, 198, 203–8; criticism of surrealism, 83,
 107; on Dada, 261; on difficult fusion of art
 and politics, 210n13; "unified vision of art
 and politics," 5
de Duve, Thierry, 152, 261
de Felice, Renzo: futurist "ideology," 40n46
Delak, Ferdo, 228, 254n25
Deleuze, Gilles, 146
Department of Pure and Applied Philoso-
 phy, 217
Depero, Fortunato, 20
dérive, 14, 83, 183, 274
de Sade, 101
Desnos, Robert, 108
De Stijl, 5
Destruction of RSG-6, 194–99
détournement, 14, 83, 186, 189–90, 199, 202,
 204, 274
Diaghilev, Sergei, 70; Ballets Russes, 90–92

Dickerman, Leah: on Dada's "New Man," 266
distribution of the sensible, 114; its redistribution, 13
Dostoevsky, Fyodor, 77
Drevin, Aleksandr, 67
Ducasse, Isidore, 189
Duchamp, Marcel, 170, 172, 259; and "art in general," 152; and ready-mades, 24

East (Eastern) Europe: artists from, 228; identity of, 237; postsocialist avant-gardes from, 7, 215
Eisenstein, Sergei, 66, 122–23, 125, 138; montage, 121; on Orozco, 123; *Que Viva Mexico!*, 120
Éluard, Paul, 95, 107
Ender, Boris, 67
Engels, Friedrich, 58, 139
Ermilov, Vasilii, 64
Ernst, Max, 87, 103, 107; and Ballets Russes, 90–92, 110
eroticism, 162; erotic textures, 160; pan-eroticism, 160
Exploding Plastic Inevitable, 169–71
expressionism, 5, 140, 259; abstract, 2; American abstract, 179; German, 17n11, 229
Exter (Ekster) Aleksandra, 43, 45, 53, 55, 61, 64, 77; design for film, 52

fascism, 10, 28, 37, 119, 121, 179, 226, 257, 283; art, 218
Filonov, Pavel, 46
$5 \times 5 = 25$, 10, 43–45, 72
Flaker, Aleksandar: on utopia and "optimal projection," 262–63, 267
Florensky, Pavel, 69
Fluxus, events, 152–53, 155–56, 159
Flynt, Henry, 153, 155
Fonseca, Carlos, 131–32
Foster, Hal, 147, 258; "rereading" of Bürger, 258
Foucault, Michel, 270
Fourier, Charles, 140
Freire, Paolo, 139; and dialogical cultural policies, 126, 139; pedagogical theory, 138–39
French Communist Party (PCF), 11, 14, 81, 87, 98–99, 105, 274; wisdom of surrealists joining, 95

Freud, Sigmund, 163; Freudian and post-Freudian theories, 161, 167
Freudo-Marxism, 161, 167
Friche, Vladimir, 51
futurism, Italian, 4, 6, 9–11, 17nn11–12, 19–23, 26, 29, 31, 34, 130, 182, 256–57, 261, 264–65, 278; aesthetic project, 31, 47; artistic-political project, 34; autonomy, 38; bringing artists to power, 36; democratic political constellation, 45; expanded notion of art, 20–23, 26–29; "founding event of modern art in Europe," 19; futurist democracy, 36; Futurist Political Party (FPP), 28, 31, 35, 281; impulse in politics, 40n46; introducing "the fist into the struggle of art," 23; life as a work of art, 36; manifestoes, 20–23, 25–27, 32–33; *parole in libertà* (words in freedom), 32; Poggioli on, 28, 139; power to artists!, 36; second phase, 38; sublation in life, 34; words-in-freedom, 34
futurist moment, 267
futurists, 20, 27, 29

Gabo, Naum, 51–52, 61, 64, 69–71
Gan, Aleksei, 44, 54, 61, 63
Gao Minglu: on Chinese avant-garde artists, 7
García, Manuel, 126, 134–35
Gastev, Aleksei, 52
General Idea, 217
Gesamtkunstwerk (universal work of art), 26, 63, 226
Ghil, René, 25
Ginsberg, Allen, 150, 172
Ginzburg, Moisei, 45, 56
Giolitti, Giovanni: reform, 29
Gollerbakh, Erik, 61
Gombrich, Ernst, 2
Goncharova, Natali'a, 55
Goodman, Paul, 161
Goya, Francisco de, 24
Gramsci, Antonio, 26, 31, 35, 134, 146
Gray, Camilla: on Tatlin's *Monument*, 11
Greenberg, Clement, 161–62; his normative formalism, 114, 128
Greenwood sisters (Grace and Marion), 127
Gris, Juan, 114
Grohar, Ivan, 233, 235

New Left, 150, 162; German, 274
New Realism, 218
Nicaraguan mural movement, 12, 126–28, 133; postapocalyptic murals, 135
Nico, 168–70
Nietzsche, Friedrich, 197
Niki de Saint-Phalle, 196
Novalis, 24
Nova revija, 233
NSK State in Time, 15–16, 223, 225, 236–37, 241, 243–44, 248, 277; as the first global state in the universe, 245; First NSK Citizens' Congress, 245–46; and "geography of time," 240; as a new medium, 242

O'Doherty, Brian, 172
O'Higgins, Pablo, 126
Oiticica, Helio: and the concept of "cre-leisure," 273
"Oldest System Programme of German Idealism," 268–69
Orozco, José Clemente, 12, 122, 124–25; *Catharsis*, 123, 126, 130, 133; "socialization of art," 138
Ortega, Daniel, 132, 134

Pachon, Avi, 245
Papini, Giovanni, 22; on futurism, 263–64
Parinaud, André, 107
Parti communiste français (PCF). *See* French Communist Party
Paz, Octavio, 123
Péret, Benjamin, 95, 107
Perez de la Rocha, Roger, 126
performances, 160, 163; Julian Beck and Judith Malina, 167; Living Theatre, 165–67
Perloff, Marjorie: futurist manifesto as precursor of conceptual art, 26
Pevsner, Anton (Antoine), 51–52, 69, 108
Picasso, Pablo, 64, 90; *Demoiselles d'Avignon*, 108n15, 114; reliefs, 64
Pinot Gallizio, Giuseppe, 180–81, 183, 188, 193
pintura campesina (peasant painting), 134
Piotrowski, Piotr, 220
Piscator, Erwin, 254n25
Plastic Exploding Inevitable, The, 170–71
Poggioli, Renato, 12, 113, 139–40, 258; artistic

and political components of human social existence, 267; on avant-gardes, 139; on modern Mexican painting, 142
politics: fusion of art and, 5; futurism's "turn to," 22, 28; futurist practical, as artistic practice, 37; political dimension of experience, 2; problem of, in Schiller, 3; Rancière on, 137; unified vision of art and life, 9
Pomerand, Gabriel, 179
Poniatowska, Elena, 119
Popova, Liubov', 43, 45, 47–48, 54–56, 61, 64, 77; advance from "art" to "science," 72; construction for *The Magnanimous Cuckold*, 73; textile and stage design, 47, 49, 71
post-avant-gardes, 7
postmedium, 15, 218; as artistic condition, 223, 241; and art practice, 224; as "open and flexible events," 224; postmedia art practice, 223, 253n15; state as postmedium practice, 224
postmodernism, 7–8
post-Nietzschean position, 37
Prešeren, France, 233–34
Prezzolini, Guiseppe, 22
Proletkult (Proletarian Culture), 46, 62
Protazanov, Yakov, 52
Psychogeographical Society, 181
Psychogeographic Guide to Paris, 185–86
psychogeography, 184
Puni, Ivan, 55, 61, 77
Punin, Nikolai, 51, 61–63

Ramírez, Sergio, 132
Rancière, Jacques, 3–5, 137–38, 174n16, 225, 265–66, 270–71; aesthetic regime of art, 259, 272, 275, 279; on aesthetics, 270; and Freire, 139; and the Greeks, 279; on Kant and Schiller, 271
Raqs Medial Collective, 217
Raunig, Gerald, 146, 154; on cultural revolution and three "moments," 148
Rauschenberg, Robert, 172
Ray, Man, 103, 107
realism, in Russia, 60
Reed, Ishmael, 172
Reed, Lou, 155, 168, 170

socialist pluralism, 126

socialist realism, 121, 218

society of the spectacle, 180, 189, 203

Soffici, Ardengo, 22

Soupault, Philippe, 87, 92

Spartacus (Marxist revolutionary movement), 260

spectacle, 15, 190, 198; critique of, 14; society of, 179

Spies for Peace, 198

Spiteri, Raymond, 11–14

Stalin, Joseph, 132; and aesthetic state, 271; on artists, 230; his cult of personality, 132; era of, 54, 77

State in Time, 216, 223–25; NSK, 7, 9, 16. *See also* IRWIN

Stenberg, Georgii and Vladimir, 44–45, 64, 70–71, 77

Stepanova, Varvara, 43–44, 50, 55, 67, 73

Superstar, Ingrid, 172

suprematism, 45, 64, 75, 217; Malevich's invention of, 59; and NSK, 250

suprematists, 59

surrealism, 9, 11–14, 93, 101, 162, 179, 182, 189, 203–4, 257, 275; as aesthetic revolution, 99; appeal to the marvelous, 94; and communism, 98–99; contested space between culture and politics, 11, 81; and critique of revolution, 83–84; cultural contestation, 84; profane illumination, 95; as "psychic automatism in its pure state," 85; simultaneous pursuit of cultural and political goals, 84–86, 89, 93, 107

surrealists, 5–6; early, 4; opposition to Ballets Russes, 92; Russian symbolists, 59, 68

Šuvaković, Miško, 8, 15

syndicalism, leaders of, 21

Szabolcsi, Miklós: on pseudo-revolution, 4–6, 137, 260, 279

Tanguy, Yves, 103, 107

Tarabukin, Nikolai, 44, 61, 63

Tatlin, Vladimir, 11, 43, 45, 50, 54, 61, 64, 66, 69, 71, 74, 77; "culture of materials," 45; hang glider, 65, 70, 76; machine art, 260; *Monument to the III International*, 11, 43–44, 54, 64, 69, 74–75, 77; Picasso's violin reliefs, 64, 78n35; *The Store*, 82

Ternovets, Boris, 73

Thaler, Zoran, 242

Theater of the Sisters of Scipio Nasica, 217, 230, 232–34

Tieck, Ludwig, 24

Tito (Broz, Josip), 220; and Day of Youth celebration, 229

totalitarianism, 17, 28, 218

trans-avant-gardes, 7

Tropicália, 273

Trotsky, Leon, 51, 88, 121, 225

Tsiolkovsky, Konstantin, 75; and afterlife, 76; and orbiting space platform, 76; and "space elevator," 75

Tugendkhol'd, Yakov, 46, 55

"ugly," the, 23–25, 37, 39n12; Marinetti's preference for, 10; in modern aesthetics, 25; ugliness/beauty, 25; ugly practices, 27

Unik, Pierre, 95

unitary urbanism, 14, 83, 179–81, 183, 185, 191, 199

USSR in Construction: Rodchenko's black-and-white photography, 66; Rodchenko's and Lissitzky's design work, 278

VanDerBeek, Stan, 159, 172

van der Rohe, Mies: and the glass house, 158

Vaneigem, Raoul, 192

Vasconcelos, José, 12

Vecchi, Fearrucio, 37

Velvet Underground, 155, 168–72

Verne, Jules, 75

Vertov, Dziga, 66, 138

Vesnin, Aleksandr, 43, 55–56, 58, 70

Vidmar, Josip: "Slovenian Athens," 235

Viénet, René, 200, 202

Vitrac, Roger, 80

Vkhutemas (Higher State Art-Technical Studios), 47

Vogel, Hilda, 12, 134–35

vorticism, 116

Wagner, Richard, 26. See also *Gesamtkunstwerk*

Walden, Herwarth, 216